10/03

Transgressions
The Offences of Art

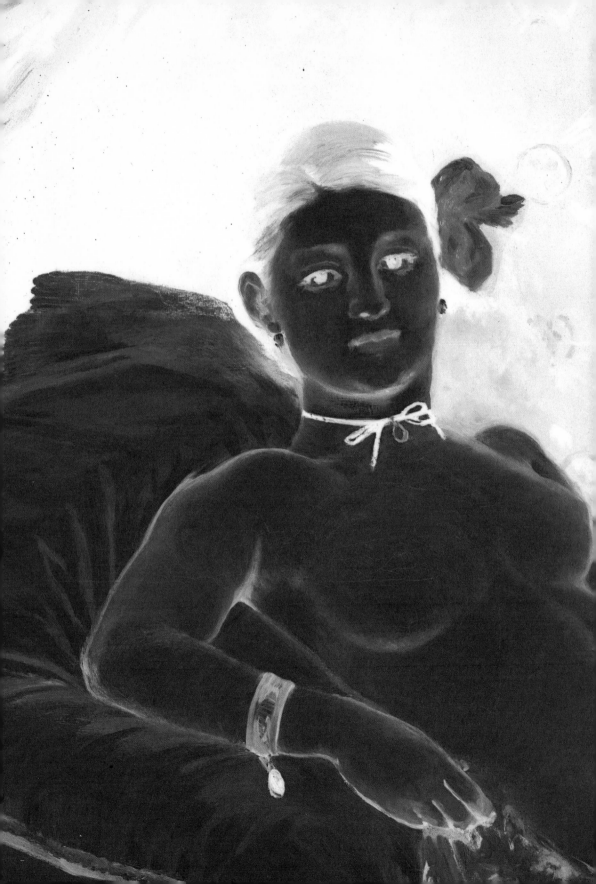

ANTHONY JULIUS

Transgressions
The Offences of Art

THE UNIVERSITY OF CHICAGO PRESS

First published in the United States of America in 2003
by The University of Chicago Press, Chicago 60637

© 2002 by Anthony Julius

First published in the United Kingdom in 2002
by Thames & Hudson Ltd, London
Printed in Italy

12 11 10 09 08 07 06 05 04 03 1 2 3 4 5
ISBN: 0–226–41536–8 (cl)

Cataloging-in-Publication Data is available

Frontispiece: Edouard Manet, *Olympia* (detail), 1863

This book is printed on acid-free paper.

Acknowledgments

The first thoughts about a book on art transgressions came to me during a conversation with Nikos Stangos, and it is to him therefore that I owe my first thanks. I cannot imagine a better editor: he has read every draft, suggested lines of inquiry, and provided invaluable advice. Thames & Hudson have been exemplary publishers, giving every encouragement and barely complaining when deadlines passed. Since Dan Jacobson was appointed my PhD supervisor at University College London, back in 1990, he has been a mentor and a friend. He took immense pains over two drafts of this book, and it has benefited from his attention. Though I have not accepted (probably unwisely) every suggestion that he made for improving the book, the very process of resisting these suggestions was immensely clarifying. Many of the book's arguments were also rehearsed with Marcel Borden during our weekly Talmud sessions, and I am grateful to him for his patient interest. I am also grateful to Andrew Wylie and Rose Billington for advice and encouragement. Many thanks also to Dr Elena Schiff for her flawless index.

I could not have written this book without the support and involvement of my beloved wife, Dina Rabinovitch. Our five youngest children (at the time) were the ones on the floor in the art galleries, with pencils and notebooks, making very good drawings, asking loudly when was it time to go to the coffee shop, and how come none of the characters from the TV show *Friends* ever has to set foot in a gallery. I dedicate this book to all our children, to Max, Laura, Chloë and Theo, to Sara-Jenny, Marganit and Nina, and to Elon Lev.

Contents

Foreword 7

I A Transgressive Work and its Defences 14

A Thought-Experiment • The Transgressive • Celebrating the Transgressive •
The Three Defences

II A Transgressive Artist: 52
The Origins of the Transgressive Period

The Period • Flaubert/Manet • The Female Nude • Jesus Crucified •
An Anti-Genre • Genres, Types, Aspects

III A Typology of Transgressions 100

The Three Types • Violating Art Rules • Breaking Taboos •
Disobedient Art • Baudelaire/Manet

IV The End of Transgressive Art 186

Demoralising the Audience • Demoralising the Artist • Art's Vulnerability

V Coda: Every Work of Art Is an Uncommitted Crime 222

Bibliographical Essay 236

List of Illustrations 265

Index 270

'The variegated richly coloured plumage of birds shines even when unseen, their song dies away unheard; the torch-thistle, which blooms for only one night, withers in the wilds of the southern forests without having been admired, and these forests, jungles themselves of the most beautiful and luxuriant vegetation, with the most sweet-smelling and aromatic perfumes, rot and decay equally unenjoyed. But the work of art is not so naively self-centred; it is essentially a question, an address to the responsive breast, a call to the mind and the spirit... Every work of art is a dialogue with everyone who confronts it.'

G.W.F. Hegel

'All theories which attempt to direct or control the Arts, upon any principles falsely called rational, which we form to ourselves upon a supposition of what ought in reason to be the end or means of Art, independent of the known first effect produced by objects of the imagination, must be false and delusive. For though it may appear bold to say it, the imagination is here the residence of truth. If the imagination be affected, the conclusion is fairly drawn; if it be not affected, the reasoning is erroneous, because the end is not obtained; the effect itself being the test, and the only test, of the truth and efficacy of the means.'

Sir Joshua Reynolds

'Laws, moralities, aesthetics, have been created to make you respect fragile things. What is fragile should be broken.'

Louis Aragon

Foreword

This book is about transgression in the visual arts of the modern period, which I take to extend from the 1860s to the present time (there are other views). My purpose is to seek to understand a phenomenon that is more often referred to than it is analysed. I first began thinking about the subject when I was commissioned in late 1997 by the *New Statesman* magazine to write about censorship of the arts during that year. My conclusion was that the year had been rather better for the cause of artistic freedom than it had been for art itself. A year or so later, I gave a paper, 'Art Crimes', at a law conference. The paper subsequently appeared in *Law and Literature: Current Legal Issues* (1999). I defined an art crime as a crime committed either against art or by art (or both: by art against art).

1997 was the year of *Crash*, a film directed by David Cronenberg, A.M. Holmes's novel about paedophilia, *The End of Alice*, 'Smack My Bitch Up', a song written and performed by the pop group Prodigy, and Marcus Harvey's *Myra*, a portrait of the murderer Myra Hindley, which had been exhibited that autumn in the Royal Academy's 'Sensation' show. There were fusses made about the works, but none was suppressed (only the film was put off for a while, and in circumstances that caused the censors to look ridiculous). Scandal gave a unity to these works, otherwise so divergent both in kind and merit. It was as if the common capacity to provoke outrage was a family resemblance that had unexpectedly been disclosed. The works were taken to adopt immoral, injurious perspectives on aspects of sexual violence: the murder and abuse of children, assaults on women, the eroticising of physical injury. Immoral, because they did not condemn the vices that they represented or to which they alluded; injurious, because this failure to condemn was thought to encourage imitative harm to others. These criticisms, it was rejoined, mostly missed their mark, because they confused wicked acts with their depiction, and moral rules with sentimental pieties. They derived, so it was suggested, from incoherent notions concerning both 'art' and 'audience'. And they

neglected art's role, which is to conquer taboos, mere social prejudices from which art can emancipate us.

This last response was made by Norman Rosenthal, the curator of 'Sensation'. He offered a glib, unnuanced endorsement of the works in the exhibition; one badly in need of correction. I was tempted to try, but in the end did not. It would have meant attempting a definition of transgressive art, and I was not quite ready for that undertaking. Instead, I offered qualified dissents to two commonly held positions regarding taboo-breaking in art: that it is always good, and that objections to it are always misguided and oppressive. I argued that taboo-breaking often wounds our sensibilities, causing us distress without enlarging our imagination, and that the censure of artists who make such artworks is within the range of legitimate responses to them. And I made a distinction between an artwork's opponents, and its critics. While the former merely strive to suppress it, the latter engage with the work, meeting its challenges with interpretations that are also judgments.

In 'Art Crimes' I argued for the creative complicity of art with crime, and isolated for special attention artworks that are crimes against other artworks. These are crimes *of* art that are also crimes *against* art – art preying upon art. In its efforts to protect art in general, the law will often outlaw particular instances – works, for example, that contain a high degree of borrowed material. I termed these strong art crimes. Transgression is essential to such artwork-crimes. It is precisely because artists force the boundaries of what is held to be art, I proposed, that they also force the law's boundaries. Just as aesthetics is said to lag behind art, so law lags behind aesthetics. There is, of course, a certain retrograde aesthetics implicit in the law itself, which is what both produces and then validates its proscriptions. Graffiti, for example, is a crime that is constructed out of the clash of alternative aesthetics (each side cries, 'Crime!'; the one for marking walls, the other for erasing the markings); and though forgery likewise is a crime, it is not a 'natural' one, because it derives from historically specific notions of writing and authorship.

This leads, from the perspective of artists, to a certain disrespect for law, a qualified antinomianism: law has no place in art, there should be no constraints on the imagination. It is the sheer clumsiness of legal interventions in the art world that most exasperates art's champions. From the perspective of moralists, by contrast, artists deserve no greater licence than any other citizen. Art – or rather, artistic status – excuses nothing. Moralists need not be Platon-

ists. They do not mistrust art; they merely hold that it should not have any special privileges. Art is liable to offend, say, against laws of decency; when it does, it should be prohibited. If art's security is to be ensured by excluding certain of its instances from law's ambit, so be it. I concluded that these two positions, the artist's and the moralist's, cannot be reconciled, and that there is no third position available to harmonise the contrary perspectives. We remain in the realm of discretion and contention. Should this or that work be prosecuted? Should this or that defendant be able to plead the aesthetic status of his or her work as a defence? These questions remain inescapable; no grand synthesis will eliminate them. Law and art will remain in tension; the best that writers and critics can do is to describe the various aspects of their conflict.

These two pieces, an article and a lecture, I now see, were preliminary steps towards the writing of this book. The first attempted a defence of the practice of 'censureship' (as distinct from censorship) under certain ideal conditions: the articulating of critical opposition to specific artworks in a climate that does not foster their suppression. It was argumentative and partisan, in keeping with the requirements of weekly 'comment' pieces. Had I been aware of this formulation of the case against censorship by art historian David Freedberg, I would have adopted it: by refusing its dangers, censorship takes away art's possibilities. The second was analytical, and set out to offer a novel classification of a limited number of kinds of artwork. The first piece was about the art of one year; the second piece ranged over the arts of many periods. On reviewing the two of them, I saw that what was needed was an account that itself broke free of law, one that did not concern itself with the question of censorship (or its benign alternative), and that grasped the historicity of the transgressive. *Transgressions* is that account. It is, among other things, a personal account, because it is about the nature of our engagement with transgressive art, and this 'our' must, at least in the first instance, mean 'my'. If I am to inquire into how we respond to a particular work, I must begin by asking myself how *I* respond to it. I have to trust that this approach will not lead me astray. And if I run the risk of falsely speaking on behalf of others when I speak on my own behalf, I also run the risk of contradicting myself in my desire to capture the sheer contradictoriness of our response to transgressive artworks: excitement, recoil, enthusiasm, dismay. I likewise have to trust that these tensions are real, rather than defects of logic or incoherences in my own exposition.

I regard the transgressive as being, among other things, a determinate aesthetic, one that promoted the making of artworks of a certain kind during the modern period. While it also has had implications for literature, I have chosen to limit myself to the visual arts, in part because it seems to me that it is here that one finds the aesthetic potential of the transgressive most fully explored. (One reason among others: while any object is at least eligible as art, literature remains subject to considerable formal and material constraints.) I have also limited myself to the art of the West, in part because it seems to me that it is here that the aesthetic potential of the transgressive has been exhausted. Given these limits, then, a story presents itself that has both a beginning and an end. To tell the story, I have had to neglect precursors. I have little to say, for example, about Courbet, even though his engagement with the genre of the nude was in many respects as radical and as subversive as Manet's. I am sceptical about claims made for the ethical value of certain transgressive artworks; I do not believe that the commonly advanced arguments offered in defence of these works adequately describe them. The estrangement, formalist and canonic defences (which I describe in chapter I) do not provide, that is, a satisfactory account of the works that they are routinely deployed to protect. They contain much truth. They have helped the reception of modern artworks. They should not (indeed, cannot) be discarded. They have become mere reflexes of art criticism, however, and they impede understanding of contemporary art in particular, and therefore also of art's direction. They are as historically specific as the artworks that they came into existence to defend.

Artworks are still made under the rubric of transgression. The transgressive continues, though only just, to provide contemporary art with a working aesthetic. It is, however, in a somewhat exhausted condition. New art, new contexts, and new defences and explanations are emerging. So it is a good time to survey the time when there was an art that was 'transgressive'. The survey, to be precise, is of what I take to be representative works drawn from what the 19th-century German philosopher G.W.F. Hegel described, in a phrase that mixes despair, awe and delight, as 'the immeasurable realm of individual works of art'. These are the works that interested me the most during the months that I spent planning this book. I found them rewarding to think *about*, and also rewarding to think *with*. There is an element of the arbitrary in the selection; no doubt some of my arguments would be different, or at least differently nuanced, had I chosen other works to write about. (Artworks will

always do more than illustrate theses; indeed, they have a tendency, on close scrutiny, to undo the very theses that they are said to support.) Exposure to many of these works was for me sometimes an exhilarating, and sometimes a demoralising, experience. And more often than might seem possible, it was both exhilarating *and* demoralising. I hope that this book registers something of the complexity of emotion of these various encounters. While it has its own rigour, I trust, it remains personal, through and through. In the prehistory of the book, its very first moment found me walking, troubled and unhappy, among the artworks on display in the 'Sensation' exhibition. My book no doubt bears the traces of this experience, too.

I make five, overlapping approaches to transgressive art: by reference to the meaning of the 'transgressive' and the common defences of transgressive art (chapter I); by reference to its origins in Edouard Manet's work, and its implications for some important art genres (chapter II); by reference to its ideal types, or versions (chapter III); by reference to its limitations, and its end (chapter IV); last, by reference to an epigram of Adorno's, 'Every work of art is an uncommitted crime' (chapter V). These approaches are driven by coexistent, discrepant impulses. I wish both to do justice to the specificity of the artworks that have prompted my inquiry *and* to locate them on the conceptual grid of the 'transgressive'. Where the tension between the two has become acute, I have tended to subordinate grid to specificity. My object is to devise methods for understanding, not trapping, those artworks that appear to me to be transgressive. The analytical categories that throng these chapters are thus provisional, porous, ultimately dispensable. I accept, however, that a certain impoverishing of the wealth of the real (Umberto Eco's phrase) is the price to be paid for the devising of even the most tentative of categories. My concern with the transgressive in art is not neutral as to period; it is not, in the jargon, 'panchronistic'. This is because, though I am not writing a history, the arguments that I develop are grounded in a sense of the defining contours of a distinct period, our own. It is one characterised by a certain conceptual lawlessness. Circulating today in the art world are a plurality of aesthetics, a multiplicity of art practices. Though some are more fertile of new work than others, none has any acknowledged precedence over any other. There are no agreed principles by which artworks may be made and judged; there is no umbrella-aesthetic under which works and their audiences may shelter. This is a consequence, in part, of the transgressive aesthetic itself. It is, in a sense,

both an aesthetic and an anti-aesthetic. Transgressive art is an art of the subversive exception made the rule. It is ruler and revolutionary in one. It has made a new, overarching aesthetic regime impossible. It is both glue and solvent, both theory and theory-virus.

Opening the Great Exhibition in 1851, Prince Albert spoke of the international nature of communication and knowledge, a world without borders. Such views were plainly already commonplace, and since then artists have endeavoured to reflect this disrespect for borders in their own work, even to celebrate it, as in the blurred state lines of the American artist Jasper Johns's *Map* (1962). Echoing the prince some hundred years later, the modern American artist Leon Golub explained that 'the new communication empires do not respect national or conceptual borders'. Artists, he said, are like 'sewer rats', low, subversive versions of just these empires, similarly disregarding boundaries and borders as they dart through imaginary underground passages, indifferent to the laws that constrain those who live above ground. The image is an instantly recognisable one, of course, and it invites a kind of unreflective assent. (Thus Chagall: 'since the Renaissance, national art has started to decline, and boundaries have become blurred.') Works of visual art, unhampered by literature's special difficulties with translation, have an international aspect, however rooted they may be in a particular culture. They are accessible, even when local. Artists themselves travel to discharge commissions. Yet as an impression of the actual activities of artists in the last 150 years (which is as far back as one can go if 'artist' is to have any single, determinate meaning), Golub's remarks are unreliable, not least because they collapse a number of real boundaries into a single, metaphorical one. The truth is that the notion of the 'transgressive', on which Golub depends to secure that ready recognition from us, has become a cliché of modern culture. It needs to be looked at afresh.

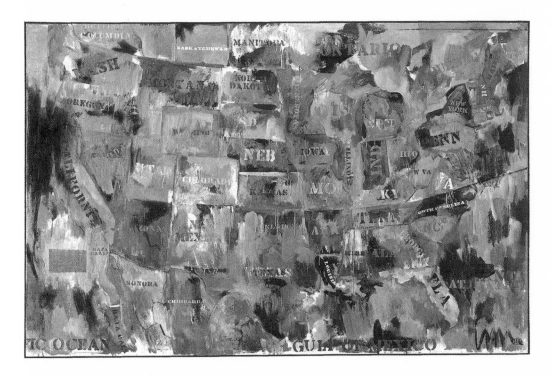

Jasper Johns
Map
1962

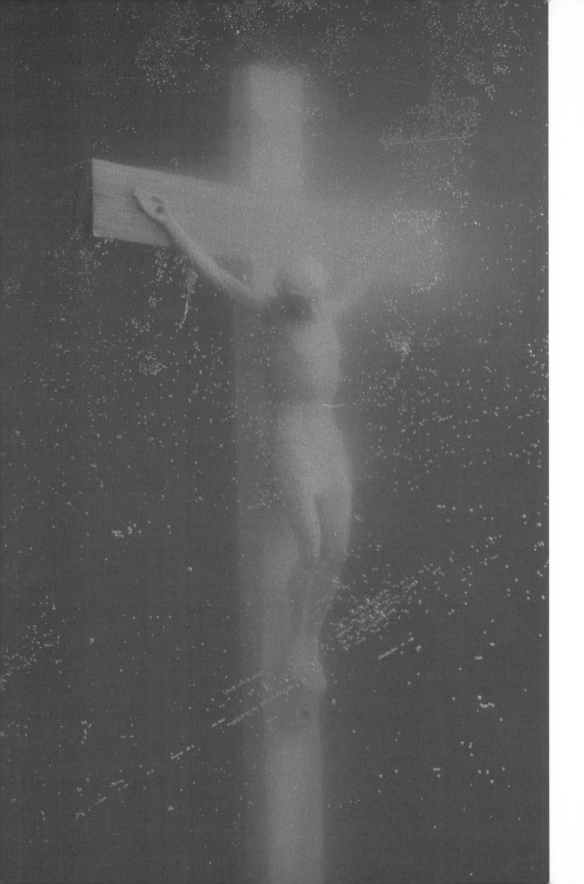

I

A Transgressive Work and its Defences

A Thought-Experiment

Imagine yourself in a gallery. You turn into a room and are confronted with an image. The title is printed near the work, but you look away from it. You do not, or not quite yet, want your impression of the work to be limited by the artist's text. You do not want to know what the work is about, you want to contemplate what it is. You want the image to do its own work, unaided by any supporting, explanatory words. Now suppose that the work that stands before you is a photographic composition by the contemporary American artist Andres Serrano. What do you see? A gallery piece, 60 by 40 inches, as large as a 19th-century history painting. It is a picture of a crucifix, submerged and indistinct, suspended in a hazy, golden substance. The composition has a blurred, rather conventional beauty. There is even something slightly kitsch about it. The crucifix, an image of torment and suffering, is made indistinct by the unidentifiable element in which it floats. The pain of the Crucifixion is thereby veiled, as if behind a liquid screen. The work itself is a photograph of silence, and it muffles the horror of its subject. One could even say: it is in retreat from the atrocity of the scene. In this reticence, it is like nothing so much as the similarly intimidated, veiled *Crucifixion* (1897) of the French Symbolist Eugène Carrière. That is to say: innocuous, reverential, obscure.

You might then move on. But you recall that you have not checked the title, and so you read the printed text mounted next to the work: *Piss Christ*. It has an immediately jarring effect. Doubly so, indeed. In its rebarbative directness, it startles you (for sure), but it is also at odds with the work itself. So much soft-focus beauty, such in-your-face belligerence. And so you recoil,

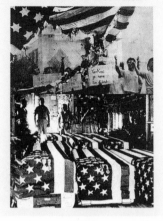

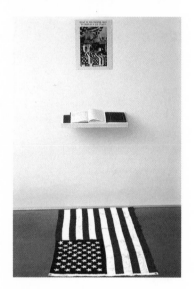

Dread Scott
*What Is the
Proper Way to
Display a U.S. Flag?*
1988

and then you look again. Your initial bafflement – what is that liquid? – is resolved. But what else does the title add to your contemplation of the work? It tells you, not entirely neutrally, that the work presents an image of Christ in urine. It implies, but does not state, that the urine is the artist's. It also implies, inescapably, that the work is the record of an act of disrespect. It is a joke at the expense both of its subject and of its audience. The picture invites reverence; the title mocks us for gullibly offering it. One risks under-interpreting the work if one overlooks this baiting of the spectator. It is a jeer, a *blague*, in the sense given to it by the 19th-century French writers the Goncourt brothers: 'that laughter which jeers at the grandeur, the holiness, the majesty, the poetry of all things.' It defiles. The title is a declaration by the artist: this is what I did to a crucifix, I urinated on it. (This is not the work's only meaning, but it *is* – contrary to the case made for it by some of its advocates – part of that meaning.) The work itself is an assertion of artistic authority: this is how powerful an artist can be, he is able to mock the principal icon of the Catholic Church. *Piss Christ* (1987) traps spectators into uttering a blasphemy, just as spectators who wished to answer the question posed by Dread Scott's work *What Is the Proper Way to Display a U.S. Flag?* (1988) were trapped into walking on the United States flag, thereby demeaning it. The artist thereby makes spectators accomplices in his own transgression. Above all, the title announces: 'this is a transgressive work.' It tells us what it is, and how to look at it. Its name declares its aesthetic purpose. It (a) conforms to several of the current meanings of the words 'transgressive' and 'transgression'; (b) invites our approval as an instance of the transgressive, a culturally valued kind of art; (c) solicits our protection from its enemies (which protection we can provide by the deploying of three defences).

The Transgressive

What then does it mean to describe an act or work as transgressive? There is a primary, theological sense of transgression. It is a sin, a super-crime, an

offence against God. In Milton's *Paradise Lost*, for example, Adam and Eve 'transgress his [i.e. God's] will' when they eat the forbidden fruit. Blasphemy is thus meta-transgressive. The violation of God's name, with the immediate sanction of death, is the very model for the transgressive. The negative charge of this meaning is complicated in its usage by a certain antinomianism, a positive celebration of law-breaking. It is by our law-breaking that we disclose our state of grace. One finds this meaning in St Paul. So there is a founding tension. Transgressions are both the best and the worst kind of law-breaking, which can perhaps be compressed thus: transgressions are outrages that can liberate. These meanings were points of departure. They were then secularised, and diluted.

When St Paul writes, 'where no law is, there is no transgression' (Romans 4:15), he intends more than the obvious point that, to be broken, laws must first exist. What he means is that law itself promotes wrong-doing, and that its very existence is evidence of our unregenerate state. Paul is scathing both about law and about our predisposition to transgress. Law does not civilise; but transgressions do not liberate. He is hard on law because when he writes about it he usually has in mind Jewish ritual, which is his enemy. He is hard on transgressions because of his conviction that, without belief in Jesus as the Messiah, and the grace that this belief is supposed to confer, we break even bad laws at our peril. But while his understanding of what makes us transgress is complicated by his hostility to law, there is no doubt that transgression itself is associated, both for him, and generally in the Christian Scriptures, with everything that is evil and worthless. For example, St John writes, 'Whosoever transgresseth, and abideth not in the doctrine of Christ, hath not God' (2 John 9). He is thinking of those who decline to accept Jesus' divinity, so that here 'transgression' is not a determinate breach of the law, but a state of mind or being, a perverse refusal to acknowledge the truth and authority of the Christian witness. Though this sense of the word has faded over time, it has a new resonance when we think about precisely how certain modern artworks might 'transgress'. *Piss Christ*, for example, 'abideth not in the doctrine of Christ'.

'Transgression' entered the English language in the 16th century, freighted with these negative scriptural meanings. The word was soon secularised to describe disobedience of the law. It was then enlarged, first to include the violating of any rule or principle and then to embrace any

departure from correct behaviour. 'I shall not spend time, and transgress on the reader's patience,' remarks a considerate mid-17th-century author. And, in this broadening of meaning, expanding from questions of theology to those of mere good manners, by the end of the 17th century 'transgressions' came to include digressions: deviations from the rule of one's discourse. It is a transgression, for example, to do violence to the natural givens, the *données*, of everyday life. Transgressions thus reach up to the most serious of misdeeds and reach down to the most inconsequential of solecisms. A 'transgression' is the name of the worst offences and of any offence.

Parallel to this expansion lie two additional developments in meaning. 'To transgress' acquires in the 16th century (though then later loses) a transitive sense: the transgressor 'transgresses against' a person, offending in some very serious manner. 'Transgression' here detaches itself from rule-breaking and becomes instead a kind of assault, although not necessarily a physical one – an insult, perhaps, or a provocation. It is not the rule that is violated, but the person. It acquires this meaning: an act of aggression that causes injury. This act of aggression can also be against a discourse or style: disrupting it with low, excluded material (a shout, the breaking of wind, a belch, a profane interjection) or by exposing its internal contradictions (drawing out inherent antinomies, introducing exceptions, identifying impurities), in each case disturbing the discourse's or style's smooth, unbroken surface. A scream is transgressive in this way, and in related ways. Painting a scream on a decorous face that sits above decorous robes is likewise transgressive (as Francis Bacon demonstrated). 'Transgression' is also used to refer to any exceeding of boundaries. This is closest to its etymological sense: to trans-gress, pass beyond, go over. Though such a use often carries a negative charge, it too is to be distinguished from any notion of rule-breaking. In an early 20th-century use of the word, for example, seas that spread over land are described by geologists as 'transgressive'. (Paul Klee sensed the sea's lawlessness: 'The sea has left its ears upon the beach / And the ridged sand the scene of a perfect crime.') This relates the word to 'trespass' – the illicit crossing of a boundary. To subvert a hierarchy, placing the subordinate above the elevated, or to mix distinct concepts or substances, upsetting demarcations that have some institutional or tacit sanction, could be transgressive in this sense. Following the transgression, the ordered may be disordered or reordered, or it may have reverted to its original condition.

Four essential meanings emerge, then: the denying of doctrinal truths; rule-breaking, including the violating of principles, conventions, pieties or taboos; the giving of serious offence; and the exceeding, erasing or disordering of physical or conceptual boundaries. Certain practices may be transgressive in a number of respects within one such meaning (breaking both a moral and legal rule, for example). Any one of the meanings may be imagined as, or related to, any other meaning. For example, by a spatial metaphor the transgressing of rules may be understood as the exceeding of limits. This substitutive facility has implications for the characterising of transgressions. Describe a rule as a frontier and one comes close to justifying its breach. Describe a boundary as a limitation, and breaching it becomes a duty (as in 'the US government must continue to stay out of the business of defining boundaries for acceptable artistic expression'). There are many social practices that are multiply transgressive, art-making chief among them. Take Manet's *The Dead Christ and the Angels* (1864), for example: it denied, or put into question, the doctrine of Christ's resurrection. It thus gave great offence. It breached the conventions of religious art. It did so in part by blurring the distinction between the divine and the human, and the subject and the model (the angels are painted as the models that they are). The meanings may thus coexist in a single work or practice. As for the reception of *Le Déjeuner sur l'herbe* (1863), a Manet scholar reports that 'some agreed that it was a truly innovative work, but for others [the artist] was transgressing the laws both of perspective and morality'. Art can both picture conventions, and break them.

In current usage, 'transgression' retains a residual religious sense. It also continues to stand for any serious violation of legal and/or moral rules, as in the final clause of the new South African constitution, which refers to past 'transgression[s] of humanitarian principles'. But the concept of the 'transgressive' lives its real life in contemporary cultural discourse, where it is highly regarded and much deployed. To describe an artwork as 'transgressive' is to offer it a compliment. 'Art, and most especially painting, was for me a realm where every imposed boundary could be transgressed,' says the writer Bell Hooks. It is successor to the Romantic ideology of the artist as genius, a rule-breaker indifferent to art's constraints. 'Unacquainted with the rules, those crutches for weakness and taskmasters of awkwardness,' rhapsodised the German Romantic Friedrich Schiller, 'the genius goes calmly and surely through all the snares of false taste.' But Schiller then adds, in a limitation

that the transgressive aesthetic will reject: 'only to genius is it given to be at home beyond the accustomed and to extend nature *without going beyond her*' (my italics).

A transgressive disregard of conceptual and geographical boundaries in art is fostered by, and in turn fosters, for example, the internationalisation of art practices and the global reach of gallery culture. For Kandinsky, the creative spirit is always engaged in the 'shifting of barriers'. The transgressive also has a certain political flavour, opposing the stereotypical and the self-enclosed, and generating the 'open' and the 'hybrid'. To borrow two phrases from Salman Rushdie, we may say: it rejoices in mongrelisation and fears the absolutism of the pure. (He writes this of *The Satanic Verses* [1988], itself an exemplarily transgressive work.) Conflicts among the academic disciplines are mockingly compared to boundary disputes, and attributed to a petty guild-consciousness. Boundaries are to be deprecated; they resonate with everything that is petrified, stale, encrusted, immobile. Boundary-breaking is to be admired; it resonates with everything that is fluid, fresh, unencumbered, mobile – and 'cool' (as in this internet art store advert for the British artist Damien Hirst's 'signature works': 'Who better than Hirst to push the old boundaries?'). When a boundary is transgressed, one tastes the infinite. 'When we reach the boundary of things set for us,' remarked the Enlightenment aphorist G.C. Lichtenberg, anticipating the modern regard for the transgressive, 'we can see into the infinite, just as on the surface of the earth we gaze out into immeasurable space.' The transgressive challenges received ideas; it breaks up everything that is petrified, established; it leads to new inventions and discoveries. 'A border,' says the modern Italian artist Gilberto Zorio, 'is an imaginary line which is concretized through violence.' Violating borders is a duty. 'We have to be at the frontiers,' declared the foremost modern ideologist of the transgressive, Michel Foucault; 'criticism indeed consists of analysing and reflecting upon limits.' When under attack by the American Right in the late 1980s, *Piss Christ* was defended as an example of the 'insistent and progressive exploration of the forbidden frontiers of human experience'.

This understanding of the transgressive, which is common enough in contemporary cultural discourse, is so removed from the jurisprudential sense of the word that in such a context the latter can only appear to it as an overdrawn, caricatured version of itself. This is precisely the significance of

Gustav Klimt's transgressive work *Jurisprudence* (1903–7), which the Viennese satirist Karl Kraus correctly analysed, but too precipitately condemned, for its impoverished understanding of law. Kraus complained: 'For Herr Klimt, the concept of jurisprudence is exhausted by the notions of crime and punishment. To him, "the rule of law" means nothing more than "hunt them down and wring their necks". And to those who are more than content to have "nothing to do with the law" he presents the terrifying image of the transgressor.' It is not transgression itself that stands, head bowed, condemned, in Klimt's work, but transgression as conceived by the law. It is law's perversely reductive, life-denying representation of transgression that is art's enemy, and the object of Klimt's reciprocating antagonism. Law does not – cannot – understand transgression's beauty; it holds art's celebration of the transgressive to be precious, misconceived, dangerous. Art is as blind to transgression's vices, law proposes, as it itself is said to be to transgression's beauties. Artworks that condemn crime, criminal laws that make exceptions for art, are mere compromises, respectively, of the aesthetic and the jurisprudential projects. The one is committed to the unfettered realising of our imaginative capacities, the other, to the regulating of our words and deeds. Art exasperates law; law oppresses art.

Celebrating the Transgressive

The high regard for the transgressive in art may be attributable in substantial measure to the influence of the 20th-century French writer Georges Bataille. For this radically dissenting essayist and novelist, the transgressive is the utopian aspect of every artwork, the one that offers us glimpses of an existence unconfined by rules or restraints. Bataille was a renegade intellectual, his imagination drawn to everything that was irregular, sordid, ignoble, defiled. His 'base materialism' displayed, he said, 'an overwhelming lack of respect'. André Breton referred to him as the 'excremental philosopher'. His books refuse the restrictions of genre, the regularities of established discourses. They are self-transgressive. A recent scholar of his work describes it as so many 'acts of sabotage against the academic world and the spirit of system'. It is a 'project against projects'. His speculations comprise not so much a theory as a fantasy of origins, a vision articulated in language both ecstatic and scholarly. His works are repetitive, unrestrained, garrulously animated; they also have footnotes. Bataille writes of the sacred, of violence, loss and death, of

the beautiful and the horrific. Erotic transgression is by implication the type of all transgressions. He himself offers some reasons for this; we may speculate as to others. It may be, for instance, because certain forms of sexuality are expressly proscribed in the Scriptures; because sexual experience itself occupies the extreme terrain of momentary pleasures; because there is an underground literary tradition of the erotic that attracts the hostility of the state; because a certain kind of sexual liberation is the principal way in which the modern age defines itself against the preceding age.

In summary, he argues as follows. We need to work to detach ourselves from our animal existence; work makes us what we are. Anything that interferes with productive labour risks returning us to that state and therefore cannot be permitted. It is 'taboo'. However, while work liberates us from one form of subordination, it subjects us to another form. We become caught up in an endless labour of production. And so we need, from time to time, to free ourselves from the means of our liberation. Hence the need for the transgression of taboo. This transgression is both a return to an animal existence, where labour is unknown, and an assertion of sovereignty over communal life, where labour is mandatory. We become conscious of ourselves as subjects through work; our consciousness of ourselves as subjects impels us to resist our subordination to work. Subjectivity is discovered in work, but expresses itself against work. Transgression thus represents a desire both for the sovereignty of subjectivity and the extinction of subjectivity – a desire to return to the world from which, through the discovery of subjectivity, man has become separated. It is an assertion of dominion combined with a kind of chthonic nostalgia. It is a moment of both elevation and debasement, and so it is accompanied by the experience of a certain anguish. One is furthest from one's origins precisely in that brief, voluntary reversion to them. Transgression is never, of course, an actual return. On the contrary: transgressions, together with taboos, make communal life what it is.

Human society is thus not only a world of work. The existence of taboos and their transgression disclose the division of society into two realms, the profane and the sacred. In the realm of the profane, taboos rule. The sacred realm depends on limited acts of transgression. It is the domain of celebrations, sovereign rulers and God. It is, Bataille argues, the domain of excess: that which goes beyond an ordinary limit, a common measure. One needs, however, to distinguish sacredness in general from the Christian conception

of the sacred. Christianity refuses to recognise the integral quality of transgression in religious experience. The sacrifice of Christ is thus not the responsibility of the faithful; they merely contribute to the Crucifixion by their sins. Christianity reduces religion to its benign aspect. Transgression becomes mere sin – a fault, something that ought not to have occurred. The taboo is absolute and transgression of any kind is to be condemned without qualification.

Transgressions, or 'useless expenditures', include art, sacrifices, eroticism. They are a protest against the servility implicit in the project of labour, the subordination to things. That part of social life that is not committed to productive labour is the 'accursed share'. Our only real pleasure is to squander our resources to no purpose; we always want to be sure of the uselessness or the ruinousness of our extravagance. Compared with work, transgression is a game. There is thus in man an impulse that always exceeds bounds, and can never wholly be reduced to order. This is the violence of desire, which always threatens to disrupt collective work. Violence is what the world of work excludes with its taboos. It is terrifying yet fascinating. The primary taboos relate to death and sexuality. When it is a question of work, the creation and suppression of life must be put aside. Our horror at corpses is a recoil from symbols of violence and the contagiousness of violence. Death is the sign of violence; sexuality likewise. The taboo within us against sexual liberty is general and universal. Whether it is a question of death or sexuality, it is the repression of violence that is the object. Man stands abashed in front of death or sexual union. It takes, adds Bataille, an 'iron nerve' to acknowledge the connection between sex and death.

Transgressions are short-lived affairs; they do not so much seek to abolish the rule as suspend it, and for a moment only. Bataille was impressed by the anthropologist Marcel Mauss's dictum: 'Taboos are meant to be broken.' For Bataille, the transgressor reinscribes the border he violates. Taboos are constraints that must be violated and preserved. Transgression asserts limits. Take sacrifice, for example, which is a religious transgression. It is the transgression, that is, of the taboo on murder. The taboo is 'jolted', not terminated. Transgressions suspend taboos without suppressing them. There is thus a profound complicity between law and the violation of law. The experience of transgression is one that mixes dread and ecstasy. It is pleasure and pain, in combination and in extremis. The French writer Julia Kristeva is, in this (if not

in any other) respect, Bataille's pupil. She writes: 'the issue of ethics crops up wherever a code (mores, social contract) must be shattered in order to give way to the free play of negativity, need, desire, pleasure, and jouissance, before being put together again, although temporarily and with full knowledge of what is involved.' That is to say: artworks, which are ethically problematic, in time return the reader or viewer, somewhat clearer-eyed, to the regularities of the briefly transgressed 'code'. They change nothing.

This politically unillusioned perspective is to be contrasted with a certain political optimism, one that has on occasion quickened into life, only then to vanish again, during the last two hundred years or so. It is an effect of brief, revolutionary episodes. One such episode immediately preceded the emergence of transgressive art. In the aftermath of the February 1848 revolution in France, with a republic proclaimed and universal suffrage conceded, and with the establishment of the Second Empire some time away, the art critic Clément de Ris took to the pages of France's leading art journal, *L'Artiste*, to exult: 'in the realm of art, as in that of morals, social thought and politics, barriers are falling and the horizon expanding.' How can one characterise this very recognisable tone, with its super-oxygenated euphoria?

It was a time of the greatest hope for radicals, one of those moments when everything that is frozen – everything that seems inevitable, unchangeable, oppressively and always just *there* – unfreezes. It was a moment of political joy, when the imperative to be reasonable was suddenly relaxed. This is revolution. Private life is neglected; the quiescent become bold, the apathetic, commanding and vigorous. Prohibitions are transgressed, the imagination expands, and emotion takes on public, collective forms of expression. It is intoxicating, exhilarating, clarifying. It is as if suddenly we can see further, and what we see, we unexpectedly have control over. We were once alienated members of a collective; now we are instances of a fused group. What was formerly only glimpsed, and then merely in its separate aspects, can now be viewed whole. At once, everything connects. It is addictive. There is an ecstatic aspect of every revolutionary event, as the German critic Walter Benjamin noted. If one had lived through such a moment, one would want to re-create it, in whatever context its return seemed possible. De Ris wrote in just that moment; and then it ended, as it always does. Political conflicts between power-seeking groups shattered the appearance of unanimity; the humdrum necessities of everyday life dampened down the excitement. The art historian T.J. Clarke writes of the

'lyric illusion of 1848'. It was over almost as soon as it began, and memorialised in the very moment of its experience. Thereafter, and in the emergence of the artistic avant-garde, a rather different nexus between art, morals, social thought and politics came to prevail. Instead of the four marching side by side, they separated. New possibilities emerged in the months and years that followed, but only through opposition – painting that went against the grain of its time. Out of just this set of possibilities transgressive art emerged.

The Three Defences

To return to *Piss Christ* (1987): the work did not go unnoticed for long. Indeed, within days of its hanging, there could have been only a very few who would have encountered the work without already knowing its title. The contest over *Piss Christ* was a battle in the American 'culture wars'. The principal objection to Serrano's work was that it was blasphemous. It desecrated a religious symbol; it dirtied the image of the Son. Its defenders were said to aggrandise art 'at the expense of sacred public sentiments'. It was unclean. It was 'deplorable', 'despicable', 'a disgrace'. The word 'filth' was used by many politicians to describe the work, including by US president George Bush. That the National Endowment for the Arts (NEA) had funded its exhibition meant that the government itself was endorsing its blasphemy. Tax dollars were being spent on artworks that insulted religion; taxpayers were thus funding artists to abuse them. Christians objected to the offence, regardless of whether they were Catholic or Protestant (even though the latter were heirs to an iconoclastic tradition in which many crucifixes were destroyed in the name of the second commandment). A campaign was conducted against the work by the American pressure group American Family Association. It was condemned in the Senate, and one senator theatrically ripped up a catalogue containing a reproduction of the work. Another senator declared, 'I do not know Mr Andres Serrano, and I hope I never meet him. Because he is not an artist, he is a jerk.' These are not Americans in the grip of that ecstasy of sanctimony (Philip Roth's phrase) which is said to characterise certain moments in the history of the United States. Serrano's work, in its outrageous provocativeness, eludes their ready understanding, and their anger thus betrays a mood that is more defensive, less certain.

Against these objections, a number of defences were advanced. The artist's right to create art, of course. Art is a privileged zone in which the otherwise

unsayable may be said, and the otherwise unpicturable may be pictured. This is commonly known as the 'aesthetic alibi'. While non-artistic expression may be circumscribed (we cannot defame, we cannot incite, we cannot blaspheme...), artistic expression trumps all objections. There was also a First Amendment defence. 'Art speech', it was argued, is as much entitled to constitutional protection as 'political speech' or 'commercial speech'. The sculptor Richard Serra argued, 'if government only allocates dollars for certain forms of art and not others, the government abolishes the First Amendment'. That there was a certain tension between these two defences – the aesthetic alibi makes art special, while the First Amendment defence assimilates it to other forms of 'speech' – was generally ignored. The arguments about state funding were also met. The implication throughout was that the criminal law should play no part in the regulation of art and, more generally, that there should be no constraints either on the imagination (unexceptionable: how could there be?) or on imaginative expression (more problematic: no constraints at all?). Serrano's adversaries replied: artists deserve no greater licence than any other citizen, and art excuses nothing. At the very least, their opposition amplified the meaning of the work.

From time to time during the controversy, three other defences were advanced. They were of a different order from both the aesthetic alibi and the First Amendment defence. They addressed not so much the rights of artists as the distinctive character of artworks. They paid little attention to Serrano himself (his lapsed Catholicism, his stated artistic ambitions, etc); they endeavoured instead to explain *Piss Christ*. These defences offered an interpretation of the work by reference, first, to its healthy effect on spectators, second, to its place in art history, and third, to those aspects of it unrelated to its subject matter. The purpose of these defences was to lead the work into the canon of modern art, where it would be safe from further assault. What were they?

First, that it is the job of art to shock us into grasping some truth about ourselves, or about the world, or about art itself, and that one way in which it does this is to alienate us from our preconceptions, by making the familiar strange and the unquestioned problematic. Art undermines pieties, challenges torpid institutions, and is always fresh and disturbing. The makers of artworks are themselves 'armed against reality', as Georges Hugnet said of Marcel Duchamp. Call this the 'estrangement defence'. Second, that such disturbing, new artworks are successors to familiar, established artworks and

must be judged by reference to them. In due course, when these new works have become familiar, further works that provoke similar initial responses will inevitably follow. It is only to be expected that new artworks will be dismaying, and we should thus be cautious when encountering them and not jump to adverse judgments which will always be over-hasty and may also turn out to be wrong. Call this the 'canonic defence'. Third, that art's subject is line, colour and texture, and that it is the form of the work that matters, anxiety about its content being misplaced; that art has its own, distinct mode of existence and is not to be confused with cognate, but distinct works of the imagination, such as propaganda or polemic. Call this the 'formalist defence'. The Serrano work both invites these defences and eludes them. They attach themselves to *Piss Christ*, and produce the following readings of the work.

1) *Piss Christ* compels us to acknowledge the interrelatedness of the aspects of experience that together comprise our existence, however much we might wish to separate them. It creates beautiful effects using low material. As Bataille reminds us, so profound is our recoil from our own waste that we are unable even to speak of the horror of excreta. So profound, that is, that the prescriptions relating to what he terms our 'foul aspects' are not even classed among the taboos through which our lives are fashioned. Serrano's work reaches down to make contact with these concealed, denied depths. It challenges both the contempt in which we hold our essential bodily functions and our refusal to admit our dependence on them. It 'cruelly juxtaposes the sacred and the profane', said one of its defenders, 'to shock the viewer into a reconsideration of the image and its true meaning'. To another advocate, it 'was so offensive to the ruling powers because it dared to defy the trivialisation of religious experience with [a] powerful new image' (*the estrangement defence*).

2) *Piss Christ* is to be situated both within the canon of religious art and within the history of avant-garde provocations. By relating the most elevated to the basest, the sublime to the excremental, Serrano's work contributes to a theologically informed art tradition that draws attention to the humanity of Christ in order to insist upon Christianity's founding miracle. Indeed, when placed next to certain early modern devotional figurations, the work is not the affront to Christianity it might seem. 'The shocking picture of the crucifix in urine can be interpreted,' wrote John Buchanan, the then president of People for the

American Way, 'as a faithful portrayal of the shocking, outrageous, offensive reality of our sinfulness heaped upon Him.' Certainly, it does not stand in principled opposition to Christianity. Serrano cannot be imagined signing his name to *Piss Christ*, as Nietzsche signed *his* name to *his* assault on Christianity, *Ecce Homo* (1888), 'Dionysus against the Crucified'. Serrano's work is dependent, even parasitic, upon Christianity.

Piss Christ alludes to the scandal of *Fountain* (1917), the Duchamp urinal, by its related subject matter, by the artful manner of the photographing, the partly 'veiled' urinal and the dimly visible crucifix, and by the public hostility both works provoked, with complaints against them of indecency, and perplexity about their aesthetic status. Another title for *Fountain* could be *Piss Art*. It also alludes to the group of 'piss paintings' Warhol is supposed to have

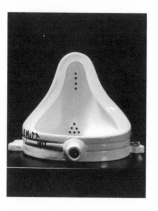

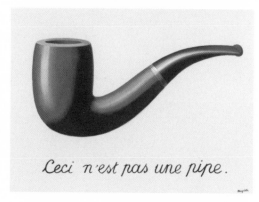

Right
Marcel Duchamp
Fountain
1917

Far right
René Magritte
The Treachery of Images
1929

made (none has surfaced) by inviting friends to urinate on canvases covered in metallic paint. Further, by the tension *Piss Christ* sets up between image and title, it alludes to those other 20th-century works that likewise divide into images and titles, sometimes by the artists' refusal to give primacy to either, and sometimes by their provocative pairing of an anodyne or otherwise commonplace object with an outrageous title. Magritte's *The Treachery of Images* (1929), for example, is not a pipe but a picture of a pipe. (*Piss Christ* might be retitled: *This Is Not a Devotional Object*.) Frank Stella's *Die Fahne Hoch!* (1959) comprises an image that reprises Malevich's abstract compositions and a title that is shared with a Nazi anthem. Morton Schamberg's *God* (1918) attaches to a humble piece of plumbing the name of the Deity. As with *Piss Christ*, while the images are unexceptionable, the titles are intolerable (*the canonic defence*).

Morton Schamberg
God
1918

Frank Stella
Die Fahne Hoch!
1959

3) *Piss Christ* is a 'work', not a 'snap'. It has certain painterly qualities: an effect of shading, an indistinctness of representation, a general diffusion of line and colour, bubbles swirling and swooping around the crucifix like spirits, and the outline of the suffering Christ, luminous but blurred. Serrano uses bodily fluids for their rich, lustrous colours. The four elements that comprise the image – crucifix, urine, red backdrop, overhead light – combine to create a single effect, and were it not for the provocation of the title, which wrongly isolates two of these elements (formalists are suspicious of titles), there would be no reason to single out any one of them (*the formalist defence*).

When talking about his work, Serrano draws on these defences as if by reflex. 'I like to make formally pleasing pictures,' he has said, 'but with an edge'. His *Milk, Blood* (1986) was, he explains, 'meant as a reference to Mondrian'. Thus does Serrano adduce the estrangement defence ('edge'), the formalist defence ('formally pleasing') and the canonic defence ('Mondrian'). The transgressive artwork has to live in the world, and as such needs to be defended. The three defences are, indeed, routinely mobilised in support of embattled artworks and literary works. To take another recent example, when called upon to defend *The Satanic Verses* (1988), and his life, Salman Rushdie offered his own versions of these defences. 1) That fiction by its nature challenges readers' preconceptions, both about the world and about themselves, that it 'tells us that there are no rules', and that his own novel is 'a work of radical dissent and questioning and reimagining' (*the estrangement defence*). 2) That the 'fictionality of fiction' had to be stressed, that his critics confused fiction with fact, that novels should not be read as the verbal equivalent of blows struck against state or religious institutions, and that in consequence the case of *The Satanic Verses* may be one of the biggest category mistakes in literary history (*the formalist defence*). 3) That his novel belonged within a certain tradition, that it was, that is, only the most recent in a long line of novels, which was as much as to say: reject my novel, and you reject much more than that alone, you reject fiction itself; indeed, the attack on *The Satanic Verses* is 'an attack on the very ideas of the novel form' (*the canonic defence*). These defences were deployed in two 1990 texts, 'In Good Faith' and 'Is Nothing Sacred?'. Each defence has its own cogency and persuasiveness, though in combination they do not make for a perfect fit. For example, while the estrangement defence hints that Rushdie's adversaries are right to

mistrust the novel (who would welcome affronts to one's beliefs?), the formalist defence endeavours to demonstrate that they have nothing to fear. The canonic defence attempts a reconciliation of the other two, relating both the formal and estranging qualities of the stigmatised work to the novelistic project itself.

The defences are not of equal consequence. It is the estrangement defence that is the most important, and it embraces both of the others. It has a relation to the formalist defence. It was indeed the most significant modern formalist movement, the Russian formalism of the early 20th century, which promoted an influential version of the estrangement defence. Art, its leading theorist Viktor Shklovsky held, defamiliarised the world, by which he meant that the introduction of new forms allows us to see the given world in a new light. The estrangement defence also has a complex relation to the canonic defence. This is what *all* art does, it maintains. The disturbing new work is thereby related to the safe old work, and that is part of its surprise. One might say: contemporary art shocks, and then it shocks again on the disclosure of its affiliations with established works in the art canon. But it does not end here, because it is in the nature of contemporary art to be subversive of the aesthetic purposes implicit in canonic art. One might *also* say, then: contemporary art makes the world strange to its audience, and is also itself estranged from the art canon.

It was not by chance that Rushdie hit upon these three defences. They have been circulating in our culture since modern art's (and literature's) inception. One effect, among other effects, of these defences is to expose art's objectors as ignoramuses: they do not understand art's purpose, they are unaware of its history, they are oblivious to the distinctness of its nature. The defences thus offer a double characterisation: of the works themselves and of their audiences. They share this plea: leave the artist to his art, do not interfere, do not suppress. The art they are best suited to protect is the kind that might otherwise be mocked or censored. It would be possible to give a cogent account of many modern works by drawing in each instance on all three defences. Much modern art criticism, indeed, does precisely that. The defences seek to explain, as well as to shield. They have a hermeneutic, as well as a protective, role. They are interpretations in the register of advocacy. Taken together, they represent the art world's understanding of the art that it most values. They comprise what might be termed its horizon of aspiration.

Artists endeavour to create works that will be worthy of these defences. The defences thus bring new artworks into existence which then solicit their protection.

The Estrangement Defence

First, then, the estrangement defence. This defence insists that artworks exist to shock us into grasping some truth about ourselves, or about the world, or about art itself. In contrast to the canonic defence, the shock is essential to the artwork, and not a mere aspect of its initial reception. In its tamest version, the estrangement defence invites us to regard art for its ability 'to teach us to see in nature new beauties of whose existence we have never dreamt' (says the art historian E.H. Gombrich). More radically, it endorses an art that shatters illusions, exposes prejudices, suspends received wisdom and generally shakes things up. It estranges us from the familiar; it denies us the pleasures of easy recognition. This is an art that takes received beliefs and exposes them as mere wishful thinking. It momentarily alienates us from everyday reality. It unsettles minds. ('What do I ask of a painting?' demands Lucian Freud. 'I ask it to astonish, disturb, seduce, convince.') Interpretations of entire oeuvres have been derived from this defence. Of Magritte, for example, it has been written: 'His life had been a solitary posture of immense effort: to overthrow our sense of the familiar, to sabotage our habits, to put the real world on trial.' If the spectator is *not* unsettled by the artwork, it is a failure. If he is *only* unsettled by it, then *he* is a failure. He clings too fiercely to the quotidian. The work may teach as it troubles, even though philistines invariably refuse to learn. That is not art's fault, though often it strains to teach, shouting noisily at its recalcitrant audience, as if in exasperation at a classroom of infants: why will you not understand that the world is such-and-such, and not as you believe? And we want to turn away, as we would when exposed to any harangue. 'It is our function as artists,' declared the artists Adolph Gottlieb and Mark Rothko, 'to make the spectator see the world our way – not his way.'

Guillaume Apollinaire, the French poet and advocate of the avant-garde painting of his time, gave a public lecture in 1917 in which he offered a characterisation of the new art. 'Surprise is the greatest source for what is new... it is through the important position given to surprise that the new spirit distinguishes itself from the preceding literary and artistic movements, and in this respect it [i.e. surprise] belongs exclusively to our time.' The best of

contemporary art is taken to be challenging, difficult, exasperating. It is anticipated that it will provoke resistance, affront, dismay. This in turn is taken to be to art's credit, and to its audience's discredit. Art invites us to recognise the complexities of our world, to re-examine our assumptions and to make contact with individual visions different from our own. Until around the middle of the 19th century, what typically was asked of art was that it divert us from our miseries or console us. Since that time, however, what art has tended to do is to dismay us, or return us to our miseries. It is an art that does not bring us relief but causes us pain. It exposes our preconceptions, our reliance on the formulaic, our tendency to settle into habitual mental procedures. All this is very unwelcome. We tend to resist the burdensome truths that art communicates; we would rather nurse our illusions. True artworks are adversary to an image-saturated culture that merely reflects back to us those illusions.

These arguments comprise a distinct way of thinking about art. Though it has a number of diverse aspects, the master thesis is: art teaches. Art exists to teach a lesson, and its shocks and disturbances are justified by this overriding purpose. The object of new art, said Giorgio de Chirico, 'is to create previously unknown sensations, to strip art of everything routine and accepted'. A pre-modern version of this defence argued for art's pedagogic purpose: specifically, to teach right conduct, or as we might say, morality. In its present form, the defence justifies the scandals that artworks provoke, and the pain they inflict, by reference to the modifications they effect in our sensibilities. Art's audience needs to be coerced out of its complacencies, and only the most jarring, disturbing art can do this. Conventions hem us in so thickly, so tightly, that art grenades are needed to blast us free of them. Art exists to rescue us from the prison of ordinary consciousness. It instructs us about the world, or about ourselves, or about art's own possibilities. It need not be restricted, says American artist Agnes Denes, by the limitations inherent in other systems or disciplines. It is more than a series of Dadaist tricks to rob the bourgeois of his sleep. Though it often teaches by combating error or illusion, it need not teach a specifically moral lesson, although sometimes it will. Art 'teaches' not by communicating lessons but by enlarging our sense of what is possible. It gives us something other than the already given. In the French thinker J.-F. Lyotard's sense, it presents the fact that the unpresentable exists. It makes the world an alien place to us, and then returns us to it.

Man Ray
Untitled
1933

Art is not a representation, then, but a presentation. It does not imitate the existent, it makes things new by making new things. It has both ethical and cognitive aspects. It liberates us from the tyranny of familiar ways of looking at things. It is counter-hegemonic, a mode of contestation. It violates common sense. It is disruptive. It forces unaccustomed associations upon us, and in some measure remakes our world. We become exiles from the known. It can make a genuine contribution to knowledge; it can make a genuine contribution to our moral education. By this re-making, it unsettles us. There is comfort as well as oppression in the familiar. A prison can be a home. Everyday life has institutionalised us; art permits us to break out. It puts the marvellous within our reach. It is precisely because art offers an escape that it is not escapist. It need not be an affair of the moment; it can be transforming. The price that one pays for this transformation is the experience of wrench, and then the experience of alienation. But estrangement can also generate comedy: see Man Ray's *Untitled* (1933).

In its strongest version, the defence purports to characterise all artworks. In weaker versions, it characterises only certain kinds, those that mistrust beauty. Within these kinds are artworks that impart to us an understanding of an aspect of life hitherto hidden, or that cause us to change our perception of something already in view. This may, but need not, be an irreversible change. The instant of demystification will not always be permanent. And then there is another kind of art, one that gives us the experience of our limitations by taking us beyond them. In such a case, one will retreat, chastened, back behind the boundaries of one's everyday conceptions, at once elevated and humbled, a witness to one's own limitations, privileged by a glimpse of what lies beyond them. We do not change our views here, we change our view of our views. The Surrealists had just this objective. We do not wish to change the way people live, they declared, but rather to show on what shifting foundations they have built those lives. The estrangement defence is thus, among other things, Surrealist doctrine. It is therefore available to Surrealism's heirs, contemporary taboo-breaking artists such as Paul McCarthy, who proposes that 'for the most part we do not know that we are alive'.

The experience of art, then, is likely to be painful. But no matter: 'il n'y a que la vérité qui blesse', only the truth wounds, and so some artists and critics

draw the inference that the greater the wound, the greater the truth. It may wound the artist as well as the audience, or the artist on behalf of the audience. An ideologist of Vienna Actionism, which staged spectacles exposing its participants to symbolic violations, argued that 'through the actual mutilation of the body, the reality of its social encoding and the mutilating function of social encoding itself are attacked.' Art injures in order to expose the wounds inflicted by the everyday world. Artists are practitioners in the ungentle art of making enemies. It is the filmmaker himself, Luis Buñuel, who wields the razor that slices through the eyeball in the opening moments of *Un Chien andalou* (1929). Buñuel thereby symbolically destroys (it has been argued) the eye of the spectator. He does this in order to disturb stereotypical perceptions and prepare us for the disturbing images that follow this sequence. The pain may, then, be the point of the work, or it may be the means by which the work communicates its truths. But if the response of the audience is that the horror is in the work alone, and not in the world itself, then the work has failed.

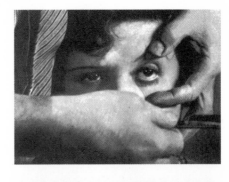

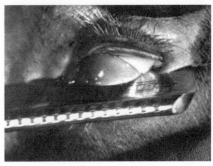

Luis Buñuel and Salvador Dalí
Stills from
Un Chien andalou
1929

There is a political aspect to this defence, and a philosophical one. There is a certain kind of despairing, sophisticated Leftist who finds in art what his or her more optimistic, simpler predecessors found in Marxism itself. Such a person finds in art, that is, the means by which the illusions of our everyday experience of the world may be exposed. Art is ideology's solvent, and thereby – if only for the moment when the spectator experiences it – substitutes truth for error. Art offers a kind of knowledge that is peculiar to itself and that cannot be paraphrased. Art is revelatory. It discloses truths either about ourselves or about aspects of our world typically concealed from us in our everyday lives. The philosophical aspect is indebted to Immanuel Kant's *Critique of Judgment* (1790). Kant argues that art in general can communicate an understanding of certain concepts (say, power or justice) or experiences (death, love, fame) that is deeper than anything mere prose exposition can achieve. This is his theory of the 'aesthetic idea'. He also argues that

experiences of a certain kind defeat our understanding. These are overwhelm-ing experiences, ones that do not just dwarf us but dislocate us momentarily from our sense of who we are. They are unanchoring; for just a moment at least, we are without our bearings. This is part of his theory of the sublime. So for Kant, art will always enlarge our understanding, and sublime art will do so by exposing to us the limits of that understanding. It enlarges our under-standing of our understanding, one might say. It is an aid to introspection. It serves the philosopher's injunction: know thyself.

The Formalist Defence

As against the estrangement defence, the formalist defence is cooler, and disengaged. It insists upon the form of the artwork; it proposes that anxiety about subject (when the work is figurative) or the absence of subject (when it is not) is misplaced. The anxiety, or shock, is caused by a misunderstanding. To find a modern, naked woman in a work by Manet, or to search for, but find, no subject at all in a work by Mondrian, and to wince in consequence, betrays an ignorance which the formalist defence seeks to address. It is the job of art to explore form. Art has no vocation either to change opinions in, or offer reflec-tions of, the world. It interrogates itself, not the state; it contemplates itself, not external reality. The spectator must learn to be contemplative. He must reflect on art's self-absorption, losing himself in the beauties of its narcissism. It has no interest in him or in his world; that is its interest.

In his *Critique of Judgment*, which both made modern art possible and ensured that it would be misunderstood, Kant distinguished between 'free' and 'dependent' beauty, thereby introducing formalism into art theory. He reserved for instances of free beauty what he termed the exercise of a pure judgment of taste. Free beauty presupposes no concept of what the object should be; the beauty is self-subsisting. Kant offers as his examples designs *à la grecque*, or foliage for framework or on wallpapers. These have no intrinsic meaning; they represent nothing. Music without words is another example. Dance, indeed, is pure form. The imagination is freely at play when contem-plating form. Free beauty depends exclusively on the formal arrangement of a perceived manifold. The formalist defence proposes that all artworks should be regarded as 'free' in this sense.

Every object has an inherent form; every artwork likewise. But in the case of a painting (which is a kind of object), the relevant form is not – or not just, or

David Bomberg
The Mudbath
1914

not principally – the shape and structure of the physical object, but rather the character of the surface of the work, which is the product of the engagement of the artist with his given materials. Each work of art is also an instance of a certain kind of artwork – or, if not wholly an instance, has a connection with one or more kinds of artwork. Call these 'genres'. Artworks thus have both their own distinct form and a genre form. It is one of art's distinctive features that it has form, and indeed this is what distinguishes representational art from what it represents. This latter has been dismissed as 'mere subject matter' by the film theorist Rudolf Arnheim. There may even be a 'formal style': it has been proposed that the art of the modern period is preoccupied with form and the problems of form. Cézanne has been credited with introducing *forme* into art. He was, enthused Clive Bell, 'the Christopher Columbus of a new continent of form'. Certain artists are more susceptible to formal analysis that others; Mondrian, remarked the art critic Harold Rosenberg, was the 'patron saint' of formalism. Taking up the cause of 'form', the 20th-century English artist David Bomberg declared of his early work *The Mudbath* (1914), 'My object is the construction of pure form', and he added, 'I reject everything in painting that is not Pure Form.'

Every work of art can be interpreted by reference to its form. There are three versions of 'formalism'. First, it is a critical practice that attends to the

artwork's formal properties, subordinating without denying its other, non-formal properties. Within this version it also denotes an influential trend in art theory, associated with the American critic Clement Greenberg and with the work of the art historians Alois Riegl and Heinrich Wölfflin. Art is understood, within such perspectives, as an inquiry into its own possibilities. Artworks that evince other, more worldly preoccupations tend to be deprecated. Artists are warned against making artworks with a content that risks distracting viewers from their contemplation of aesthetic form (Leo Steinberg's phrase). Formalists, for example, do not care for Surrealism. Second, it is a term of deprecation. 'Formalist' was prominent in the lexicon of Soviet abuse during the decades of Socialist Realism, and in particular during the Cold War. It was utterly inclusive in its rejection of avant-garde art, dismissing all departures from academic illusionism. (The Soviet artist Alexander Tyshler, his widow disclosed, 'did not believe in the canons of official art. For many years he was labelled a formalist and suffered discrimination from the authorities'; while Prokofiev, in coerced self-criticism, said: 'Elements of formalism were already peculiar to my music 15 years ago. The contagion appeared evidently from contact with a number of Western friends.') Third, it is a defence. The formalist defence is militant formalism. It is theory in battle-dress, an intervention in a controversy. It is mobilised to defend art of a certain kind in a certain period. It is thus invariably overstated in its expression, disregarding of other aspects of the work in question. It is administered as a corrective, when there is a danger of form being overlooked altogether, perhaps because of a scandal of content. It is strategically related to a certain conception of the course taken by art in this century, and is thus related to the canonic defence: overlook the formal properties of this artwork and you have misunderstood the art of the modern period. (Modernism, the art historian Rosalind Krauss has written, staked everything on form.) It draws on all the other senses of 'form', from the undeniable (every work has form) to the theoretical (a work's form is what matters), and proceeds thence to the epochal (we live in a formalist period).

It is to the formalist defence that most defenders of difficult, scandalising artworks turn when protest about their 'content' threatens to overwhelm them. Formalists argued in the first decades of the 20th century that regard for the independent beauty of forms enjoyed a mandate from Plato, quoting from the *Philebus*: '[forms] are by their very nature beautiful, and give pleasure of

their own quite free from the itch of desire.' Zola invented the defence, deploying it in relation to Manet's *Le Déjeuner sur l'herbe* (1863). The content of the work was, he explained to an outraged public, the solution to a purely painterly problem: how to pose lifesize figures in a landscape? The painting had provoked huge controversy; Zola intervened to rescue it from censure. It was condemned for its lack of finish. It was also condemned for its lack of decorum. It was, finally, condemned for its mocking, sardonic posture towards its audience. Zola's defence was intended to neutralise these multiple offences. Long after the scandals had passed, the defence was governing the reading of Manet's work. Almost exactly one hundred years later, for example, another French intellectual, André Malraux, was celebrating – as if he were a contemporary of Zola's, addressing precisely the same audience – 'the green of *The Balcony*, the pink patch of the wrap in *Olympia*, the touch of red behind the black bodice in the small *Bar des Folies-Bergère*'. They 'are obviously colour-patches signifying nothing except colour'. Art is made when forms are transmuted into style. For Malraux, Manet 'opened the way to a new freedom', and his name symbolised 'a new art era', our own.

Zola de-clawed *Le Déjeuner*, and then insisted on its harmlessness. The figures of the women permit an effect of strong contrasts and bold masses, he said, and their firm flesh has been modelled in broad areas of light. The public are mistaken in their preoccupation with content. They see nakedness instead of colour; they find scandal rather than form. Baudelaire had written in similar, general terms about the significance of form in art, but without this edge of embattled advocacy. 'Painting,' he remarked in his 'Salon de 1846', 'is interesting only by virtue of (*par*) its colour and form.' The 'art-ness' of art lies not in its content but in its formal properties. The spectator's inability to relate to these properties becomes an inability to relate to the artwork as art. To be affronted by the artwork is to misinterpret it, to see a woman rather than a form. (Presenting his audience with more and more transgressive material, says the critic Wendy Steiner, the modern artist dares us to 'read *this* as formal, or *this* or *this*'. The audience was confronted with the dilemma, Steiner adds, of choosing between 'a sublime uplift that [feels] like sterility, and a lubricity that [is] supposed to be beside the point'. Zola was the first writer about art to advance this formalist position as a defence for a scandalous work. This is the significance of his case for Manet. It was ingenious and misleading, and in one respect actually exacerbated the offence caused by the work.

Edouard Manet
The Execution
of Maximillian
1868–9
(Mannheim version)

The indifference to content that Zola found in Manet's work, and that he urged upon the work's audience, was itself a provocation. The posture of neutrality before different kinds of subject matter, which is the moral aspect of the formalist defence, was intolerable to Manet's adversaries. Zola's defence was not so much an answer to them, then, as a fresh incitement. Zola praised Manet for treating figure painting 'as only still life paintings are allowed in art schools to be treated'. When it came to rendering the last moments of Emperor Maximilian's life, this principled refusal of Manet's to animate his life-subjects made the work unreadable. 'Manet deliberately rendered the condemned man's death with the same indifference as if he had chosen a fish or a flower for his subject,' observed Bataille. The emperor's gaze is disengaged, and his posture relaxed, as if a spectator at his own death. The work stifles indignation; it inhibits empathy. This quality of neutrality, or affectlessness, which is to be understood as the apprising of heterogeneous entities by reference only to their common denominators (colour, form), and a refusal to arrange the distinct representations that comprise a work into a hierarchy of significances, is intolerable to audiences unable to accept art as a separate

realm in which the everyday moral distinctions between kinds of people, actions, things and places do not apply.

This formalist defence is not in every respect an easy attitude to accept, and the difficulties that audiences may have are not lightly to be dismissed. There is a glibness, then, about an artist like Robert Mapplethorpe or a film-maker like Quentin Tarantino asserting just this neutrality, this formalism, in relation to their own difficult, challenging work. 'My approach to photograph-ing a flower is not much different than photographing a cock... Basically it's the same thing. It's about lighting and composition'; '[I have] a formalist approach to it all, which I haven't seen in photography or pornography' (Map-plethorpe). 'To me, violence is a totally aesthetic subject. Saying you don't like violence in movies is like saying you don't like dance sequences in movies' (Tarantino). Such observations, when offered as a defence, amount to no more than a double failure. They are ineffective in fending off philistines and the censor (given the subject, the formalism aggravates its offence); they encour-age the disregarding of essential aspects of the work being thus defended. Straining to capture this combined dependence upon, and subversion of, the vocabulary of formalism, in Mapplethorpe's photographs, Wendy Steiner praises them as 'formalist masterpieces that shatter formalism'.

Francis Bacon, talking to the critic David Sylvester, once remarked that he perceived a problem with canvases filled with human figures. They prompted the viewer to imagine a relation between the figures, and from there to spin out a story. This was contrary to his intentions for his works, he said. He wanted instead to be able to make a great number of figures without a narra-tive. (Hence the challenge to him of the Crucifixion: how to paint *that* while eschewing narrative?) Sylvester responded that Bacon must therefore have been annoyed by the tendency of people looking at his *Crucifixion* (1965) to speculate about the character of the person wearing a swastika armband. Is he a Nazi? Is he merely dressed like a Nazi? And so on. Yes, said Bacon, he did dislike that kind of thing. It was perhaps stupid of him, he conceded, to have put the swastika there. But he wanted to break the continuity of the arm and to add the colour red round the arm. It had nothing to do with identifying the figure as a Nazi, everything to do with 'the level of its working formally'. Sylvester acknowledged, without comment, this 'show of indifference to the practical implications of props', and then passed on to other topics. A slight discomfort on Sylvester's part is detectable from his tense language.

Francis Bacon
Crucifixion
1965

His use of 'show' and 'prop' mitigates the force of Bacon's indifference. 'Show' implies that the indifference was feigned, assumed for aesthetic effect; 'prop' implies that the armband had no more significance than a pantomime sword or horsehair moustache. Sylvester is right (if I have read him correctly) to be troubled, even if he did not quite own up to it. The swastika will for some time to come have more than formal implications, both for the artwork itself and for its reception.

The Canonic Defence

Here is the Abstract Expressionist Willem de Kooning talking to Harold Rosenberg: 'It is so satisfying to do something that has been done for 30,000 years the world over.' This expansive, relaxed acknowledgment of the absolute continuity of his labours with the labours of all predecessor artists is exceptional in an artist of the modern period. In radical contrast to de Kooning's breeziness, consider the canonic defence. This exists to support works that might seem to be unrelated to anything hitherto recognisable as art. It insists that they are indeed to be located within a tradition. The defence seeks thereby to subdue the audience's shock, by putting these works in the context of other (once) shocking artworks. In contrast to the formalist defence, it does not dismiss the shock; in contrast to the estrangement defence, it does not actively seek it either. It identifies and accepts it, but seeks to work through it to an acceptance of the artwork itself. It regards the shock as temporary. The canonic defence argues for the continuity with a given tradition of the

particular artwork under attack. As the philosopher Joseph Margolis puts it, in an extreme formulation, 'what's new is probably at least two hundred years old'. What then appears as radically new and without antecedents is shown to be related, in possibly quite intimate ways, to earlier artworks, and is thus vindicated as art by this lineage. The foundling work arrives without ostensible antecedents. These the canonic defence then supplies, sometimes in overabundance. Family relations crowd in, all invited for the express purpose of conferring legitimacy on the new arrival. Manet's friend and advocate Antonin Proust wrote of *Le Déjeuner*: 'nude women having lunch with clothed young men, such corruption was intolerable, and the writers of the time cried out against indecency, forgetting the painting by Giorgione in the Louvre which Manet loudly declared had inspired him.'

This defence gives the audience history lessons. You reject this? Then you must be unaware of that, and of the other, both hallowed instances of art, each one a canonic artwork. Rebuff this new work and you must, in consistency, refuse these earlier ones too. And that would be absurd. Time-proven art is thus enlisted in support of new art. The defence also insists upon the distinction between official or conventional art and the art of the canon. As Gombrich argues, the history of art in the 19th century can never become the history of the most successful and best-paid masters of that time. It must instead be the history of a handful of lonely men who had the courage and the persistence

Richard Serra
Tilted Arc
1981

to think for themselves, examine conventions fearlessly and critically, and thereby create new possibilities for their art. By repudiating the conventional, these artists took their first, critical step towards the canonic. Of course, the more challenging the work – the more disconnected, that is, it appears to be from the art of the past – the more urgent the defence, the more extreme the language with which it is advanced. To take a contemporary example: Richard Serra's *Tilted Arc* (1981), in urgent need of protection, and facing a destructive dismantling, was defended by one critic by reference to the historical line of Picasso, Brancusi, Schwitters, Tatlin and Lissitzky, all of whom were once vilified (the killer blow) by the Nazis. 'When we wish,' remarked the art historian Kenneth Clark, 'to prove to the philistine that our great revolutionaries are really respectable artists in the tradition of European painting, we

point to their drawings of the nude.' This is the 'canonic defence'. It can be highly effective. When, for example, London police questioned the owner of the gallery exhibiting Jake and Dinos Chapman's *Great Deeds against the Dead* (1994), he was able to placate them by producing the Goya print from which the Chapmans' work was derived.

The canonic defence was born, I suggest, of a colossal failure of nerve by art critics following the immense success of Impressionism. That they could have been so utterly wrong in their evaluation led to a loss of prestige from which as a group (says Gombrich) they never recovered. Ever since, the tendency has been to find in every unusual, new artwork a canonic precedent. This defence exists, of course, in a number of versions. Each version argues for a continuity between the challenged work and earlier works. One kind of continuity (one version of the defence, that is) is the continuity of reception. This is how, it is said, all innovative, original, etc works are first received by their audiences. Avant-garde art is always first received with incomprehension and hostility. But initial judgments tend to be premature and adverse. After a while, this art is accepted, and becomes the standard by which subsequent art is measured. A defender of Manet, for example, responded to the artist's mockers: 'You were disgusted with Corot for 40 years, weren't you? And now you praise him to the skies. Well, well! Corot is the father of Manet. If you ridicule Manet, then ridicule Corot.' First reactions are often perplexed, intemperate, conservative. These reactions, paradoxically, both confirm the merit of the new work and establish it in a line of meritorious works that prompted similar reactions. It will always take time for audiences to catch up. Here are just three examples. Thomas Eakins wrote in 1894: 'My honors are misunderstanding, persecution and neglect, enhanced because unsought.' In 1918, on his deathbed, Egon Schiele's last words were: 'Sooner or later, when I am dead, they will revere me and admire my art. Will they do so in the same measure as they formerly reviled me, scorned and rejected my work?' Recently, Gilbert and George's dealer, Anthony d'Offay, mused: 'If Gilbert and George were completely accepted, then they'd have cause to worry. Is any radical art completely accepted in its time? Beuys was not accepted in Germany, Warhol not in America.' Putting new art in the context of existing, familiar art accelerates this process of catching up.

There is also a continuity of artistic practice. This is what, it is also said, all innovative, original, etc artists do when they make their art. As the London

Times's art critic Richard Cork points out, introducing a history of the annual British Turner Prize, the rejection by artists of existing rules has been usual throughout the history of art. Michelangelo was no different in this regard from Picasso. Artists will experiment; few will want to rest on the practices adopted by their forebears. They will test new materials; they will invent new genres; they will work hard to catch their audience off balance. And we should be grateful – not seek to legislate against innovation, but welcome it, critically. (Of course, naming the prize after Turner was itself a deployment of the canonic defence. 'I can't help feeling that Turner, a dab hand at making an impact, would have taken to it no end,' said one defender of the controversial prize.) A good example: the poster for the 1913 Armory Show incorporates the pine-tree flag of the American Revolution. It asserts: this is revolutionary art, and therefore in the tradition of American culture. The flag became the symbol of the exhibition, which put on display leading works of European and American avant-garde art. It introduced an American public to utterly unfamiliar works by an act of symbolic appropriation to an essential, original 'Americanness'.

There is, too, a certain continuity of theme or content. A new work may be defended by indicating its relation with earlier, similar works. Tracey Emin's *My Bed* (1998), the London art scandal of 1999, could be explained by pointing out its art historical relation to Robert Rauschenberg's *Bed* (1955). Again, in response to tabloid – or tabloid-style – rage at Gilbert and George's *Naked Shit Pictures* (1995), it was said that they belonged to 'a time-honoured tradition of ordure in art', to a 'uniquely English tradition', that they were related to medieval representations of decomposing corpses. 'If people find seeing a penis in an art gallery shocking,' a curator argued, 'then I don't know how we would ever be able to show anything from the Renaissance.' Renaissance art is a decisive move in this kind of

Top
Tracey Emin
My Bed
1998

Above
Robert Rauschenberg
Bed
1955

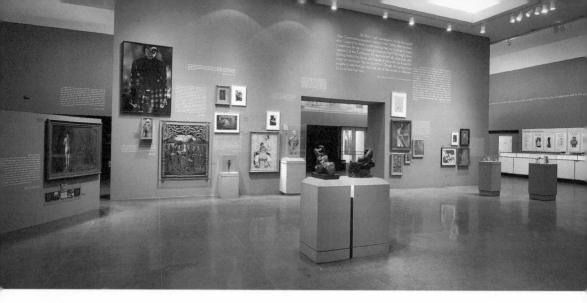

argument. In the aftermath of the Serrano affair, the conceptual artist Joseph Kosuth created *The Brooklyn Museum Collection: The Play of the Unmentionable*. Kosuth put together a number of artworks regarded as objectionable at one time or another, and added various quotations on the artist's role in society. One of his objects was to bind together hostility-provoking contemporary artworks and canonic works acknowledged to be 'masterpieces', by placing examples of each kind of work in the context of the other. The canonic works thereby became more challenging; the contemporary works less objectionable. They were understood to derive from the same aesthetic imperatives. As Kosuth explained, 'works that eventually come to be seen as masterpieces, and thereby reflect a certain cultural authority, do so precisely because they represented serious problems for their original audiences.'

There is, last, the continuity of discontinuity. The Fauves were defended, in the catalogue to the 1905 Salon d'Automne exhibition in which the work that earned them their name was first shown, thus: 'To put ourselves in contact with the younger generation of artists we must be free to hear and willing to understand an absolutely new language. Listen to them, these primitives.' Italian Futurism, known as *antipassatismo* (the 'down-with-the-past movement'), is in this respect the meta-avant-garde movement (better, the parody avant-garde movement) of the 20th century. It is avant-garde precisely because of its posture of aggressive repudiation towards a generalised 'past'. The very desire (in the language of a 1968 manifesto) to define oneself for oneself in the language and gestures of one's own discoveries is itself confirmation of one's own belatedness, and the inescapability of repetition.

All these versions of the canonic defence tend to be deployed at moments of cultural stress. For example, it was argued on behalf of the 'artrageous' Young British Artists (YBAs) whose works were shown at the 'Sensation' exhibition that their very originality was proof of their indebtedness to the past, that they were doing what artists had always done, that it was the nature of avant-garde work to scandalise before it was accepted, that their work was within an English tradition of painting, and that certain individual artworks in the exhibition were continuous with, and in certain instances were critical reflections upon, earlier masterworks of the canon. Sir Phillip Dowson, the Royal Academy's president, wrote in the exhibition catalogue: 'it is fitting that "Sensation" will be followed by the exhibition "Art Treasures of England", a selection of great works of art from English regional museum collections.' And three years later, a London *Times* columnist called on the new mayor of London to ensure that the 'Sensation' artworks were added to such a collection. 'Sensation' was a 'key event in the recent history of British art' and the mayor had a 'duty to history to keep "Sensation" for ever.' The catalogue to the 2000 'Apocalypse' R.A. show (the Academy's postscript to 'Sensation') reproduced across the top of its opening pages a series of canonic artworks, as if encouraging the conclusion: the exhibition's works are successors to these predecessor masterworks.

This defence is a short-term measure, intended to keep new art safe, as it were, until time does its own work. After a while, the work will be accepted, or it will disappear. Of the three defences, the canonic, then, would appear to have the least staying-power. (It also attracts the most scorn from the avant-garde. Exemplary of this is André Breton's gesture, the Surrealist encased in a sandwich board inscribed thus: 'For you to like something, you need to have seen and understood it for a long time, you idiots.') And yet a whole theory of art has been erected on this slender contention. It has been described by the philosopher Jerrold Levinson as the 'historical theory' of art. It is reducible to the minimalist proposition that an artwork is a work that has an intentional relation with (other) artworks. It distinguishes between new, original and revolutionary art. A new artwork is simply one that is not identical to any previous artwork. An original artwork is a new work that is one significantly different in structural or thematic properties.

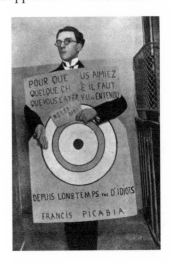

André Breton with placard by Francis Picabia, at the Dada Festival, Paris, 1920

However, neither the merely new nor the original artwork will change the 'stock of ways' in which artworks are regarded. Only revolutionary art does that, which is indeed what makes it revolutionary. It answers to that ambivalence we feel about the great works we most admire. They civilise us, but they also colonise us, and they chain our hands invisibly (to adapt some lines of the poet Derek Walcott). Still, since the historical theory of art defines artworks as works that have a relation with past artworks, the revolutionary artwork presents a problem. What to make of the 'artwork' that has no relation with previous art? The problem is resolved by including in the understanding of the 'artness' of artworks an antagonistic, even repudiatory, posture towards previous art. A work that rejects previous artworks is thereby art. Anti-art is consecrated as art; the revolutionary artwork is co-opted to the canon by the very violence of its disavowal, an involuntary embrace. And, of course, history now allows us to add: the break with tradition has its own tradition.

The art that most solicits these three defences, that many artists thus strive to create and that critics like to praise, eludes given categories; aspires to the unstable condition of anti-art; is oppositional, adversarial, anti-academic and/or politically dissenting; may adopt stereotypical representations, but only in order to expose them to censorious scrutiny – it will be ironic (and protest its irony against naive viewers who take it literally); alternatively, it may be confessional – unmediated, raw, refusing the civilities of ordinary social existence, dragging into the exalted public space of a museum the representation of a private emotion or experience.

Each one of these defences has a relation both to a theory of art and a body of artworks. The defences mediate between that theory and those artworks. (The canonic defence, for example, is a forensic application of the unexceptionable interpretive principle that to understand a new artwork requires putting it into a context of other artworks, a necessarily historical endeavour. As Harold Rosenberg said, if you don't know how, for example, Newman and Mondrian exist in relation to the art of the past, all you will see is stripes.) Theory tends to have pretensions to explaining all art; individual artworks resist conformity with theory. The defences establish a fit between theory and work, by qualifying the theory on the one hand, and privileging, or highlighting, certain aspects of the artwork on the other. Theories change when they are mobilised as defences. In certain respects, they get sharper. Developed in response to attacks on favoured works, they acquire a certain edge. But they

tend to become less nuanced. Artworks likewise suffer, but by being obfuscated. The defences mask those aspects of artworks that they cannot satisfactorily explain. Of the works that I have described above, the aspect that is thereby put into the shade is the transgressive.

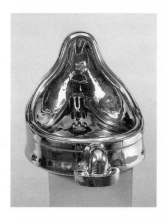

Sherrie Levine
*Fountain/After
Marcel Duchamp*
1991

The estrangement defence depends upon, without acknowledging, a residual pedagogic/moral case for art. It fails to distinguish between works that are 'disturbing-captivating' (the philosopher Jane Bennett's phrase) and works that are 'disturbing-repelling'. Both kinds are estranging, but to very different effect. Moreover, the defence also overlooks the fact that art-making will often be an activity by which we make our alien world familiar. Art can have an estranging effect, certainly, but it can also tame, and make the remote accessible. It is one method by which we can acquire knowledge of the hitherto intimidatingly alien. The formalist defence treats difficult content as a distraction. It also leads to the systematic undervaluing of artworks of periods and styles that resist purely formal analysis. The canonic defence undoes itself. It is both suffocating and strategically useless, reducing each new artwork to the uniform grey of every established artwork. Furthermore, it banalises the complex, often repudiatory relations between transgressive art and predecessor, canonic art, and, indeed, between transgressive artworks themselves. For example, Sherrie Levine's *Fountain/After Marcel Duchamp* (1991) extends the Duchampian notion of the 'readymade' into the realm of art itself. None of these defences is equal to the challenge of many modern artworks. Taken together, they encourage the overvaluing of many such works, while concealing valuable aspects of others. They comprise a critical discourse about modern art that tends to neutralise actual artistic practice. This discourse offers a *defence* of art, even though a satisfactory *description* of it in such terms is inapposite. To speak up for art in this way is thus to give a false account of its nature. To adopt forensic language, one might say: represented, it is misrepresented. Each defence represents an attempt to come to terms with, while also denying, the transgressive nature of modern art. These defences have been deployed, sometimes to great effect, in response to prosecutions of artists. During the 1990 obscenity trial of a Cincinnati museum director for exhibiting Mapplethorpe photographs, both the formalist and the canonic defences were advanced by the defendant's lawyers. The sociologist Steven Dubin compares

49

the defence witnesses to 'alchemists who recast images of extreme sexual acts into figure studies, and transformed the arc of urine being directed into a man's mouth into a classical study of symmetry. This deflected attention from the difficult subject matter of the photographs onto formalist considerations such as composition. In some instances these specialists also drew on art-historical analogies, likening the children's portraits to Renaissance putti.' It was, concludes Dubin, 'a well-conceived strategy, and extremely well-executed'.

Though it resulted in an acquittal, the strategy did less than justice to the works themselves. Consider, for example, Mapplethorpe's *Self-Portrait* (1978). Part of a series, it has a certain notoriety. When the art critic and philosopher Arthur Danto writes of 'the standard agony of putting oneself in the presence of Mapplethorpe's art', he might well have this work in mind. It shocks, and so there is a risk that the precise nature of the shock will remain unexplored. It has a number of aspects. There is the self-exposure, allied to a well-established gesture of contempt – showing one's behind, as if to say: this is a display of my disdain for you. It is an extreme instance of a certain absence of civility – of restraint, of decorum – towards the viewer. Mapplethorpe exposes himself, one might say, the better to emphasise his detachment from his audience. And there is the insistence upon the sexuality of the artist, the concentrated look not a pose, but a sign of the artist's absorption in the autoerotic experience itself. It is the impassivity of his expression, one that intimates an emotion that is experienced but not communicated, that reminds one of Manet's figures. The subtlety of the work's compositional geometry and the complexity of its art-historical references comprise additional provocations. It alludes to numerous genres: medieval representations of the devil, with tail; the nude; the self-portrait; both the body and performance art of the last few decades. It is the work, remarked the art critic Robert Hughes, of a man who knows the history of photographs, and for whom the camera is an instrument of quotation.

Such a work thus defies the very defences on which, on occasion, it has had to rely. *Piss Christ* likewise. This too is multiply transgressive. It scandalises; it breaks implicit rules of aesthetic propriety; it celebrates both the erasing and breaching of boundaries, the distinctness and customary elevation of the crucifix blurred and then lost, submerged in the thin viscosity of Serrano's own waste. To relate the work to artistic precedents only

exacerbates the offence it causes; to praise its compositional qualities is one-eyed; to make a case for its moral purpose is mere sophistry. The formalist defence disregards much of the meaning of the work, and altogether ignores the title. The estrangement defence disregards the aspect of insult which is essential to the experience of the work. The canonic defence wavers unsatisfactorily between inviting a suspension of judgment (only time will tell...) and making a positive judgment (all great works of art shock, surprise, violate taboos, etc).

Serrano's *Piss Christ*, Mapplethorpe's *Self-Portrait* – these are among the final works of

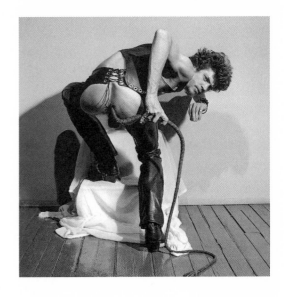

Robert Mapplethorpe
Self-Portrait
1978

©The Estate of
Robert Mapplethorpe

the transgressive period: *Self-Portrait* because it forces the logic of the three defences beyond their limits, violates the implicit bond between spectator and artist, and realises the transgressive principle (with the result that transgressive art cannot go beyond it); *Piss Christ* because its uncoupling of text and image, title and picture, is a lame reprise of just that activity of uncoupling that was characteristic of the modern period. Its attempt to retrieve beauty is also an implicit acknowledgment of the tiredness of the transgressive as an aesthetic. And, finally, both works because they demonstrate the passage from representation to presentation, an inevitable consequence of the pursuit of the transgressive aesthetic, which cannot bear too much illusion. It is not enough that it is a picture of a transgression, or that the making of the work itself is transgressive, it must also record an act that in turn was transgressive.

This combination of current meanings, endorsements and defences amounts to the conventional, or received, understanding of the transgressive in art (let me call it the 'received version'). The received version tends to regard the transgressive as a permanent, uniform and benign condition of art-making. It is thus ahistorical, indifferent to the varieties of the transgressive, and sentimental in its attachment to a notion of transgression as liberating for both artist and audience. It adheres to defences that as much conceal as explicate the challenge of transgressive artworks. One of my objectives is to offer an account of these works that is significantly different to the received version.

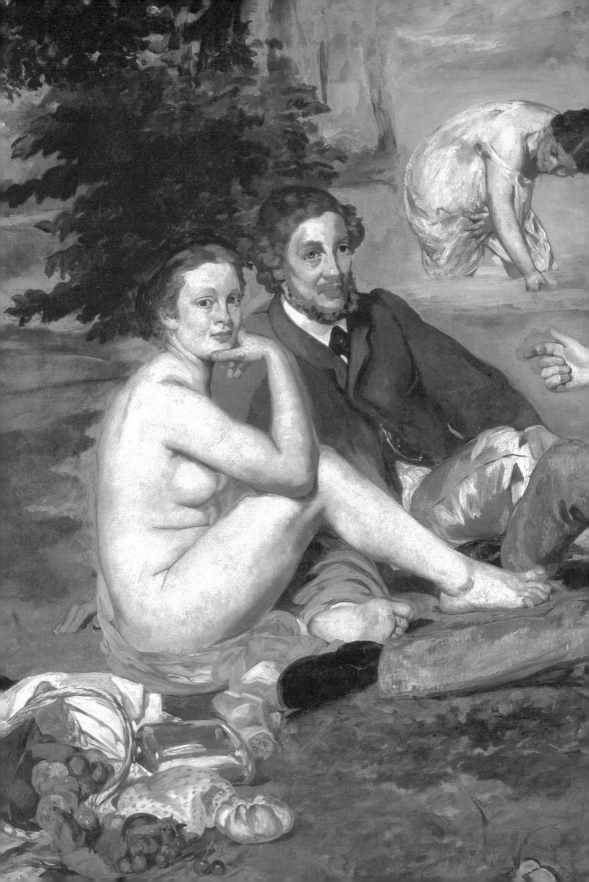

II

A Transgressive Artist:
The Origins of the Transgressive Period

The Period

There have always been transgressive artworks; transgressions are as old –
almost as old – as the rules they violate or the proprieties they offend. To revolt
against accepted standards, against tradition itself (however tendentiously
conceived), has been the prerogative of Western artists since, at the latest,
the Renaissance. 'No man on whom a good fairy has not bestowed at birth the
spirit of divine discontent with all existing things will ever discover anything
new,' declared Richard Wagner. But it is only from the middle of the 19th
century that the making of such works itself contributed to the definition of
the project of art-making. 'We love Manet,' wrote the Cubists Gleizes and Met-
zinger, 'for having transgressed the decayed rules of composition.' In doing so,
Manet inaugurated the transgressive period. This period is now coming to an
end. The transgressive aesthetic has exhausted its potential. The creativity of
the period – principally, a set of transgressive art practices – has expended
itself. 'Periods' are hard to define and are of questionable value. Dividing a
historical continuum into discrete periods offers certain opportunities for
understanding. But it is only a device, one of a number in the interpreter's box;
it does not live in the continuum itself. The taxonomist's tendency to treat his
work as the classifying of already-existing differentia is a self-deception. The
value of maintaining any such classification thus depends entirely on its use-
fulness. Many of the major artworks of the past 150 years or so may usefully be
described as transgressive. During this time, the opportunities for certain
kinds of transgressive art were exploited to the full. One could say, risking
paradox, that the transgressive was hegemonic. Before the period, the trans-
gressive existed; for the period's duration, the transgressive was constitutive
of its character; now, to the extent that the transgressive continues to animate
artists' understanding of art, it tends to be a constraint on the emergence of
genuinely new art. The transgressive inhibits; it represents a boundary that
today's artists must transgress.

Opposite
Edouard Manet
Le Déjeuner sur l'herbe
(detail)
1863

Within the context of the inauguration of the modern in art, there was a turn to the transgressive. The causes of this turn? Even the simplest of cultural phenomena have plural causes; they are always overdetermined. And this particular phenomenon, by contrast, was complex. I am trying to capture something intricate, and half-concealed. One can say this: the 1850s and 1860s marked the beginning of a period in which cultural certainties began to collapse. What was taken to be true was questioned; what was taken to be good was subverted; what was taken to be beautiful was mocked. Artists and writers intuited this, very early on. ('The way we grasp the world changes, the artist knows first,' says the philosopher and novelist Iris Murdoch, 'like the animals whose behaviour foretells an earthquake.') Related to these developments was the accelerating speed of science-led change, which itself had an impact on art as on everything else. All this by now has passed almost beyond cliché; we know so completely that we have no certainties that this knowledge has itself become a dogma. The cultural analyst Marshall McLuhan, with his gift for inventing commonplaces, put the dogma best: 'The mark of our time is its revolution against imposed patterns.'

This sense of the revolutionary, in which changes in given boundaries have unpredictable consequences, perhaps leading to new configurations that cannot be anticipated, rapidly became a commonplace of the time, to be turned derisively against radicals (a French critic of the 1863 Salon des Refusés criticised the exhibiting artists for 'pushing back the boundaries of stupidity') – though sensitive, acute minds gave the intuition of fundamental change the imprint of their own, more individual consideration. The French art critic and historian, Théophile Thoré, in a series of essays published in the years 1855-7, related this collapsing of boundaries to a tendency towards a greater universalism, which he welcomed. He found in France and elsewhere what he described as a strange uneasiness, an irresistible aspiration towards a life altogether different from that of the past. All the conditions of the former society, he said, have been overthrown. Incomparable discoveries have given unlimited extension to every fact and idea. Whatever becomes known in one place is soon known everywhere. Before, each people was shut up in narrow, territorial boundaries, enclosed in their distinctive superstitions and cults. Now, each is subject to a generalising expansion, with the result that laws become humanised, opinions become enlightened, customs become liberalised and the interests of each mingle with the interests of all others.

The moral frontiers between peoples have been removed. A universal art will emerge from this, one to which nothing human will be alien.

Flaubert/Manet

Against this optimism, by no means banal or unwarranted, certain reflections of Flaubert's must be placed. Flaubert had an early intimation of the transgressive and its relation to the fragility of cultural boundaries. He wrote about it in a remarkable letter to Louise Colet, dated 4 September 1852. It was thus sent in the interval between the promise of the 1848 Revolution and the 1857 prosecution of Flaubert for his novel *Madame Bovary* – between, that is, moments of euphoria and oppression, false optimism and failed censorship. He has, Flaubert explains, his fair share of worries. He is harassed by his household. A cousin is expected to arrive soon, further disrupting his domestic life. Why is it not possible to live in an ivory tower? Money is the problem. If he had money, he would be able to unburden himself. As for Louise, he loves her, and delights in her body. His grumbles about the inconveniences and irritations that beset him are, he acknowledges, pointless. They comprise the very law of existence. We should be religious, he says, by which he means resigned.

He clings to his task, which is his writing. Since he receives no encouragement from other people, and the outside world disgusts him, he must seek within himself a suitable place to live. He has become a kind of aesthetic mystic. Unless things change, others soon will come to adopt this perspective on life. This impending revival of mysticism may well lead to beliefs about the end of the world, or the arrival of a new Messiah. Such expectations will of course be without any theological foundations, and people will chase after every kind of idol – sex, the old religions, art. What a subject for a novelist! But it will be too late for Flaubert himself. His career, he laments, will be over by then.

All sense of this imminent future, he continues, quite eludes both the socialists, with their materialism, and the republicans, with their plans to re-organise the whole world. The socialists deny the reality of pain, they revile much of modern poetry, they do not understand that the blood of Christ which flows through our veins will not be staunched. The republicans do not see that rules of all kinds are dissolving, that barriers are coming down, that the earth is being levelled. The world cannot be reordered. That first moment of reform, in which the established order melts, leads to an irreversible

dissolution. Thus while the socialists are blind to the spiritual dimension of our lives, the republicans erroneously believe that they can rationalise it.

Pain, and the disordering of rules, will characterise our art. All around there is confusion, and who knows where it will take us? Perhaps to liberty. Art, which always leads the way, has indeed followed this path. It has turned its back on rules. This induces a certain cultural vertigo. It is not just that we are lost; we are also without the means of recovering our bearings. We no longer know where we stand; we no longer know on what we stand. Indeed, what poetics, what theory of literary propriety, still prevails? None. As for the plastic arts, they are becoming even more impossible. We have a rigorous vocabulary for art, but ideas that are hopelessly vague and unformed. It is hard to guess what will come of all this, Flaubert sighs. Beauty itself may become a feeling for which humanity has no further use. And so the best that we can do is exhibit our own virtuosity with works of self-display. Innocence, the simple telling of stories or picturing of nature, is an illusion.

And then, as if the strain of this divination suddenly overwhelms him, Flaubert breaks off and concludes instead with a backward glance. I cannot, he concedes, see things to come. I would have enjoyed, he adds irrelevantly, living in earlier times.

This is discursive, even loosely associative, writing. Flaubert is thinking aloud, passing from theme to theme, enjoying the freedom of an intimate correspondence to write whatever occurs to him, as it occurs to him. It is not a letter that reads as if its author had first read it back to himself and then revised it before sending. It is as familiar and unmeditated as an embrace. But it is also reflective, and full of a sense of the doubts and anxieties of the times. It intimates chaos, and an impression of the transgressive as a symptom, with uncertain, troubling effects, of general dissolution. Flaubert's account of the vanguard nature of art, though itself unqualified, is in a minor key. He offers an intuition of collapse. It is not the violation of rules that Flaubert witnesses, but their decay – or rather, their easy violation because of their decay. Literary categories, genres, the domain of literature itself – all are losing their defini-tion, their demarcations. Flaubert's letter is a meditation on transgression. He is appalled by it, and resigned to it, and stirred by it. It defines his project, and it is his predicament.

It was not, of course, merely a predicament. It also offered artists and writers many opportunities to unsettle given political and cultural conditions.

Within the fine arts, this turn to the transgressive led to immediate, remarkable achievements. It led, that is, to Manet, the first transgressive artist of the modern period. In May 1867, after a series of reverses at the annual Salons, Manet exhibited 50 paintings, including works accepted or rejected by the Salon juries from 1859 to 1866. Paris was the capital of the academic tradition, yet Manet continued to be surprised and dismayed by the reception given to his artworks. The catalogue to the exhibition contained an unsigned Preface, the sentiments of which (if not all of its phrasing) are to be attributed to Manet himself. It was headed 'Reasons for a Private Exhibition':

> The artist does not say today, 'Come and see faultless work', but, 'Come and see sincere work.'
>
> This sincerity gives the work a character of protest, albeit the painter may merely have thought of rendering his impression.
>
> Manet has never wished to protest. It is rather against him who did not expect it that people have protested, because there is a traditional system of teaching form, technique and appearances in painting, and because those who have been brought up according to such principles do not acknowledge any other. From that they derive their naive intolerance. Outside of their formulas nothing is valid, and they become not only critics but adversaries, and active adversaries.

This understated the radicalism of Manet's work, its repudiation of 'traditional systems', and the extent and nature of its 'protests'. The Preface continued: 'Manet… has presumed neither to overthrow earlier painting nor to make it new.' But this was precisely the ambition of his work. It is transgressive in the complex, adversarial relations it establishes both with its audience and with the art canon, in its overrunning of boundaries protective of social pieties, in the secularism of its handling of religious themes, in its breaking with the academic conventions that governed art-making. 'Conventions of any kind,' remarks the art historian Juliet Wilson-Bareau, 'were anathema to Manet and his strategy was to concentrate on their destruction.' This strategy earned the artist, from one hostile critic, the title 'recidivist of the monstrous and the immoral'. Of his *Portrait of M. and Mme Auguste Manet* (1860), another critic complained: 'To him nothing is sacred! Manet tramples under foot even the most sacred ties. The artist's parents must more than once have cursed the

Edouard Manet
*Portrait of M. and Mme
Auguste Manet*
1860

day when a brush was put in the hands of this merciless portraitist.' This is the transgressive artist, whose subject is the sacred, but to whom nothing is sacred.

During the 1860s, then, Manet painted a series of pictures in which the transgressive impulse can be seen in the process of becoming an aesthetic. The most immediate, plainest evidence of this emergent aesthetic can be found in Manet's adversarial engagement with that aspect of the 'traditional system' concerned with genre. Classified and ranked by the academies, art's subjects – history painting, religious painting, the landscape, the nude, the still life, the portrait – were available to the artist under prescribed conditions. Manet broke with the governing protocols of all the major genres with a disabling forcefulness. In his study of Manet's 1860s paintings, Michael Fried suggests that this break was intentional, programmatic – and that *Le Déjeuner sur l'herbe* is itself an epitome of all the genres, including religious painting. *Olympia* violated the master secular genre of Western art, the female nude. *Jesus Mocked by Soldiers* and *The Dead Christ and the Angels* secularised the master religious genre of Western art, the Passion. *Le Déjeuner* foreshadowed that counter-genre of the 20th century, appropriation art, in which modern art explains, to those who had hitherto failed to grasp the fact, that artworks address not the world but themselves, and are derived not from the world but from other artworks. Manet's works are rule-breaking, and taboo-breaking. They depart from conventions of representation; they assault pieties. They are also an invitation to artists to join a project, one aspect of which is the project of repeating *Olympia* and *Le Déjeuner* themselves. No other modern works have been so relentlessly appropriated, and cancelled, by subsequent generations of artists, and one can thus trace distinct art sequences that start with these artworks and lead to subsequent artworks during the following century. Transgressive art, not being a genre in itself, does not have a single history. It has instead a series of heterogeneous histories, of which one variety consists of a number of just these sequences. What follows is an outline of just three of these (there are others). In the chapter that follows I take a different tack, presenting a typology of transgressive artworks, limited to the modern period but having no regard to chronological priorities.

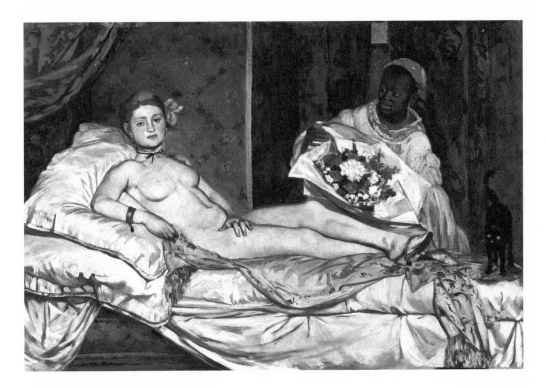

The Female Nude

Manet's *Olympia* (1863) was exhibited at about the same time that the word 'pornography' first appeared in the German, French and English languages. One might say that within the same brief period modern art and the pornographic were invented. *Olympia* was itself pornographic in the etymological sense (the Greek word *pornographoi* means 'whore-painter', and Olympia was a name commonly adopted by prostitutes). It is a portrait of a naked woman posing as a nude. Her pose, that is, is a candid pretence. The work makes a display of its artifice. *Olympia* was an affront both to the art canon and to the aesthetic sensibilities of its Paris audiences, who were able immediately to identify the nude as a prostitute. 'Olympia? What Olympia?' a critic exclaimed. 'A courtesan no doubt.' Furthermore, one that gazes out with a certain calm self-containment at the audience (the object viewed viewing the viewer, as one critic puts it). It was the first masterpiece, says Bataille, before which the crowd fairly lost control of itself. This response gave it the impact of a radical break in art history. It was a negation of Olympus, of the mythological monument, of monumental conventions. It was taken to be evidence of 'an armed

Edouard Manet
Olympia
1863

59

insurrection in the camp of the bourgeois: a glass of ice water that each visitor gets in the face when he sees the beautiful courtesan'. Ice water, precisely: it was in fact the *anti*-erotic quality of the work that was indecent. Writing almost a century later, Kenneth Clark was troubled by the work's deviations from tradition. Although no longer shocking, he said, *Olympia* remained exceptional. To place on a naked body a head with so much individual character jeopardised the very premise of the nude. Manet succeeded, Clark concluded, only because of his perfect tact and skill as a painter. Such praise masks the nature of Manet's achievement.

Olympia both refused the support of the regulating conventions of the fine-art tradition and yet alluded to the canonical works that exemplified those conventions. The genre was founded on the following principles: that there is a distinction between nude and naked; that art is concerned with the nude, not the naked; that the body cannot be made into art by direct transcription; that the nude is not the subject of art, but a form of art, invented by the Greeks in the 5th century BCE. Principled nudity dominated the canon. Female nudes peopled scenes of pleasure; male nudes, scenes of torture and death – battles, martyrdoms, the Crucifixion and other moments in the Christian drama. *Olympia* put the genre of the female nude under threat, just as Manet's *The Dead Christ and the Angels* (1864) put the genre of the male nude, the crucified Jesus, under threat. *Olympia* did it in part by admitting a pornographic subject (a contemporary woman, unclothed for the pleasure of the spectator) into the precincts of high art, and in part by enlarging the genre's vocabulary. It subverted the genre, *and* expanded it. It undermined it, *and* gave it new strength. It worked on two sides of the conventional genre picture: it was a painting of a naked woman, unclothed by genre conventions, and it was a picture of the genre itself. It exposed the model, and the genre, to critical, open-eyed scrutiny. It unmasked the connection between picture-gazing and prostitute-using, and thereby diminished to near-zero the (impliedly, considerable) distance between the contemplative pleasures of art and the urgent gratifications of sex. 'Never has anything so strange,' remarked one reviewer, 'been hung on the walls of an art exhibition.' 'I can say nothing about her in truth,' commented another, 'and do not know if the dictionary of French aesthetics contains expressions to characterise her.'

Olympia, said Mallarmé, 'is scandal and idol, power and public presence of society's wretched secret... she makes us think of everything that conceals and

preserves primitive barbarity and ritual animality in the customs and practices of urban prostitution.' That the genre was incapable of anything other than a feeble decorativeness at that time is evidenced by Alexandre Cabanel's *Birth of Venus* (1863), the target of a scornful commentary by Zola. 'This goddess, bathed in a flood of milk,' he wrote, 'has the air of a delicious woman of easy virtue, not in flesh and bones – that would have been indecent – but in a kind of white and pink almond paste.' It maintained precisely that distance between spectator that permitted erotic contemplation without threatening engagement. It is a kitsch fantasy of sexual submissiveness. Cabanel's achievement was to make transparent the implicit conventions of the genre. But Manet's break was with the canon itself, and not just the conventional within the canon. (Manet, to his friend Antonin Proust: 'It seems I've got to do a nude. All right, I'll let them have one.') While thereafter the nude was no longer, in Baudelaire's phrase, 'cette chose si chère aux artistes, cet élément nécessaire de succès' ('Salon de 1846'), it continued to provide opportunities for art. Nudes were painted in spite of Manet. But in consequence of its paradoxical achievement, *Olympia* was responsible for initiating two distinct developments in art-making. The nude genre divided into two separate, indeed antithetical, projects: one, subversive; the other, revisionist.

The subversive project appropriated the pornographic in order to interrogate art conventions and the art canon. It used the pornographic as an engine of transgression. It was able to do this because it is the very existence of

pornography that establishes the separateness of art, and yet also makes that separate status insecure. Art is defined against pornography, while also partaking of it. Pornography can thus be mobilised against art; in different ways, Duchamp and the Pop artists took just this course. Pornography is latent in the canon, there to be denied. It has recently been said that art history carefully polices the boundaries between various sites of visual representation. Better, perhaps, to say that art history first postulates, and then polices, these boundaries. One such boundary is that separating the nudes of high art from the naked women of pornography (which is not to imply that pornography does not have its own conventions). In much of Duchamp's work, for instance, and in the work of the Pop artists, the latent, pornographic aspect of high art is exposed. The revisionist project, on the other hand, commits itself to the re-representation of the nude. This is a reflexive project, self-aware, and sensitive to Manet's challenge. He robbed the nude of its generic innocence, with the consequence that the picturing of nakedness could no longer be taken for granted. The very process by which the representation is put on the canvas, the relation between artist and model, thus becomes the subject of artistic scrutiny. There is a complicating of the 'givenness' of the image of the nude. After Manet, it ceased to be available, or quite so readily available, to the gaze of the viewer.

These projects are transgressive. The subversive project, because it refuses, or blurs, the distinction between fine art and the pornographic (a metonym for popular culture), and the distinction between the disinterested and the engaged gaze of the spectator. The revisionist project, because it relocates the boundary lines between the nude and the naked, and the artist and the model. In each case, the spectator is likely to be perplexed, at least at first. These distinctions, these boundary lines, continue to comprise – though endlessly revised and assaulted – the received wisdom concerning art and its 'proper' appreciation. They constitute the borders, formerly certain and intact, now indistinct and fractured, that enclose artist and spectator in a sanctioned, aesthetic space. Both projects, the subversive and the revisionist, have been completed. They have been transacted in the context of periodic scandals of reception. Klimt's *Philosophy* (1897–9), *Medicine* (1900–7) and *Jurisprudence* (1903–7), for example, were accused of crudeness of conception and aesthetic deficiency, of violating the canons of academic nudity, of pornography. There were subsequent comparable scandals.

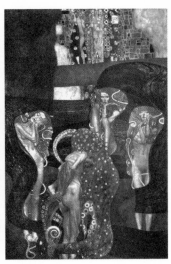

During the trial of Flaubert for writing *Madame Bovary*, the prosecutor, Ernest Pinard, concluded his speech with this peroration:

> Morality does not stigmatise realist literature for painting the passions. Hatred, revenge, love, all our lives are grounded in them, and art should paint them, but not without limits and standards. Art without rules is art no longer; it is like a woman who would shed all her clothes. To impose upon art the single standard of public decency is not to enslave but to honour it. Nothing grows in stature without rules.

A naked woman becomes, in this account, the most suitable metaphor for an 'art without rules'. It is a complex metaphor because, of course, in one sense the nude was an entirely conventional subject for art, rule-bound in execution and, when exhibited in the appropriate context, quite in conformity with 'public decency'. And yet, in another sense – in Pinard's sense – a woman without clothes or, more precisely, a woman ready to strip, represents the greatest imaginable affront, both to art and to the public. (To understand this affront, the examples to have in mind are not strip-club workers, but women who would breast-feed in London restaurants, wear short sleeves or trousers in Jerusalem's Orthodox Jewish quarter, or go out in public with face exposed in Teheran.) It is one and the same body that is both the safest and most

Left
Gustav Klimt
Philosophy
1897–9

Middle
Gustav Klimt
Medicine
1900–7

Right
Gustav Klimt
Jurisprudence
1903–7

regular of spectacles and yet also the most dangerous and unlicensed. Context is everything.

For Pinard, then, a woman ready to strip is the best metaphor for an art without rules, just as the nude itself is the best synecdoche for canonic art. For Manet, picturing a woman ready to strip, or having stripped (but not quite – there is the choker), is *itself* a breaking of the rules. With Manet, metaphor becomes means. That is to say, the pornographic image becomes the means by which art rules may themselves be violated. It is the perfect instrument for this attack, partly because of pornography's own limited subversive capacities, but more importantly because of the effect it has when inserted into a high-art context. This attack, this project of subversion, was taken by artists after Manet in two quite distinct directions. The first, and less interesting direction, was to make artworks that insisted upon the complicity of high art with pornography. As if fearful that Manet's transgressive lesson would otherwise be unlearned, these works restated it, imitating or reproducing images from pornographic texts, in ever more unmediated terms. Jeff Koons, in his *Made in Heaven* series (1989), works the hardest to teach the lesson, so it is dispiriting to read it praised for 'transubstantiating smut into art' by art historian Irving Sandler. The second, and less developed direction, was to explore porno-graphic themes as the means of a more general subversion of art's rules, by which I mean the rules that govern the making of art, and its reception. This was Duchamp's direction.

The subversiveness of pornography has been overstated. It can, on occa-sion, break the rules. It may, perhaps, subvert certain conventions. But its fantasies of licence tend to reinforce the regularities of conventional sexuality. It offers an imaginary universe in which certain given values are suspended. It cannot precipitate political liberation, notwithstanding the fears of cultural conservatives. Confined to magazines, clubs and the internet, it does not test its consumers, it feeds their addiction. It is only when the pornographic strays beyond these precincts, only when 'it refuses to obey the laws of a minor genre' (the observation of the critic Denis Hollier), that it acquires a subversive potential. It is out of place, and yet also at home, in the art canon, in which the female nude is a metaphor for art-making and a metonym for beauty. Art has a tacit, unacknowledged complicity with pornography, as it does with advertis-ing, pornography's 'U'-rated cousin – John Berger's celebrated reproach in *Ways of Seeing* (1972). Feminist art scholarship has laid bare those aspects of canonic

art isolated and replicated by pornography. It has exposed the nude. The pleasure taken in looking at certain images is implicated in oppressive practices; fine art keeps in circulation representations of unequal gender relations. It has been the work of several decades to make this evident; only in pornography is it disarmingly, almost comically, plain. Our understanding of what is latent in the canon has now caught up with our ready apprehension of what is manifest in pornography.

Pornography can thus be used against art. It scorns high culture's pretensions. It exposes the fragility of the philosopher's distinction between contemplation and

Richard Hamilton
*Just What Is It
That Makes Today's
Homes So Different,
So Appealing?*
1956

desire, and between content and form. It undoes the project of aesthetics at every point: disinterestedness, elevation, genre. Our aestheticians, Nietzsche mocked, never weary of asserting that, under the spell of beauty, they can view undraped female statues 'without interest'. But Pygmalion, he adds, was 'not necessarily' an unaesthetic man. The erotic tug of an artwork cannot be excluded from the repertoire of its aesthetic effects. (How to define the erotic? Perhaps as the product of this equation: the beautiful plus the transgressive.) The British artist Richard Hamilton once said that the *Playboy* 'Playmate of the Month' pull-out pin-up provided us with the closest contemporary equivalent of the odalisque in painting. It finds its way, therefore, into his *Just What Is It That Makes Today's Homes So Different, So Appealing?* (1956). This artwork effects a double transgression, a double blurring of boundaries, between art and everyday life, and within art, between the canonic and the popular. It is a representation of the contemporary home and so it is also a representation of representations. It pictures the society of the spectacle, in which pornography plays a principal part.

Hamilton's Pop artwork was followed by many other artworks that playfully compromised the 'high-art' nude by 'low-art' strategies. These comically subversive paintings were indebted to Duchamp's more radical subversions. Apollinaire remarked of Duchamp that he was 'the only painter of the modern school who today [autumn 1912] concerns himself with the nude'. He had

Right
Marcel Duchamp
The Bride Stripped Bare by her Bachelors, Even (The Large Glass)
1915–23

Opposite, top
Man Ray
Marcel Duchamp as Rrose Sélavy
1921

Opposite, bottom
Marcel Duchamp
Nude Descending a Staircase (No. 2)
1912

himself photographed in drag by Man Ray, assuming the name Rrose Sélavy: Eros was his life (Eros, c'est la vie). Duchamp's work consists of (a) Dadaist anti-art gestures and (b) subversive art engagements with the nude. Of the gestures, Duchamp's 'readymades' are the principal product. By their notoriety, their beauty and their collectability, they risk losing their art-resistant particularity and thus being appropriated as art. They have already been appropriated as art by museums, and for certain art theorists this is enough to make them art. Harold Rosenberg described them as a kind of infra-art that accompanies art itself as the minus sign of its qualities. Of the engagements, three comprise his most significant work: *Nude Descending a Staircase* (1912), *The Bride Stripped Bare by her Bachelors, Even* (1915–23), and what has been described as its naturalist, posthumous version, *Etant Donnés* (1946–66). The variety of their titles, the diversity of their material, ostensible subject matter and form, and their avant-gardist resistance to immediate, recuperable meaning, risk obscuring the essential unity of their interrogation of the female nude.

Duchamp reprises and parodies (takes to parodic extremes) Manet's transgressive project of the 1860s. 'Eroticism is a subject which is very dear to me,' Duchamp once remarked. The 1912 *Nude*, indifferently male and female, condenses in one work the male and female nudes that Manet presented in the same year to the Salon, *Olympia* and *Jesus Mocked by Soldiers*, a gesture that asserted their generic equivalence. Duchamp was forced to withdraw the work from the Salon des Indépendants. 'A nude never descends the stairs,' the hanging committee declared; 'a nude reclines.' *The Bride Stripped Bare* alludes

to the group in *Le Déjeuner*, the woman stripped bare, the men clothed. *Etant Donnés*, its peephole disclosing a naked mannequin, inert, legs askew, is a savage restatement of that 'dual rite of voyeurism and aesthetic contemplation' (the judgment of the Mexican poet Octavio Paz) that *Olympia* first

exposed to scrutiny. Taken together, these works endeavour to close down the nude as a genre and thereby to disable art, by denying the very possibility of beauty. They operate on either side of the genre's limits, both by denying or overstating its gendered representations and by putting into play, while also withholding from completion, rites of sexual initiation.

Manet withdrew the nude as an art *donnée*. If nudes were to be painted, the undertaking had to be justified. Following Manet, representations of the nude tend to be reflexive, containing their own justification. They are their own

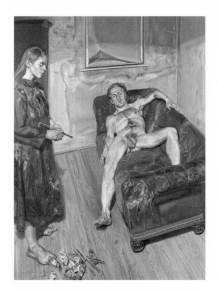 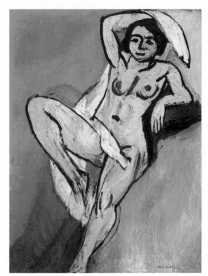

advocates. Some artists, not content merely to paint their justifications, insist on adding verbal explanations too. These tend to be verbose, overstated: 'For as long as we exist, we shall have the symbol of the nude, woman as the eternal source and continuation of our race' (the German artist George Grosz). We may say: post-*Olympia*, artists critically examined just those conventions of representation that *Olympia* itself put on display, and sought new generic conventions to put in their place, ones that took the measure of Manet's challenge. The very process by which the subject was realised, that is to say, the relation between artist and model, ceased to be transparent, automatic. The availability of the model to the artist, that ready submission that may be expressive of an erotic dependency, could no longer be taken for granted. In addition, there is a complicating of the 'givenness' of the image of the nude, by which I mean that the nude ceases to be available, or at least quite so readily available, to the gaze of the viewer. In summary: the hitherto settled relations both between artist and model, and between work and audience, were disturbed.

Lucian Freud's *Painter and Model* (1986–7), for example, creates a puzzle to which no certain answer is possible: which is the artist, which the model? The man sprawls in a pose alien to the genre. It is the pose from which, for example, Matisse shrinks in *Nude with a White Scarf* (1909) (compare his source, the 2nd-century Barberini Faun). Can he be the model? He is *a* model, certainly, but for him to be *the* model, the woman must be the painter. And yet, eyes cast

Left
Lucian Freud
Painter and Model
1986–7

Right
Henri Matisse
*Nude with
a White Scarf*
1909

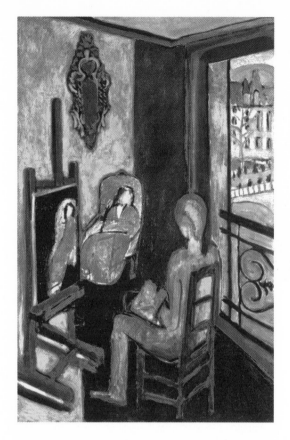

Henri Matisse
*The Painter
and his Studio*
1917

down and barefooted, without canvas and easel, squeezed paint tubes and discarded brushes scattered on the floor as if redundant, she is denied the authority of that role. Her paintbrush, gripped in both hands, suspended before a void, is more prop than tool. The unsettling of the hierarchical relations between artist and model can give to the nude qualities of both the androgynous and the autobiographical. Matisse, for example, who himself painted a picture in which the artist is nude while the model is clothed – see *The Painter and his Studio* (1917) – identified a 'certain moment' in the painting process when, in 'a kind of revelation', he finds that 'there is a virtual doubling of myself: I don't know what I am doing, I am identified with my model.' His nudes are both female representations and male self-representations. Every portrait is a self-portrait too. If with *Olympia* Manet made a certain kind of nude painting impossible –

the pandering to, while affecting to deny, the erotic interest of the male viewer in the female nude – then Matisse followed it with works that delivered nudes possessing a considerable erotic charge while rendering them in a certain sense unintelligible. In Matisse, the genre's erotic implications are both frankly acknowledged *and* contested.

This dividedness, a simultaneous showing and not-showing, and this doubleness, a simultaneous presentation of artist and subject, painter and model, characterise those post-*Olympia* nudes that have learned the lesson Manet has to teach. Degas's obsessive renderings of the figure of the prostitute, over 50 times in monotype in 1879–80 alone, are acts of self-disclosure, records of an extended surveillance which thereby record the artist himself engaged in his most intimate practices. The theme of artist and model, the making of art as a subject for art, in part a reflexive account of the model *as* model, was a preoccupation of Picasso's: see, for example, *Sculptor and Reclining*

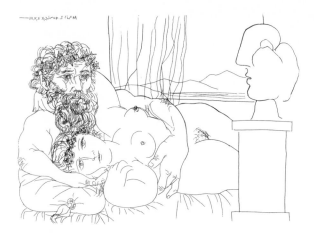

Model Viewing Sculptured Head (1933), *Painter and Model* (24 December 1953), *Painter and Model* (25 December 1953). In such works the nude is volunteered and yet withheld, the artist as if both advancing a proposition and denying it, or proposing a rule and transgressing it. The symbol of just this dual motion of affirmation and negation, a meta-picture, one that pictures the picturing of the nude, is Thomas Eakins's *Study of a Seated Woman Wearing a Mask* (1874–6).

One might, at first glance, be inclined to dismiss this work as a conventional representation, the naked, blindfolded woman submitting to the male gaze – call it 'art sexism'. It has indeed been characterised in just this way. It is

Pablo Picasso
Sculptor and Reclining Model Viewing Sculptured Head
1933

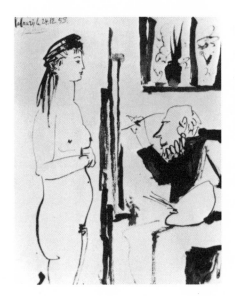

Far left
Pablo Picasso
Painter and Model
24 December 1953

Left
Pablo Picasso
Painter and Model
25 December 1953

of course a particularly powerful instance, and the presence of the mask not only literalises the unreciprocated nature of the gaze, but also relates the woman to the medieval personification of Judaism as a blindfolded woman, symbol of everything that is wilful, recalcitrant and obtuse. She is masked because she is obdurate. She has merited her blindfold. And yet blindfolds are also put on the condemned before execution, so that they should not witness the moment of their own death. To blindfold a model is in this sense to protect her from exposure to a certain kind of attacking stare, and to cast the audience in the role of firing squad. What is more, there is a certain quality of overstatement about the blindfold. It is as if the artist is drawing attention to something that is best left implicit: the inequality of relation between model and

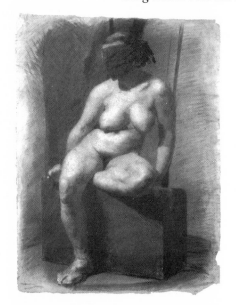

audience. By exaggerating that inequality, we are no longer able to take it for granted.

The drawing thus both instantiates and repudiates art sexism. It expands our sense of the genre-concept 'the nude' by combining art sexism with its critique. It is one thing, and its opposite. It embraces what it rejects, and rejects what it embraces. It is *a* and *not a*. To argue either that it is sexist or that it is a rejection of art sexism is in each case to misdescribe the drawing. It is example *and* critique. It is a picture, one might then conclude, that discloses an aspect of how art represents women. It is a reflexive artwork. It demystifies the tradition of which it is an instance. It is both an especially brutal image of female subordination and an exposure of the fine-art ideology of that

subordination. There is an art that is both exploitative and non-exploitative. It is an art that both instantiates and exposes the pornographic. Eakins's work is exemplary of this art; Manet was its founder; Cézanne – *The Rape* (c. 1867), for instance – was one of its great practitioners. It re-emerged in the United States in the 1980s, where its then principal practitioners were Eric Fischl and David Salle: see, for example, Salle's *Saltimbanques* (1986). It is pornographic, exposing the model's nakedness to the male spectator's sexualized scrutiny. It is also anti-pornographic, exposing pornography's mechanisms, thereby prompting the spectator's troubled self-scrutiny.

Paul Cézanne
The Rape
c. 1867

David Salle
Saltimbanques
1986

The analogy is with a duck-rabbit picture. We see art sexism, then a critique of art sexism, but while we never see both at once, we know that they are both present. They are constitutive of the one object. The boundary line demarcating concept from counter-concept is thus both affirmed and denied.

Ludwig Wittgenstein
Duck-Rabbit
1953

Art sexism embraces its opposite. The way in which our knowledge of the work exceeds our ability to see it is like the knowledge of art sexism that the work gives us which yet exceeds our ability to articulate it. There is thus an aspect of transgressive art that concerns itself with the simultaneous endorsement and subversion of given practices and beliefs. This is what transgressive art shares with non-transgressive art, but then takes somewhat further. It offers not just multiple meanings, but contradictory ones. Its 'aesthetic ideas' (Kant's phrase) refuse to cohere. That duck-rabbits are endemic in modern art is demonstrated by the Pop art of the United States. This was the artist Claes Oldenburg's ambition, to indicate a 'double view, both for and against' American culture. Pop art both rehearses *and* mocks the clichés of modern consumer culture; treats patriotism reverently *and* irreverently, affirming *and* denying Americanness; amplifies and deflates national symbols; burnishes new icons *and* pulls them down; satirizes *and* celebrates free-enterprise politics; endorses *and* critiques mass culture. It is both alienated from, and receptive to, what it represents. And throughout, Pop art thereby risks frivolity. This is especially evident in Pop art's nudes: see Tom Wesselman's *Little Great American Nude #6* (1961), one among many acceptances of Manet's invitation.

Tom Wesselman
Little Great American Nude #6
1961

Artworks resist prose summary because the experience they communicate eludes conceptual reduction. When a concept is attached to a representation of the imagination, it submits to an unbounded expansion. Artworks do not engage us in argument; instead, they expand and deepen our understanding beyond the power of words to express. What the artist seeks to convey 'transgresses' (Kant's word) the limits of our experience. The very idea that we have of beauty is given an unbounded expansion by the artwork. (An artwork that is no more than the visual equivalent of an experience or concept is art of an inferior kind, while an artwork that is merely illustrative barely merits the name.) A transgressive artwork, such as Eakins's, submits the genre-concept of the nude to a special kind of expansion, instantiating and subverting it at the same time. It presents a

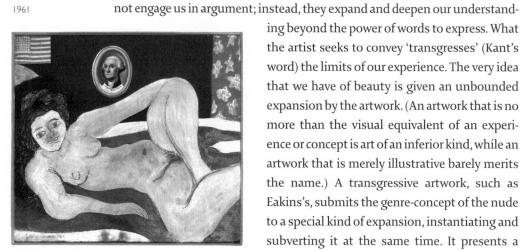

naked woman, and a representation of a nude. We see both the picture itself and the person that the picture represents. We 'see' both the convention and the model. Such a work thereby despatches two illusions we might otherwise have nursed: one, about the nature of our mental processes; two, about the naturalness of the genre. They demystify, in the sense that they teach us something both about ourselves and about the world. These lessons cannot, however, be summarised for the benefit of others. They can only be communicated direct by exposure to the works themselves.

Jesus Crucified

In the period between the 3rd century CE through to the middle of the 19th century, some of the principal themes of the Western art canon were established and worked out: scenes of Jesus' birth, his ministry, and his crucifixion, death and resurrection. It was the period when art *served* Christianity and its dogmas. In Iris Murdoch's words (and with her emphasis): 'Western art, so solid and so clear, has helped us *believe*, not only in Christ and the Trinity, but in the Good Samaritan, the Prodigal Son, innumerable saints...' The end of this period marked a steep decline in religious painting's authority. Christian art once defined art's project, but by the 19th century it was merely one genre among others. Though it continued to cast its shadow, it had lost its supremacy. The Spaniard Picasso was able to experience this diminution as a provocation, but he was unusual: 'What do they mean by religious art? It's an absurdity. How can you make religious art one day and another kind the next?'

The period that followed was inaugurated by two kinds of rejection of religious painting: a rejection of the narrative on which it drew, and a rejection of the truth of that narrative. There was, first, Courbet's rejection. The Christological drama, with its cast of divine, and divinely graced, beings, was not a proper subject for a realist art, one that concerned itself with the given, material reality of contemporary life. And then, second, there was Manet's rejection. He would paint scenes from the drama, but without any commitment to its implicit affirmation of transcendent significance. *This* rejection would provide opportunities for an aesthetic that, by the studied neutrality of its representations, or the promiscuousness of its play with Christian iconography – say, the syncretist Gauguin's *La Orana Maria* (1891), its Jesus present at the Annunciation – repudiated the pieties that audiences expected to find endorsed in art.

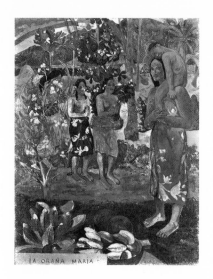

Above
Paul Gauguin
La Orana Maria
1891

Opposite
Jacques-Louis David
*Marat at his
Last Breath*
1793

Of these two rejections, it was Manet's that was the more damaging. To ignore the subject leaves it intact; to render it in such a manner as to deny the claims made for it leaves it reduced, disabled. Courbet, impatient with all religious painting, exclaimed: I cannot paint what I haven't seen. I have never seen men with wings. How then can I paint an angel? Manet, perhaps equally impatient, but subversive as well, responded by painting angels such as might be seen at a theatre, and a Christ submissive before costumed characters in one work, and patently dead in another. In *Jesus Mocked by Soldiers* (1865) and *The Dead Christ and the Angels* (1864), Manet secularised religious painting, and reversed a certain trajectory in the canonic representation of the male death. Christ's death, and the deaths of Christian martyrs, had once, not so distantly, provided an ennobling, sanctifying context for such images. In Jacques-Louis David's *Marat at his Last Breath* (1793), for example, the martyred Marat dies like Christ: selfless, betrayed, naked. Manet's two works, by contrast, comprise a kind of collective anti-*Marat*. They deny to the representation of Jesus the Christ-like pathos accorded to the representation of Marat. David consecrates a secular event; Manet secularises a spiritual one. Manet tore away the mask that had been placed by Christianity on human suffering. The belief that pain and death have redemptive value is, to adapt a phrase of André Malraux's, 'the lie of lies'. Manet's two Christ pictures expose that lie. To the particular invitation that these works propose, it was the atheist Francis Bacon who responded with the greatest vigour, his bleak, unredeemed landscapes of butchered flesh as far removed as is imaginable from the transfigured body of the victim Christ.

Jesus Mocked by Soldiers was a double scandal. Its Jesus is a feeble, passive figure, dominated by oddly clothed men, identifiable as soldiers only because of the title. The painting withholds dignity from its subject. 'The artist seems to have taken pleasure in bringing together ignoble, low and horrible types,' a contemporary critic complained. As if to underline the provocation, Manet submitted it to the Salon in the same year that he submitted *Olympia*. The two subjects were thus given an intimacy of association that was itself a provocation – Christ and a prostitute, a male nude and a female nude (one, furthermore, whose 'body, of a putrefying colour, recalls the horror of the

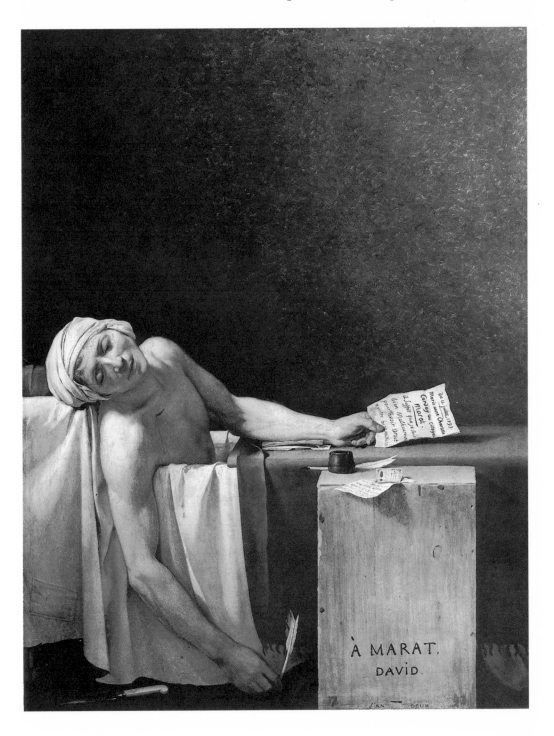

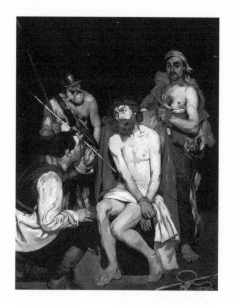

Edouard Manet
*Jesus Mocked
by Soldiers*
1865

morgue', according to one critic). The work's absence of pathos, or affect, had a significance for the course taken thereafter by art. Representations of Christ's humiliation and death taught pity; to withhold pathos from this subject (of all subjects) was to ready art's audiences for a kind of art that refuses to teach that lesson. It is perhaps no surprise therefore that Manet's ambition to paint a Crucifixion – a subject that he regarded as the 'foundation, the poem, of humanity' – remained unrealised. It was left to Francis Bacon to paint *that* subject in a style faithful to the Manetian precedent. Instead, Manet himself painted Christ before, and after, the Crucifixion.

The Dead Christ and the Angels pictures a dead body, propped up, and bearing the marks of crucifixion, but otherwise indistinguishable from any other recently deceased person. The angels have been described, justly, as two draped female models to whose shoulders large wings have been attached. Having painted a model posing as a nude, Manet painted two models posing as angels. Gautier complained that they 'have nothing celestial about them, and the artist hasn't tried to raise them above the vulgar level'. The critic was even angrier about the depiction of Jesus, 'who seems never to have known the use of washing. The lividity of death is mixed with muddy half-tones, with dirty, black shadows which the Resurrection will never wash clean, *if so decayed a cadaver is capable of resuscitating at all*' (my italics). The work also seems to deviate from religious iconography by placing the wound on the left side of the body. (Baudelaire, for one, thought Manet had got it wrong, and advised him to change its location, to avoid giving 'ill-wishers an occasion to laugh at you'.) And then there are the feet, which, as several critics have noticed, show signs of having worn modern shoes. The scene lacks spiritual resolution: the slightly obscure bustling of the angels and the cadaverous immobility of Jesus together make for a jagged, discordant spectacle, one incapable of moving the viewer to pious reflection. It has no sacramental aspect whatsoever.

The central image of Christianity is a man in torment. For Hegel, the transcendent moment of God's life is in his vulgar and disgraceful death, 'the story of the Passion, the Golgotha of the Spirit'. The canons of classical art could not

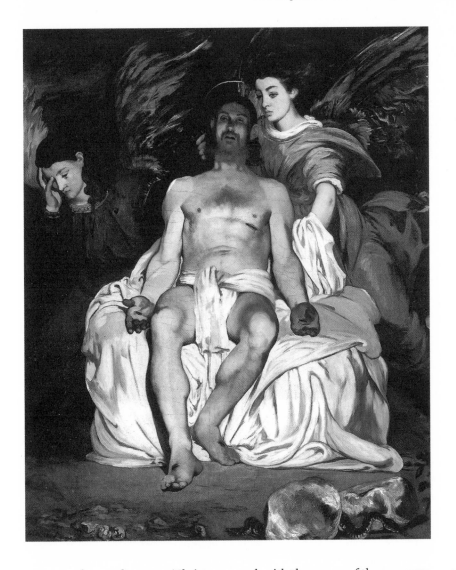

accommodate such a story. 'Christ scourged, with the crown of thorns, carry-ing his cross to the place of execution, nailed to the cross, passing away in the agony of a slow and torturing death': none of this was consistent with the Greek ideal of beauty. Indeed, depiction of this protracted agony was only possible within Christian art because it was but 'a point of transition'. The Cru-cifixion is made tolerable by the Resurrection and Ascension, the negativity of death itself negatived. It was a saving death. Without this, Christ's suffering and death would be an outrage from which it would be difficult to recover.

Edouard Manet
*The Dead Christ
and the Angels*
1864

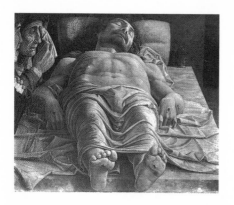

Andrea Mantegna
The Dead Christ
1480–90

It would be shocking in its meaninglessness. Now, it is precisely this shock that Manet delivers. If Christianity offers us suffering without final death, Manet offers us death without visible suffering. In his painting, we get death, *simpliciter*. It is the first instance of a certain kind of pitiless art, the first in a line of such artworks, among the most recent of which is Ron Mueck's *Dead Dad* (1996–7). Mueck's work offers the human wreck unredeemed, a secular riposte to those countless versions of *Dead Son* (an alternative title for scenes of the Crucifixion and Entombment), and a joke at the expense of pieties towards both one's parents and the dead. In a gallery, it is all that one can do to avoid tripping over *Dead Dad*. It is perhaps at the terminal point of this line of works. The body, dead but unburied, shrunken, exposed and ridiculous, is laid out on the floor, its vulnerability quite without pathos.

Predictably, *The Dead Christ and the Angels* affronted religious sensibilities. It was, thought Thoré, a deliberate mockery of its audience's expectations. Other, less reflective critics were simply dismayed. Concealed in the depths of Manet's talent was an 'anti-social or anti-religious theory'. They had never seen 'such audaciously bad taste'. The work 'was executed for Renan', that is, shorn of any supernaturalism. Ernest Renan's *Life of Jesus* (1863) treated its subject as any other historical figure might be treated. The author denied the reality of miracles, and held that belief in them was an obstacle to modern faith. 'If ever the worship of Jesus loses its hold on mankind,' he wrote, 'it will be precisely on account of those acts which originally inspired belief in him.' Manet's work, it was said, followed Renan's most scandalous conclusions: 'the passion of a hallucinating woman gave the world a resuscitated God!' 'Do not miss M. Manet's Christ,' mocked a critic, 'or *The Poor Miner pulled out of a peat bog*, painted

Ron Mueck
Dead Dad
1996–7

for M. Renan.' In its refusal of the sacred, one might say that Manet's work is impious. It was, in Michael Fried's phrase, 'out of bounds'. It seemed at the time, he says, to be 'incomprehensible, provocative, crudely drawn, hastily painted, in short conceived and executed with blatant disregard for accepted norms of intellectual decorum, pictorial coherence, and technical competence'. It is the antithesis of those great artworks that take the dead Jesus as their subject, such as Mantegna's *The Dead Christ* (1480–90). It is a precedent, in its lack of respect for its subject, for Serrano's *Piss Christ*.

Courbet's expostulation made way for a realist 'religious' art, one that depicts modern subjects of religion and sanctity – processions, ceremonies, religious events and so on (I borrow the phrasing of a critic of the 1860s, who saw a 'new' religious art emerging, one that had made its peace with realism).

Far left
Jean-François Millet
The Sower
1850

Left
Vincent Van Gogh
The Sower
1888

Below
Jean Fautrier
Head of a Hostage
1945

Purely secular art is born of a desire to break free from, and exist independently of, the Christian premises of the art canon. This is a difficult, almost impossible undertaking. Take, for example, Millet's *The Sower* (1850) and Van Gogh's *The Sower* (1888). Though ostensibly secular and free of religious convention, the images resonate with the parable of the sower recounted in Mark 4:1–20. The consequence is a secularity in art that continues to register, while insisting upon its independence from, the influence of canonic Christian iconicism. (I say nothing about the secularised Virgin and Child images that pervade late 19th-century popular art.) Christian iconography is especially difficult to avoid in the making of artworks that endeavour to represent or testify to death or suffering. Only a few artists have been able to do so, the French sculptor Jean Fautrier principal among them: see *Head of a Hostage* (1945). Fautrier's achievement is astonishing. It resists the twin

temptations of post-Christian art: to make either secular versions of the Cruci-
fixion or images that substitute for the Crucifixion. That succumbing to the
first temptation produces flawed, even bad, art is plain from Chagall's Crucifix-
ion paintings. That there is a certain desire for works that succumb to the
second temptation is evident from the common misreading of Picasso's
Guernica (1937) as a humanist icon (a misreading, it has to be said, that the work
itself encourages).

Religiously subversive art, by contrast, acknowledges Christianity's con-
tinuing, though compromised and embattled, presence. It denies divinity to
sacred images, while continuing to paint them, or overstating and thereby
subverting tacit aspects of their iconography: for example, the American
photographer F. Holland Day's *Crucifixion* (1898). Although both kinds of

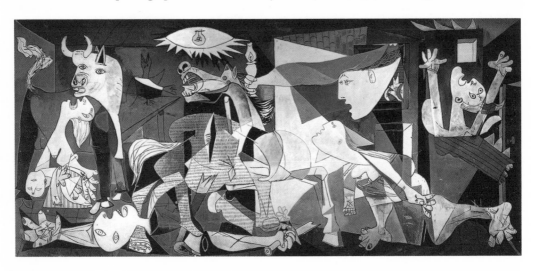

Pablo Picasso
Guernica
1937

art, the secular and the religiously subversive, when addressing dead, even
mutilated, bodies, convey the implicit conviction that the deaths are without
purpose or aftermath, and that death itself is both pointless and final, it is only
the religiously subversive project that does so with a sense of dread. Manet's
works inaugurated this religiously subversive art.

Bacon's *Three Studies for a Crucifixion* (1962) and his *Triptych Inspired by T.S.
Eliot's Poem 'Sweeney Agonistes'* (1967) are exemplary works at the terminal point
of this project. The triptych form alludes to medieval and Renaissance reli-
gious art. Bacon painted Crucifixions from the very beginning of his career.
One painted in 1933, when the artist was only 23, was prophetic (says David

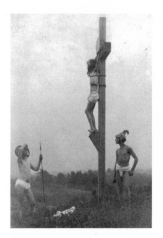 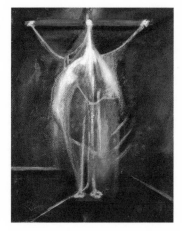 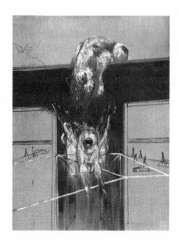

Sylvester) of his mature work, both in style and subject. Bacon himself regarded another Crucifixion-related work, the triptych *Three Studies for Figures at the Base of a Crucifixion* (1944), as marking the beginning of his career. Thereafter, further Crucifixions followed, instances of what has been described as a demystified art, cleansed both of its religious halo and its moral dimension. In *Fragment of a Crucifixion* (1950), a dead dog is spread across the junction-point of a T-shaped cross, and a ghastly, winged creature hovers in the place the crucified Jesus would occupy. This is not a devotional image. It does not make the viewer a witness and participant in Christ's drama. For Bacon, the Crucifixion was about death only, and he associated it with pictures of slaughterhouses and meat. 'To me,' he remarked to Sylvester, 'they belong very much to the whole thing of the Crucifixion.' Bacon's theme is antagonistic to religion because it refuses the consolatory. It offers neither pity nor comfort. It takes the Crucifixion in order to deny the strongest case made in our culture for the redemptive nature of suffering and death. It is a disenchanted art, an art of subtraction: flayed bodies minus suffering, religious iconography minus faith. It empties the Crucifixion of significance. (Now return, for a moment, to the swastika in the 1965 *Crucifixion*: has this not likewise been denied its significance, by the same kind of voiding? It is not formalism that does this in Bacon's work, not the artist's commitment to colour and line, but instead a pondered refusal to admit transcendental meanings, either of good or evil, and the consequent rendering, in Lawrence Gowing's phrase, of defecating dogs and regal popes in the same broken paint.) His works, argued the art critic Peter Fuller, are a horrible assault upon our image of ourselves and each other.

Left
F. Holland Day
Crucifixion
1898

Middle
Francis Bacon
Crucifixion
1933

Right
Francis Bacon
Fragment of a Crucifixion
1950

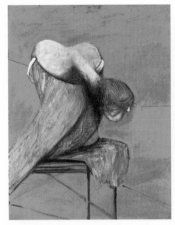
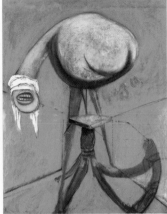
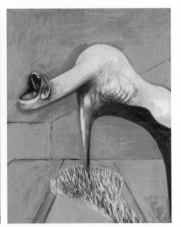

Top

Francis Bacon

Three Studies for
Figures at the Base of
a Crucifixion
1944

Above

Francis Bacon

Three Studies for
a Crucifixion
1962

Right

Cimabue

Crucifixion
c. 1272–4
(shown upside down)

He achieved something extraordinary, using the shell of the high tradition of European painting to communicate a view of man utterly at odds with every-thing that that tradition affirms. The 1962 work takes Cimabue's *Crucifixion* (*c.* 1272–4) and inverts the figure, the shape of the carcass following Cimabue's Jesus. And to do this, to turn an object upside down, as the philosopher Merleau-Ponty remarked, is to deprive it of its meaning. Bacon described his impression of the Cimabue work to Sylvester: 'I always think of that as an image – as a worm crawling down the Cross. I did try to make something of the feeling which I've sometimes had from that picture of this image just moving, undulating down the Cross.'

The *Triptych*'s precise point of contact with Eliot's dramatic poem is in the lines 'Birth, and copulation, and death / That's all the facts when you come to

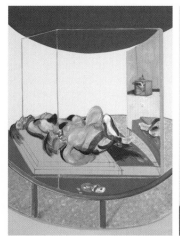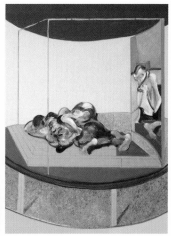

brass tacks: / Birth, and copulation, and death.' These are, of course, the three events most bound up in taboo, most regulated by religious ritual, that is, the events least reducible to mere 'fact'. Each panel consists of a picture of a room. The rooms in the outer panels are windowless, while the room in the middle panel appears to have a window. In the outer panels there are circular wooden boards on round, raised green plinths, a yellow floor and glass rectangular cages with bodies, or what resembles bodies, inside. Indistinctly misshapen, they have a special hideousness. In the first panel, they are on their backs, legs buckled, knees jutting up towards a brown, spherical ceiling; in the third, the bodies become flesh, merged in sex or mutilated death, less sharply separate, and a man seems to regard them, under a black ceiling of the same contour as

Francis Bacon
Triptych Inspired by T.S. Eliot's Poem 'Sweeney Agonistes'
1967

the first panel. (Bacon 'bones' his sitters before your eyes, a critic once remarked.) The triptych is not abstract, but nor does it propose any direct correspondence to objects in the external world. It is figurative but not representational. It consists of unexpected blurrings and correspondingly unexpected distinctnesses. Areas of colour are bisected by lines; fleshy masses merge, as bodies hover between life and death.

In the middle panel, on what appears to be a small covered table, or perhaps a chair, there is something appalling – a bloody torso, perhaps, with what might be formal evening clothes draped around it. The ensemble is propped on a flat blackboard, edged in a wood corresponding to the wood of what might be a door on the left of the picture, and a structure on its right. By contrast with the outer panels, the floor is a dark blue, a deeper blue than the sky visible through the window. The colours are bright, clashing, violent. The cage in each of the outer panels appears to contain a mirror, disclosing something going on in the part of the room that the viewer cannot himself see. What the viewer sees is not the whole scene. It is instead glimpsed, panel by panel. This complicates its horror. While there is the sense conveyed of the painter compelling attention, squarely, to the rooms' most gruesome contents, there is also the hint of additional, undisclosed horrors. The window, by contrast, discloses nothing. The staleness of the blood (a darker red, on being exposed to the air, and yet still liquid), the violence of murder, the moment at which a body becomes a corpse, and the time when that corpse decays – this is the horror of the middle panel, the one most drawn to death. In its rapt exposure of the degradations of the flesh, it discloses a sensibility in thrall to the horror of unredeemed death. An acute critic of Bacon's paintings refers to their 'uncanny conflation of the living body with death', an exact inversion of the Christian resolution, which conflates the dead body with resurrected life. It is a slaughterhouse imagination, suffering without redemption, death without resurrection, a savage joke played on the Christian art canon, turning it upside down, like the Cross itself.

An Anti-Genre

Certain artworks are crimes, that is to say, they are crimes committed by their makers – call them 'criminal artworks'. Among such works may be found works of blasphemy and obscenity. They have a relation with crime that is enabling and creative. Transgression – in this context, the open and acknowl-

edged breaking of the law – is essential to their making. Within the category of criminal artworks there is a subset of works that take as their victim other artworks. These crimes stay in the realm of art itself. They are special instances of art preying upon art. Though art crimes are a constant in the history of artmaking, it is only in the modern period that the committing of art crimes against artworks becomes an aesthetic project, and criminal artworks, objects of aesthetic interest. There are two types of these art crimes: offences of reproduction and offences of destruction.

Offences of reproduction are at or near the terminal point of a notional arc that begins with an original work, and then travels through pastiche, plagiarism, breach of copyright, misattribution of authorship and passing-off, to forgery. Offences of destruction are at the terminal point of an arc that begins with an original work, and then travels through adaptations, then parody, then breach of moral rights, trespass, suppression or other breach of speech rights, to criminal damage. (My language is drawn from English law, but most jurisdictions have the same or broadly similar crimes and civil wrongs.)

The plagiariser steals from one person in order to deceive another. His is thus a double crime: misappropriation followed by misrepresentation, or theft followed by fraud. The destroyer of an artwork diminishes the world, and violates the respect due both to the artist and to the principle of creative labour. Artworks both explain the world to us and make us at home in it; to destroy an artwork is an unusual act of dispossession, leaving desolate not just its owner but a much wider circle of admirers. Such offences are violations not just of private property but also of valued collective goods: the pleasure that we take in art, its enhancement of our lives, its implicit celebration of the power and gifts of the imagination.

While offences of reproduction are attacks on a work's uniqueness, and offences of destruction attack its existence, both thereby attack the work's economic value. They have a common origin in forms of derivative art, or 'art in the second degree' (the title of a work by the French literary theorist Gérard Genette), but then divide during their descent through civil wrongs towards criminality. They meet again in their final destination, the prison cell.

Conventional wisdom holds there to be a boundary dividing the artist from the criminal, art from crime, instances of the supererogatorily good from instances of quotidian evil, the originating from the parasitic (whether duplicative or destructive). Cross this boundary and one is no longer an artist

but a criminal. It is a boundary by which art is protected and true artists distinguished from bogus ones. We may thus imagine two kinds of person, the artist and the criminal, and two kinds of offence, copying and destroying. Indeed, it is precisely out of such binarisms that the received understanding of art is constructed. Now, it is just this understanding that much of the art of the modern period sets out to undermine, collapsing these complementary antitheses, finding the criminal in the artist, discovering opportunities for destruction in duplication. What after all is that staple of postmodernism, the parody, but a destructive copy of the parodied original?

The connection in art between copying and wrecking, and its adoption as an aesthetic, was first made (so far as I am aware) by Ruskin. This was not for him something to celebrate. Indeed, that so much of the art of his times consisted of the one or the other was a sign, he considered, of its degeneracy. Here he is, lecturing in 1870 to an audience of Oxford students:

> We live in an age of base conceit and baser servility – an age whose intellect is chiefly formed by pillage, and occupied in desecration; one day mimicking, the next destroying, the works of all the noble persons who made its intellectual or art life possible to it: an age without honest confidence enough in itself to carve a cherry-stone with an original fancy, but with insolence enough to abolish the solar system, if it were allowed to meddle with it.

As for his students, what should they do? 'In the midst of all this, you have to become lowly and strong; to recognise the powers of others and to fulfil your own.' Ruskin had in mind a kind of extreme disrespect for institutions, one without any redeeming creativity. And there was little to choose between the two versions of that disrespect, the aping or the vandalising of the canon. They were related aspects of the same failure of contemporary artists to establish the correct relation with the art of their predecessors.

There is much that is wrong in Ruskin's account. It is exasperated and disparaging, and out of touch. He did not grasp the complexity of the iconoclastic motive, which can at once be both creative and destructive. Iconoclasm is both a form of expression and the means by which the expression of others is attacked, both an object and an instrument of suppression. And yet, for Ruskin to have intuited the relatedness of iconoclastic and plagiarising art

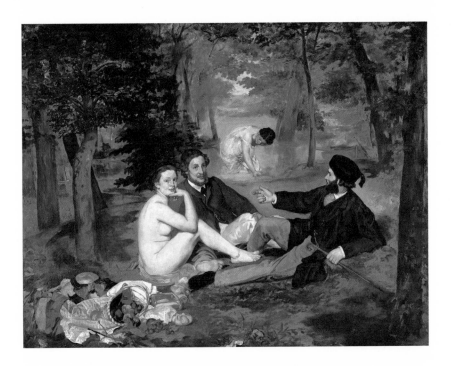

practices was impressive, and to have divined that they would be constitutive of modern art, more impressive still.

Edouard Manet
Le Déjeuner sur l'herbe
1863

He was not quite ahead of art itself, however. What he had so brilliantly grasped had in fact made its first appearance a few years earlier in Paris at the Salon des Refusés. Manet's *Le Déjeuner sur l'herbe*, exhibited in 1863, scandalised precisely because it ostentatiously copied what it equally ostentatiously derided. Its allusions, in Robert Hughes's fine phrase, 'stick out like elbows'. It was a version of Giorgione's *Fête champêtre* (*c.* 1505) and Raimondi's engraving after Raphael's *Judgment of Paris* (*c.* 1520), works familiar to Paris audiences.

Far left
Giorgione
Fête champêtre
c. 1505

Left
Raimondi
(after Raphael)
The Judgment of Paris
c. 1520

These images, and images thematically related, were circulating in the culture of the period. *Le Déjeuner* was in this respect the first work of Pop art, though without Pop art's own, compromising ambivalence towards *its* images. Until Manet, artists copied other artists to learn their craft or enlarge their visual vocabulary, or as an act of homage (Fuseli found Blake 'damn good to steal from'), or because they were working in an established genre dominated by the work of a few Masters, or because they subscribed to the doctrine of imitation, promoted by the academic tradition in its early stages. Thus was the past preserved by the present and art's continuity ensured. This art ideology of copying also provided a theory of what has been termed 'recycled genius': the imitation of genius by genius. 'Raphael, in imitating the ancients endlessly, was always himself,' said Ingres. But Manet's work turned all this upside down. It copied to taunt, addressing the past to deride it. Manet borrowed extravagantly, and he borrowed mockingly.

This is not common ground. Many of Manet's contemporaries were simply puzzled that an artist of his evident ability should follow slavishly the manner of an earlier age. For a writer of a later generation, Oswald Spengler, this 'resurrected old-master style' was evidence of decline. For the art historian Aby Warburg, though he did not share Spengler's cultural pessimism, it was a defect that the picture clung too closely to precedent. We know, he observed, that this work is deeply implicated, both in its form and iconography, in the tradition of Western art. But what of it? The work liberated art from the fetters of academic virtuosity; why should scholars now seek to confine it by chatter of influence and model? And yet, to Warburg's dismay, it was Manet himself who insisted upon his standing as a responsible trustee of art's history. Why did he bother to refer to the example of Giorgione when defending the grouping of dressed men and naked women in the open? Was it really necessary, in his stride towards the light, for Manet to look backwards in justification of his enterprise? Surely, Warburg asks, it is obvious that the possibility of creating something new cannot exist unless one shares in the heritage of the past; so why emphasise the point? The borrowing was a reflex of self-deprecation, a gesture of ingratiation, and in itself to be deprecated. It was a failure of nerve in what Warburg conceived as art's fight against the constraints imposed on the human spirit by superstition, piety, taboo. His conception of art's purpose thus derived from an essentially Enlightenment perspective, and Manet slightly disappointed him. Michael Fried, by contrast,

Opposite, top
Andrea Mantegna
The Man of Sorrows
with Two Angels
c. 1500

Opposite, bottom
Marcel Duchamp
L.H.O.O.Q
1919

holds that in this work Manet succeeded in the estimable endeavour of bridging the divisions between the present and the past, establishing the connectedness of his art with the full range of great French painting. It was a project that had a canonic, national trajectory ('everything that was French seduced him'), and was undertaken in the greatest seriousness.

Others saw the mockery, and simply hated it. One critic exclaimed on viewing the picture: 'This is a young man's practical joke (*blague*).' Jokes mattered in the 19th century. The *blague* was 'that great destroyer, that great revolutionary, that poisoner of faith, killer of respect' (the Goncourt brothers, again). Manet followed this joke with several others, also condemned for their destructive imitativeness. Of *The Balcony* (1868–9), a critic commented: 'Very few remain indifferent to this strange painting, which seems both the negation of art and yet also to adhere to it.' Of *The Dead Christ and the Angels*, a critic wrote: 'Manet cannot serve as a model since he has broken loose from rules accepted by centuries of logic.' This work was too close to, and yet too disrespectful of, Mantegna's *The Man of Sorrows with Two Angels* (*c*. 1500). By refusing to accept the authority of existing models, Manet had forfeited the right to be considered one himself. It has been suggested that *Le Déjeuner* constituted as destructive and vicious a gesture as Duchamp's in painting a moustache on a reproduction of the *Mona Lisa*. This may be true, but it was not quite the *same* gesture. It had a comparable effect and was of a similar character, but its relation to its model, the copied work, differed from that of *L.H.O.O.Q.* (1919) to Leonardo's original. The scandal of Manet is that, while purporting to do what other painters did, he achieved something subversive. The scandal of Duchamp is that he achieved something subversive precisely by refusing to do what other painters were in the practice of doing. (What was inimitable about Duchamp, remarked

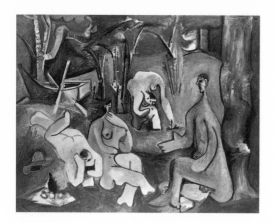

Pablo Picasso
*Le Déjeuner sur l'herbe
after Manet*
1961

Harold Rosenberg, was the discipline by which he kept himself on the edge of art; he was a permanently borderline case.) Manet parodically adapted, while Duchamp replicated and defaced.

This copying to destroy, or alternatively copying *and* destroying, became a trope of modern art. David Sylvester found in Ernst, for example, the 'nicest balance' between 'irony' and 'nostalgia', that is, destruction and replication. The critic and artist Lawrence Gowing, to take a further example, wrote of the reception of Bacon's first one-man exhibition at the Hanover Gallery in 1949 that it was received as 'an outrage', 'a mimic capitulation to tradition', 'a profane pietism', 'everything unpardonable'. Gowing disclosed the cause of this distress in a laconic, penetrating judgment: 'the paradoxical appearance at once of pastiche and of iconoclasm was indeed one of Bacon's most original strokes.' Such 'strokes' are to be distinguished from those more deferential strategies by which artists throughout art's history have negotiated their relations with prior canonic works. There is a sense in which artworks modify or even violate each other through their very coexistence. But Manet initiated a quite different practice. It has since been taken in a number of directions.

First, there is the continuation of Manet's project. Picasso is exemplary of this principal version. It is therefore no surprise that among the works Picasso appropriated obsessively should be Manet's own, one artist returning, as it were, to the scene of another artist's crime. His *Le Déjeuner sur l'herbe after Manet* (1961) consists of 157 drawings, 27 paintings, five works of sculpture and 18 preliminary cardboard studies, and several linoleum plaques and cuts. It was the single largest concentration of material prompted by any individual artwork that Picasso ever produced, and represented, says one Manet scholar, the artist's attempt to bury the achievement of his predecessor. Robert Motherwell put it too mildly, then, when he remarked, 'every intelligent painter carries the whole culture of modern painting in his head. It is his real subject, of which everything he paints is both an homage and a critique.' 'Homage' and 'critique' are somewhat anodyne versions of the real dynamic of modern art, which is better caught with the words 'copy' and 'destruction'.

Certain artworks by the American artists Robert Rauschenberg and Ad Reinhardt are extreme, more recent instances of this project, in which the destroying takes precedence over the copying (Rauschenberg) or eclipses it altogether (Reinhardt). In the winter of 1953, Rauschenberg took a Willem de Kooning drawing and erased it. He then framed the erased picture and hung it in his studio with the caption: 'Erased de Kooning Drawing. Robert Rauschenberg, 1953.' He had wanted to create a work by erasure. He already had a drawing by de Kooning, one that he had taken from the artist. But, he felt, for the erasure to 'work' he needed the painter's co-operation, so he told

Robert Rauschenberg
Erased de Kooning
Drawing
1953

de Kooning his plan. The older artist obliged him by leafing through a portfolio to find the right drawing. He pulled one out, and then rejected it – 'No, I'm not going to make it easy for you. It has to be something I'd miss.' Another was finally selected and Rauschenberg took it back to his studio. Erasing it was hard work. He had to trace over the lines until they disappeared (this was a special kind of copying). Rauschenberg's work is both the most transparent and the most destructive kind of palimpsest, because while nothing is put on the surface of the substituted work, and its former existence is acknowledged, the work itself is erased and therefore cannot be recovered. It was both a parody of the Abstract Expressionists' own repudiation of the art canon, and a repudiation by Rauschenberg himself of the art of his peers. 'Determined not to mimic their work,' his biographer explains, he made 'the point about his independence in a particularly outrageous manner' – that is, the act of copying was a refusal to imitate.

Ad Reinhardt's ambition to make the 'last paintings anyone can make' restated Rauschenberg's ambition, but at the level of art history itself. Rauschenberg's work addressed a single, anterior artwork; Reinhardt's addressed everything that had ever been painted. 'You can paint anything, and you can paint out anything. You can begin with anything and get rid of it. I already got rid of all that other stuff. Someone else doesn't have to do it.' Painting itself, in the American conceptualist Joseph Kosuth's gloss on Reinhardt, 'had to be erased, eclipsed, painted out in order to make art.' This is not ending painting to start over again, it is ending painting, period. Reinhardt does not propose himself as art's next genius, the most recent in a canon-sanctioning sequence. His work does not seek to reinvent painting but rather to reach its terminal point, self-erasing in the very act of completing (Kosuth's phrase). The *Black Paintings* could be subtitled *Erased Art Canon*. And yet, painting survived, even in the *Black Paintings* themselves. They have a spiritual aspect, and have received the careful attention of theologians. Reinhardt himself wrote of 'the divine dark' and 'the luminous dark'. David Sylvester, reviewing the first showing of these pictures in London, initially thought that after half a century of anti-art, Reinhardt had reached the ultimate, and that the blackness of the pictures was perhaps an invitation to mourn art's passing. But these first responses gave way to rather more engaged emotions. 'Once involved in one of these paintings, I find it difficult to tear my attention away,' Sylvester wrote. 'My entire capacity for attention has been focused into gazing at a contrast of colours

that is scarcely perceptible and totally absorbing.' And so the project of paint-
ing out painting survives, just as painting itself does, while the French artist
Daniel Buren endeavours now to achieve, with his vertical stripes of identical
width, what Reinhardt could not.

There is a political version of this project, one in which art preys upon the
images of popular culture in order to subvert them (where the estrangement
defence, that is, equates to the work's aesthetic). The British artist Victor
Burgin and the Situationists were among the leading practitioners. During the
1970s, Burgin explained, 'I had the feeling that the world was saturated with
images, and that there was no point in manufacturing more... I felt that
an artist's job was to take existing images and rearrange them so that new
meanings appeared.' He describes his strategy as 'guerilla semiotics', which
he glosses as 'capturing images and turning them against themselves'. The
aim is to turn upside down our experience of everyday life, one that is replete
with images that dominate us but of which we are not critically conscious.
Burgin is essentially describing here the Situationist project of the late 1950s
and the 1960s which he took up in his own work a decade later. The Situation-
ists developed the practice of 'détournement', defined by its principal theorist
Guy Debord as 'the reuse of preexisting artistic elements in a new ensemble'. It
'clashes head-on against all social and legal conventions'. The Scottish-born
artist Richard Lawson, who moved to New York in the mid-1970s, described a
similar project when he talked of his 'dialectical reduplication' of images. It is
by this interrogation of the image itself, which entails but is not completed by
its appropriation, that these artists declare their debt to Manet and Duchamp.
A good example of this kind of art practice is the work of the American artist
Jenny Holzer. In 1982, a number of her aphorisms – PRIVATE PROPERTY
CREATES CRIME, MONEY CREATES TASTE, YOUR OLDEST FEARS ARE YOUR
WORST ONES – were flashed on an advertising board in Times Square, as if
they themselves were commercial messages from corporations addressed to
consumers. It was a different kind of appropriation, occupying a medium of
commercial culture rather than taking one of its images.

There is also a postmodern version of the project, in which the artist
seeks to demonstrate the impossibility of originality, and the unavoidability
of visual quotation. (This too has a political aspect because the artist thereby
provokes copyright questions, foregrounding fine art's status as private
property.) The theoretical locus of this version is Rosalind Krauss's essay

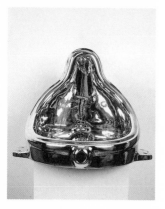

Top
Sherrie Levine
After Walker Evans #19
1981

Above
Sherrie Levine
Buddha
1996

'The Originality of the Avant-Garde', an originality that she describes as a 'modernist myth'. In her formulation, modernism represses the concept of the copy, postmodernism acknowledges it. What was always there, that is, but as a prohibited thought, is brought to the surface. The illusion of originality is exposed as a mere 'originality-effect'. 'Appropriation art' emerged in the 1980s. It was a banner under which primarily American artists, Sherrie Levine and Richard Prince among them, were content to work for a while. Appropriating practices included the detaching of images established in one context and inserting them in a new context, the overlaying of the reproduced image with commentary designed to undermine the image's own intended message and the simple reproduction of the image and the designation by signature of the appropriated image as the appropriator's own. See, for example, Levine's *After Walker Evans #19* (1981) and *Buddha* (1996). These works respectively reframe and adapt predecessor works that themselves go beyond the received fine-art tradition, with its valorising of creativity and originality. Levine's 'medium', in Rosalind Krauss's ironic phrase, 'is the pirated print'. This 'act of theft', Krauss continues, has a demystifying effect because it 'opens the print from behind to a series of models from which it, in turn, has stolen, of which it itself is the reproduction.' If it is an act of theft, however, it is of a special kind, because it is open about the appropriation. Levine's pictures are better understood, perhaps, as reconceptions of given artworks, and thus cognate with those other kinds of reconception in contemporary art, the pastiche and the parody. While the appropriation artists themselves displayed a certain ambivalence about what they were doing ('I ransack art history and photographic sources. I usually change the images in some way. But I do unashamedly appropriate from found images' – Nancy Spero), the effect of these practices is generally held to have interrogated and subverted received notions of originality and authorship, and indeed to be the visual version in this respect of those aspects of the work of Roland Barthes, Michel Foucault and Jean Baudrillard that are concerned with the ideology of originality. Levine borrows to remind us that all artists borrow, a postmodernist putting modernists straight. Her framing is a re-presentation of a representation. It is a covering, of sorts. It can leave the

Jeff Koons
String of Puppies
1988

anterior work (the anterior 'gesture') diminished, encompassed by another sensibility. It is a kind of iconoclasm, and iconoclasm is among the principal creative impulses of our times. It thus has a family resemblance to other iconoclasms, other attacks on surface and precedent, art's own space and time.

There has been sustained resistance to such explorations. They come up against not just the prejudices of an uninformed art public, but the protective reflex of every artist when confronted by any threat to his art. Carl Andre, for example, when asked by the critic Peter Fuller why people should value his work, responded: 'because that pile of bricks is my work... I have a monopoly supply... [it] can be forged or plagiarized, but then one would be dealing with the work of a forger or plagiarist.' If others, he continued, were to attempt reconstructions of his work, 'these would not be art because art is not plagiarism'. This is a common enough stance for an artist to adopt. When the not-very-well-known artist Art Rogers sued the very-well-known Jeff Koons for appropriating his postcard photograph in the making of *String of Puppies* (1988), the Supreme Court held that Koons had breached Rogers's copyright. The 'lifting of images' (the artist Haim Steinbach's phrase) can be a hazardous enterprise. Levine, in particular, had difficulties of her own, and in two quite distinct respects. She could not avoid creating new images, notwithstanding her declarations of her sense of belatedness. 'We can only,' she insisted, 'imitate a gesture that is always anterior, never original.' She could not get beyond Duchamp, for all that she described herself as a 'plagiarist'. But equally, her appropriation of canonic images was itself appropriated as a practice by

Barbara Kruger
Untitled
(Your Gaze Hits
the Side of my Face)
1981

commercial artists. For example, so far from being confined to avant-garde practices, *Le Déjeuner* is regularly appropriated by the advertising industry.

Notwithstanding her best efforts, Levine's works were her own (and nobody else's) and her practices became those of Madison Avenue – a double defeat. It is precisely to this anticipation of defeat that Barbara Kruger's work responds, appropriating the appropriations of advertising culture: *Untitled (Your Gaze Hits the Side of my Face)* (1981). Thus do the avant-gardist and the commercial artist communicate, half-snarling, half-purring. Kruger's statement '*Taking*' *Pictures* is an anti-manifesto, both defining a programme and doubting its efficacy. There is no escape from the recuperations of the market, or from audiences determined to find in artworks sources of flattery. The very negativity of her work, Kruger concedes, 'can merely serve to congratulate its viewers on their contemptuous acuity'. This is a recurrent feature of transgressive art, its ambivalence towards the boundary or convention with which it engages. The spectator will be led to wonder, regarding a nude: does this work reproduce, or expose, the quotidian representation of women (Matisse, Eakins, Salle)? Or, regarding a work that purports to bring the whole enterprise of painting to an end: does it cancel painting or restate its spiritual depth (Malevich, Reinhardt)? Or, regarding a work of appropriation art: does it embrace or distance itself from the image it has taken? The best answer, in most such cases, will be 'yes' to both questions. These works both reproduce *and* expose, both cancel *and* restate, both embrace *and* distance. It is precisely in this respect, indeed, as much as in any other, that they are transgressive.

Genres, Types, Aspects

The transgressive is a cultural instinct, the desire to subvert what culture itself has given. Emerging in the mid-19th century, it became an artistic practice. It initiates developments in genre; it undermines genre; it establishes anti-genres. It makes it difficult to treat art's subjects 'in the customary manner'. But there is no transgressive genre itself. Philosophers accord the highest status to the 'transgressive', but it is also purely incidental to many artworks and can occur by chance. By which I mean that it is both doctrine and an unintended consequence – one among a number – of unrelated endeavours. It is a

distinct aesthetic, and yet it is also, in varying measures, an aspect of every artwork worth more than a glance, of every artwork other than the most rule-bound, the least enterprising. In its most developed mode of existence (that is, in its terminal phase), it approximates to certain themes in postmodernist literary and artistic practices. The transgressive is about the necessary violence of the artist towards his forebears (recall Picasso's motto, 'In art one must kill one's father'), and it is also about the commitment of art itself to 'the perpetual immoral subversion of the existing order' (Apollinaire's project). It is about what is most characteristic of the art of the modern period, and it also about the absurdity of bringing together the art of the modern period in any category, even the counter-category of the transgressive. More critically, it is the 'formless', that which resists conceptualising. Its object is to *de*classify, undoing philosophy's best efforts to 'fit what exists into a mathematical frock-coat', writes Bataille. It is a practice that exists to undo theory. It does not belong to the same space as the idea, writes a Bataille scholar, except as something that subverts it. It is Dada, subverting the pretensions of Cubism; it is Surrealism, subverting modernism; it is neo-Dada, subverting the pretensions of Abstract Expressionism; it is conceptual art, completing the project of interrogative art rule-breaking, the testing to destruction of art's boundaries (to anticipate an argument in chapter III). The transgressive is to be glimpsed, as a motion to be registered, in certain artworks, in the manifestos of certain movements (where it goes under many guises), and in the many subversive cultural projects by which artists and writers trouble prior, tacit affiliations with predecessors and audience. If it is an aesthetic, then, it is only because it is also an anti-aesthetic. That it is both an initiator and an aspect of artworks of the past 150 years has been the argument of the present chapter. The next chapter supposes a transgressive aesthetic in three versions: art rule-breaking, taboo-breaking and politically resistant. I am not proposing a reordering of modern art by reference to these versions. They are ideal types: nowhere to be found in empirical reality, they are convenient, critical categories formed by the abstracting of certain dominant characteristics from given artworks. They do not, then, correspond to any single artwork, though many artworks may be understood, at least in part, by reference to them.

III

A Typology of Transgressions

The Three Types

There is a received idea of the artist as lawless, necessarily violating the conventional and the lawful in the realisation of his genius. Rules are mere constraints on his creativity; the art canon is a tyranny from which he must free himself. He must surmount many obstacles, among which is the burden of art's own past. His family may suffer, laws may be broken, he may even have to defy the state itself. This is the heroism of the artist, a transgressor for the sake of his art. (William Blake advised the artist: 'You must leave Fathers & Mothers & Houses & Lands if they stand in the way of Art.') It is a familiar role. As the authors of an art textbook write: any outstanding artist is bound to transgress the bounds of the collective. Yet this proposition, and the set of ideas from which it is derived, is misleading. In certain respects, indeed, it is a fraud.

Then there is a second received idea of the artist, quite distinct from the first but just as commonplace. It supposes that artistic creativity and the immoral represent the two poles of human endeavour, the one elevated, the other debased, the one God-like in its bringing of new worlds into existence, the other villainous in its diminishing of the given world. While art enhances our lives, immorality degrades. Art opens our imagination, immoral acts intimidate us into wary self-interest. Art endures, immoralities are ephemeral – vicious but short-lived. The artist is masterful, and the artwork represents his triumph over the given, resistant materiality of the world; the immoral man, in his very law-breaking, is most subordinate to his passions. As the French philosopher Maurice Blanchot expresses it: 'art and works of art seem to affirm and perhaps restore the dignity of being: its richness escaping all measure, its force of renewal, its creative generosity, and everything that the words *life, intensity, depth, nature* call forth.' This idea, though appealing, is likewise misleading. It promises too much of art. At best, it is true of only a limited, though estimable, class of artworks. It too, therefore, is a fraud.

Opposite
Francis Picabia
The Cacodylic Eye
1921

100

Different though they are, these two ideas converge in one respect, and that is in relation to the elevated status of the artist. For the one, the artist is superior to morality; for the other, the artist is a moral superior. That is to say, either above morality or morally exemplary. 'The painter,' remarked the Italian artist Emilio Vendova, 'is unable to recognise himself in existing moral standards' and 'must go beyond the conventions that have lost their hope'. This shared conviction so dominates our thinking about the artist in general that it has become the focus of a certain contemporary art anxiety. The New York artists' collective Group Material, for example, made a point in their participatory art projects of giving equal rights to both artists and non-artists. But in doing so they merely confirmed the distinct virtue of the artist, and indeed by the perplexing generosity of their gesture, gave it additional weight. Only the artist, in his supererogatory goodness, would deny himself the primacy to which he is entitled; only the artist, in his very lawlessness, would disregard the boundary that separates him from non-artists. (Artists, says the American artist Rosemarie Castoro, 'are the saints of the world'.) And when the artist abuses that primacy, prostituting those gifts, he commits something like a blasphemy. Giorgio Vasari, the 16th-century inventor of the 'artist-as-hero' biographical genre, remarked of an artist who squandered his talent making obscene engravings: 'the gifts of God should not be employed... in things wholly abominable, which are an outrage to the world.'

These companion notions of the artist as saint or sinner, but in either case morally exceptional and thus transgressive (exceeding the boundaries of ordinary goodness), are false in that they pay undue regard to the artist and neglect the artwork. They fail, that is, to discriminate both between kinds of artists and kinds of artworks, and between kinds of transgression. They promote the artist at the expense of the artwork. They are slaves to an undifferentiated, ahistorical and clichéd notion of the transgressive. In place of these large, empty theses about artworks and their makers, I wish to substitute the following, much more limited thesis. The modern period may be characterised in part by three distinct kinds, or versions, of transgressive art: an art that breaks art's own rules; an art of taboo-breaking; a politically resistant art. That is to say, there is an art that repudiates established art practices, an art that violates certain beliefs and sentiments of its audience, and an art that challenges the rule of the state. These are, of course, abstractions, and incomplete ones at that. In addition, 'taboo', an irrational interdiction, summarises an entire,

dismissive account of certain aspects of social reality, one from which I strongly dissent. Individual artworks often are multiply transgressive, though one kind of transgression usually dominates. Among art's rules, for example, are rules of artistic decorum that are companion to social rules. Break the one kind, and the other is put into question. Similarly, when art rules are legislated by the state (paint *these* subjects, in *this* style), to violate them is directly to contest the state's authority. These three kinds may be grouped under the umbrella of a single aesthetic, the transgressive.

By 'art rules' I mean everything from given painterly conventions to painting's commonly understood limits, that is to say, everything from *how* paintings are to be executed to *what* paintings can be. (There are also the 'un-

written rules' which restrict choice of subject. For example, it has been said that there was an 'unwritten rule' in the Soviet Union against the painting of nudes.) Violating an art rule might lead to the making of a bad painting or it might lead to something that cannot be recognised as a painting at all. Alternatively, it might lead to the making of a work that enlarges our understanding of how paintings can be made or of what a painting can be. E.H. Gombrich tells the story of Gainsborough's challenge to Reynolds's prescriptions. Reynolds had told his students at the Royal Academy that blue should not be put in the foreground of paintings but instead reserved for the distant backgrounds. Gainsborough responded by painting a blue-costumed boy in the central foreground of the work *The Blue Boy* (1770). The artist thus proved, says Gombrich, that such academic rules are usually nonsense. 'Academic' means pervasive, monolithic, authoritarian: that is to say, an art ideology akin to a state religion. It also means canon-submissive, doctrinaire, imitative: that is to say, an art piety akin to ancestor worship. Rules of this kind are always being broken, and there is nothing that is distinctively modern about the practice. 'Art is not the application of a canon of beauty but what the instinct and the brain can conceive beyond any canon,' said Picasso. As one style succeeds another, the laws of the former style are violated. However, the artworks most readily recognised as among the masterpieces of the modern period are rule-breaking in the stronger sense of compelling us to admit as paintings works

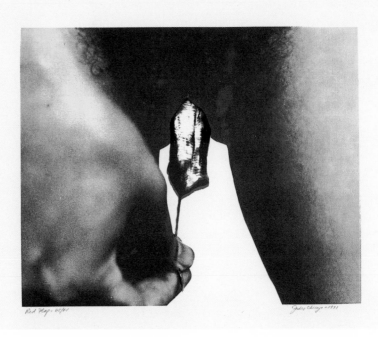

Judy Chicago
Red Flag
1971

that fall outside the limits defined by the sum of existing paintings. They are canon-violating rather than canon-augmenting. As Willem de Kooning put it, 'every so often, a painter has to destroy painting. Cézanne did it, Picasso did it with Cubism. Then Pollock did it. He busted our idea of a picture all to hell. *Then there could be new paintings again*' (my italics). Art dies to be reborn. But this does not mean that anything is possible, at any time. One should not confuse a boundary with a horizon.

There is an innovative rule-breaking, undertaken because the rules are experienced as constraints on an artistic project. The artist wants to paint that subject, this way, and the rules say he can't. Well, to hell with the rules. This is the artist as hare, effortlessly traversing boundaries. Barry Flanagan's hare figure is the very self-image of the innovative transgressive artist, whose rule-breaking is indifferent to the rules. The artist will, by a gesture of incorporation, take subjects proscribed by decorum; art forms that have hitherto remained separate will be merged; the very distinction between artist and art-work will be erased. A relatively recent, typical example of this incorporating gesture is Judy Chicago's *Red Flag* (1971), of which the artist writes: 'women have been deprived of images that affirm our experience... I wanted to validate

female subject matter by using a "high art" process.' It is a breach of decorum in pursuit of a greater inclusiveness, boundary-enlarging in its boundary-breaking, and thus rather different from the taboo-breaking art that preserves the boundaries it violates. The rule-breaking innovative artist bears a certain resemblance to a Raymond Chandler cop: 'We're supposed to read [homicide reports] the same day. That's a rule, like you shouldn't search without a warrant or frisk a guy for a gun without reasonable grounds. But we break rules. We have to.' Many instances of this expansion by artists of the boundaries of art amount to a kind of art imperialism. ('First I eat the fish,' remarked Picasso, 'then I paint him.') Representation of the world was followed by its annexation, argued Malraux. The collages of Braque and Picasso are examples of just this project of enlarging art's domain, incorporating printed oilcloths, newspaper pages and other material recovered from the world: see, for example, Picasso's *Still Life with Chair Caning* (1912). These artists were geniuses in a precise, Kantian sense. The philosopher declared: genius gives the rule to art. By which he meant that art is rule-giving, not rule-complying. It is in the nature of a certain high artistic creativity that it should produce works for which no definite rule may be given. These works then serve as a standard for others; they are not mere eccentricities, the outpourings of madmen. To adopt Harold Rosenberg's wonderful phrase, they are like formulae derived from the testing of explosives. From the process of destruction there emerges a rule.

Then there is an interrogative rule-breaking, one that is reflexive and prompted by an interest in art itself. It is in part the child's curiosity: let me bend this toy to see whether (better, when) it will break. It is also in part the philosopher's curiosity: let me test the received notions of what constitutes art. Rule-breaking artworks of this kind take as their subject art itself; they seek both to be an instance of art and an interrogation of art, both to ask and to answer the question: what is art? They do not play *by* the rules, they play *with* the rules. This is, more than any other modern artist's, Marcel Duchamp's enterprise: he is the type of the interroga-

Barry Flanagan
Hare on Curly Bell
1980

Pablo Picasso
*Still Life with
Chair Caning*
1912

tive artist, defining in subversion a concept of art. Indeed, in consequence of Duchamp, the Belgian artist Marcel Broodthaers has affirmed, the maker of an artwork is the author of a definition. He does not so much create an object as add a visual gloss on the word 'art'. Neither art nor non-art, many of Duchamp's interventions in the art world questioned the premises from which judgments about artworks were (and continue to be) derived: the belief in the necessary originality of the artist, the belief in the necessary uniqueness and beauty of the art object, the belief in the mandated primacy both of the image over the word and the artist over the critic, and the tacit dependence of art on the market. Duchamp fostered the role of the museum in determining the artistic status, or 'art-ness', of objects proposed by artists for exhibition. His interventions – a better term, in certain respects, than 'works' – unsettle their audiences, which is their object. Interrogative art, when most itself and not something else too, approaches the condition of anti-art.

Supposing these two, the innovative and the interrogative, to be ideal types, one could say that while innovators redraw boundaries, interrogators disturb them. Innovators are explorers, interrogators are ironists. Innovators enlarge, interrogators subvert. But such oppositions are purely analytical. Few works are wholly innovative, none is merely interrogative. Cubist works, for example, have both innovative and interrogative aspects. They extend art's boundaries; they provoke questions about the nature of art. The constructivist Naum Gabo, writing in 1937, captured just this double ambition:

> Cubism was a revolution. It was directed against the fundamental basis of Art. All that was before holy and intangible for an artistic mind, namely, the formal unity of the external world, was suddenly laid down on their canvases, torn in pieces and dissected as if it were a mere anatomical specimen. The borderline which separated the external world from the artist and distinguished it in form of objects disappeared; the objects themselves disintegrated.

That is to say: Cubism both enlarged the domain of art and excavated it at its foundations.

These transgressions, the innovative and the interrogative in combination, often entail, in the artist's self-understanding, a trumping of one rule with a notionally higher rule or 'law', thereby justifying the disregard for the

rule by reference to its inferiority to the other rule or law. (This is not to be confused either with the adoption, in a ruleless art world, of self-imposed constraints as the conditions for art-making, or with the exploration, within the individual artwork, of its own internal laws. The artists of the Oupeinpo movement are the best example of the former. Works of concrete art are exemplary of the latter, because, as the artist Max Bill defines them, they establish patterns which, 'having their own causality, are tantamount to laws'.) The writings of modern artists and art critics are dense with the contrast between mere academic conventions and those laws of art or nature that it is the task of the artist to embody in the artwork. Fidelity to these laws trumps the duty to comply with conventions. The highest level of aesthetic sensation, writes Le Corbusier in an essay, is 'the clear perception of a great general law'. As for art, 'in all ages and times, great works… have been composed by imperious regulating lines'. Purism, he explains, 'is the application of the laws which control pictorial space'. And then, just at the end of his piece, as if in afterthought, he adds: 'Purism strives for an art free of conventions.' Mondrian, to take a second example, wrote that while 'abstract art is opposed to the conventional laws created during the culture of the particular form', it is nonetheless 'at one with the laws of the culture of pure relationships'. This crux of committing to one law and thereby repudiating all others is best instantiated in Hans Arp's *Collage Made According to the Laws of Chance* (1916). Adherence to these laws mandates the violation of the very regime of art.

Hans Arp
Collage Made According to the Laws of Chance
1916

The second kind of transgressive art, the taboo-breaking sort, may by contrast be entirely conventional in its execution. Its violence is directed more at its audience than at the art canon. It does not so much wish to extend or challenge art as to extend or challenge the spectator. Just as the art canon is in a certain sense the subject of the art rule-breaking artist, so the spectator is the subject of the taboo-breaking artist. The difference between the two can be grasped in their contrasting deployments of the faecal, the speaking or picturing of which is a means of declaring a commitment to a certain

concept of art, one that is indifferent to boundaries of taste or taboo. This is thus a recurrent event in modern culture. The cry 'merdre' (*sic*) with which Alfred Jarry's *Ubu Roi* (1896) opens is one of the early, even initiating, events in this enterprise. It recurs in many forms, with diminishing impact. Michel Leiris, one of Bataille's associates, made this entry in his diary one day in the 1930s: 'At present, there is no means of making something pass as ugly or repulsive. Even shit is pretty.'

Consider the work of Piero Manzoni, Gilbert and George, and Chris Ofili. These artists are unembarrassed by their subject or material. They hope that their audiences will likewise free themselves of their initial discomfort. They want to paint the world in all its variety, or use the world's materials in all their variety. They regret, or claim to regret, the disquiet their work may cause. They seek an infant's ease with the faecal (Freud: 'the excreta arouse no disgust in children'), and their work is in part an invitation to their audience to share something of that desired composure. They wish to represent or use the meanest, most despised substances and thereby give them a hitherto denied value. Their object is to turn upside down culture's hierarchy, in which the spiritual is at the apex and the grossly material is at the base. This has ever been a transgressive, carnival enterprise. In the modern period, it becomes an enterprise of high art, and subverts that practice among writers from the Renaissance through to the 18th century of ranking the arts, and ranking genres within each art. It crowns the fool; it celebrates the faecal; it mocks, teases, invites its audience to take pleasure in its own relaxed, playful subversiveness. (During the debate on whether to exhibit Duchamp's *Fountain*, the artist George Bellows bellowed: 'You mean to say, if a man sent in horse manure glued to a canvas, we would have to accept it?') Arte Povera is the art movement most closely allied to these aspirations for art. It sought, explained Mario Merz, to gather objects very remote from being art into a new art. It was innovative to the extent that it incorporated new material in art. It was interrogative to the extent that it thereby raised the question: can art accommodate this material? It wished to emancipate us from our anxieties. It was inclusive both of the world's material and its audience. It celebrated, said one of its enthusiasts, a boundless openness, a willingness to live elastically in a state of flux.

That audiences will tend to resist such works may be expected. This resistance may be characterised as deriving from a 'taboo'. The artist's purpose is to retrieve the faecal from the realm of the forbidden and to make it a subject for

SPIT
ON
SHIT

Gilbert and George
Spit on Shit
1996

art. Of their *New Testamental Works*, Gilbert and George thus explain that they are trying 'to break down taboos'. Their pictures are 'visual love letter[s]... to the viewer.' This is, of course, the love that leaps boundaries and triumphs over every obstacle. George adds: 'A lot of people think we... want to impose our free way of life on them. This is not the case. We are filled with taboos. We are terrified of shit. It is an adventure together with the public, together with the viewer.' There will, naturally, be faint-hearted viewers who will flinch from the rigours of such an adventure, but the invitation remains open to all. The artists want, they say, to 'de-shock' us. Disagreeable as *Spit on Shit* (1996)

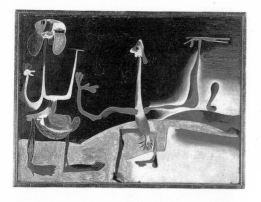

is – however reluctant one would be to live with it, or indeed give it more than a glance – it has its own integrity.

Now consider, by contrast, Miró's *Man and Woman in Front of a Pile of Excrement* (1935) and Dalí's *The Lugubrious Game* (1929). In Miró's work, a couple celebrate, with extravagant, excited gestures, a sculptural pile similar in colour and contour to their own bodies. They are the artists of their own excrement, which they embrace as material for their art-making, building it on the high ground, totem-like, rather than evacuating it in secret and then disowning it. In its grotesque inversions of human practice, the work establishes a parallel universe in which the sacred becomes the profane, the taboo becomes the totem, and what is forbidden the obligatory. It casts our world in relief. In Dalí's work, a man exposes stained shorts and a right leg, to which sticks viscous, diarrhoeal matter. What animates this work is *not* the desire to paint the as yet unpainted (thereby, but only incidentally, breaching rules of decorum), but rather the desire to paint the unpaintable. It is an event, not an object, that Dalí pictures. Its purpose is not inclusivist, bringing within art's circle a hitherto excluded subject, but confrontational, coercing the spectator into an unwelcome encounter. The work has an autobiographical resonance. The artist was a witness to just such a scene when a child of ten or 12, and in the most troubling of contexts. Dalí's father arrived home one weekend, after an absence of some days, and announced to all, making no attempt at concealment, 'I've crapped.' This came to Dalí, remarks his biographer, with all the force of an authentic trauma. He wants in this work to preserve, rather than dispel, the horror and the disgust. The art of Dalí, said Breton, constitutes a real menace.

There is no emancipatory dimension to this second project. The notions of the 'innovative' and the 'interrogative' are irrelevant. These works of Miró's and Dalí's are transgressive in their violation of taboos associated with human waste. But unlike Gilbert and George's work, their object is not to liberate us from fear of those taboos but to excite our anxiety about them. They violate the taboos in order to violate their audiences. This is not to collapse the two: there is a comedy about Miró's staging of his scene that distinguishes it from Dalí's work, and that makes it less troubling. Dalí's work shocked the Surrealists, who had their own 'taboos', Dalí noted: 'Blood they allowed me. I could add a bit of shit. But shit on its own was not allowed. I was authorised to represent the sexual organs but not anal fantasies. Any anus was taken in very bad part.'

Taboo-breaking artworks put under threat certain under-articulated or unspoken sentiments and beliefs to which their audiences may be taken to adhere. These are beliefs about what should be protected or safeguarded. If they were still capable of cogent expression (they once were, but are no longer), and if we wished to speak well of them, we might term them pieties. How are we to characterise such 'beliefs'? They are most commonly termed taboos: ancient, tacit prohibitions and loyalties. Some derive from a consciousness of debt: to one's parents, to one's country. Some derive from a consciousness of station: the deference one owes to certain kinds of person. Some derive from an intuition of the distinctness of things, and a recoil from everything that is mixed, everything that is hybrid. These pieties are a heterogeneous bunch. 'Respect' is a thin, inadequate substitute for the word, but not a pejorative one. That duty is done by 'taboo'. (The current, dismissive meaning given to 'taboo' is no longer congruent with the current, neutral anthropological meaning – the sanctified proscription of physically feasible activity – and has much more to do with a late 19th-century anthropological meaning, on which more below.) Moral rules are often subversive of piety, because of their implicit refusal to recognise (a) distinctions between moral agents (for example, between family members and strangers), or more radically (b) obligations towards non-moral agents (for example, the nation, the dead, animals). The violating of taboos or pieties becomes the project of this kind of transgressive art, with mixed results. In its later phases it acquires an obsessive, aesthetically thin character. It also becomes naive – a curious development. This remark of the

Opposite, top
Joan Miró
*Man and Woman
in Front of a Pile
of Excrement*
1935

Opposite, bottom
Salvador Dalí
The Lugubrious Game
1929

performance artist Carolee Schneemann is representative: 'you get an instinct for where the repression is and you go for it. I always thought that my culture would be gratified that I was putting it out, but instead they want to punish you.' Of course. Taboo-breaking art, when it does not merely bore, will often excite a penal response. The taboo-breaking artwork must thus find its way past both indifference and censorship.

The third version is the weakest of the three. The project of making transgressive political art has not been a great success over the last 150 years, all things considered. The relations between art and power are complex and ancient. New genres and new contexts reconstituted and impoverished this relationship in the mid-19th century. The principal elements in the new nexus included the establishment of the non-art genre of propaganda, a cultural anxiety about the connection between art-making and political engagement, the eclipsing of an earlier, politically engaged artistic avant-garde by a quietist one, and the state sponsorship of art as a means of communicating with its subjects. The failure of a transgressive political art to flourish has led to the making of artworks that sentimentalise suffering, or falsely universalise suffering, or are misread as political because of the political affiliations of their maker. The 20th century is full of instances of all three kinds of work, each one an evasion of the politically resistant. Many artworks give political offence by chance, some set out to cause it. State institutions will often respond, censoring the work, punishing the artist. Such activity amounts to a reading of the work imposed by an enemy. It is a repressive hermeneutics, interpreting *and* injuring the work. This interpretation will always be incomplete, and will often be wrong. Politically resistant art exposes to scrutiny the coercive authority of the state, sometimes just by provoking the state into showing its hand.

Artists, like the rest of humanity, live by the grace of political institutions. 'Art is free and must remain free, so long as it conforms to certain conventions,' said the Nazi Joseph Goebbels, and though the modern period is replete with proofs of the truth of his judgment, it is one that certain artworks refuse. This refusal is often expressed as a kind of strong defiance, sometimes as a wilful failure to understand art's own subordination to these institutions and to the state itself. Artists who paint such works seek to violate the limits that clerics, tyrants and other rulers (who also of course sponsor art) seek to impose on us. They do so by art-making acts that are analogous to, and

are often also instances of, acts of civil disobedience. Call them 'politically resistant artworks'. Politically resistant art both puts into question the legitimacy of state actions (sometimes, of the state itself) and is responsive to the contingencies of political life. The making of politically resistant artworks may amount to a criminal act, but of an unusual kind. These artworks confront the law-giver; they are reflexive; they are disinterested; they are public. By committing his offence, the artist-perpetrator wishes to give offence.

Politically resistant artworks have divided audiences: those against whom they are directed, and those whose morale they are intended to lift. The stance of the artist is thus both oppositional and representative. His artworks are pitched against one audience, but made on behalf of another one. They are transgressive and affirmative – in a sense, transgressive *because* affirmative. Politically resistant works are exceptional. There is no place for them in two contrasting kinds of state. There is the state whose citizens take for granted, correctly, that they order their own lives, and that institutions exist to serve them. Politically resistant artworks are not *needed* in such a state. And then there is the state where these assumptions are not made and in which politically resistant artworks are not *possible*. Such works will be exceptional, then, either because of the acquiescence of accommodating states or the harshness of repressive states. One kind of state is usually too hard to offend; the other kind of state is usually too quick to respond. Compare the anti-Vietnam War art in the United States with the art briefly on display at the September 1974 Moscow 'Bulldozer' show. While the former, with exceptions, was unable even to engage the state's attention, the latter could not survive its brisk dismissal. In Moscow, artworks were thrown into skips and destroyed, and visitors chased away with waterhoses mounted on trucks. On the one side, then, there tends to be a surplus of political works, existing, as artists experience it, in a vacuum of indifference, while on the other side there is a dearth of works, surviving against expectation. 'Do you want to go abroad?' USSR premier Khrushchev once interrogated the artist Zheltovsky. 'Go on then, we'll take you free as far as the border.' Which is where, metaphorically, the artist was anyway.

Each version of transgressive art has its own history. Art rule-breaking art (the innovative kind especially) is continuously in evidence in the modern period, and is also continuous with pre-transgressive art. Politically resistant art, by contrast, is neither. It is both specific to, but only sporadically evident

in, modern times. Prior to the mid-19th century, a combination of state or church censorship, the dependence of artists on official or elite patronage and the low place given to contemporary subjects in the hierarchy of the art genres made politically resistant art all but impossible. Since then, a partial relaxing of these constraints, accompanied by the emergence of certain new inhibitors, has allowed this dangerous, liberating kind of art to make only limited, fleeting appearances. Taboo-breaking art is different again. It is discontinuous with pre-transgressive art; in our times, it has had three distinct moments. There is the originating moment in 1860s Paris, with the exhibiting of *Olympia* and those other works of Manet's that I considered in the last chapter. There is then the moment of maturity, which is Surrealism. Here, the transgressive aesthetic is realised in a series of remarkable, uncompromising artworks. And last, there is the moment of closure, which begins in the 1960s and is itself just ending. It tends to substitute representation for presentation (body art, performance art, photography), to disengage from the pieties and content itself with stimulating mere shock, and to play variations on Duchampian and Surrealist initiatives. (Robert Hughes has described *Piss Christ* as 'a fairly conventional piece of postsurrealist blasphemy'.) Such art, so Arthur Danto has proposed, 'will never become something that pleases the eye and enlivens the spirit'. In the first of these moments, transgressive artworks had a complexly antagonistic relation with the academy (representatively, the Paris Salon); in the second, it was outside, and indifferent to, the academy (all academies); in the third, it tended to be inside, and complicit with, the academy (representatively, the Royal Academy in London).

Malraux has suggested that today we base our aesthetic on our direct response to the artwork. We no longer try to establish hard-and-fast rules, he says. We instead seek to elicit a psychology of art. No 'law of art' can be deduced from the past and projected onto the future. But Malraux is only partly correct. He disregards the experience of rule- or law-breaking that certain artworks impart, and that must therefore be incorporated in our understanding of our 'direct response'. Any adequate psychology of art, that is, must take into account our apprehension of the artwork's rule-breaking qualities. While we may ourselves have abandoned the project of constructing rules for art, we continue to be aware of art's own transgressiveness. Transgressive artworks, indeed, compel this awareness as the very condition of our engagement with them.

Violating Art Rules

In *Human, All Too Human* (1886), Nietzsche praised the artists and poets of ancient Greece for 'dancing in chains', that is, fettering their expression with inhibiting conventions and then triumphing over them. Indeed, 'inventiveness' in art always entails the adoption of new, self-imposed fetters, according to Nietzsche. Three-quarters of Homer, for example, is convention. And Homer himself then added to these inherited formulae and epic narrative rules further conventions within which his successors were obliged to work. The Greeks did not live in fear of conventions, which comprised the achieved artistic means, the common language established across generations, by which artists addressed their audiences. Today, by contrast, 'originality' alone is admired, sometimes even idolised, though rarely understood. To what, Nietzsche asks, does the modern rage for originality point? The transgressive aesthetic, in its art rule-breaking version in particular, is one consequence of just this rage for originality, one that realises itself in the violating of all given conventions.

It is the heterogeneity, and opacity, of modern art's movements that is so striking. The names alone are liable to perplex and mislead: the Fauves were not wild; the Metaphysical painters were not metaphysicians; the Cubists did not paint in cubes; Rayonism did not radiate; the Futurists had no grasp of the future and celebrated an essentially 19th-century version of their own, early 20th-century present. But the existence of distinct movements, and the manifestos that many issued, contributed to the combative, oppositionist milieu in which artists freed themselves from what had come to be experienced as constraints. These movements were alternatives to academies, and their manifestos and programmes substitutes for academic courses of training and study. ('Academies exist to preserve traditions, not to create new ones,' a secretary of the Académie des Beaux-Arts once said.) They were in a sense anti-academies. They sought to go beyond the given limits of art. 'They know no programme and no compulsion,' wrote Franz Marc of the Brücke painters, 'they only want to go forward at any price.' To go forward, that is, across art's given boundaries. Original art, said Harold Rosenberg, is both art and non-art at a glance.

The history of modern art may in part be written by reference to art's liberation from the laws of perspective and genre, and the properties of the easel picture. Perspective adds a pretend third dimension to two-dimensional

Top
Arman
Crusaders
1968

Above
Giulio Paolini
Untitled
1961

space. Break with this art rule (I use 'rule' in the widest and non-technical sense) and one rejects the illusory, instead inviting the undeceived eye to rest on the picture plane itself. Genre organises the world, selecting suitable subjects and determining the nature of their representation. It proposes a simulacrum of the world. Break with genre and the world presents itself unmediated by convention, or so it seems. The regime of a limited, determinate number of genres, it appeared to critics of the 1860s, had given way both to an anarchic proliferation of genres and a similarly anarchic blurring of genres. This is Michael Fried's point: 'what was registered was a disconcerting fluidity of the discursive space in which paintings were identified, described, compared, judged.' There was no turning back. Pictures made by the application of a paint-soaked brush to a canvas supported by an easel and thereafter framed are a mere sub-set of all possible paintings; they do not define the art form itself. Surrender the frame or the brush, apply new materials to the canvas or use existing materials for new purposes – the wit of Arman's *Crusaders* (1968), the *reductio* of Paolini's *Untitled* (1961) – and quite new kinds of art become possible. And the quest that precipitated these liberations? To find, in Max Ernst's phrase, a painting 'beyond painting'. It is the search for an anti-aesthetic of the undeceived, and undeceiving. It seeks a reality principle to guide its practice. 'Reality,' say Gleizes and Metzinger, 'is deeper than academic recipes.'

It is to reality that art's rules are most often expected to defer, as in this encomium to Man Ray: 'All means were justified in attaining his end – to delineate reality. There were no rules, no taboos.' About this, in general, there is nothing that is especially new. Géricault, for example, was praised for representing 'frankly, naively' what he had seen, and for giving himself 'wholly to the desire to substitute reality for convention'. What *is* new, however, is the pursuit of a reality that requires the abandonment of precisely those rules that

enable reality's illusion to be created. Out of such an abandonment – say, of the rules of perspective – whole new art forms emerge. Installation art, for example, arranges objects in three-dimensional space. It represents a working-out of certain possibilities of post-Cubist art. Perspective allowed represented objects to be arranged on the canvas; its abandonment flattened objects or projected them off the canvas altogether into the space in front of the wall. Illusion made way for one or other reality: the reality of the picture plane, or the reality of the three-dimensional installation. The innovative artist disregards the rules in order to create a new reality. 'All the rules, all the canons of art,' the Belgian artist James Ensor declared, 'vomit death.' The innovative artist places the reality principle, let us say, above the given conventions of his medium. Pursuit of this reality principle (which is not to be confused with reality itself) invariably results in breaches of decorum, or expansions of either the physical properties or generic conventions of the artwork. Manet was praised by a contemporary as follows: '[he] has never, thank heavens, known those prejudices stupidly maintained in the academies. He paints, by abbreviations, nature as it is and as he sees it.' This reality principle offers a double liberation: the world is presented plain, by an eye that itself is unobstructed by academic formulae.

Innovative art rule-breaking may be very serious, or just frivolous, but it will always have a quality of the fortuitous about it. Rule-breaking is not the object of innovative art, merely a consequence. It is the art that is most continuous, in this sense, with the art that preceded the inauguration of the transgressive period. 'All good painting,' said the artist Frank Auerbach, 'looks as though the painting has escaped from the thicket of prepared positions and has entered some sort of freedom where it exists on its own, and by its own laws, and inexplicably has got free of all possible explanations.' It is a rule-breaking that is free-spirited and bold, and sometimes leads to the adoption by others of new practices. It is avant-garde in the old-fashioned way: an advance party that sets out with the object of arriving at a shared destination, just a little earlier than everyone else. Thus Malevich: 'I have transformed myself in the zero of form and have fished myself out of the rubbishy slough of academic art. I have destroyed the ring of the horizon and got out of the circle of objects, the horizon ring that has imprisoned the artist and the forms of nature.' And then others started painting like Malevich, and a new orthodoxy emerged – against which a new dissent was then registered. The maverick

George Grosz
*Homage to
Oskar Panizza*
1917–18

founds a new school, the rebel a new orthodoxy. (Often to the pioneer's distaste. André Masson contrasted the energy of the young Surrealists of the 1920s – of whom he was one – with Surrealism's 'new academicism' in the 1940s. 'Should one conform to it?' he asked. 'Of course not.') Malevich's short-hand target, 'academic' art – art that is taught or made by reference to given conventions – limits the artist in choice of subject, in choice of art material, in choice of art form, in the very boundedness of the picture frame. There are subjects he may not paint, materials he may not use, forms he may not combine, limits he must not exceed. It is these constraints, these rules, these prescriptions, these physical borders, against which the modern artist pits himself, the boundaries he transgresses. (There are whole histories that could be written, for example, about the modern artist's argument with the frame.) America became for many artists the teacher of art's boundlessness. 'There's a fine-art quality about European art, even when it's made from junk,' observed the sculptor Anthony Caro. 'America made me see that there are no barriers and no regulations.' During the Cold War, defenders of modernism in the United States were able to draw on the American ideology of the frontier in defence of artistic experimentation: 'we believe that the so-called unintelligibility of some modern art is an inevitable result of its exploration of new frontiers.'

Even though artists had secured the right to choose their subjects by the closing decades of the 18th century, and exercised that right freely, thereby breaking with the established tradition of Western art, it was only in the 19th century that the choice of subject scandalised. Indeed, many of the art scandals of that period were caused by nothing other than the work's content. It was almost as if it was the object of the new work's representation itself, rather than the artist or the artwork, that constituted the offence. Content outraged. Not so much because of any inherent novelty of subject – adding to the sum of representations of the world does not in itself involve any rule-breaking – but

because certain new subjects were taken to be inappropriate for art, inconsistent with its assumed dignity or purpose. Courbet's oeuvre includes many examples of such works, provocations every one of them. Grosz's oil painting *Homage to Oskar Panizza* (1917–18) takes a subject considered unsuitable for elevated treatment – the chaos and squalor of modernity – and renders it in the grand manner. 'My aim,' declared Fernand Léger, 'is to prove that there

Judy Chicago
Birth Project
1981

is no such thing as Beauty that is catalogued, *hiérarchisée*.' This is Judy Chicago's ambition too. Her *Birth Project* (1981) takes as its subject an important, but hidden, aspect of women's existence. Artists contrained by notions of decorum merit only mockery. 'What a miserable fate for a painter who adores blondes to have to stop himself putting them into a picture because they don't go with the basket of fruit!' said Picasso. 'I put all the things I like into my pictures.' 'The artist,' he added, 'is a receptacle... we must not discriminate between things.' This refusal to discriminate, which is a refusal to acknowledge the lines that demarcate one kind of thing from other kinds, is the founding gesture of a certain kind of modern, transgressive artist.

Art greedily, even promiscuously, consumes everyday objects. No longer content to picture the world, it seeks to appropriate it. It freely commandeers to itself any material, or incorporates within itself any already existing object. (A friend of the artist, celebrating this gift of appropriation: 'When I pick up a stone, it's a stone. When Miró picks up a stone, it's a Miró.') It transgresses as the ocean does when it exceeds the shore line, running over everything that is given in the world, subordinating it to its own motion of erasure. The only objections to these appropriations are now legal rather than aesthetic. A significant proportion of the art of the last century was responsive to this incursive reflex: collage, Arte Povera, Art Informel, 'combine painting'. This is a reflex that reached its terminal point in the wrapping art of Christo and Jeanne-Claude. The wrapped object was, so to speak, the world's, but now it belongs to art: see *Wrapped Coast* (1968–9). It is art's triumph over the world, imagination's over external reality, creativity's over the given. The very composition of the world submits to the transfiguring authority of art. Claes Oldenburg enthused: 'I am for an art that embroils itself with the everyday crap & *still*

119

comes out on top' (my italics). Each artwork is a victory over the infinitely heterogeneous material out of which it is created. It is an adversarial engagement, one in which art triumphs.

Such victories can take different forms. Some artists convert objects that have an everyday use, other artists take rejected material – rubbish, the detritus of everyday life. The former treat the world as art's laboratory; the latter restore to art a redemptive power. (Art now redeems its material rather than its audience, an earlier ambition.) The former material is given a new function; the second, formerly functionless, a function. There is an aspect of Michael Craig-Martin's work that is typical of the first kind; certain artworks of John Chamberlain's are typical of the second. Craig-Martin's plywood boxes, mirrors, milk bottles, buckets, venetian blinds, clipboards 'test', he says, 'the limits of the real'. These materials do this by submitting to the authority of art. They had one use; now they have another. Chamberlain's *Etruscan Romance* (1984), by contrast, takes material for which we have

no use whatsoever, and confers on it an aesthetic dignity. What one critic has written of the American artist Gordon Matta-Clark may stand for all artists with his, and Chamberlain's, ambition: 'the metapsychology of Gordon's art was to embrace the abandoned. He worked in old buildings, neighbourhoods, in a state of rejection. He would nurture a building that had lost its soul.' He would reanimate it, but for his own purposes. These artists are not restorationists, they are appropriators. In Matta-Clark's case, that appropriation consists in destroying the given materials that comprise his work: for instance, *Splitting* (1974), an abandoned house cut down its middle by the

artist. This act of appropriation has an irradiating effect, charging the given material with new meaning. As the British artist Tony Cragg put it: 'any material that comes near to us, any material that we even see, automatically becomes more intelligent because it assumes metaphysical qualities in addition to its physical qualities. The material starts to have information attached to it, to have a history, to assume poetic qualities.' This is the artist as force-field, transforming whatever comes his way by mere contact.

In her essay 'Grids', Rosalind Krauss discloses the grid as modernism's emblematic structure. It first surfaced in France, then in Russia and in Holland, all in the early part of the 20th century. It is present in prewar Cubist painting, and thereafter becomes ever more stringent and manifest. It lowered a barrier between the arts of vision and those of language, Krauss argued,

thereby walling the visual arts into a realm of exclusive visuality and defending them against the intrusion of speech. It speaks for modern art's will to silence, its hostility to discourse. By implication: an open set of overlapping artistic and literary practices was abandoned in favour of two autonomous, hostile realms, 'art' and 'literature'. This is where Krauss ends her story, though it has both a prehistory and sequels. The quarrel between word and image, and the related quarrel between philosophy and art, are constitutive of the very dynamic of Western culture. Modernism's resolution of these quarrels was to separate the antagonists, and then reject philosophy and the word in favour of art and the image. Other, later resolutions, conceptual art principal among them, reversed the favoured terms. It put in retreat the object, the material form of the image, as if in obedience to that 1968 Parisian graffito, 'OBJET CACHE-TOI!' Throughout the modern period, however, a larger ambition has also been pursued, one that contemplates the erasure of the boundary-lines separating the two realms. Roland Barthes believed that he was witnessing its birth in 1969: 'Something is being born, something which will invalidate literature as much as painting... substituting for these old cultural divinities a generalized ergography, the text as work, the work as text.' This is the utopianism of the innovative art project, one that embraces its own extinction. Breaching art's limits is perceived to be too modest, too slight an ambition. 'Art' itself is experienced as a gaol. The artist needs to escape from it, not extend its borders. The constraints it imposes on creativity will disappear only at the moment of its own destruction. It is a category, and all categories break up and petrify the free flow of creative expression. 'Once you get rid of the notion of art,' says Jean Tinguely, 'you acquire a great many wonderful freedoms.' His words are addressed to both artist and audience. Let the artist reject art, and he will be able to embrace instead an open series of art practices. Let the audience reject art, and they will thereby open themselves to work made by such artists. Each is thereby freed from the mind-forged constraints imposed by the concept of 'art'. Tinguely's own work did not quite precipitate this second liberation – his audiences admit his work as 'art'. This splitting of the atom of 'art' is the last innovative project. And now that aesthetics has caught up with it (by the philosophical work of Arthur Danto and the French philosopher Jean-Marie Schaeffer), it may be considered to have completed itself.

To characterise innovative rule-breaking art as transgressive is to risk collapsing it into other kinds of transgressive art practices, ones that are radically

different in execution and effect. 'There is no law, no principle, based on past practice,' Ruskin stated, 'which may not be overthrown in a moment, by the arising of a new condition, or the invention of a new material.' But he did not have Surrealism in mind when he wrote this, nor could Surrealism be defended by reference to it. It is to the kinds of transgressive art that exceed such concessions that I now turn. First among them, and alongside the innovative project, is a related, but colder, one. It does not wish to escape art's constraints or enlarge its realm. It is utterly uninterested in uncovering art's true diversity beneath that carapace notion, 'art'. It is instead analogous to taboo-breaking art. 'Art' itself stands as its taboo, one that it wishes both to violate and to preserve. It wants, that is, to induce a certain aesthetic anxiety in its audience. This is interrogative art. The artist's posture is one of a certain disdain, a cool belligerence. You think you are able to recognise an artwork? You cannot. Duchamp's submission of *Fountain* to the New York Independants of 1917 is the type of this gesture. Accept such an object as art, and art's boundaries are expanded to the point at which its distinct existence is put in jeopardy (if art can be anything, then it is nothing in its own right). Reject the object as art, and one is committed to restrictions that would exclude much else. Either way, the audience is at fault. Gullible or proscriptive, it misses the point.

There is an art-joke of Duchamp's that, in a typically sly, discomforting way, indicates the possibilities of the interrogative art project. It is an exhibition catalogue, an object of a type that has a dependent relation to artworks. For the 1947 International Surrealism Exposition, Duchamp devised a rather unusual catalogue. It had on its front cover a pink rubber-foam breast, and on the back cover the printed invitation 'Please touch'. This must have been troubling to visitors. Was the catalogue to be regarded as a guide to what was on display or was it perhaps itself a Surrealist object? If a guide, then why was an invitation to touch necessary? If an object, wouldn't touching it breach that fundamental rule of spectating, which is *not* to touch the exhibits? What is more, what precisely was it that one was being invited to touch? Touching a breast in a museum (even one from a set of 'falsies') raises improbable questions of etiquette. Were visitors required to touch? And if so, how and for how long? Duchamp's tease probably made visitors both blush and think. Specifically, to ponder: What part does the tactile have to play in the experience of artworks? Isn't art supposed to require a certain distance from its audience? What is the relation between the erotic and the aesthetic? The experience of

pornography also involves not touching. Duchamp's catalogue points to what the aesthetic and the pornographic share. Duchamp's 'cover', which is also an 'uncover', exposes pornography's challenge to art, and the opportunities it offers. And there is more. Are we to take the catalogue as an artwork? Museums house (a) art objects (paintings, installations, statues, etc), (b) non-art objects (fire extinguishers, tables, etc) and (c) intermediate objects (catalogues, post-card reproductions, etc). Is Duchamp's catalogue an art object or an intermediate object? It is both (a) and (c) and neither, and therefore eludes each category.

That his work had been appropriated to art was for Duchamp a matter of deep regret. 'When I discovered readymades,' he complained, 'I thought to discourage aesthetics. I threw the bottle-rack and urinal in their faces and now they admire them for their aesthetic beauty.' He devised anti-art interventions that were received as innovative artworks. The interrogative provocation was interpreted as an innovative challenge to its audience's understanding which, after an interval, was then accepted as art by the art world. In a sense, the interrogative artwork will always fail. It will either be accepted as art (in which case it ceases to be interrogative) or it will be disregarded altogether. Attacking art with artworks is an artistic activity that provides audiences with an aesthetic experience. With some relief, they learn to welcome the attack itself as art. It is the breadth of this aesthetic embrace, its near-inescapability, that makes the interrogative art project such a heroic one. The project subverts the distinction between art and non-art, and proposes a fresh category, anti-art, one comprising many unpredictable instances, including ironic prescriptions for art itself. Ad Reinhardt's 1957 art-cancelling art manifesto, *Twelve Rules for a New Academy*, is exemplary of this project. It commands: no texture, no forms, no colours, no space, no time, no object, no subject... So the rules continue, choking off the possibility of art in their prescriptions for art.

There is implicit in all this a kind of aesthetic self-abnegation, a suicide of the work, effected in order to escape both art's promise of permanence and the lure of the market. Such artworks contemplate or invite their own disappearance, either by the active intervention of artist or audience, or by another, more passive process. These are quite distinct from artworks that are realised in performance, within which extended category I include body art. They are artworks that belong to, while repudiating, genres that typically promise permanence. This promise marries the transcendent with the commercial. Art endures, while all else fades, and fails; art appreciates, while all else decreases

in value. The promise is also intended as a defeat of death and an acknowledgment of its sovereignty. It stands over and against human mortality; it is also a monument to the dead. It is a triumph of the human over nature, and a permanent investment. An artwork that refuses this role, and connives in its own end, seeks to defeat this promise, art's most fundamental purpose. It wishes to be transgressive by its self-transgression. And the arguments against the making and unmaking of such a work comprise both the arguments against suicide, and the arguments against iconoclasm.

Gustav Metzger's work is a good example of what one critic has described as this disdain for permanence. On one occasion, he used acid on nylon sheets, fashioning and refashioning the sheets, which took on new shapes as they shrunk in size, the artist creative and destructive at the same time, reducing his materials to a zero while transforming them: making more *and* less of them. In Robert Smithson's *Spiral Jetty* (1970), rock, salt crystals and earth projected out into Great Salt Lake, Utah. They represented a boundary line that the lake would eventually transgress. The work *was* the boundary line. The 'dialectics of site and nonsite whirled into an indeterminate state, where solid and liquid lost themselves in each other,' Smithson wrote. Rather earlier than expected, it was submerged by the lake, the water running over its lines, erasing the boundaries of the artwork. Its transgression was itself the subject of a transgression. It became invisible, traced on water. It passed into nothingness. It marked the point at which the perishability of art and its subversiveness co-

Robert Smithson
Spiral Jetty
1970

exist, not as a paradoxical singularity but as a project: art subverted by its very perishability. Transgressive art discovered here its own limits. In its refusal of a certain art arrogance (art survives while all else perishes; art redeems), in its embracing of the entropic, it is, in the artist's words, 'an artistic disaster, a quiet catastrophe of mind and matter'.

Blanchot's characterisation of literature may be applied to these artworks. Literature, he proposes, is essentially a power of contestation. It contests established power: the forms of literary language, and indeed whatever exists – the very fact of existence. It even contests itself. It constantly works against the limits that it helps to fix, and when these limits, pushed back

indefinitely, finally disappear in the knowledge and happiness of a truly or ideally accomplished totality, then its force of transgression becomes more denunciatory, for it is the unlimited itself, having become the limit, that it denounces. Literature is always vanquished, vanquished by itself, vanquished by its victory. It consumes itself.

There is a transgressive project marked by defeat, one that aims to make artworks that resist commercial embrace, works that cannot be 'commodified', that is, converted into cultural goods to be bought and sold in the market. This battle against the market is commonly regarded as a struggle characteristic of some 20th-century avant-garde artists (but as a corrective, recall Picasso's commercial astuteness, and what has been described as the 'worry-free commercialism' of the YBAs). It is, in one sense, an aspect of the larger interrogative art project, and it is made up of a number of distinct elements. There is a Romantic sense that 'art' and 'money' represent polar values: 'Where any view of Money exists,' declared the poet William Blake, 'Art cannot be carried on, but War only.' In its trivial version, this may be recognised as a familiar anti-bourgeois disdain for trade, or a desire to keep trade distinct from art. (Duchamp, in a letter asking a New York acquaintance to find him a job: 'I am afraid to end up being in need to sell canvases, in other words, to be a society painter.') Most artists resent the demotion of their art to the status of mere commodities, and scorn artists who pursue profit. (Recall Breton's contemptuous anagram for Dalí, 'Avida Dollars', and Dalí's rejoinder, 'Breton: so very much intransigence for such a small transgression!') It diminishes the artwork's spiritual value into mere property value. 'The art market system has been the curse and corruption of the life of art in America and in the world,' complained the sculptor Carl Andre. Allen Kaprow saw the posturing as well as the corruption: 'If the artist was in hell in 1946, now he is in business.' Then there is the realistic conviction that good art will often define itself, initially at least, against economic success. Art thus becomes a game in which the loser wins. This has become a trope of speaking or writing about the artist's career – for example, Walter Gropius, the Bauhaus director, addressing his students: 'a whole group of you will unfortunately soon be forced by necessity to take up jobs to earn money, and the only ones who will remain faithful to art will be those prepared to go hungry for it.' There is also an anxiety to defend art from the market's compromising embrace. When, for example, Miró and Ernst accepted a commission to design the costumes and scenery for a ballet, the

Surrealists staged a violent demonstration in the theatre on the first night, and the following day published this statement, signed by Aragon and Breton: 'It is inadmissible that thought should be at the command of money.' Last, this anxiety may develop into the more activist desire to use art as an engine to subvert the market, and thereby capitalism itself.

Protests flare, and die; the relations between art and money fluctuate in intimacy and regard. (The one constant, remarked Marcel Broodthaers, is the transformation of art into merchandise.) In 1984, the art collective known as Political Art Documentation/Distribution, for example, held a 'Not for Sale' show, exhibiting work that was neither for sale nor marketable. An art that by its nature is unmarketable is the auto-destructive art practised by Gustav Metzger, because it has no commodity status. (Though tickets can be sold to those who wish to witness its staging.) It follows that its antecedents come from outside art: in heretical religions, in alchemy and in witchcraft. Some of the sculptural installations of David Mach, temporary works in public spaces, likewise cannot be sold. They can, however, be commissioned. Rejecting the market usually entails clasping the hand of the state. Conceptual art, as a movement, tried very hard to escape the market. As Lucy Lippard explained, speaking in 1969 on behalf of 'artists who are trying to do non-object art', theirs was 'a drastic solution to the problem of artists being bought and sold so easily, along with their art'. It is an unequal contest. The fate of Picabia's *The Cacodylic Eye* (1921) is exemplary. It was intended as an assault on art-market commercialism. It mocked the fetishising of the signature by dealers and collectors. The image matters less to them, the artist asserts, than the signature, and so I will give them what they want – a crowd of signatures and a negligible image. When it was hung at the Salon d'Automne in Paris, it provoked the inevitable scandal. It is now, however, an immensely valuable painting. Investors in the work would be content to accept the mockery in return for the signatures. Each attempt is doomed to disappoint. Elements in German Dada complained: 'Dada is bourgeois art marketing.'

This has led to art-making of three kinds. First, an aesthetic of the event, as if thereby to elude the market. Works are transmuted from object to performance and thus become marketable as a show (or the record of a show – hence the emergent value of photographs and videos of such works). It is congruent with a certain aesthetic of the impermanent, the works denying investment value to the buyer by extinguishing themselves before they can

appreciate. Second, money itself is made the subject of art, in open acknowl-edgment of art's relation with the market: for example, Warhol's 1982 $ series of pictures. The occult interdependence of art and money – a matter of complex financial transactions, commercial intermediaries, international galleries and banks – is made exoteric, transparent. This is Warhol's trick: to condense this esotery into a series of objects, material and accessible. He makes money into art, neutrally, and thereby turns art into money. 'Business art is the step that comes after Art. I started as a commercial artist,' Warhol said, 'and I want to finish as a business artist. After I did the thing called "art" or whatever it's called, I went into business art. I wanted to be an Art Business-man or a Business Artist.' Third, the making of art gestures, acts of witness to art's degradation by the market. When Joseph Beuys distributed Deutsche Mark notes inscribed with the legend 'Kunst = Kapital', he was not taking a Warholian pleasure in the equation. He was crossing the boundaries of the art world to protest art's commodification. The more elevated one's conception of art, the greater the shame at the spectacle of its immersion in the market. The more radical one's politics, the greater the embarrassment at the mar-ketability of one's artworks. Thus Leon Golub, discomfited at a seminar. Question: 'Do you ever veto any particular buyers of your work?' Answer: 'I have made no attempt to do so.'

The career of J.S.G. Boggs, performance artist, draughtsman and copier of banknotes, draws these three kinds of art-making together. His art is event not object, because it comprises in part an exchange which the artwork then records, or documents. It draws its audience into its staging, spectators becom-ing participants, completing the artwork by their response to Boggs's offer of a banknote drawing as payment for goods or services. Money is the subject of art, because Boggs replicates it, though usually on a scale different from the notes themselves, or with quirky additions that betray his hand. Boggs's works make money by becoming money. He summons cash from paper, the alchemy of his art. It is a series of art gestures, interventions in the regulation of the market, ones intended to provoke disquiet and which risk prosecution (Boggs was acquitted of forgery by the grace of a law-defying London jury). The ges-tures have a benign aspect too. They are an artist's response to the aesthetic properties of the banknote: 'Part of my work is intended to get people to look at such things… money is easily more beautiful and developed and aesthetically satisfying than the print work of all but a few modern artists.'

Breaking Taboos

There is a remark of Goya's that is immensely frustrating to read because it indicates a direction that art might have taken, but did not (certain minor artists excepted). The failure of art to follow this path explains both the projects pursued by much transgressive art and some of its limitations, among which is the making of a politically compromised art – one that is not so much compromised by any accommodation with a given regime or institution (though tacitly there is this too), but by its refusal to adopt anything other than a posture of belligerence towards its audience. The remark that I have in mind was made in the margin of a study for *The Sleep of Reason Produces Monsters* (one of the plates in the series *Los Caprichos*). Goya wrote: 'The author's intention is to banish harmful beliefs commonly held, and with this work of *caprichos* to perpetuate the solid testimony of truth.'

Contemporary transgressive artists and their advocates take Goya as a forebear. His work comprises an especially strong instance in the deployment of the canonic defence. See, for example, Matthew Collings's book *This is Modern Art* (1999). But such a reading of Goya is misconceived. In Goya one finds a commitment to the project of the Enlightenment: the dissolution of old, diffuse and magical ideas, the liberation of men from fear, and the establishing of their sovereignty. We may imagine Goya declaring: where prejudice, folly, wickedness and strife are, there shall instead be reason, wisdom, virtue and peace. Goya's art is mobilised in pursuit of this project, or else is witness to the artist's despair at the prospect of ever realising it. The human asses in the series – doctors, teachers, dishonest artists, the leisured classes – resist instruction. The dead hand of the past throttles the living. (You cannot, remarked Apollinaire, carry around on your back the corpse of your father. Goya had already visualised the burden.) Ancestor worship, that most traditional of pieties, stymies the creative instincts of the present. The 'carnival' aspect of Goya's work, which might appear to be a precursor of the modern transgressive, is instead an Enlightenment disdain for a superstitious populace, a cruel and arbitrary legal system, and a corrupt, persecuting church. Priests are mocked, as in the carnival, but not in the name of a world turned (temporarily) upside down. They are mocked instead as obstacles to the rule of reason, oppressive and ridiculous in equal measure. For transgressive artists, by contrast, 'harmful beliefs commonly held' are the material out of which art is to be made. These artists do not wish to banish, but rather to preserve,

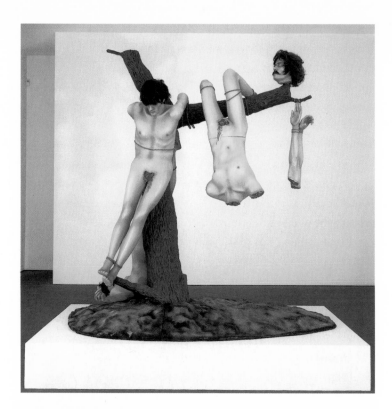

Jake and Dinos
Chapman
**Great Deeds
against the Dead**
1994

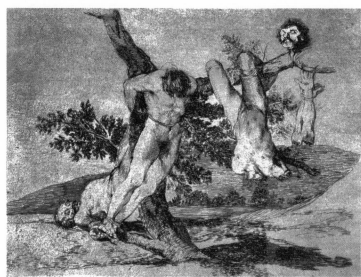

Francisco de Goya
*Grande hazaña
con muertos*
*(Great Deeds!
Against the Dead!)*
1810–12

these beliefs in the medium of their disrespect for them. They welcome the monsters produced by the sleep of reason.

For the transgressive artist, then, the following notice, which announced the publication of *Los Caprichos*, would be impossibly naive in its commitment to public education by mockery:

> The author is convinced that censuring human errors and vices – although it seems the preserve of oratory and poetry – may also be a worthy object of painting. As subjects appropriate to his work, he has selected from the multitudes of stupidities and errors common to every civil society, and from the ordinary obfuscations and lies condoned by custom, ignorance or self-interest, those he has deemed most fit to furnish material for ridicule, and at the same time to exercise the author's imagination.

The transgressive artist takes these stupidities more seriously than Goya, in part because he knows how difficult it is for the artist to stand outside them. They – or many of them – are more than just mistakes, capable of easy correction. They comprise not just the surface misconceptions and follies to which only the most benighted are subject, but also those more generally held beliefs that I described in the last chapter as pieties, but that can also be characterised, more impatiently, as taboos. Against these, confident, enlightened ridicule is ineffectual. The transgressive artist is oppressed by this knowledge, which gives his work a despairing, intemperate edge, and leads him to a nihilism which scorns all values, not for the sake of the good or the true but for its own sake. Goya has two audiences in mind. There is the one to which he appeals, and the one that he attacks. There is little overlap between these two. The transgressive artist, by contrast, refuses the distinction. He has only one audience, and he attacks it. Goya's enterprise had a political aspect: to incite scorn, and thereby to diminish the influence, of Spanish reaction. Ridicule always solicits assent, and intends reform. Neither of these, however, is an ambition of the transgressive artist. His most characteristic work is apolitical; his most characteristic posture is one of undifferentiated belligerence towards his audience.

Jake and Dinos Chapman's *Great Deeds against the Dead* (1994) confronts us with an image of barbaric cruelty. We don't want to look; if we do, it is only by

an effort of abstraction, looking at part, not whole, or emptying the bodily configurations of meaning. We can only contemplate it if we first abstract from it all representational qualities. Formalism becomes the refuge for the dismayed, assaulted eye. The work replicates an etching from Goya's *The Disasters of War* series, *Grande hazaña con muertos (Great Deeds! Against the Dead!)*, which depicts broken, dismembered bodies, arranged on a tree, itself mutilated, as if on display. They once were soldiers – or were they civilians? It is hard to say. This image of the dismembered dead is one of a series of aquatints memorialising the Spanish insurrection against the French puppet king, Joseph Bonaparte, which became the Peninsular War. The title's bitter irony points to the cowardice of the attack and to a certain paradox of war – that attacks on the living are somehow more acceptable than attacks on the dead. One is expected to be a pacifist in relation to the dead.

The shock and dismay *in* the picture is paralleled by the audience's imagined shock and dismay *at* the picture. Look, Goya says, this is what war is like; he strains to express his revulsion, the sombre restraint of the draughtsmanship collapsing in the excitable, outraged double exclamations of the title. And we recoil. This recoil is complicated, of course. It is made up of a number of distinct reactions. There is shock at the sight of bodies in this state, and shock also that the bodies came to this condition because of 'great deeds'. We may thereby be shocked out of our complacent misconceptions about the heroism and chivalry of war. Picturing the dead in this condition is another indignity heaped on them. It is not enough that they should have been mutilated; now, their mutilated bodies are exposed to anonymous scrutiny. They have been deprived of the privacy of the grave by their assailants; they have now become material for art. Goya takes the risk that his work will be judged to violate its subjects, to prey upon the dead, exploiting them in their passivity, their vulnerability. He risks, that is, a certain disrespect for the dead. A moral philosopher would say (indeed, has said): when a man dies we are left with his corpse, and while a corpse can suffer the kind of mishap that may occur to an article of furniture, it is not a suitable object for pity. But in a more generously conceived moral universe, in which piety (or taboo) has its place, what happens to corpses *as corpses* does matter. Here, corpses are not value-equivalents to furniture.

The Goya sketch pictures the violation of this piety; the Chapman picture *is itself just such a violation*. The Chapmans repudiate the bargain that Goya

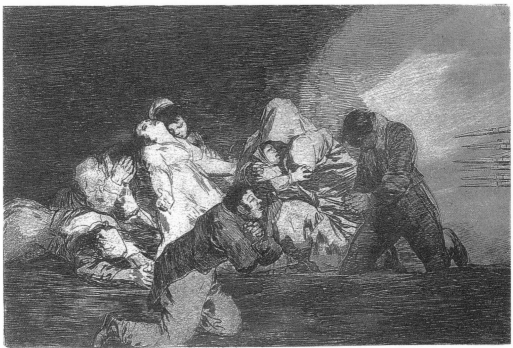

No se puede mirar

strikes with his audience: I will show you something horrible for your moral education. Another engraving, *One Can't Look*, provides the meta-caption to Goya's series (executed between 1810 and 1812, but published posthumously in Madrid in 1863). One can't look – yet one must look. It is impossible, and yet it is necessary. Now consider the Chapmans' version. To look is neither impossible nor necessary. To chance upon it at an exhibition is akin to the experience of an ambush. It is an incident in a war between artist and audience; it is transgressive in the simple sense of an attack. In Goya's work, a private act of cruelty is transformed into a public image that condemns cruelty. In the Chapmans' work, it is merely advertised, and thus becomes a public act of cruelty. It takes the work of a humanist artist and turns it into something deeply unpleasant: a great deed done against the dead Goya.

If art rule-breaking art arises principally out of the artist's adversarial engagement with the art canon, then taboo-breaking art arises out of his adversarial engagement with his audience. While art rule-breaking has the consequence of likewise challenging the audience (can this work be

Francisco de Goya
One Can't Look
1810–12

admitted as art?), taboo-breaking art engages its audiences in non-aesthetic respects, while often conforming in execution to established art-making criteria. As Dalí remarked, his most subversive effects were achieved by using 'all the usual paralysing tricks of eye-fooling, the most discredited academicism'. His *Tuna Fishing (Homage to Meissonier)* (1966–7), which he described as 'the most ambitious picture I have ever painted', acknowledged a debt to the late 19th-century academician, the photographic accuracy and licked surfaces of whose works, and their 'stupid minute descriptiveness' (the art historian and curator Alfred H. Barr's phrase), were the antithesis of the typical modernist artwork. Academicism, then, is put in the service of taboo-breaking transgressiveness, which is itself a provocation (the audience is at greatest peril in this least threatening, most accustomed of art contexts). Taboo-breaking art is an art to which the estrangement defence answers most precisely. Just as the estrangement defence is chief among the defences of transgressive art, so taboo-breaking art is the master among the versions of transgressive art.

What do I mean by 'taboo-breaking'? There are certain values by which we live but which cannot (or not without a stretch) be described as moral principles. These are pieties, and relate to certain aspects of our lives that tend not to be regulated, or not regulated exclusively, by moral rules. They are more than prohibitions, though they are often experienced in negative form. (A totem is a 'yes', a taboo is a 'no', says the artist David Smith, simplifying for the sake of his totemic art – but we do not share his privileges.) I am thinking, for example, of our dealings with children, the deference we show to the elderly, our relations with animal life, our scruples about the dead. I am also thinking about the respect that we customarily show towards established religions, and about sentiments of belonging, or of fidelity, to a community, a region, a nation. They are also connected with a certain sense of the distinctness of categories of persons, things and qualities, and the importance of not muddling them. They are about respect for boundaries, then, and the panic we can experience when they are transgressed or muddled.

As against moral principles, these pieties tend to be more intimately expressive of our identity, they tend to be less amenable to explanation, and they have a relation both to religion and to art, that is to say, to our sense both of the divine and of the aesthetic. They are embedded in custom, they may in some cases be residues of former religious beliefs, they are acquired by a process that has little to do with formal instruction. They are experienced

Salvador Dalí
*Tuna Fishing
(Homage to
Meissonier)*
1966–7

intuitively; they do not cohere; they certainly cannot be systematised. They are a challenge to the universalism of morality: against the injunction that all should be treated alike, they substitute more particularist loyalties. If the test of a genuine moral imperative is that I can universalise it, the test of a genuine piety is that I cannot. These pieties make up the content of much of the ethical life of national or ethnic communities, but they also comprise those inherited prejudices and fears that can lead the members of such communities into acts of viciousness against strangers. They are most precious to us yet least understood by us, and they are composed of the most disparate materials. Taboo-breaking art addresses these pieties. I would prefer to describe this art as 'piety-breaking' but it seems precious to do so, even though 'taboo' is a word used by transgressive art's apologists in the course of dismissing objections to it.

Consider, for example, the familiar experience of dismay when we are presented with the spectacle of unburied corpses, as in, say, Sue Fox's photo-

graphs of dead bodies in a Manchester morgue: for instance, *Untitled (Bitten)* (1996). The artist has received hate mail from visitors to the gallery where the works were exhibited. One critic has attributed this to the fact that the 'photographs confront significant taboos and are being punished for doing so'. Serrano has likewise photographed corpses, in his case (apparently) in breach

of laws intended to protect the dignity of the dead: *The Morgue (Knifed to Death I)* (1992). There may be an aspect of our dismay at such works that responds to the violation of a moral principle. These pictured dead may have been unlawfully killed. It may also be that we have the sense that their privacy has been violated, that they have been wrongly exposed to the scrutiny of strangers. While we may thus find reasons to disapprove of what has been done to them, these reasons

are inadequate in themselves to explain our likely recoil from what we see. There is scarcely any other matter, remarked Freud, upon which our thoughts and feelings have changed so little since the very earliest times, and in which discarded forms have been so completely preserved under a thin disguise, as our relation to death. It is fair to conclude, then, that the horror of dead bodies is caused by something other than, or additional to, a moral consciousness (where 'morality' is understood in the non-sociological sense of a set of universally applicable rules of conduct). What are the springs of this horror?

To answer this question, we need recourse to words not found in morality's vocabulary. We will not speak of rule, obligation, judgment, censure. We will instead speak of disgust, aversion, ugliness, distaste; of taboo, pollution, defilement, dread, abjection; and of scandal, indecency, affront, outrage, desecration. This is not the language of duty, choice and rationality, but of compulsion, instinct, habit, and of intuitions that are opaque to themselves. The answer, then, must draw on the language of disapproval in the vocabularies of art and religion. We will speak, then, about those aspects of our life to do with sentiment, with fear and with instinct, and we will speak of the symbolic violation of everything that to us is customary, settled, expected, safe. These emotions tend not to be aspects of duties to others, though sometimes they are. Some relate to children, some to death and to the dead themselves, some to violence done to the body, some indeed to our very sense of self. Some appear as if from nowhere, and we only become aware of them when they are disturbed – when art disturbs them.

These pieties are often not admirable. A number are positively destructive of ethical positions. Some indeed fall into Goya's category of 'harmful beliefs commonly held'. When they are aggregated into collective terms such as 'public decency' or 'community standards', they can be used as a cudgel to bludgeon heterodoxy, dissent and even simple eccentricity. What is called in the United States 'Comstockery' is related to these terms: suppressing representations of sexuality in the interests of a public not soliciting protection. (A recent instance: former New York mayor Giuliani's April 2001 call for the establishment of a 'decency panel' with powers to veto curatorial decisions by publicly funded museums.) To the extent that they forbid inquiry, they lay obstacles before self-understanding and the understanding of the world. What is more, the very principle of revering sentiments that cannot be articulated encourages an obscurantism that can be oppressive, even pernicious.

Opposite, top
Sue Fox
Untitled (Bitten)
1996

Opposite, bottom
Andres Serrano
The Morgue
(Knifed to Death I)
1992

137

In its pathological form, this appeal to piety over reason is the appeal of a certain kind of Fascism. It can justify sectarian hatreds. It stands against everything that the Enlightenment project represents.

It is my case that there is an aspect of the art of the modern period that explores and challenges just these pieties. In part it is subsidiary to the Enlightenment project, in part it is a challenge to it. It is a creative, unsettling equivocation. It does not dismiss the pieties as illusory. It takes them seriously, as the enemy. (When it does not, and merely seeks to allude to them, the result is either bathos or phoneyness and condescension: the bathos, for example, of Jackson Pollock's early work, with its insistent, celebratory invoking of a generalised mythology, ritual and animal sexuality; the phoneyness and condescension of a certain, persistent kind of 20th-century Western interest in 'primitive' art.) It affirms their continued presence. It acknowledges that we need these pieties, indeed, that we are in some sense even constituted by them. I will elaborate on this below, and suggest some reasons for the issuing of this challenge, but first some examples drawn from recent transgressive art, baroque in their final drawing-out of the implications of the transgressive aesthetic.

Serrano's *Milk, Blood* (1986) prompts the kind of disquiet that, while lacking any obvious explanation, derives from a combination of contradictory

Andres Serrano
Milk, Blood
1986

intimations. Blood both threatens and gives life. Scripture prohibits contact
with blood; the Mass celebrates its consumption. There is an allusion to the
contemporary AIDS-related panic about exposed blood. The work encourages
an even more diffuse worry. Why is the blood there? How has it been removed?
To whom does – did – it belong? The blood alone, then, would be disquieting.
Its contiguity with the milk provokes a further set of anxieties. Milk and blood
are bodily fluids with complexly overlapping and contrasting cultural conno-
tations. They are similar: milk nurtures, blood animates. They are different: we
ingest milk, we celebrate its flow, we obtain it with a caress; we may *not* ingest
blood (save symbolically, or else to save our lives), we fear its flow, we obtain it
painfully, invasively. This pairing of substances that are both like each other
and antithetical to each other gives the work a quality of the surreal. It will
trouble Jews by its mixing of antithetical categories, in violation of the laws of
kashrut, and it will trouble Christians because their religion is supposed to
have rejected such rules, and yet here they are, instantiated in their very viola-
tion. That the work is a photograph, furthermore, brings its own troubles. We
know that what we see is real, but we are also struck by the abstract quality of
its arrangement by the artist, which invites us to disregard our misgivings and
contemplate the work's purely formal qualities. (And we cannot.) There is a

Helen Chadwick
Loop my Loop
1991

tension between presentation and form, and not as
in painting between representation and form, which
is a lesser thing. We cannot say that the artist has done
anything wrong by staging this image, but (and also,
therefore) it unsettles us.

Helen Chadwick's *Loop my Loop* (1991) is another
unsettling work. Here, a lock of hair is looped around
a sow's intestine. The artist has brought together, in
contempt of the boundaries that keep them apart,
what should remain internal and what is intended to
decorate a surface, what is human and what is animal,
what exists to be seen and what should not be seen.
Chadwick has not so much staged the fortuitous
encounter on a dissecting table of a sewing machine
and an umbrella as the deliberate, violent bonding
of opposites, an ornament and an organ. It is both
pretty and hideous, and hideous because pretty.

The pinkness of the tones, the similarly looped nature of the ribbon and the intestine, and the intimacy of their association in the work itself force a sense of their affinity – their elective affinity, one might say – that is contrary to our sense of propriety.

It was intended that the installation of the Chinese artist Huang Yong Ping, *Le Théâtre du monde*, would comprise a terrarium in which assorted insects were to be allowed to roam freely. It was planned for an exhibition, 'Hors limites', at the Centre Pompidou in November 1994. The artist would stage for his audience encounters that would otherwise be both random and hidden from our view. But it was objected that the artwork would be cruel to the insects. Not because the terrarium itself was inhospitable, nor because they would be deprived of the means to sustain themselves. In addition to water, they would have each other – or more precisely, some of them would have the others. The cruelty was to those species that had been put at risk by having to share an environment with their natural predators. (Animals are not safe in the art world; from time to time, they are exposed to harm in the interests of art.) A scandal ensued, and there was even some litigation. A compromise was reached: in place of the insects themselves, there was a note explaining the artist's conception, together with various documents that the controversy had generated. The director of the Centre Pompidou complained: 'It's terrible. The object of the exhibition is precisely the transgression of taboos' (that is, the transgression of non-moral prohibitions).

The artist Orlan submits her body to cosmetic surgery, not to beautify herself but for the sake of the unbeauty of contemporary art. She makes of herself both artist and model – artist, because model. She has taken the logic of the genre, the artist's self-portrait, and the logic of the counter-genre, appropriation art, each to its respective transgressive terminus. She is a body artist *and* a conceptual artist. Her cerebral art is inscribed in the flesh. *Orlan* is to comprise a miscellany of canonic quotations. Her mouth will be the mouth of Boucher's Europa, her forehead, the forehead of Leonardo's Mona Lisa, her chin, the chin of Botticelli's Venus, and her eyes, the eyes of Gérôme's Psyche. This is an art that repels and provokes. While the surgeon cuts, the artist speaks, and both the operation and her commentary are recorded on video. It is her 'transgressive witness' (a sceptical critic's phrase). She violates the boundaries of her body; she erases the line between artist and subject, and between artist and artist's materials; she invades the privacy of the operating

theatre; she makes a spectacle of her pain, and invokes rituals of sacramental suffering dimly recalled. Meanwhile, the bloodletting pieces of fellow performance artist Franko B are undertaken only once every four months or so, to ensure full recovery. Of his work, he explains, 'my body is a site for representation', and 'I use my body as a canvas to make images'. His self-assaults are also assaults on his audience, who thus flinch twice, once at his masochism, and then again at his sadism. 'I am trying,' he says, 'to make the unbearable bearable.' He parodies martyrdom, in which the injuries are suffered for the sake of faith, and his work has an oblique, critical relation to Christian iconography. The extremism of the martyr is chastening, daunting. It is this extremism, shorn of redemptive context, that characterises so much 'ordeal art'. 'I try to suffer as Christ did,' Orlan says. This is not a carnival art, one that celebrates the 'grotesque body', the body unconfined by culture; it is an *anti*-carnival art, one that exposes the natural body to additional torments in the name of culture.

Sally Mann's *Virginia at 6* (1991) is a difficult, problematic work, one of a kind that comprises 'at once the most common, the most sacred and the most controversial' representations of our time (to quote from an account of modern images of children). It is a photograph of the artist's daughter, artfully posed, as if in imitation of a mermaid, hair decoratively plastered, hands ready for diving, cropped legs hinting at a tail. The exploitation of children is, of course, an uncomplicated moral wrong. (One critic has fancifully pitied Mann's 'helpless art-abused children'.) The exposure of their most intimate parts to unsought scrutiny is an abuse of the trust that they repose in the maker of the pictures. The manufacturing of images for consumption by paedophiles feeds an abusive practice that puts children themselves in jeopardy. Making images that can be abused for that end is the moral 'problem' raised by Sally Mann's work. The scrutiny of childhood sexuality, the troubling of cultural distinctions between infancy and maturity, innocence and experience, the deflating or reformulating of the cult of the child, the narrowing of the gap between the ignorance of the child and the perversity of the adult – this too is what certain kinds of child photography do. To this extent, the problem that such work poses is not moral, though it may be 'taboo' (in the modern, received sense). The complex, tangled distinctions that we make between systems of morality and taboo, hinted at but not resolved in references (as above) to the 'sacred', are made apparent to us in works of this kind. They do this by exposing those obscure depths of feeling we experience, but

Damien Hirst
*Mother and Child,
Divided*
1993

Laocoön
2nd century BCE/
1st century CE

are unable adequately to explain, when contemplating childhood. One of the sentiments that we acquire as we leave childhood is a belief in the innocence of the child. It is our backward glance at our own lives. It is also the child's alibi, and the artworks that expose it as a fiction are the object of especial resentment and hostility. One might say: the artist uses his own special freedom from responsibility to undermine the child's parallel claim to that freedom. The aesthetic alibi trumps the child's alibi.

The animals in Damien Hirst's *Mother and Child, Divided* (1993) are divided twice over. Separated from each other *and* themselves, they have been both disengaged *and* bisected, though the distances are not equal. One can walk between the mother and child, but not their divided halves, which could be taken to mean that separation from one's child is almost, but not quite, as unendurable as being torn in two oneself. This sentimentality, invited by the title (not cow and calf, but mother and child), coexists with the display of indifference effected by the installation itself. To exhibit dead animals so ignominiously, suspended in a formaldehyde solution, each in the presence of the other – reminiscent of Laocoön and his sons, each a

witness to the death agonies of the others – suggests a certain heartlessness. This tension between the pathos of the title and the insouciant arrangement of the containers intimates the meta-title: *Artwork and Title, Divided*. The title alone informs the work's audience that it is in the presence of parent and child. While it thereby relates the work to High Renaissance images of Madonna and Holy Infant, it does so parodically. The work substitutes the bestial for the divine, division for unity, pitilessness for reverence.

There is a mixing of the human and the animal in Jane Alexander's art that is both perplexing and disturbing. It does not allow for contemplation, because it simultaneously engages and frustrates the viewer in an unresolvable categorising exercise: into which category, human or animal, should the

Below left
Jane Alexander
Butcher Boys
1985–6

Below right
Jane Alexander
Bom Boys
1998

Bottom
Thomas Grünfeld
Misfit (Cow)
1997

presented images placed? They are neither ducks nor rabbits, nor are they duck-rabbits. It is our *inability* to alternate between coexistent representations that comprises the challenge of these artworks. The hybridity of the figures in *Bom Boys* (1998) and *Butcher Boys* (1985–6) is freakish, unsettling. They comprise, to borrow Rosalind Krauss's phrase, 'a transgressive thought of the human'. They also disclose modern transgressive art's debt to Surrealism (consider André Breton's impossible observation, 'The birds have never sung better than in this aquarium'), and its ambition to exceed Surrealism's own transgressive imaginings. That most fundamental of hierarchies, which places the human above the merely animal, is subverted. These are not liberating images, and their makers are not to be mistaken for animal rights activists. They do not wish to

break down, in the interests of animals, what one such activist has described as the 'thick and impenetrable legal wall [that] has separated all human from all nonhuman animals'. They merely undermine that wall, here and there, for the sake of the dismay that it causes to those on its privileged side. These works are not instances of that benevolent postmodern celebration of 'impurity, intermingling, the transformation that comes of new and unexpected combinations of human beings, cultures, ideas' (Salman Rushdie, on *The Satanic Verses*). On the contrary. They are counter-Enlightenment taunts. They present the monsters, the taxidermic abberations, that a humanity unconstrained by moral scruple, basest when least confined, will produce: see Thomas Grünfeld's *Misfit (Cow)* (1997). They crow: our reason has brought us down – John Isaacs, *Say It Isn't So* (1994). They are bleak: Arsen Savadov and Georgy Senchenko's *Bloody Mary* (1998). But they are also sometimes farcical: Paul McCarthy, *Spaghetti Man* (1993). These man-beasts, minatory or comic, deny the divinity of the human form that is the premise of Western art.

What do all these works have in common? They (a) disturb the tacit relations between taboos, legal rules and moral principles; (b) address pain, death and dismemberment from a detached, speculative perspective; (c) bring together elements that should remain apart, in their hybridity refusing what might be termed the ordinary integrity of things; (d) are recent works, instances of what is perceived to be a new genre, 'shock art' (or cognate to that genre). Let me take these common features one by one.

The works operate at the point at which taboo or piety appears to diverge from morality: the suffering body, animals, insects, blood and milk, that is, what lives alongside us, what sustains us. Our relations with the body, with these creatures, with these substances, are influenced by sentiments of reverence and repulsion that are not assimilable to principles of morality or law. Indeed, these artworks disturb and oppress us in part because they deny us the means by which we might frame our objections in purely moral or legal terms. Can we say, for example, that Hirst and Ping have wronged the creatures they enlisted for their art? These works catch us in a bind. It may well be, as the philosopher Leszek Kolakowski has proposed, that religion is not a collection of statements about God, Providence, heaven and hell, nor is morality a codified set of normative utterances, but, instead, together they represent a lived allegiance to an order of taboos. But against this, there are compelling cultural pressures that take us in quite another direction. The liberal distinction between law and morality, the Christian distinction between ritual and faith, the philosophical distinction between the brutish and the reflective, when taken together, make us ashamed of our taboos, unless we can incorporate them in philosophy, religion, law, morality. And we cannot, or not without struggle, and then only partially.

Taboo-breaking artworks compel us to engage in just this struggle. Opponents of Ping's installation maintained that it breached sections of the penal code relating to the treatment of animals, and that it was analogous to a cockfight, pitting animals against each other for human gratification. It failed to respect the dignity of the animals, suitors for our moral concern, but instead treated them instrumentally, as mere things. It failed to respect human dignity, because it debased its spectators. The spectacle was degrading. It appealed to instincts that should be suppressed: a certain delight in the spectacle of death, a certain pleasure in witnessing displays of violence. That is to say, the objections were cast in entirely moral and legal terms. Supporters

Opposite, top
John Isaacs
Say It Isn't So
1994

Opposite, bottom left
Arsen Savadov and
Georgy Senchenko
Bloody Mary
1998

Opposite, bottom right
Paul McCarthy
Spaghetti Man
1993

responded: the installation offered an example of coexistence, its limits and its possibilities. It encouraged reflection on the nature of human communal life. Are we like insects? Can we do better than them? So far from indulging low emotions, it stimulated elevated reflections. There was also a brief, inadequate gesture in the direction of the canonic defence: a list of other artworks involving animals was produced.

Each side thus fought for the moral edge, disregarding the work's engagement with other fears, other beliefs, relating, for example, to our place in the natural world, our dealings with other species, our sense of the balance of nature, and of what we risk if it is disturbed. They thereby exposed a certain thinness in given moral positions, so neglectful of just those fears and beliefs. It is just this thinness to which artists and writers since the mid-19th century have been sensitive. In a poem in his great cycle *Illuminations* (1886), Rimbaud supposes himself to be a citizen of a modern metropolis that has expunged all hint of its citizens' religious past. Here, he comments, you do not find even the trace of a monument to superstition. In short, he adds, morality and language are reduced to their simplest expression ('La morale et la langue sont réduites à leur plus simple expression, enfin'). We may say: since the mid-19th century, one of art's projects has been to retrieve that lost complexity of both morality and language, and it is within this general undertaking that transgressive art is to be located, transacting its own subversive enterprises.

These works are concerned with pain, with suffering: the artist's own pain, the pain to be imputed to the animals and insects. In consequence of the Chadwick and Ping works, lives were brought (or would have been brought) to an end. Violating bodies or picturing their violation puts our sense of own bodily integrity into momentary jeopardy. Certain kinds of performance art in particular, in which the artist suffers (or appears to suffer) self-inflicted injuries, do not merely make us wince, they also make us feel under threat, in consequence of that reflex of sympathetic identification that binds audience to artist. The works thus raise this question: what is our relation to pain, to suffering, as a spectacle? Recall Nietzsche's sermons: without cruelty there is no festival; cruelty is one of the oldest festive joys of mankind. In the context of ritual, symbolic significance is attributed to blood, pain and death, to the taking of animal life and to the scourging of self. But no ritual is enacted in these works. On the contrary. When we encounter them, it is as if we have stumbled across fragments or echoes of some unidentifiable ritual that is no

longer available to us (assuming, that is, that it ever existed). Art begins in ritual, and then it begins once again when the very possibility of ritual has died. This second beginning is perhaps the inauguration of the modern period. The philosopher Cynthia Freeland has examined this bogus but potent appeal to a notion of ritual (not to ritual itself) in contemporary art. It communicates to its audience an experience of pure loss. Against the community of purpose and belief of participants in a ritual should be placed the perplexed passivity of spectators at an art gallery. Participants in rituals realise themselves in their gestures and words; spectators in galleries retreat into themselves, silenced by what confronts them. When the Vienna Actionist Hermann Nitsch asserts, 'I take upon myself all that appears negative, unsavoury, perverse and obscene, the lust and the resulting sacrificial hysteria, in order to spare YOU the defilement and shame entailed by the descent into the extreme', we can only respond, No, you do not.

Taboo-breaking transgressive art mixes things up, creating falsely distinct categories from divided wholes, bringing into proximity or conjoining distinct, alien entities or objects, imagining impossible forms of existence, jumbling everything that should remain distinct, separate, apart. By its creative disordering, it compels us to confront both our desire for a certain tacit 'orderedness' and our inability to endure category confusion, hybridities that threaten our understanding of the world. Jews, responding to an imperative that is not specific to their own faith, mark the moment at which the Sabbath passes into the first of the weekdays by praising God for making distinctions, *inter alia*, between the sacred and the profane, and between darkness and light. If we are to praise the transgressive artist, however, it is for subverting such distinctions by gestures of interpenetration. We desire to keep distinct the classes of creation; these artists do not let us. Their works thereby puncture the complacencies we may entertain about our rationality, which surely can dispense with such desires, and about our self-awareness, which surely is equal to analysing those desires? (Yet it cannot, it is not.) Jane Alexander's work, for example, might have come into existence for the express purpose of mocking the following observation of Mary Douglas's: 'Now that we have recognised and assimilated our common descent with apes nothing can happen in the field of animal taxonomy to rouse our concern.' She makes this claim in *Purity and Danger* (1966), an anthropological study of pollution and taboo remarkable for its lack of interest in art, and in art's predatory relation with what is forbidden.

And last, they are all recently executed works. They are among an open series that continues to attract newspaper headlines such as 'Alarm at Modern Art's Atrocity Exhibition' (*Guardian*, 27 January 2001). They are customarily taken to represent a trend in contemporary art. They are united by a common aesthetic, the transgressive. More precisely, they are all works representative of its 'baroque' period, in the sense defined by Borges in the Preface to the 1954 edition of *A Universal History of Iniquity*. They are works, that is, that deliberately exhaust, or try to exhaust, the possibilities of the transgressive aesthetic. They border on self-caricature, as if specifically made in order to answer the question: what is a transgressive artwork? They defeat all attempts at parody. They are in fact at the final stage in the realisation of the transgressive aesthetic, when its resources are flaunted and squandered. They are intellectual, and therefore (to follow Borges) inherently humorous. They recapitulate the inaugural moments of the transgressive aesthetic, born out of the great cultural collisions of the mid-19th century. One of those collisions took place between two stories that were being told, two genealogies that were being constructed, about the nature and origin of morality. Of the transgressive aesthetic's many points of origin, this is one of the lesser known, and the more important.

There was, first, the story of our emancipation from a magical, non-ethical superstition, from taboo, irrational fear and tribal loyalties, and our development towards the enlightened, self-aware rationality of a universal morality. And then, second, there was a story of the unmasking of just that morality as mere superstition, tradition, custom, etc. Morality thus was both realised ideal, and sham. The stories were told across roughly the same period, although the first story had its roots in the 18th century and therefore began somewhat earlier than the second, which was essentially of the late 19th century. I associate the first story with the anthropologist J.G. Frazer, and the second with his near-contemporary Friedrich Nietzsche. In these rival genealogies, morality is first placed above custom, convention, piety, and is then dethroned, which in turn leads to a restatement, a return, of custom, convention and piety. This 'return' takes a number of different forms, among them: (a) the emergence of classical sociology, which restates morality in communal terms; (b) transgressive art, which preys upon just that restatement; (c) various, mainly noxious, political ideologies that privilege membership of, and loyalty to, particular entities (usually the nation) above membership of, and loyalty to, humanity itself.

This is the first story. 'Taboo' arrived in the language as a gift from Captain Cook, come home from the South Sea Islands. It is an interdiction, to be contrasted with 'noa', the unspecific, the free, the common. It puzzlingly embraces both the sacred and the unclean. There was something senseless and funny to Cook about the islanders' food prohibitions, especially given their lack of inhibition in dress. Towards the end of the 19th century, historians of religion took up the notion when explaining pre-Christian religions; anthropologists, when explaining 'savage' or 'primitive' societies; historians of ethics, when explaining the emergence of a morality liberated from laws of purity. W. Robertson Smith, in *The Religion of the Semites* (1894), though distinguishing between taboos relating to the holy and the polluted or unclean, regarded them all as mere superstition. They were legalistic prohibitions mostly without spiritual value. Avoiding contact with blood or dead bodies was pure primitivism, to be set against the lofty Hebraic ideals inherited and developed by Judaism's successor religion, Christianity. As Judaism gave way to Christianity, so taboo gave way to morality and law. 'Even in advanced societies the moral sentiments... derive much of their force from an original system of taboo. Thus on the taboo were grafted the golden fruits of law and morality, while the parent stem dwindled slowly into the sour crabs and empty husks of popular superstition on which the swine of modern society are still content to feed.' So wrote J.G. Frazer, in his *Encyclopaedia Britannica* (1875) entry on 'Taboo'. Henry Sidgwick's *History of Ethics* (1886) traced the emergence of a distinctive Christian ethics as the consequence of the 'moralising' of 'a ceremonial aversion to foulness or impurity', that is, the system of taboo. 'When Christianity threw off the Mosaic ritual,' Sidgwick wrote, 'this religious sense of purity was left with no other sphere besides morality.'

Taboos comprise precisely those practices and beliefs that cannot be defended. If they *were* defensible, they would be something else: laws, or principles of morality, or good manners. To describe a modern belief as a taboo is thus to condemn it. Taboos are both prior to, and residues exceeding, morality and/or law. They have done their work; that they are still among us is an embarrassment. 'Taboo' now has four related meanings: (a) injunctions of silence and invisibility regarding disagreeable practices or subjects, in the sense that talking about or displaying a practice, or acknowledging its 'proper' name, might be said to break a 'taboo' (examples: the artist David Wojnarowicz arguing that 'describing the once indescribable can dismantle the power of

taboo'; a Tunisian filmmaker explaining that 'we were simply doing our job, speaking out on forbidden subjects, breaking taboos'; a defender of Mapplethorpe praising him for 'making minority sexual subcultures visible'); (b) an injunction against physical contact with certain classes of person or thing (for example, with AIDS patients); (c) a restraint or prohibition without defensible content, the justification for which can no longer even be remembered ('I have not intervened in order that Nazi art be shown, but in order that art from the years 1933 to 1945... not be saddled with a general taboo'); (d) a comic prejudice, as in 'the mention of her neighbours is evidently taboo, since... she is in a state of affront with nine-tenths of them' (an *OED* reference, dated 1826, on a 'touchy lady'). The taboo thus invites mockery. It has lost its quality of sacredness. It may indeed be the consequence of an entirely personal foible. It lives in a certain unreflective sentimentality. We will eat lamb, but we don't care to see it dismembered. If compelled to, we may acknowledge that one day we will die, but we don't care to be confronted with evidence of our mortality. And so on.

Adhering to a taboo is at best a mental habit, at worst a socially coerced restriction without moral justification. Taboos are not worth obeying; on certain occasions, their violation may be a duty. Taboos are broken in the name of the humanist affirmation, nothing that is human is alien. So the UN General Secretary to the pop star Bono: 'As an artist, activist, and advocate for the poor, you have made a real difference, crossed boundaries, and broken taboos.' The taboo-violator invites the notionally misfitted, the 'other', into human society. Men who are fearful of their own impulses will always seek to restrict the freedom of others with what Walter Lippmann in the once influential *A Preface to Politics* (1914) called 'the method of the taboo', 'the merely negative law, the emptiest of all the impositions from on top'. So to violate the taboo is to strike a blow for political freedom, too. There is thus a quality of light about the breaking of a taboo: something that was dark or shadowed is illuminated. No subject, no practice, no truth, should either be concealed or regarded as off-bounds. Taboo-breaking becomes both a valuable form of truth-telling and a means of including the hitherto excluded. The taboo then is trivial, or it is pernicious, or it is trivially pernicious. It protects something that does not merit protection; or it assists in the concealing of something either important or unimportant. Voltaire argued this case most succinctly: 'there is no morality in superstition, it is not in ceremonies, it has

nothing in common with dogmas. All dogmas are different, whereas morality is the same among all men who use their reason. Therefore morality comes from godlike light. Our superstitions are nothing but darkness.' Taboos, superstitions, at best comprise merely the prehistory of morality, and continue to exist as residues of primitive beliefs.

But what if there is nothing but taboo? What if Frazer was wrong, and there is no ascent from superstition to reason, from taboo to morality, but rather a descent into more and more convolutedly self-deceiving superstitions? Alternatively, what if – a lesser objection – our rationality is only insecurely grounded, and we are at risk of a return to taboo at any time, under the slightest pressure? This too was the subject of some speculation at about the same time, and then a little later. An emergent scepticism about the rational basis of morality accompanied a scepticism about the moral status of taboos or pieties. This is the second story, and it has two aspects, a philosophical one, and a political one. The intellectual, philosophical one is told through a consideration of Nietzsche's project, the unmasking of morality. The political, institutional one is told through a consideration of World War I and its immediate aftermath, which also made a contribution towards the discrediting of the institutions of morality.

Nietzsche wrote in his autobiography, *Ecce Homo* (1888), of his 'campaign against morality'. Morality was a 'prejudice'. He predicted that in the future his name would be associated with 'a crisis like no other before on earth, of the profoundest collision of conscience', in which 'everything that until then had been believed in, demanded, sanctified' was put in question. 'I am not a man,' Nietzsche declared, 'I am dynamite.' He distinguishes between two kinds of deniers of morality. The first merely denies the existence of those moral motives that men claim as the inspiration for their actions, which makes such a claim self-deceiving. The second denies that moral judgments are based on truths. They may well genuinely inspire men, but they are errors nonetheless. This was Nietzsche's position, which he elaborates in *Daybreak* (1881), subtitled *Thoughts on the Prejudices of Morality*: 'I deny morality as I deny alchemy.' Nietzsche described himself as a 'subterranean man', excavating, and thereby undermining, morality's foundations. His 'chief proposition': 'morality is nothing other (therefore *no more!*) than obedience to customs, of whatever kind they may be; customs, however, are the *traditional* way of behaving and evaluating. In things in which no tradition commands, there is no morality.'

The philosophical thinker who is the critic of all customs becomes thereby the antithesis of the moral man. To be moral is to act in accordance with custom, to practise obedience towards a law or tradition established from of old, said Nietzsche in *Human, All Too Human* (1886). He is good who does what is customary as if by nature, as a result of a long inheritance.

There are several aspects of the experience of World War I relevant to this critique. I can do no more than offer a list; to do anything else, to purport to offer an analysis, one supported by evidence (as it would have to be), would take me beyond the limits of this book. (a) There was a disintegrating of universal, non-national imperatives: general obligations shrank to particularist loyalties, and ultimately (on the front line) to the ethics of fidelity to the platoon. (b) New universalities took their place: the obligations to kill and to hate replaced ethical rules, and murder became routine and collective. (c) The state, the church, the army, institutional structures in general were discredited, perceived as incompetent and phoney: the 'bottom was knocked out of everything' as a result of the war, says a character in an Aldous Huxley novel. (d) A new knowledge of the unbounded and destructive nature of human capacities was acquired, together with an acute consciousness of frontiers as places of violation, terror and contestation.

The art that is most closely connected with the first story, and given programmatic expression by Goya, is best represented in our own time by certain versions of Feminist art, by art-responses to AIDS, and by those artworks that are intended by their makers as determinate interventions in political events or controversies. This kind of art attacks 'taboos' in the name of reason and public education, and also of compassion, or of moral outrage. On occasion, it can be rather preachy. The art critic Lucy Lippard has written extensively about such art. She describes it as engaged in 'the ongoing battle against stereotypes', as being 'didactic in the best sense', and (of certain kinds of body art) as 'not so much masochistic as it is concerned with exorcism, with dispelling taboos, exposing and thereby defusing the painful aspects of women's history'. She describes some contemporary, politically engaged artists as 'challenging the taboos against subject-matter considered unsuitable for art – such as unemployment, work and domesticity, budget cut-backs or militarism'. One such artist is David Wojnarowicz, whose work protests the oppressions of gays, communicating an experience of homosexuality that is a means of self-expression and enlarges the understanding of heterosexuals. It is inclusive

and aspirational, the artist adding his voice to the existing community of voices, trusting that it will be accepted, intending that it will benefit us all. This art therefore tends, notwithstanding its often brutal, dark visual language, towards a certain sentimentality. It urges us to be the best that we can be; its object is 'not to shock but to empower' (says one advocate). It wants us to complete precisely that journey mapped by Frazer from local taboos to a universal morality, indifferent to all particularities.

The art most closely connected with the second story is the anti-art of Dada. It staged a series of anti-art gestures intended to expose modernity's moral, cultural bankruptcy. It adopted what has been described as a 'principle of disrule'. Dadaism declared: the concept of humanity has been destroyed; rioting individual pathologies have taken its place; neither art, nor politics, nor religious faith is adequate to dam this torrent; there remains only the *blague*; belief in the progress of law and morality is illusory; 'everyone dances to his own personal boomboom'. European culture is a sham. It is sustained by hypocrisy. And Dada's ambition? A systematic work of destruction and demoralisation; unlimited revolt; a direct attack on the staid morality and sentiments of the public; an assault on everything held to be sacred; the rubbishing of aesthetic standards. We destroyed, we insulted, we despised and we laughed, said the Dadaist Hans Richter. We claimed the freedom not to care a damn about anything. Dada emerged not out of art, but out of a sense of disgust with 'catalogued categories', and with politicians, philosophers and priests. As Dada marches, it continuously destroys. (I am summarising from Dadaist manifestos and memoirs.) 'Dada is without discipline or morality and we spit on humanity,' declared Tristan Tzara. Something of Dada's perspective survived in the French *Documents* group of the 1930s, led by Bataille. In the *Critical Dictionary*, published as part of the group's journal, 'civilisation' is glossed as a crust of 'moral habits and polite customs' that cover 'the coarseness of our dangerous instincts'. It is at risk of breaking at the slightest impact, revealing our 'horrifying savageness'.

Taboo-breaking art exploits the tension between these two stories. It does this by refusing to distinguish between morality and convention; by restating and subverting the potency of taboo; by mocking our more general pretensions to rationality from which our morality purports to be derived. It exposes our attachment to sentiments that, though they share certain characteristics with morality, are not moral. It exposes, that is, our tendency to moralise.

Though it compels us to reflect on beliefs and then reaffirm or repudiate them, it is not remotely 'progressive'. It does not assume, as did Goya and his successors, that our pieties can be overcome; it does not dismiss those pieties, as did Dada, as mere illusion and hypocrisy. It is a protest against that tendency, 'under the pretence of civilisation and progress', to exclude everything 'that might be termed superstition' (Breton, in the 1924 *Surrealist Manifesto*). Taboo-breaking art can also intimidate us with its nihilism when it values at zero what we justifiably esteem. It can violate our sensibilities. It can force us into the presence of the ugly, the bestial, the vicious, the menacing. These are all kinds of cruelty. Artworks can celebrate cruelty; they can themselves practise cruelty. Taboo-breaking art thrives in the moment when 'taboos' are sufficiently visible for them to present themselves to a certain artistic consciousness as subjects for aesthetic assault. According to Stendhal, art follows civilisation and springs from its customs, even the most baroque and ridiculous among them. This view, which is common enough, does not quite allow for transgressive art. It has a critical, dissenting relation with these customs. It does not reflect them, it engages with them, subversively.

Taboo-breaking art is not philosophy. Philosophy attacks taboos by investigating them; art attacks taboos by breaching them (or enacting their breach). Philosophy wants to let the fly out of the bottle; art wants to keep it there, but to madden it. Philosophy pursues the truth; art delights in subverting fictions. Sometimes they are allies; often they are not. (Socrates would not have admired the Surrealists, even though both scorned the dominion of common sense.) Philosophy and art provoke people in quite different ways. Though both may be discomfiting, only philosophy can amount to a 'persistent invitation to the overturning of habitual evaluations and valued habits' (Nietzsche's claim for his own work). Philosophy, for the purposes of this exposition, is the project of the Enlightenment: to make rational men out of men capable of rationality. Andreas Riem's *On Enlightenment* (1788) defines this project by reference to what it opposed: superstition. Superstition is mere prejudice; prejudice is but a shameful synonym for falsehood. It is thanks to our enlightenment that we can calmly listen to the thunder roll. The European who persists out of dumb obstinacy in his prejudices locks up the powers of his spirit within himself just as much as any wild and uncultured man. Christianity has nothing to fear from enlightenment. Indeed, it carries on Christ's work against the Jews, and Luther's against the Catholic Church. It was the

miserable Pharisees who cried 'Crucify! Crucify' against the wise enlightener. 'Taboo' encapsulates everything Riem rejects. And the paradox: piety towards our forebears requires us to continue the struggle against the pieties. 'One of our forefathers must have read a forbidden book,' teased G.C. Lichtenberg.

Art, by contrast, has a more ambivalent relation with the Enlightenment. (Recall Picasso's admonition of Braque on the subject of *art nègre*. You will never understand it, Picasso said, because you are not superstitious.) It conserves discredited ideas, and inherited practices and beliefs, if only to play with them. Artists can thus never be in the foremost ranks of the Enlightenment, said Nietzsche. Of Manet's *The Bullfight* (1864), Thoré commented, 'his painting is a kind of challenge, and he apparently wants to exasperate the public like the picadors in his Spanish bullfight jabbing arrows with multicoloured ribbons

into the neck of a savage adversary.' The bullfighter, Thoré noted, was 'another victim of ferocious customs.' This is to cast Manet in the role of an Enlightenment polemicist, antagonistic to the Spain of Voltaire's scornful account (benighted, superstitious, Inquisition-oppressed, clergy-ridden, enjoying 'the peace of galley slaves, who row uniformly and in silence'). But this characterisation is misconceived. Manet's art – transgressive art in general – takes a different route. These 'savage customs' comprise Manet's material, not his enemy. He does not wish to extirpate infamy, he seeks instead to paint it. It suffers, of course, by its representation, and we suffer more. The transgressive artist engages with taboos in the conviction of their permanence.

Edouard Manet
The Bullfight
1864

Once again, there is a certain parallel with the themes of classical sociology. The French Enlightenment intellectual Paul d'Holbach declared: 'let men's minds be filled with true ideas; let their reason be cultivated; let justice govern them; and there will be no need of opposing to the passions such a feeble barrier as the fear of the gods.' Against this, both classical sociology (Durkheim, Weber, Simmel) and transgressive art 'fear' the gods. They respect their potency, the continued power they exercise over the modern mind, and our inability to weaken that hold by mere reason (we cannot think ourselves out of our own irrationality). They derive from the 'ambience of regard' for religion (the sociologist Robert Nisbet's phrase) that was characteristic of the period. Compare, for example, Rimbaud's city in which 'morality and language are reduced to their simplest expression' with Durkheim's proposition that, in the absence of religious sentiment, we are left 'with an impoverished and colourless morality'. It is the same critique, but with radically different consequences.

What sociology struggles to understand in its obduracy and complexity, transgressive art takes as its target. Not, however, for our enlightenment, but rather for our mortification. Transgressive artworks consist of individual representations that are dependent upon, but subversive of, those collective representations ('myths, popular legends, religious conceptions of all sorts, moral beliefs, etc' – Durkheim) that make up our understanding of our world. If religion is an affirmation of the first-person plural, then transgressive art is the counter-affirmation of a dissenting first-person singular. This is Surrealism and the art that continues to be made in its wake. Durkheim described our moral character by reference to the habits we have contracted, those prejudices and tendencies that motivate us and for which we cannot completely account to ourselves, all of which are residues of a collective past to which we are involuntary heirs. These possess a quality of the sacred, he concluded. Against this, Surrealism is, in its essence, an affront to all pieties. Breton said, 'the words family, fatherland, society, for instance, seem to us now to be so many macabre jests.' How complete a dissent from given values that 'for instance' intimates! This art revives the very language that is needed to condemn it. At bottom, it pronounces dead the pieties that sustain communal life, and it then holds them up to ridicule. The master gesture of Surrealism is thus mockery of the dead, because it is the dead who bequeath to us the pieties that hem us in, that make us most conventional, least deliriously ourselves. Of the just deceased, nationally mourned man of letters, Anatole

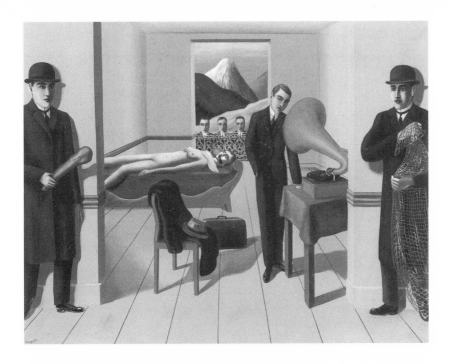

René Magritte
The Menaced Assassin
1926

France, Aragon asked in his mocking pamphlet *Un Cadavre* (1924): 'Have you ever slapped a dead man?' 'There are days,' he mused, 'I dream of an eraser to rub out human filth.' Aragon's imaginary slap has a double target: France himself, and the piety that holds that the dead merit respect (however little the subject merited it during his lifetime, however much the dead might impede the projects of the living). And so, for example, of Rimbaud, to whom the state proposed to erect a statue, Aragon said: 'France [the nation] disgusted him. Her mind, her great men, her manners, her laws, symbolized for him everything that was lowest and most insignificant in the world... Rimbaud? He did not allow anyone to salute the dead in his presence.' As for Rimbaud himself, he said: 'newcomers have a right to condemn their ancestors.' This repudiation of respect for the authority of the dead is the first characteristic of all transgressive art: canon-violating art, politically resistant art, taboo-breaking art, alike.

Consider, as an example of this dissent, René Magritte's *The Menaced Assassin* (1926). The picture brackets a murderer and his victim with two men set to apprehend him. The one has a limb-shaped club, the other a net of the kind that might be thrown over a tiger or lion. They are ready to pounce. Three other

men, either colleagues or witnesses to the murder, stare into the room from the window, which frames mountains. The murderer is oblivious to his peril and stares at a gramophone, relaxed, with his back to the woman he has just killed. The men wear business suits, as if shop-window dummies, while the dead woman has a mannequin's nakedness. Only the blood that gushes from her mouth gives the impression of movement. The effect is of a curious kind of tableau: contrived, melodramatic and yet passionless. A tableau, that is, of demoralising incongruity: the costumes mismatch the weapons, the interior mismatches the glimpsed landscape, the calm mismatches the violence. It might be a parody illustration of a crime novel's dénouement. Crime fiction may be imagined as an intimate dance in which the genre leads and the audience, held in its tight embrace, willingly follows. We surrender to its direction and are rewarded with reconfirmation of our most banal beliefs – the triumph of the good, the defeat of the wicked, the simplicity of human motivation and the benevolence of state institutions (the police, the judiciary). *The Menaced Assassin* is Magritte's macabre jest at the expense of just these beliefs. It records a crime not to expose it to justified retribution but so as to commit a further transgression – against its own audience. Magritte said of his titles that they were intended to deny the viewer 'any mediocre tendency to facile self-assurance'. To which one might respond: not just the titles.

Consider, too, Meret Oppenheim's *Objet: Déjeuner en fourrure* (1936). It was contributed to an exhibition of Surrealist objects. A cup, saucer and spoon are covered with the fur of an unidentified animal. One could not drink from the cup, one could not use the spoon. The immediate effect of the surrealising of the objects is thus to render them useless for their intended purpose. The ensemble was in this respect an exemplary Surrealist object, as well as a sly

Meret Oppenheim
*Objet: Déjeuner
en fourrure*
1936

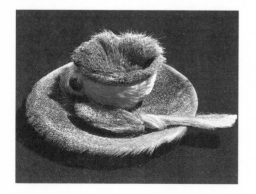

allusion to Manet's uncovered *déjeuner*. Oppenheim disables her object – the lined cup cannot be drunk from – so as to make it into art. A further effect is to give the object a certain independence, a certain integrity. Put on display, it ceases to be a mere receptacle. It now contains its own meaning. Oppenheim improves on the Surrealist practice, following Lautréamont, of bringing into collision objects that have no everyday relation with each other. They do not 'go' together, and yet they have

Max Ernst
The Virgin Spanking
the Christ Child before
Three Witnesses:
André Breton,
Paul Eluard and
the Painter
1926

been put together. They are proximate, yet alien. What Oppenheim does is to create a new object out of this collision. Her work does not consist of a cup and a fur skin, but of a furred cup. The work stimulates a complex and untotalisable mixture of sensations of pleasure and disgust: at the prospect of rubbing one's face against fur and the coincident prospect of eating fur. There is an erotics and an anti-erotics at play in this work which provokes a certain perplexity, and divides its audience by the subtlety of its sexual challenge. It is a perplexity that is caused, I suggest, by our dim sense of the irreconcilability of the distinct, compelling responses stimulated by the work.

And consider, last, Max Ernst's *The Virgin Spanking the Christ Child before Three Witnesses: André Breton, Paul Eluard and the Painter* (1926). One summons up, against

Man Ray
Monument to de Sade
1933

this work, three tableaux: the adoration of the Magi, the Virgin and Child, and the Crucifixion. That is to say, scenes of the birth, infancy and mortal suffering of Jesus, the three principal themes of religious art (for long, the master genre of the Western canon). Ernst collapses them into a single, anachronistic, mocking image: the three wise men are prominent Surrealists, the early life is a moment of humiliation and violence, and Christ's sufferings are no more elevated than the suffering of any other naughty child. The bathos of a spanking is substituted for the transcendent meaning of the Crucifixion. The *sacra conversazione* of the Virgin and Child with Saints, a popular subject for religious art, is parodied: the Virgin and Child, absorbed in their own drama of physical punishment inflicted and received, are unaware of the secular 'saints' who observe them, engaged in their own, profane conversation. Ernst described the work as a 'painting manifesto'. It is a direct hit. Ernst attacks that substratum of sentiment beneath the principles of Catholic faith – that is to say, Catholic pieties – and thereby composes a considered blasphemy. Robert Hughes regards the work as a 'remote ancestor' of *Piss Christ*. It is one among a number of Surrealism's blasphemies, and gives a quality of belatedness to Serrano's project: see, for example, Man Ray's *Monument to de Sade* (1933). Surrealism is the principal, programmatic transgressive art project of modern times. Its ecstatic indifference towards any constraint on the free exercise of the imagination, its resistance to abstraction and its desire (notwithstanding the ascendancy of abstract art) to continue to explore the subversive potential of figurative art, its resistance to the developing conventions of modernism, its posture of belligerence towards social and religious institutions, its hostility to conventions, its uncertain and ambiguous politics (Breton's difficulties with the Marxist Left, Dalí's flirtations with the Fascist Right), its post-Dadaist delight in the disruptive and the unsettling as defining aesthetic principles, its celebration of law-breaking most widely defined, its embracing of sexual fantasy as creatively transgressive, its delight in mixing up literature and the visual arts, and art and everyday life – all this makes Surrealism the point of origin for

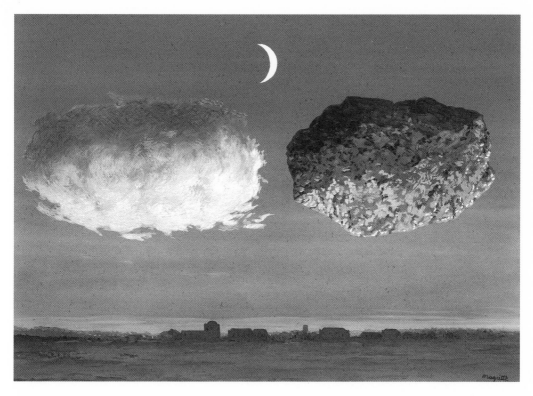

René Magritte
*The Battle of
the Argonne*
1959

much contemporary art. This is an art of violation, including self-violation. In response to Nicolas Poussin's principle, one of a number set out in a letter written in 1665, that 'nothing is visible without boundaries', the Surrealists may be taken to declare: we make visible everything that boundaries conceal. Theirs is thus an art that testifies to the enlarged capacities of the modern mind. Even the laws of gravity cannot now resist imagination's authority, as in Magritte's *The Battle of the Argonne* (1959). Art is but one significant instance of the liberating effects of an uninhibited imagination. True poetry, said Eluard, is present in everything that does not conform to a morality that can offer us nothing better that banks, barracks, churches, prisons and brothels.

Just as de Sade was held prisoner in the Bastille, said Aragon, those who refuse all limits are held prisoner by ignoramuses. The Surrealists loathed the post-World War I reinstating of national boundaries, adjusted to follow the consequences of victory (so trivial a consequence of so destructive a labour). Against this 'peace' they committed themselves to two undertakings: the internationalising of art and the transgressing of all boundaries. Their work dissented from the bogus normalisation of post-Versailles Europe. For the Surrealists, many of whom had fought in the war, 'the field was free only for a

revolution, fantastically radical, extremely repressive, that extended to every realm' (Breton). It followed that they would also not be satisfied with the boundaries of any programmatic literary or artistic movement. Surrealism was not, they insisted, a movement, it was (in Breton's phrase), a 'complete state of distraction'. It refused all alliances, including one with their audience. There is a post-Surrealism that elaborates upon this refusal. It rejects the collaborative aspect of Surrealism. It does not wish to involve audiences in its liberations but to intimidate them. This alienating, anxiety-inducing intention was always implicit in Surrealism – its partnership with its audience was always conditional, often purely gestural, rarely effective. Perhaps the Surrealists disliked *The Lugubrious Game* so much because in it Dalí exposed to them Surrealism unmasked. In the work that followed Surrealism – by, say, Francis Bacon and Damien Hirst – the ambition of partnership was abandoned.

Among the taboos that Surrealist artworks challenge are those that protect our tacit belief in the indivisibility of our identity and the supremacy of our consciousness. They challenge, that is, the integrity of the conscious subject, following Freud in splitting the unified 'I' and allowing the Unconscious to realise itself. And the hoped-for consequence? The Unconscious eludes the constraints on expression imposed by Consciousness, and the artwork overruns the boundary-line between the conscious and the unconscious parts of the mind. It was Surrealism's aim, it has been suggested, to reveal the Unconscious in representation. This is almost, but not quite, true. The implication that the Unconscious was just another subject for art, perhaps a difficult one, but no different in kind to any other, is wrong. It was not Surrealism's 'subject' in the sense that Stalin was Socialist Realism's 'subject'. What matters in Surrealism just as much is the communication of the experience of the disclosure of the Unconscious. Surrealism's subject is not the Unconscious in itself but rather the disturbing process by which the Unconscious is revealed. So what one gets is a kind of undraping of the mind, an embracing of monsters, which is doubly unsettling. The disclosure itself troubles, and the consequent undermining of the sovereignty of Consciousness (or the 'self') troubles too. The self, Breton said, was 'hateful' (he added: in poetry 'more than anywhere else'). Of course, as far as the Surrealists themselves were concerned, they attacked the subject for the reasons that scientists attacked the atom. It was split in order to release its power. It was a liberation precipitated by an assault. 'We are the mind's agitators,' announced Aragon.

The passage from Surrealism to the taboo-breaking art of the last decades of the 20th century is marked by a retreat into a certain literalism, prompted perhaps by an impatience with implication and allusion, and a desire to confront the audience, in as direct and unmediated a manner as possible, with the actual violation of a given prohibition. The artist's task thus becomes a matter of staging this violation, either by himself or by arrangement with proxies (who may be dummies). What matters is that the violation happens or, at least, that the artist gets as close to realising it as circumstances permit. Mapplethorpe's photographs of sadomasochists and Paul McCarthy's *The Garden* (1991–2) and *Cultural Gothic* (1992) are of just this kind. To assert that the works of these artists are immoral is to miss the nature of the challenge that they pose. When we say of an artwork that it is immoral, what we mean is that the maker of the artwork is immoral or that it is likely to cause others to act immorally. It is only human beings who can act immorally, and it is only

human beings, when they persist in such behaviour, who can be described as immoral. An artwork may have improving effects and yet a vicious gestation, or a wholly innocent gestation but vicious effects. Artworks themselves will always have aesthetic properties that are independent of their moral aspect. An artist may set out exclusively to wound, but the conditions he must meet in executing that intention will cause him to produce a work that is likely to be more than just an assault. It will have a life beyond its immediate purpose; it will be viewed by many who are unaware of the artist's motives, or even of the unjust injury he has done by his work. It is precisely because the artwork

Left
Paul McCarthy
The Garden
1991–2

Right
Paul McCarthy
Cultural Gothic
1992

is not just an act but also an object that it can never wholly be reduced to its moral aspect. The artwork's longevity and its accessibility, which are features of its distinct mode of existence, give it an independence from its maker's intentions that mere blows or slanders can never achieve. While they disappear into the body of the assailant's victim, the artwork remains. Its necessary complexity thus makes immoral art much more interesting than other kinds of immoral acts.

Artists have all the ordinary moral obligations, but they also have additional obligations by virtue of their vocation. There is, then, an artist's *common*, as well as his *professional*, morality (we can speak of 'art ethics' in the same way that we speak of 'medical ethics'). It has been argued from time to time that an artist's professional morality overrides, or trumps, his common morality. 'When Benvenuto Cellini crucified a living man to study the play of muscles in his death agony,' remarked Oscar Wilde, 'a pope was right to grant him absolution. What is the death of a vague individual if it enables an immortal work to blossom and to create, in Keats's words, an eternal source of ecstasy?' This has become a commonplace. William Faulkner once remarked that if a writer has to rob his mother, he will not hesitate. 'Ode on a Grecian Urn', he added, is worth any number of old ladies. And Breton declared that Picasso was absolved by his genius from all primary moral obligations. He may have agreed, however, that artists have certain obligations that arise in consequence of their artistic vocation, obligations owed to specific classes of person: their models, their subjects, their forebears and contemporaries, their audiences. These are obligations of respect. The photographer Richard Avedon, for example, has been criticised by Arthur Danto for stripping his subjects of dignity, and if the criticism is justified (as I think it is, in several instances at least), then Avedon is guilty of a moral lapse. By extreme contrast, Bonnard's loyalty to his principal model, Marie Boursin, was absolute, and in consequence caused the artist to fail in his duty to another model, Renée Monchiaté, by destroying, at Marie's insistence, almost all his pictures of her. As for the artist's audience, he will always, and at the very least, owe it the truth about the provenance of his work. Some have suggested that the artist owes his audience rather more. Not to corrupt it, certainly. Not to invade its privacy, perhaps. (The American artist Julia Scher installed a video camera in the men's toilet of the Hamburg Kunstverein and then screened the recorded events on surveillance monitors in the gallery, to the indignation of many of those

filmed.) Artists also have obligations to themselves. There is a duty of self-realisation which benefits not just the artist but the rest of us too, because it results in the making of artworks. This duty to oneself can be recast as a duty to art itself. It may be a matter of luck – moral luck, that is – whether any particular artist's decision to sacrifice the interests of others to his art can be justified. Undoubtedly, art provides the artists among us with many opportunities to act badly.

There is little in the art of the modern period, however, that makes it distinctively 'immoral'. The transgressive aesthetic is not an aesthetic of immorality. It is an aesthetic, rather, of a certain moral indifference. On being shown Manet's *The Absinthe Drinker* (1858–9), Thomas Couture remonstrated with the artist: 'An absinthe drinker! Can you create such an abomination? But my poor friend, it is you who are the absinthe drinker, it is you who have lost all moral sense!' The transgressive artist abstracts from his subject its given moral colouring. He lacks

Edouard Manet
The Absinthe Drinker
1858–9

'moral sense'. Take Marcus Harvey's *Myra* (1995), for example. Myra Hindley is a British woman convicted in 1966 for collaborating in the killing of several children. She is serving a life sentence and is unlikely ever to be released from gaol. Built up by the application of a stencilled, child's palm print, Harvey's work reproduces the well-known police photo of Hindley, expressionless, menacing in its impassivity. *Myra* provides a double shock. First, because portraiture tends to be taken as a celebration of its subject (and what is there to be celebrated in Hindley's life?) and because one of its historical uses was to communicate a person's appearance – to a suitor, say, or to the generality of the person's subjects (and Hindley is neither bride nor monarch). Second, and more painfully, because, given the subject's crime, getting children to help in creating her image seems a violation of them. Taken together, the picture horrifies in its implicit subordination of Hindley's victims to their tormentor. It is as if they were being compelled to praise her. For her image to be constructed out of a child's palm print is to enlist her victims in its creation.

Marcus Harvey
Myra
1995

The 'Sensation' curator Norman Rosenthal argued, in relation to this work, that child abuse is one of the great issues of our time. He was wrong, of course. There is no 'issue'; it is purely a police problem. It raises no questions other than penal ones. Paedophilia is unlawful. Injuring children will always attract severer sentences than would any corresponding harm to adults. These laws derive from the conviction that children, in their vulnerability, dependence and relative weakness, deserve special protection. This conviction is supported by a belief in the sanctity of childhood. It is this belief that gives a quality of taboo-violation to any criminal act against a child. To the extent that the existence of a taboo against harming children gives them additional protection, nothing should be done – surely? – that undermines it. At the very least, Marcus Harvey's *Myra* exposes this taboo to scrutiny. There is a cost involved in such an exercise, even though the capacity of art to act upon boundaries with permanent effect tends to be overstated, from their contrasting perspectives, both by art's advocates and its adversaries. Nevertheless, taboos – some, at any rate – have a value that it is risky to disregard. *Myra* does not provoke questions about the injustice of Hindley's crimes or the justice of her punishment. Nor does it cause us to ponder that sanctification of childhood, one that leads to the demonising of its violators. The work instead stimulates a mild panic in its audience by its indifference towards just these matters. *Myra* is disengaged from its subject's life, while being absorbed entirely in her celebrity. Not an immoral work, perhaps, but certainly demoralising.

Disobedient Art

There is a poster made by the German artist Klaus Staeck, *'Beware Art!'* (1982), that implicitly addresses a warning to the state and its institutions, one that is minatory yet self-defeating. It defeats itself, that is, both by the ambiguity of its representation and the detail of its threat. The image is either of darting lines breaking up a globe or of the globe itself, in its disintegration, throwing out rays, perhaps as an exploding star might do. The names of mostly 20th-century artists appear alongside these darts or rays. But are the artists responsible for, or merely the consequence of, the destruction of the globe? There are several possibilities: art precipitates

Klaus Staeck
'Beware Art!'
1982

change; art reflects changing times; art is an aid to the understanding of changing times and thus a precipitant of further changes. The poster equivocates, representing its artists as cause, and effect, and cause *because* effect. This already divided message is then further undermined by the names on which it relies. Few of these artists constitute the kind of danger of which the state need pay heed. Quite the reverse: in the main, their works are honoured cultural commodities. There is also a rather arbitrary quality about the list. It aggregates the names, as if they were interchangeable instances of a singular entity, 'the artist', invested with political capacities of a kind to make rulers tremble. They are indeed all artists, but beyond this there is no single quality that they all share. It would be artificial to connect them even by the more generous criterion of family resemblance. I read this poster, in every other respect a minor and slightly hysterical work, as a kind of image-allegory of politically resistant art in modern times. Like the poster itself, our times may in part be characterised, first, by the immense claims made for art's political capacities (to subvert, to empower, to command), but second, by the prevalence of representative artworks, exemplary of the best work of the period, that are quite without those capacities.

The modern period inaugurated reflections on the relation between art and political institutions that took for granted the considerable authority of both. Right about the state, but wrong about art, these assumptions tended in consequence to encourage the overstating of art's subversive capacities. Some writers proposed of art that it indicates, by its very nature, an alternative to quotidian politics. It is, they argued, the fruit of a utopian politics that refuses all boundaries. It is itself insurgent. 'All art is anarchical,' maintained Clive Bell; 'to take art seriously is to be unable to take seriously the conventions and principles by which societies exist.' Art is ontologically subversive. Its autonomy means that it both protests, and rises above, given social relations. Art thus subverts the dominant consciousness, the ordinary experience. All artworks are 'nonconformist', suggested the American artist Ben Shahn in his 1957 Harvard lectures. Indeed, every authentic work of art is revolutionary. It is an indictment of established reality. If it attempts a more direct engagement with the world, it will fail as art. Its power lies in its very remoteness. Thus, the more immediately political the work of art, the more it reduces the power of estrangement and the radical, transcendent goals of change. The autonomy of art contains the categorical imperative: things must change. It is continuous

with the ability of the artist himself to change things, to transform the world into art, indeed, according to Duchamp, by mere designation. And so, in defence of *Fountain*, following its rejection, he insisted: 'Whether Mr Mutt with his own hands made the fountain or not has no importance. He CHOSE it.' But it was unstable, this exalting of the artist: with Joseph Beuys, the notion of the shaman-artist, most set apart from his fellows, collapsed into the notion of everyman-as-artist. 'The artist breaks through the barrier of the distorted perception of the world,' said Beuys. But he also said: 'Every human being is an artist.'

Another proposal: not *all* art is subversive, for sure, but *only* art is. A number of artists have taken this position. While the politically subversive is not a necessary aspect of art's mode of existence, it is taken to be exclusive to art, now at least that every other form of political resistance has been neutralised. 'What still interests me in art,' remarked Victor Burgin, 'is its ability to criticise. Art is, in fact, the only area in which such criticism can still take place.' This is a more recent position, caused by a certain disillusionment with the political process itself. In postwar Germany, Beuys did not find it difficult to conclude that 'only art is capable of dismantling the repressive effects of a senile social system that continues to totter along the deadline: to dismantle in order to build a social organism as a work of art'. Art offers the means by which politically dissenting perspectives can be introduced in a culture, with subversive results. 'The opening up of the symbol system – particularly visual art – to the voices and experiences of women, people of colour, gays and lesbians, and other marginalized groups challenges the control of representation upon which the prevailing value system rests,' Judy Chicago has written. The notion here is of art as a kind of political assembly with representatives who are returned under a limited franchise. The voices of the unfranchised intrude and the effect is to destabilise the assembly. This has liberating consequences, it is believed, not least because this notional 'assembly' both parallels and influences the state's own, similarly limited forums.

Embraced by artists as projects, such claims for art have been difficult to realise. It is hard to introduce a hitherto excluded voice; it is almost impossible to do so in a manner that challenges the state. Robert Colescott's *George Washington Carver Crossing the Delaware: Page from an American History Textbook* (1975) is confounded by just this ambition. There is a quality of comic resignation in its representation of Black stereotypes. Colescott paints what one

critic describes as 'rowdy black down-home types'. It is as if this African-American artist is conceding the impossibility of representing African-Americans in anything other than objectionable, clichéd terms. His design on his audience seems too palpable, too controlled, and yet also frustrated and ineffectual. Racist art's mockery is itself unmockable, and so when such mockery is attempted, it can only produce a self-cancelling work, one that undoes itself in its repudiation by appropriation of a whole tradition of derisive portraiture. It too causes offence, both to racists (which is good) and to those dismayed by its reliance on racism's own visual vocabulary (which is not good). It is a thwarted art. Critics who celebrate Colescott's work thus mistake its essential mood, which is one of melancholy, disguised by a certain false jollity. To praise him for 'flout[ing] taboos in art, sex, race, money, power, and politics' (a typical endorsement) is too upbeat. Such praise is no more than an art-critical reflex, one that here takes refuge in the language of taboo-breaking in order to avoid a perplexing encounter with a troubling art failure.

There is a more modest kind of art, one that does not so much challenge as coax, and is mildly transgressive in its breaching of boundaries. Robert Rauschenberg's 1980s collective enterprise, the Rauschenberg Overseas Cultural Exchange (ROCI), was brought into existence to cross cultural divides. 'If Israel could see India, and Japan could see Mexico, an international chain of artistic understanding might begin,' Rauschenberg enthused. ROCI would go to a country 'which may not be familiar with contemporary Western artists, interact with the artists and artisans there, learn their aesthetic traditions, make work in their settings, talk to students.' The undertaking was successful, in a minor, low-key way: see, as an example, *Mexican Canary/ROCI Mexico* (1985). What Rauschenberg set out to do was what art does anyway. It is the aspect of art that John Dewey's influential, optimistic *Art as Experience* (1934) privileged. For Dewey, every artwork may be regarded as a gift from one culture to the world, momentarily undivided by the grace of the gift. Art provides a means of contact between cultures. Obstructions are thereby overcome, and limiting prejudices melt away. Art flows over the barriers created by language. It helps us to surmount the division of humanity into non-communicating sects, races, nations, classes and cliques. It encourages the dissolution of distinct, singular identities. ROCI made an entire aesthetic out of this aspect of art.

Though Rauschenberg encountered opposition from time to time, his project was largely accepted on its own benevolent, unthreatening terms. It is thus to be contrasted with the politically resistant artwork. This work lives in the moment, and for a moment. It is vivid, dangerous, exhilarating. It flares into dazzling light, and is then extinguished, or extinguishes itself. Its existence is proof of the proposition (advanced by the sociologist Zygmunt Bauman) that morality may manifest itself in insubordination towards socially upheld principles, and in action openly defying social solidarity and consensus. The anonymous *Goddess of Democracy*, which stood in Tiananmen Square for four days in May–June 1989, is exemplary of this short-lived, defiant, accusatory art. It was destroyed by soldiers when firing upon the demonstrators who thronged the square. The politically resistant work will be suppressed, or the moment will pass. There is no tradition of such works, only a discontinuous series, erupting into disobedient life and then

Opposite, top
Robert Colescott
*George Washington
Carver Crossing the
Delaware: Page
from an American
History Textbook*
1975

Opposite, bottom
Robert Rauschenberg
*Mexican Canary/
ROCI Mexico*
1985

Below
Anonymous
Goddess of Democracy
1989

171

expiring, either by censorship or by acceptance. While these works may continue as material objects, and may even enjoy a continuing half-life in art institutions, they will have lost their quality of resistance. It is as if the moment at which an artwork can safely be exhibited is also the moment at which it ceases to be transgressive. Its arrival in the gallery marks its retirement from subversion. Politically transgressive art is not made to last. In radical contrast (say) to the statuary of the Soviet Bloc, which was intended to last forever, the politically transgressive artwork does its damage and then withdraws.

There is an element of defiance in politically resistant art, either a refusal to participate in an existing discourse framed by state institutions or a refusal to be silenced by the state. Either way, it is art's version of the most desperate, least problematic kind of civil disobedience: this law makes my continued existence impossible, I will therefore disregard it. There thus has to be an element of risk for art to be politically resistant. If it can be co-opted, then it is not resistant. And the most difficult form of co-option to resist? To be co-opted *as art*. Of the anti-Vietnam War 150-artist collaboration *Collage of Indignation* (1967), artist-collaborator Leon Golub wrote, 'this is not political art, but rather a popular expression of popular revulsion'. One witnesses an internal violence – a kind of ontological self-lacerating – as the political artwork (such as the *Collage*, indeed) struggles to overcome its status as a *licensed* transgression. 'I considered as futile,' wrote George Grosz, 'any art which does not offer itself as a weapon in the political struggle. My art... was to be a gun and sword: my drawing pens declared to be empty straws as long as they did not take part in the struggle for freedom.' This is typical of a certain kind of declaration of commitment made by 20th-century artists. In his 1944 public statement 'Why I Became a Communist', for example, Picasso wrote that he had never considered painting to be an art simply of pleasure, of diversion. Line and colour were his weapons.

Willi Baumeister's mischievous graffito is exemplary of this kind of transgressive art. It bears the descriptive title *Arno Breker's 'The Avenger' with Head Drawn by Willi Baumeister*, and was executed in or around 1941. (The uncertainty of the date of its completion is itself typical of its genre.) With wonderfully subversive mockery, Baumeister makes comedy out of the

Various artists
Collage of Indignation
1967

heroic nude by Breker, Hitler's favourite artist. He too is an avenger, not throttling the snake but framing the phallus. He avenges those artists whose work has been suppressed – throttled – by the Nazis. The penis becomes a long nose, the face a Jewish caricature that mocks the Nazis' deepest, most fantastical fears about the emasculating effect of Jewish power. Deflating, iconoclastic and derisive, this graffito secretly defies a dangerous, even annihilatory state. It invites comparison with that other 20th-century art gesture of disrespect, *L.H.O.O.Q.* (1919), though in its affirmation of a human-scale art, it lacks Duchamp's aesthetic irony – that is its strength. It is a work that could not be shown – that is its weakness. It is one of those rare works of political resistance that enlivened the art of the modern period.

Willi Baumeister
Arno Breker's
'The Avenger' with
Head Drawn by
Willi Baumeister
c. 1941

Breker's own work was widely exhibited during the Nazi period, and he exercised considerable power over artists and sculptors. In 1937 he was appointed 'Official State Sculptor'. In 1940, he received as a personal gift from Adolf Hitler a large house and studio. His Neoclassical pastiches were exemplary of the Nazi aesthetic: pompous, derivative, oppressive. *The Avenger* was exhibited in 1941 in the House of German Art. Numerous reproductions were distributed in the Occupied Countries. Baumeister's career was the opposite of Breker's in almost every relevant respect. He was sacked in 1933 from his job at the Frankfurt Art School and forbidden to exhibit. He painted clandestinely in the years that followed, and the only public exposure his work subsequently received was when it was held up to mockery at the 1937 'Degenerate Art' exhibition. He had a brush with the Gestapo when his 'corrections' to catalogue reproductions from the 1938 'Grosse Deutsche Kunstausstellung' fell into the hands of the authorities. Thereafter, he went completely to ground. In 1950, angered at the postwar success of artists such as Breker, he was among those who signed the petition 'Against Hitler's Favourites: A Protest by German Artists'. Late in his life, he wrote: 'No one knew I continued to paint, in a second-storey room in utter isolation. Not even the children and the servants must know what I was doing there... Terrible was the idea that one would never again be able to show such pictures in public.' It is precisely this terror

that both intimidates and drives forward the makers of politically resistant art, and that defines the nature of their project.

In 1971 the proposed exhibition of an installation by the German artist Hans Haacke was cancelled by the Guggenheim Museum. It was, the officials declared, 'muckraking', and not art. 'An alien substance,' the Guggenheim director said, 'had entered the art museum organism.' The curator protested, and was sacked. The installation was said to fall outside the museum's remit and therefore could not be shown. It comprised a chart, maps, charts and photographs, identifying the holdings of the major property companies in Manhattan. The object was to make transparent the ownership of the buildings and land in the city that housed the Guggenheim, which in turn housed major works of art and would also have housed Haacke's own installation. The work would have exposed the foundations on which these major works rested. It was in this sense a piece of meta-art, that is to say, a work of art defined in part by reference to its critical posture towards other artworks. Entitled *Shapolsky et al. Manhattan Real Estate Holdings, a Real-Time Social System, as of May 1, 1971*, it has been described as an economic X-ray of New York City. The refusal to exhibit the work conferred on Haacke, Arthur Danto remarked, 'a qualified martyrdom'. It was, he added, a tribute to art's precociousness that, before the sacredness of real-estate ownership had generally been grasped, an artwork could induce a feeling of desecration in an audience by exposing such matters to scrutiny. In just this way, then, the connection between the second and third versions of the transgressive, the taboo-breaking and the politically resistant, is disclosed.

In the mid-1960s and early 1970s, the theory of 'repressive tolerance' had been developed by certain circles of the American Left. The capitalist nations, it was argued, had an almost unlimited capacity to absorb and thus neutralise challenges to their legitimacy. One consequence of the theory, first advanced by Herbert Marcuse in *One-Dimensional Man* (1964) and then refined by him in *A Critique of Pure Tolerance* (1967), was to collapse the 'accommodating'/'repressive' model, and instead treat all states as repressive, the distinction simply then being between those that are openly repressive and those others that are covertly or obliquely repressive. All advanced industrial societies are fundamentally alike. Liberal institutions are both incipient totalitarian institutions and already their equivalent. The treatment of Haacke's work encouraged just this account of life in the West. *Shapolsky et al* is a political

Hans Haacke
Shapolsky et al:
Manhattan Real Estate
Holdings, a Real-Time
Social System as of
May 1, 1971 (detail)
1971

work that could not be accommodated by a representative public institution of the state. It exceeded the limits of what the museum could tolerate, and it gave offence. But note the limitations of place and time. It was impossible at that time, and in that place. The installation could have been exhibited elsewhere – in another gallery or some other privately owned space to which the public had access. It is also possible to imagine the installation being exhibited at the Guggenheim itself at some later date, perhaps as part of an amends-making show of political, suppressed work (but long after it has ceased to give offence – when Manhattan's landlords are no longer as described in the work).

During *Arte-Reembolso/Art Rebate* (1993), a performance work undertaken by more than 30 American artists, ten-dollar notes were given to 450 illegal aliens who had crossed the Mexican border into the United States. The work was financed in part by the National Endowment for the Arts. 'Undocumented workers' contribute to the Californian economy. They pay sales tax, and they provide underpaid labour. They are needed and despised. They are an underclass, exploited and criminalised. The piece had certain resonances.

Left
Anselm Kiefer
Occupations
1969

Right
Anselm Kiefer
Untitled
(Heroic Symbols)
1969

The Mexican–American border is the dividing line, running for about two thousand miles, between the industrialised West and the Third World. It is also an arbitrary barrier separating people of shared ethnicity and history. And last, it is the physical trace of certain political events: part of the southwestern states belonged to Mexico until as recently as 1848, which makes the answer to the question 'Who is the alien?' uncertain. The response to the work was part of the work. It exposed hostile perspectives both on certain kinds of politically engaged art and on Chicanos. A local politician complained: 'I can hardly imagine a more contemptuous use of taxpayers' hard-earned dollars.' A newspaper characterised the artists as 'loonies'. Letters about the piece ran for many weeks in San Diego newspapers.

There is a tendency to value the politically resistant work without regard to its politics, or the politics of the state it opposes. Yet not every state is oppressive, and not every subversion is liberating. (One might add: not every repression is unjustifiable, and not every liberation is welcome.) A politically resistant work can be objectionable from the very perspective that welcomes, say, the intervention of a Baumeister or a Haacke. Consider, for example, the

early work of the German artist Anselm Kiefer. Kiefer has exhumed Nazi themes and gestures buried since 1945. He himself thinks of this in terms of the violating of taboos. 'The past was put under taboo,' he has said, 'and to dig it up again generates resistance and disgust.' Kiefer digs it up, for example, in his photographic work *Occupations* (1969) and in the watercolour *Untitled (Heroic Symbols)* (1969). He has been praised for these transgressions of the taboo against the deployment of Third Reich icons. But to characterise resistance to such deployment as a generalised taboo is to misunderstand its nature. Fascism is 'taboo' in Germany because it has been found to be evil. Its icons, its themes and its gestures were thus not so much repressed as rejected. The rejection took the form of a repudiation and a proscription. Having endured the Third Reich, Germany did not wish to repeat the experience, or any aspect of it. Nazism was not to be permitted to return, and this entailed blocking every route by which it might creep back: by means of flags, salutes and uniformed processions, in propaganda sheets, street-corner demagoguery and militias. They were outlawed because they were considered to be dangerous. The West German state committed itself to these prohibitions, which became constitutive of its very identity. When Kiefer photographed himself in the 'Heil Hitler' pose, it was against this state self-definition that he was setting his artistic project. Fascism fascinates Kiefer, and his work is at the very centre of what is most problematic about the unreflective contemporary endorsement of the transgressive.

The perspective of the politically resistant work is not wholly critical, of course. It will always incorporate an implicit affirmation: these are the true values, the ones at risk of suppression, represented in this artwork. These critical and affirming tendencies combine most economically in certain kinds of United States flag art, in which the national flag serves both as the symbol of state power *and* as the symbol of popular aspirations. Those artworks that assault or otherwise violate the flag both affront and seek to affirm patriotic pieties (though often they are more successful in the first than in the second ambition). Faith Ringold's *The Flag Is Bleeding* (1967) has three figures in front of a flag. It addresses its American audience: we are bleeding and must be healed. The African-American represents the extremes of loyalty and menace, with one hand pledging allegiance, but with the other gripping a small knife. The White man and woman stare blankly, less can be expected of them, less feared of them, though – arms linked – their futures are bound up with the African-American's.

This flag art is unusual. In the main, the transgressive aesthetic has been unable to foster its own version of political art. This is so, principally, because such art needs friends as well as enemies, and speaks of solidarity as well as opposition, while transgressive art – especially in its dominant taboo-breaking version – is indifferent to such considerations. And there is a second reason, too: transgressive art has needed to defend itself in the 20th century and these defences have tended to argue for a neutral, non-engaged under-standing of art that is inconsistent with any political purpose. (The German artist Oskar Schlemmer, an early victim of Nazi iconoclasm, wrote in protest to Goebbels: 'Artists are apolitical to the depths of their being – necessarily so, because their kingdom is not of this world.') It follows therefore that although we may be said to live under a regime of transgression, it is one that has rarely provided the context for artworks that give political offence, or break the law in the manner of civil disobedients (that is to say, publicly and disinterestedly), or exceed the tacit conventions of political discourse. Even the Surrealists could not successfully generalise their commitment to the transgressive to include serious political dissent. As Maurice Blanchot put it, Surrealism came to Marxism in the name of poetry and then immediately withdrew in the same name. In consequence, artists who wish to take up politically resistant posi-tions in their work tend to be dismissed as propagandists, or else seek to avoid that judgment by painting falsely universal complaints about injustice and suffering. The work of the contemporary American artist Leon Golub is the best recent example I know of an artist wrestling with this very dilemma.

There is a picture of Golub's called *Interrogation II* (1980–1). It is typical of his oeuvre. A naked, blindfolded man, legs splayed and member exposed, has been tied to a chair. He is a family relation of Thomas Eakins's masked model, another object of predatory male attention. Worse, actually, than Eakins's. He is the object of only an indifferent, intermittent attention. The torturers chat, smirk, joke with each other. Their responsibility for the suffering of their pris-oner weighs lightly upon them. It does not interfere with their capacity for levity. The job, after all, is arduous and dull and they need to take breaks from it. *Interrogation II* is an ugly picture, the open-faced gregariousness of the tortur-ers inviting our complicity, the faceless victim too anonymous to engage our empathy. It is as if it were painted in response to Brecht's invitation to 'non-objective' painters: 'you would do better to show in your paintings how man in our times has been a wolf to other men.' Golub paints just these wolves.

This work is not a call to action. It is, very precisely, *not* a mode of contestation. The interrogators are not real, identifiable sadists, men who should be captured and prosecuted. They are not even fictional employees of a specified state (though there is something Latin American about them), against whom protests and diplomatic measures might be taken. They are of a type imagined by the artist, stereotypes comparable to the torturers in Harold Pinter's play *New World Order* (1991), in which two men coolly chat in the presence of a third, blindfolded and sitting on a chair. 'He hasn't got any idea at all of what we're going to do to him,' says one of them. Golub's subjects are facile hate-objects, available to prompt indignation in *bien-pensant* audiences. Golub, says one of his admirers, shows us that political art need not be propaganda. By 'propaganda' is meant the kind of work that exhorts its audience to act in a specific, directed way: to join the army, or to increase industrial output, or to hate Communists. This is propaganda as the reverse of art, commonly understood. Just like pornography, propaganda is a category defined in relief; it is an aspect of what art is not. Propaganda works are those texts and images without an aesthetic. But this is to underestimate propaganda in order to overestimate Golub's art. Propaganda works do have an aesthetic; Golub's work is only weakly political.

Leon Golub
Interrogation II
1980–1

If one takes (for example) the state-approved images produced under the Nazis, without making any distinction in advance between art and propaganda, it is possible to see that they are in fact united by a common aesthetic. There are of course differences. Artworks are intended to endure, while most propaganda works – posters, fly sheets, cartoons and the like – have a more limited life. But both fly sheets and monumental sculpture alike derive from an aesthetic that in turn derives from a political philosophy that, at the most abstract level (that is, quite emptied of specific content), divides the world into friends and enemies. Friends are beautiful; enemies are ugly. Friends merit celebration in weighty, permanent artworks; enemies deserve lesser works, appropriate to their degraded status. The cheap, ephemeral quality of the material on which this latter work is reproduced is thus itself a significant aspect of its aesthetic. It was thus precisely Fascism's aesthetic that determined the properties of works of both 'propaganda' and 'art'. (This is Susan Sontag's insight, which is to be qualified by Saul Friedlander's insight that Fascism itself is predisposed to being aestheticised.) More generally, an artwork can make a determinate intervention in politics.

Correctly understood, it is the weakness, not the merit, of Golub's work – given his ambitions for it – that it is *not* propaganda. He may know this himself. In certain other paintings he has tried to make the focus more specific. There were the Vietnam works of the early 1970s, when Golub – along with other American artists – aimed to 'bring the war home' to domestic audiences. This was a self-styled 'angry art'. A more recent work, *White Squad/ Disinformation* (1985), places alongside a generalised scene of torture a newspaper clipping about the World Court, the United States and Nicaragua. But the complexity of the story does not find any correlative in the bland starkness of the image. We infer from what we know of Golub that he does not care for US policy in Central America, and that this policy entails many abuses of human rights, but the work itself does not tell us that. Golub himself has said that his art is intended to occur in real time, in the common spaces of the world, and to be, as exactly as possible, somehow a picture of the real. ('I think that one has to fight to remove what one construes as evil.') Like Grosz, Golub wants his art to be a weapon. But it is not; it is just a tease. It suggests action, but lacks point. It is tendentious, but defeated. Hanging in the Art Institute of Chicago, one museum piece among others, to what purpose does it seek to rouse its audience?

It is compromised by a certain indecision. It does not know whether it wants to engage its audience or attack them, it doesn't know whether to operate at the level of taboo-violation or at the level of political action. It wants, of course, to do both. But these are opposing ambitions and cannot be reconciled, other than in a certain utopian liberationist politics (which exists only as unrealised theory). Golub's work is shot through with just this irresolution. The impact of physical trauma, of psychic trauma, Golub says, is strong in his paintings. Viewers may recoil from it, because it is too close to them for their comfort. Represented violence, if it is raw enough or if the surface is physical enough, is an uncomfortable analogy to actual violence. His work, he maintains, refuses the audience that aesthetic distance that would allow for an unthreatened, disinterested contemplation. His paintings, he declares, 'bite'. But whom do they bite? The museum-going audience? That is an ambition for a Mapplethorpe, or for the Chapman Brothers. The perpetrators of the horrors represented on the canvas? Now *that* is an ambition for a political artist, a maker of politically resistant artworks. But it eludes Golub. Iris Murdoch, thinking perhaps of the great Russian novelists of the 19th and 20th centuries, writes: 'The intense showing, the bearing witness of which art is capable is detested by tyrants who always persecute or demoralise their

Leon Golub
White Squad/
Disinformation
1985

artists.' Goya exemplifies this 'intense showing', this 'bearing witness'. Golub does not.

In 1852, the inaugural year of the Second Empire, the French minister of police wrote a memorandum that contained this tribute to art:

> Among the means employed to shake and destroy the sentiment of reserve and morality so essential to a well-ordered society, drawings are one of the most dangerous. Drawing offers a sort of personification of thought, it puts it in relief, it communicates it with movement and relief, so as to thus present spontaneously, in a translation everyone can understand, the most dangerous of all seductions.

David Wojnarowicz
Globe of the US
1990

He had caricatures and political cartoons in mind. Golub would no doubt wish to extend the thought to fine art, and there are artworks that do indeed have this 'seductive' quality. But transgressive artworks tend to have it only to a problematic and limited extent, notwithstanding the fact that shaking, if not destroying, sentiments of reserve and morality is precisely what they are about. It is *against* the transgressive – understood as the invasion of another's space, the infringing of another's rights – that a political artist would wish to protest, yet how can he if he is committed to an ideology of the transgressive that finds only good things in, say, boundary-subverting? A good, because typical, example of this double bind is David Wojnarowicz's *Globe of the US* (1990). The artist has taken a college globe and pasted over it cutouts of the United States. The world has become America. Explaining the work, Wojnarowicz represented it in entirely transgressive terms. 'Borders are really psychic things... by ripping the map into pieces I've erased all these borders and I've completely joined opposing governments.' His work, he says, 'is a metaphor for a sense of groundlessness and anarchy'. But it could also be read as objecting to American transgressive-

ness. What after all is the Americanization of the globe but a refusal to respect the integrity of national boundaries, where 'boundary' means cultural autonomy, self-determination and a respect for the rights and life-projects of others?

It was, initially, as a consequence of certain Enlightenment tendencies that politics became both a predicament and an opportunity for art. The story has recently been told by Jürgen Habermas, and he does this by recapitulating themes to be found in Kant. This is how it goes. At one time, human understanding was considered to be indivisible and subordinate to divine revelation. There was thus one realm, and it had one sovereign. But the philosophers of the Enlightenment divided the realm into three. The new realms were science, morality and art. Each was autonomous and had its own norms, respectively: truth, justice, beauty. Each was to be developed according to its own inner logic. Each was institutionalised; each was investigated, and practised, by its own experts. Each was cut off from the quotidian existence of the wider, non-specialist public. Art was thus independent, but it was also neutralised. It was not a challenge either to truth or justice. It was isolated from scientific inquiry and political enterprise; it was also isolated from everyday life.

The art of the last two centuries has developed within, and latterly against, this model. At first, artists were willing to stay within art's prescribed boundaries. Kandinsky struggled against academy art, he records, in order to breach from the outside just these boundaries: 'Thus did I finally enter the realm of art, which like that of nature, science, political forms, etc, is a realm unto itself, is governed by its own laws proper to it alone.' Art began to chafe at the constraints imposed upon it. Autonomy came to be experienced as imprisonment; art broke loose. This breaking loose took a number of forms. Surrealism was one. It attempted, argues Habermas, to blow up the autarkical sphere of art and force a reconciliation of art and life. But at the same time, artists continued to seek for themselves and for their work a certain self-sufficiency. They wanted both to create artworks free of external interference, and for those works to be interpreted by reference to their inner logic alone. They did not want to be told what to do; they did not want their works to be judged 'true' or 'moral' (and certainly not 'false' or 'immoral'). 'Ideologues have ruled long enough over expression,' declared the French avant-garde journal *Tel Quel* in 1960; 'it's about time a parting of the ways took place; let us be permitted to focus upon expression itself, its inevitability and its particular

laws.' Or, as the American artist Robert Smithson expressed it, 'the rat of politics always gnaws at the cheese of art'. Autonomy was thus an ambition that had both a political and a hermeneutic aspect. In the 20th century, the two split. Most artists continued to want independence for themselves, even though a number of them rejected independence for their work. Of this number, many produced a 'committed' art that positively declared its fidelity to truth and morality. Politically resistant artworks, by their adversarial posture, avoid the dangerous banalities of commitment and the innocuous banalities of aestheticism. They offer a respite to art audiences otherwise afflicted by the more quotidian engagement or hermeticism of modern art.

Baudelaire/Manet

There is a prose poem of Baudelaire's called 'The Rope'. It is close to being a short story – a very short, short story. An artist tells the narrator of a young boy from a poor family who would pose for him from time to time, and who then, somewhat later on, came to work for him at his studio. All went well, though the boy suffered periods of depression. He also developed a passion for sweets and liquors, and this led him to trivial pilferings. Though warned by the artist, and warned again, the boy continued with his thefts. Then one morning, something new was found to be missing. The artist's patience snapped. I am sending you back to your parents, he told the boy. Returning that afternoon to the studio, the artist found the boy dead. He had hanged himself. The artist visited the parents to tell them of their son's suicide. The mother received the news impassively; the father restricted himself to the comment that it was just as well. At the time, the artist had taken this apparent indifference of the mother as evidence of a grief too deep for words. This interpretation was at first confirmed to him when she visited him and begged for the nail and rope the boy had used in killing himself. But over the next few days he received letters from tenants in his building asking for snippets of rope, and he then understood the purpose of the mother's request. She wanted to sell the items! The curative, magical powers attaching to the suicide's means of death would allow a high price to be demanded.

The story is told with a certain tone of realism, even cynicism. One might think, the artist remarks, that a mother's love can be relied upon. Not a bit of it! A piety is thereby exposed. We like to think that a mother's love is eternal, unfathomable, but we are wrong. It is a received idea that does not survive the

telling of this tale. We might also think that we have reached a certain stage in civilisation, that we are not slaves to superstition. Again: not a bit of it! This is so much sentimentality, a story that we tell ourselves to make the world appear a more rational, less perplexing place. The artist receives a veritable bundle of letters, and not just from a 'despicable, vulgar class', soliciting threads of the cord. We might think that policemen are protective of the innocent, ferocious with the guilty. Not a bit of it! They are equally ferocious with the innocent and the guilty. They do not exist to defend the one against the other. They are not instruments of justice and order. They are a class set apart, with powers and privileges exercised without regard to the interests of

victims of crime, or the public at large. We might think that our fellows are ready to respond to calls for help. Not a bit of it! They are self-absorbed, and indifferent to the pleas of others. Certainly, they never want to involve themselves in hanged people's affairs.

Edouard Manet
Boy with Cherries
1858–9

The poem is dedicated to Manet. The story was the artist's own. It was Manet who had engaged a young boy, quarrelled with him about pilfering and found him dead in his studio. The boy is the model in the artist's *Boy with Cherries* (1858–9). Though this in itself would be sufficient to justify the dedication, Baudelaire has another reason. In the sceptical, amused view it takes of the pieties, this prose poem is a proof-text of the transgressive impulse. It is dismissive of claims made for the authority of moral impulses; it takes pleasure in exposing, and disturbing, superstitions and taboos; it is sceptical of all schemes of political reform; it regards human folly as a subject for art, but treats it neutrally (it is not satirical, and Baudelaire is not Goya). It shares the aesthetic animating Manet's work and the art that followed in its wake.

The End of Transgressive Art

I have argued both for the modernity and the diversity of transgressive art. It has a history, one that contributes to the history of our own times; it exists in several versions, which are the versions that have largely defined art practices for the last 150 years. Its formal innovations have been continuously revolutionary; its assaults on the unarticulated premises of Western culture have been sustained and penetrating; its political challenges have, however, been muted. It is thus a time-specific, plural phenomenon. It is to be related to transgressive practices in literature; more recently, it has become the beneficiary of a broad, cultural embracing of the transgressive principle. The demoralising effect that much taboo-breaking transgressive art has on its audiences is the first of the three themes of this chapter. The second, related theme concerns the state of transgressive art today, which suggests that the transgressive aesthetic may be playing itself out, making way for other art-making practices, among which is a practice sensitive to art's vulnerabilities. These new practices are the third theme, one that I open by returning to Manet. I am throughout concerned only with the strongest version of transgressive art, the one that I have defined as taboo-breaking.

Demoralising the Audience

The unreflective esteeming of the transgressive has had several unhappy consequences. It has promoted the treatment of the canonic, the academic and the merely routine or conventional as an undifferentiated common enemy. It has contributed to the impoverishing of our moral consciousness by its contempt for pieties. It has muddled boundaries that need to be protected with those that ought to (or may) be breached. It has blurred the boundary, that is to say, between different kinds of boundary. It should be, and yet it seems not to be, possible to affirm that there are certain boundaries that ought not to be crossed even in the name of art, and that there are certain other boundaries that art itself needs for its own self-defence. (When the Mapplethorpe

prosecution failed, Hans Haacke celebrated. A jury of the people, he announced, in whose name the advocates of morality claim to speak, has declared, 'The Constitution draws a line that must not be crossed!') It should also be possible to acknowledge that there are some limits that we need, and others that we need breached. Further, that while there are some constraints that make us human, others impede our ability to realise ourselves.

The greatest art is responsive to these affirmations, these acknowledgments. So why is it that, when made in art-world contexts, such affirmations appear to possess an almost risible quality of the arbitrary? Perhaps, in part because they tend to be made as preliminaries to a menace by people one instinctively despises: those moral entrepreneurs, the professionally outraged, who would ban a work, prosecute an artist, shut down an exhibition, as readily as they would weep sentimental tears over the vulgar, the kitsch, the aesthetically vicious. Perhaps too, in part (to make a large, but I believe readily recognisable, claim), because we live in a culture in which life tends to be experienced as a series of transactions conducted in the shadow of many unstable, shifting boundaries. These are lines that separate the impossible from the feasible, strangers from friends, the known from the unknown, the comfortable from the troubling. How can one talk of defending boundaries when one's life is defined by reference to their essential mutability?

The best that can be done, I think, is to try to grasp the complexity of the problem. Why is the experience of contemplating taboo-breaking artworks – especially those intractably avant-garde works that define a limit that one senses will *always* be a limit (Arthur Danto's formulation) – so often the very reverse of exhilarating? Contemplating Jacob Epstein's *The Rock Drill* (1913–14), a sympathetic, but baffled critic concluded: 'the incongruity between an engine with every detail insistent and a synthetic man is too difficult for the mind to grasp.' This critic did his best, but the work defeated him. This defeat was to him an occasion for regret. As a type of non-engagement with an artwork, it should not be confused with those other occasions when a work is met with hostility, even hatred (which was in fact the fate of most of Epstein's works). These latter occasions, especially when they become the pretext for a moral panic, media-fostered, tell us very little about the artwork itself. The raging against

Jacob Epstein
The Rock Drill
1913–14

everything that is subversive or difficult or challenging or new, those short-lived crusades against supposed perils to given values or interests, conducted with a maximum of iconoclastic belligerence, a 'know-nothing' intransigence, a refusal to admit doubts, uncertainties, or even the unusual or the unfamiliar, are part merely of the pathology of modern life. Artworks – *any* and *all* artworks – need to be defended against such intemperateness, such persecutory zeal, which caricatures the artwork and denigrates its maker in a carnival of malice. Put this to one side. I have in mind instead those sentiments of unease and discomfort, those emotions of dismay and retreat, a kind of shrinking away, induced by a certain kind of transgressive artwork, the taboo-breaking artwork. When we confront it, we can have the sense that it entertains sadistic intentions towards us. The question is: how to explain this response?

First, because we acquired these art-broken beliefs, or taboos, as children and we have not since then thought to explain them to ourselves. Indeed, we lack the vocabulary to do so (both sociology and religion attempt, but largely fail, I believe, to give us the words). These artworks thus draw to our attention what we would rather overlook: that governing our lives are sentiments acquired in infancy, carried unexamined into adulthood, and which largely take the form of fears. We are not the authors of our own lives; what we believe – and therefore, who we are – is largely a matter of inheritance. (We may regard taboo-breaking works as immoral in part because of a coincidence: our moral intuitions are also acquired in infancy, invariably within the context of family life, and so an attack on one kind of belief can be taken as an attack on all beliefs derived from the same place.) Beliefs are judged well- or ill-founded according to how we came by them and how we can justify them (a point made by Leszek Kolakowski in the aptly titled essay 'On Superstition'). If we do not know from whence our beliefs came, and we cannot in any event justify them, we are in trouble. Artworks that aggravate our awareness of this double handicap are unwelcome. Our beliefs constitute us, but are hard to defend. These beliefs are both more important, and less capable of justification, than we at one time thought. We cannot slough them off; we cannot ground them in reason. This is very unsettling. But if we want art, rather than kitsch, can we complain when artists take risks with our sensibilities?

Second, the breaching of a piety places its existence in jeopardy. It is robbed of some of its authority. Combating taboo-breaking artworks is fraught with difficulty, and we thus experience a sense of powerlessness

before them. Art offences against taboo do not result in the artist-malefactor's ruin. (In Polynesian culture, by contrast, the prohibitions of the taboo were strictly enforced; every breach was punished with death.) The breaching of the taboo, and then putting that breach beyond the reach of censure – because it cannot be contested, perhaps because it is protected as art, perhaps because in certain circumstances it breaches no existing legal rule – induces anxiety, even a certain momentary anguish. To what can we appeal, in our dismay? To the law? – but even when criminal charges are possible, prosecuting a piety-violating artwork itself violates a piety: respect for artistic freedom. There is thus a self-defeating quality about all such legal moves against artworks. Consider, for example, the criminal conviction of British sculptor Anthony Noel-Kelly. He stole body parts and then produced casts, burying the unprotected remains in a hole in the ground. The parts had been removed from storage in the London premises of the Royal College of Surgeons. They had been there for some time, and neither their original owners nor their new ones had any further use for them. When the casts were exhibited in 1997, Noel-Kelly was arrested and charged with theft. At the trial the prosecutor insisted that the case was neither about art nor the outraging of public decency, but simply about the wrongful appropriation of property belonging to the Royal College. On sentencing the sculptor, however, the judge expressed quite different sentiments. 'The offence you committed,' he told the defendant, 'was a revolting one and an affront to every reasonable and decent concept of human behaviour.' This is the language of taboo violation, not of the criminal law, even allowing for judicial histrionics. The artist was gaoled. Upholding one piety, respect for the dignity of the dead, had thereby led to the violation of not one but two others, respect for art-making, and indeed respect for the dignity of the living (conditions in UK gaols are, with rare exceptions, appalling).

Third, in our recoil from these works we become aware of our limitations, that is to say, the limits of what we can tolerate. It is in our reaction to what is disagreeable that we most readily discover ourselves. Confronted by images to which we warm, we experience an unconfining; an emotion of enlargement. Beauty is a 'greeting', it fills the mind yet invites the search for something beyond itself, says the critic Elaine Scarry. But confronted by something that troubles us, we draw into ourselves, and the work discloses a boundary that is the limit of ourselves. When we recoil from such work, we are not just turning away from something that is horrible. The work makes visible to us

our own boundaries, the contours, so to speak, of our own personhood. When we turn away from this work we are thus turning away from ourselves. This is both impossible and unavoidable. How can we emancipate ourselves from ourselves? Taboo-breaking art can thus cause acute but unresolvable psychological discomfort, while also challenging us to admit this discomfort into the repertoire of our aesthetic responses. If we lost our taboos we would be unrecognisable to ourselves: this art gives us the vertiginous experience of our own otherness. So while the ZERO artist Gunther Uecker may write, 'I have tried to attack certain taboo areas in order to create ever new associations of consciousness', the truth is that only rarely do works with this ambition lead us towards any sense of new possibilities. More usually, their effect is to induce a momentary anxiety about our grip on given actualities. And in that moment we may find ourselves responding in the same absurd, farcically reactionary manner as the Madrid crowds who, rioting against new freedoms given by the 1814 constitution, cried, 'Give us back our chains!'

Fourth, because taboo-breaking artworks often present a spectacle of excess, a passing beyond limits, one in which the spectator is not invited to participate, but instead must observe, apart, alienated, even repelled. This is a post-Christian art, one for which the Crucifixion can no longer provide the ultimate test of our capacity for enduring spectacles of violated order. Excess provides a source of comic effects; it is the origin of all impropriety. The *Documents* group glossed 'excess' as everything that does not 'amply make room for daily life and its hurly-burly of deals endlessly concluded'. It is characterised by an extremism of action and emotion that threatens good taste, political order and reason itself. It is in this account of excess that, say, the performance art of the Vienna Actionists and the video art of Paul McCarthy may be located. They posit a kind of behaving that is entirely without restraint or purpose, and then stage a fantasy of that behaviour for our consumption. It is transgressive, *regressive*, art. 'It is impossible,' Bataille wrote, 'to behave differently to the pig rooting in the slop-heap.' One of the Actionists, Günter Brus, defecated while singing the Austrian national anthem, then smeared his body with his waste. Prosecuted, his defence was that he had brought the secret act of defecation to general awareness. This is a secularised version of holy folly; such artists avail themselves of the fool's privileges. They locate themselves, Brus writes, in a 'reality without barriers'. No longer content to paint on canvas, they lay hands on themselves. The one 'taboo' that this art does not assault, indeed,

Marisa Carnesky
Jewess Tattooess
2000

the one on which its performances are predicated, is the one that protects art itself.

Fifth, and this is the most difficult to capture, I believe that these artworks stimulate a certain cultural memory. When Paul, speaking on his Master's behalf, abrogated Jewish law, he did away with precisely those rules that many of these artworks symbolically violate. (By contrast, *actual* art-violations of Jewish law are likely to be too local, too specific to a particular set of cultural circumstances, to carry much of a transgressive charge. See, for example, the Jewish performance artist Marisa Carnesky's *Jewess Tattooess* [2000], the point of the work being that the tattooing is contrary to Jewish law.) Against the rules prohibiting contact with corpses or blood or the carcasses of animals, for example, they picture or present exposed bodies, bloodied or lifeless, unburied and unredeemed. Since Christianity's rejection of the laws of uncleanness, the prohibitions these laws encompass have only rarely, and never adequately, taken legal form. (They have, as Mary Douglas observes, been relegated to the kitchen and the bathroom and to municipal sanitation.) But to abolish the law is not to abolish the taboo. One just drives it under ground, where it lingers, its mandate withdrawn, potent but illegitimate. This is what Christianity did. Indeed, in rejecting Jewish purity laws, Christianity may be said to have rejected the principle of taboo itself, which of course then returned, violated, in a certain kind of transgressive art. This art is thus, in a certain sense, taboo's protest at its repression. Ernst, indeed, made a picture out of it: *Totem and Taboo* (1941). The indistinct forms of putrefying vegetation, which incorporate human profiles and torsos, thrust upwards in a jungle landscape. It is as if all the matter that should be disposed of, or kept out of sight – burned or buried – has been voided by the earth and has reappeared, in its rank decay. Ernst realises our taboos in his art. It is art's revenge against Christianity. The religion that once justified art, providing it with a legitimising context, has become art's self-chosen adversary.

Sixth, because taboo-breaking artworks, in contrast to those medieval and early-modern carnivals in which settled social hierarchies were briefly and symbolically subverted, do not have an assigned place within our culture, but instead float freely, taking us by surprise in a series of ambushes. While in modern society art breeds mistrust (as the critic Suzi Gablik has noticed), the

carnival caused no such anxieties. It took place around February each year, offering a prescribed respite from the rigours of the given order of society and followed by Lent fasting. The great Soviet critic Mikhail Bakhtin, celebrating in *Rabelais and his World* (1968) the carnivalesque (an event elevated into a principle), found that medieval men and women led two lives: the one, official, the other, of the carnival and public places. The first was monolithic, sombre, hierarchical; the second was full of ambivalent laughter, sacrileges, the violation of all things sacred, disparagement and unseemly behaviour, and familiar contact with everybody and everything. The rituals of the 'feasts of fools', for example, were a grotesque degradation of various church rituals and symbols and their transfer to the material bodily level: gluttony and drunken orgies on the altar table, indecent gestures, disrobing.

But the carnival was planned for, its duration was finite, it changed nothing. It turned the world upside down, and then turned it back again. It was regulated chaos. Indeed, it affirmed the very order that it mocked, both by demonstrating what the social order could encompass, and by playing its own extravagant, vicious variations on the social order's own most sanctioned practices, such as the quotidian persecutions of the Jews (which was

Max Ernst
Totem and Taboo
1941

why the French revolutionary Jean-Paul Marat described it as a festival fit only for enslaved peoples). We, however, do *not* lead lives sanctioned by custom and by the institutional authority of church and state. Taboo-breaking works, in consequence, elude our moral calendar. They do not invite our participation, they are not traditional, we cannot 'place' them. They affirm nothing, they cut us adrift. They tend to be forbidding works, and their jokes (their *blagues*) are only tenuously related to the laughter of the carnival, which was, remarks Bakhtin, a victory over fear, in all its forms: mystic terror of God, awe at the forces of nature, oppression and guilt regarding all that was consecrated and forbidden. Laughter punctured divine and human power, prevailed over authoritarian commandments and prohibitions, defeated both death and punishment after death. It clarified consciousness and opened its partici-pants' eyes to the future. It was the precursor of a permanent liberation. But it itself then vanished. There are traces of this laughter in Surrealism, though its character has changed in several respects. It is random; it is without institu-tional support; it isolates the person who laughs from the generality of humankind. (André Breton, in the *Anthology of Black Humour* (1939), defines humour as 'a superior revolt of the mind'.) For the Surrealist, laughter is the means by which we avoid the expenditure of feeling demanded by pain. It is a response to suffering, not a break from it. It is the mortal enemy of sentimen-tality. It is savage and pitiless, and it finds exemplary expression in the work of de Sade. It realises itself in mockery, and its audience is often its butt.

Seventh, art itself is the beneficiary of a distinct set of pieties that are protective of artwork and artist, conferring on both an exalted status, even a spiritual one. The cultural critic Jacques Barzun once briskly remarked that 'it was that overrated sentimentalist Albert Camus who said that only artists have never harmed mankind'. Barzun demurred, correctly, but with too much despatch. Camus was expressing a piety about art that cannot so lightly be dismissed. The artwork enchants, as perhaps magic once did. Crimes against artworks thus tend to be experienced as assaults not just on private property but also on certain collective values and goods: the pleasure that we take in art, its capacity to enhance our lives, its implicit celebration of the power and gifts of the imagination, the moral relation we establish with the artist through his work. Such crimes cause particular dismay (hence our horror at certain acts of iconoclasm). Artworks both explain the world to us and make us at home in it; to destroy an artwork is an unusual act of dispossession, leaving desolate not

just its owner but a much wider circle of adherents. It is destruction, of course, but it is also desecration. Our deepest response to an artwork is likely to be one of love. So when the work breaches some other piety, our values will collide, leaving us perplexed and shaken.

When the British artist John Latham made artworks out of books that he had destroyed, he engineered just this collision. It was both ingenious and reckless of him. He burned book towers outside the British Museum, intending thereby to invite us to surrender our typically compartmentalized thinking. He made a wall-relief out of the charred remains of books, *Untitled Wall Relief* (1963), with the same purpose. He chewed up and spat out a Clement Greenberg book, and then exhibited the remains, along with related material. These perverse destructions are deeply upsetting, violating our tacit belief in the indivisibility of art, in the preciousness of books as repositories of learning and culture, and in the communicable wisdom of previous generations. Such art transgressions break one barrier, but erect others, dividing artist from audience, artwork from art itself. And our response is one of dismay, perhaps even of consternation. We shudder at these barriers thrown up, divorcing humanity from humanity, splitting the race of man into two (to adapt some lines from William Wordsworth).

In 1977, a gallery-organised art event took place in the former Kosher Luncheon Club in London's East End. (The club, which had closed down three years earlier, was next door to a synagogue, itself long disused.) Two women, seated at a table on a raised stage, were engaged in stamping old books with large rubber gadgets. These prayer books, burial registers, receipt books and other archive material were the abandoned property of the Great Garden Street Synagogue. Stamping each page, the women then ripped them out and threw them on the floor. Protest from a person in the audience brought the event to an unplanned conclusion. Called to the site, confronted by the objector, the organisers of the event apologised. They did not appreciate, they said, the significance of these particular books. The desecration was unintended, they added. But in its folly, it resonated with other desecrations.

Only an amnesiac art-making practice, one that lives in an ahistorical present, and for which the transgressive reflex (barely, any longer, an aesthetic) is the sole imperative, could sanction such proceedings. Thirty-six years earlier, on 27 August 1941, in the Lithuanian capital of Kovno, the Germans captured stray dogs and cats and brought them into a yeshiva, a

Jewish house of study, where they shot them. They then forced the students and their rabbis to tear up a Torah scroll and to use the sheets of parchment to cover the carcasses of the animals. Other Jews were taken to the scene and forced to watch. Many of these witnesses later went to the rabbi of Kovno and asked him to specify what penance they should do. Those who saw the scroll being torn had to rend their clothes; those who heard about the dese-cration from others had to contribute to charity (as also did those too weak to fast). The community as a whole was exhorted on the following Shabbat to repent. There is an art that answers to events such as these, but it is not, cannot be, a transgressive one. It is instead an art of witness and of memory, one that concerns itself with symbolic gestures of repair rather than violation, of sanctification rather than desecration. It is an art of piety.

In Book III of *The Histories*, Herodotus tells the story of the sacrilege com-mitted by Cambyses, the Persian king, when he was in Memphis. He broke open ancient tombs and examined the bodies, and entered the temple of Hephaestus in order to jeer at the god's statue. He also entered the temple of the Cabiri, which no one but the priest was allowed to do, and made fun of the images there, actually burning one of them. To Herodotus this is evidence of derangement. It is the only possible explanation, he observes, for the king's assault upon, and mockery of, everything that ancient law and custom had made sacred in Egypt. Everyone, comments Herodotus, without exception believes his own native customs, and the religion he was brought up in, to be the best; and that being so, it is unlikely that anyone but a madman would mock at such things. To the madman, we may now add: the transgressive artist.

Demoralising the Artist

By 'the transgressive artist', I mean all such artists, without restriction as to time, school or location. The risk to the audience of demoralisation is especially great with taboo-breaking transgressive artworks. It is there for the audience of a Manet work, as it is for the audience of a Chapman Brothers work. What, though, of the risks of demoralisation to which the *artist* is exposed? All artists, transgressive and non-transgressive alike, risk being demoralised by their audience's rejection or scorn. The disconsolate artist, humiliated by the neglect or contempt of the art world, is a familiar enough figure. But there are distinct, additional risks for contemporary makers of transgressive artworks, risks that arise in consequence of their works'

belatedness. For a number of decades now, artists have asked themselves the question posed by David Sylvester in a 1958 radio broadcast: 'Is art still possible, or is it too late now?' When they answer the first question affirmatively, as they must, they risk inconsequence, triviality. That is, transgressive artists in particular risk that their artworks will be academicist, or that they will lose themselves in pursuit of mere shock, or that they will be driven to repeat, in reluctant imitation, certain effects of predecessor art, or that being at the terminal point of a certain development, they will discover, indeed, that they have nowhere to go. Much contemporary transgressive art is made in acknowledgment of, and in response to, just these risks. The best of this late art is, as a result, inventive, resourceful, sometimes desperate, edgy, reckless; the worst is duplicative, shadowy, anxious, even at times fraudulent.

This is, best *and* worst, a demoralised art, made either without expectation of disturbing its audience or in single-minded pursuit of that end. It tends to be characterised by an extravagance of presentation, often allied to a poverty of conception; typically, its ingenuities are secreted within a larger predictability; there is a certain straining for effect. It arrives at the moment at which all the obvious, all the readily available, possibilities of the transgressive aesthetic have been exploited. It comprises both remarkable work and dull work, but it does not quite comprise an integral body of work. It is a demoralised art, then, in this further sense: it has ceased to constitute a project. It has fractured into myriad micro-practices; the last *body* of transgressive artworks was made by the Surrealists. New transgressive art does not contribute to any collective art endeavour. It has become a lonely, isolated art, appealing mainly to maverick or self-destructive sensibilities (hence its tendency to throw up celebrity artists). In recent decades, *non*-transgressive artworks have been made that may be defined, at least in part, precisely by their absence of exposure to just these risks. Their makers are artists who may be supposed to have forsworn, for one or more reason, the transgressive aesthetic in favour of another. Some have done so because they want to make artworks that are responsive to the Holocaust, which is indeed impossible from within a transgressive perspective.

I consider this further at the end of the chapter. In the next few pages I explore the dimensions of this new, demoralised transgressive art. To summarise, I conceive of it as striving to assert itself against an art-world consensus that the endeavour to which the transgressive artist wishes to

contribute is over. This consensus is evident, paradoxically enough, in the over-use of the word 'transgression', the very pervasiveness of the notion of the 'transgressive', as the specificity of the individual artwork is masked by a generalising, clichéd art vocabulary, one that recasts every work as the same, one work. That transgressive art has exhausted itself, that the avant-garde project has collapsed, that the very enterprise of art itself has in some sense been completed: these are art-world opinions that both reflect and influence developments in art itself. (Call this the 'exhaustion problem'.) The transgressive artist may make a number of responses to this problem. First, the problem; then, the response.

The Problem

Over the last few decades, there has been a certain playing-out of the logic of the transgressive. What, for example, is Edward and Nancy Kienholz's *Still Live* (1974) but the *terminus ad quem* of a certain art-enterprise of exposing the audience to sights that shock or dismay it? This installation invites the spectator,

Jeff Koons
*Inflatable Flower
and Bunny*
1979

having signed a legal release, to sit in an armchair facing a loaded rifle timed to fire at a random moment within a hundred years. 'I have long been interested,' explained Edward Kienholz, 'in making an environment that could be danger-ous to the viewer.' The artist speaks on behalf of the transgressive art project itself. It too is committed to the making of dangerous environments, though the danger is rarely so literal, so grossly corporeal. Likewise, in relation to the interrogative art project, the interrogative rule-breaking initiated by Duchamp, and advanced by Warhol, has now been concluded by Koons. Warhol is Duchamp's true successor: in the commercial undertaking that defines much of contemporary art, Duchamp is the inventor, Warhol the entre-preneur. And Koons, in turn, is Warhol's successor. Duchamp's readymades are objects that had, before they were appropriated by the artist, a certain evident utility and were not products rooted in contemporary consumer culture. Warhol's readymades were utterly contemporary, but likewise had a certain utility. Koons's readymades are contemporary, but have no utility: they are items of junk-luxury, that is to say, examples of kitsch. To identify the line,

consider *In Advance of the Broken Arm* (1915); *Brillo Boxes* (1964 and 1968) and *Inflatable Flower and Bunny* (1979). There is of course no tension between Koons's bunnies and spaniels, and his clinches with his former wife, Ilona Stoller. Self-exposure, the confessional image and the revelatory word, is itself an aspect of contemporary kitsch.

The French artist Amédée Ozenfant warned, in his *Foundations of Modern Art* (1931), that 'we must beware lest new and futile obligations be forced upon us. It would seem that this is exactly what the academic attitude to revolution in art does stand for. The art of storming nonexistent Bastilles quickly becomes "vieux jeu".' What does it mean to storm a nonexistent Bastille? The Bastille was one prison among others in Paris, housing an eclectic group of offenders. When it was stormed, few prisoners were in residence to be liberated. This historical Bastille coexisted with the more fearsome, symbolic gaol of the same name, representative of the radical indictment of the *ancien régime*. It helped to define for opponents of state power, Simon Schama has explained, the vices of the monarchy: arbitrary, obsessed with secrecy, vested with capricious powers over its citizens. Beyond this revolutionary context, the prison continues to represent everything that is benighted, stifling and despotic, or more generally still, whatever may be said to inhibit the imagination or enslave the soul. To storm such a place would be to earn the title of emancipator. But what, then, of a nonexistent Bastille? For Ozenfant, it is an institution of the assailant's imagination, a fiction devised to justify the clamour and violence of his enterprise, or more precisely, the novelty and merit of his art-making. It has become the convention that artworks are made by the violating of art's own institutions, its rules, its protocols and its authorities. This is doubly misconceived, Ozenfant implies. First, because art does not have to be made according to this prescription. But second, because there are, in any event, no rules left to be violated. Ozenfant's scornful reference to 'the academic attitude to revolution in art' rehearses a well-established story.

It is a version of the story that each generation tells its successor generation: all the essential battles have been won. The story of the triumph of the avant-garde and its consequent extinction has been recited sufficiently often to have acquired the status of received wisdom. In its simplest version, it relates that, first, there was an academy, and then second, there came the avant-garde, which opposed the academy and everything that it represented. It was radical and subversive and the source of everything that was fresh

and challenging and new. As Malraux put it, painting progressed from academicism to modern art. In time, avant-garde art prevailed in its struggle with the academy, and in doing so, ceased to be either radical or subversive. A slightly more complex version of the story acknowledges both that this single avant-garde was no more than a composite, made up of a succession of distinct avant-garde movements, each antagonistic or at least wary of the others, and that the struggle with the academy was marked by reverses, the reign of the avant-garde being punctuated by moments of anti-modernist creativity, an intermittently productive 'backward march'. Then this alternating ceased, and the avant-garde and the academic merged. This is where we are supposed to be now. Capitalism has at last dissolved the opposition between system and transgression (which was Marx's great insight). The avant-garde enterprise, however elastically defined, can no longer exceed the capacity of the art world to absorb it, nor can this subversive endeavour distinguish itself within a culture defined by subversiveness. No transgression without interdiction, one might say. The thesis is confirmed by American avant-gardist Cindy Sherman's lament: 'I wanted to make it very clear what my concerns were about, and try to be different and challenging. I've always been so well received publicly that it started to bother me. I wanted to make something that would be hard to be well received publicly. It's still been pretty well received.' The avant-garde artist is condemned to produce, in Ozenfant's sense of the word, 'futile' artworks.

This is the consensus view. In *The Origins of Postmodernity* (1998), Perry Anderson typically proposes that, in the absence of an academicist establishment against which to pit itself, principled avant-gardism was destined to collapse. Now occupying its place, but as no more than a squatter, is the pseudo-avant-gardism of a certain kind of attention-seeking young artist: 'the title and site of the most deliberately lurid brat-pack show in Britain says everything: *Sensation* – care of the Royal Academy.' And so sentence is passed, over and again, on everything that is new and purportedly insurgent. The contemporary avant-garde – or what passes for it – can now do no more than stage 'bourgeois spectacles' (the critic Hal Foster), or 'dissipated scandals' (the artist Robert Smithson). A recent *Art Newspaper* headline, over a report on the high prices obtained at auction by works by Maurizio Cattelan and Chris Ofili, exclaimed: 'Transgression + Media Coverage = Big Bucks'. And so, though the somewhat spectral notion of the 'academic' is still available as a scare word –

TELJESITEM A KÖTELESSÉGEM TELJESITEM A KÖTELESSÉGEM

Emese Benczùr
I Am Doing my Duty
1995

as in, 'a new academy claims the walls of our galleries and museums' (a 1979 editorial in the art journal *October*) – the academy now tends to be regarded as nothing other than the new home of the avant-garde. It is thus the place where protests at a similarly bogus 'academic' art ethic may in safety be made. During her final term at the conservative Budapest Art Academy, for example, the contemporary Hungarian artist Emese Benczùr embroidered the words 'I am doing my duty' each day on a curtain border, and then hung it around the exhibition hall below the other students' paintings. This was both an unexceptional and an unexceptionable work.

New artworks are made all the time. But this has not prevented some thinkers about art to conclude that the project of art itself has ended. We are said now to live in posthistorical times. This 'end of art' thesis was advanced by Arthur Danto in 1984, and then later both taken up by others and further refined by Danto himself. The critic Donald Kuspit has argued, for example, that every boundary has been blurred or erased, leaving no further boundaries to assault. (He postulates 'idiosyncrasy' as the 'final frontier', which makes only paradoxical sense.) An earlier, influential version of the thesis was proposed by Hegel. For this early 19th-century thinker, history is best understood as the unfolding of human self-understanding. After extensive preliminaries, consciousness realises itself progressively in art, then in the Christian religion, and finally in philosophy. But while Hegel's aesthetic is thus to be located within a far more inclusive metaphysic, Danto's is not. The latter is a theory about the specific capacities of the art project, about, that is, what art itself wants, and it is complete in itself, save that – as with Hegel – for Danto art in due course is succeeded by philosophy. 'Philosophy', Danto argues, has disenfranchised 'art'. This notion of art is, he admits, a 'heavy metaphysical conceit'. It is art with a capital 'A', one that has only two periods, the

period of mimesis, and the period of theory. It is upon the completion of this second period that art gives way to philosophy. In the first period, art's object was to give the most accurate account of reality. That ended when photographs and films proved impossible to rival. In the second period, art investigated the conditions of its own existence. This art was reflexive, and inward-looking in its explorations. It ended with Warhol's *Brillo Boxes*, physically indistinguishable from the Brillo boxes on sale in supermarkets. In the last decades of this second period, artists overran every boundary in art and exceeded every limit of what art could be. All the constraints gave way. This means that there are now no longer any *a priori* constraints on what an artwork can be; art rule-breaking art has a past, but little future. Anything visual can be a visual work. The single story of art has come to an end. In its place, there are now innumerable stories, none advancing 'art' as such. Danto calls this a 'certain kind of closure'.

For Danto, this post-terminal condition is good news. It is now open for artists to be what they wish, without the burden of continuing the master-narrative. They have no duty to art; they can now serve human needs. They no longer have to make works that are (in David Sylvester's phrase) relevant to art's future. The price that they pay for this freedom, however, is a somewhat diminished status. They are no longer committed to a project greater than themselves. 'Art' is now no more than a composite of individual styles. Today's artists are no longer indentured to their vocation, they are entrepreneurs in an art world that is also an art market. They can choose to be Pop artists, Abstract Expressionists, realists or indeed anything else they like. They are free to do as they wish, and so live in an inconsequential paradise. Or so the thesis goes. It is not one that is invulnerable to criticism. Danto's account of art's second period is arguably too limited; even if his periodising is correct, it does not preclude the possibility of a third period, one that would carry forward art's 'story'; the past is endlessly being written and rewritten as history, and Danto's writing of art's past may in due course be supplanted by a rewriting that attends to certain of its other aspects. But notwithstanding these demurrals, Danto is persuasive on the terminal course taken by art's self-interrogation, and – perhaps just as importantly – his thesis has contributed to that ambience of belatedness that afflicts the contemporary artist (Danto is, among other things, the art critic for the American magazine *The Nation*). What then is the artist, and in particular the transgressive artist – my special focus – to do?

The Response

The transgressive artist's response to what I have defined as the exhaustion problem tends to be one of denial. This is as it must be, if he is to be of good heart and not abandon his sense of vocation. He trusts that his denial will have creative consequences. He may thus attempt to extend a particular art enterprise, perhaps by appropriating and revising an artwork exemplary of an earlier moment in that enterprise, in the hope that the appropriation will be interpreted as a creative deformation of that work. He will assert, against art-world nay-sayers, that the logic of a particular transgressive project *can* be developed further. For example, the American artist Mike Bidlo's *Not Andy Warhol (Brillo Boxes)* (1995) attempts a certain effect of spirited despair, as if to propose that the only new images that are left to be made are those that both reproduce and yet are not already given images. Artists who commit themselves to this response may also find themselves engaged in the playing of tiny riffs, minuscule variations on a set of themes quite spent. Consider, for example, the contemporary British artist Mark Wallinger's *A Real Work of Art*. This is a racehorse part-owned by the artist, and the title of the work is the name that he bears. He is a special kind of a Duchampian readymade, partly because he is a living creature, but principally because as a highly prized thoroughbred he will have been the object of a certain kind of aesthetic appreciation even before being appropriated as an artwork by Wallinger (which, of course, makes questionable the purity of Wallinger's Duchampian jest).

Or the transgressive artist may attempt to counter established transgressive practices, reversing them as a means of reanimating the transgressive principle itself. Artists and art writers find themselves grappling with paradoxes when endeavouring to express this ambition and the dismayed pessimism that lies beneath it. So Anselm Kiefer, for example, asserts that 'to be subversive in the sense of Dadaism would be reactionary, because now it would be the attitude of model students.' It has thus been proposed that, when the avant-garde declines into orthodoxy, the academic becomes subversive. This is what John Nava's *Dancer (Teresa)* (1992), for example, is said to be about. The affirmation of the rule against its customary infringement becomes the necessary, transgressive gesture. Transgressive artists will want to adopt 'academicist' disciplines, so it is suggested, in order to resist the routine anarchy of the art world. They will violate a normative rule-breaking. The transgressing of 'transgression' is itself transgressive, because transgression

Opposite, top
Mike Bidlo
*Not Andy Warhol
(Brillo Box)*
1995

Opposite, bottom
Interior of Mike
Bidlo's studio,
with copies of
masterworks, 1987

John Nava
Dancer (Teresa)
1992

itself is a rule-bound practice. We are invited to contemplate the vertiginous thought that the exceeding of boundaries itself represents a notional boundary to be exceeded. Conformism becomes deviance, and religious devotion a Dadaist gesture in the face of quotidian sacrilege. This was, indeed, Dalí's declared ambition at one time, and his complaint about the Surrealists: 'in dreams, one could use sadism, umbrellas and sewing machines at will, but, except for obscenities, any religious element was banned, even of a mystical nature. If one simply dreamed of a Raphael Madonna without any apparent blasphemies, one was not allowed to mention it.' Yet can one pass full-circle – in Dalí's case, reverting to a simulacrum of simple piety – while remaining distinct from that first, law-bound point of departure?

Or the transgressive artist may treat the project itself as his subject, so that his work becomes a contribution to a meta-project, say, by a parodic

presentation of the project's essential features. There is a more promising transgression of the transgressive here than in the mere switching of terms in the binary couple, 'academic: transgressive'. Paul McCarthy's oeuvre, precisely because of its comic excess, may be interpreted in just such a manner. It takes transgressive art *so* far, to such ludicrous, ludic extremes, that it prompts in its audiences the critical thought: what does it mean to describe an artwork as a transgressive work? It does this by a kind of puerile resourcefulness, and is thus a substitute for less immoderate inquiries into just this question (such as the book you are now reading). It is precisely because *The Garden*, let us say, cannot be taken seriously as a transgressive work – sex with a tree? – that it permits us to glimpse the very form of the transgressive project.

Or the transgressive artist may resort to administering shocks to his audience, believing that the specific kind of novelty provided by surprise is a novelty worth striving for. Indeed, it may be, if only in the sense that in a culture that prizes new sensations this belief is likely to be shared by the artist's audience. Against the burden of transgressive art's given history, and the obsequies of writers on art, the temptation to go for simple shock is strong, even perhaps compelling. 'Shock art' tends to be taken these days as a distinct genre; to the extent that this is so, however, it is the consequence of a certain fetishising of one aspect only of avant-gardism. (Miró, for example, once said: 'Above and beyond all, it is the visual shock that counts. Afterward one wants to know what the artwork says, what it represents. But only afterward.') It also has the effect of somewhat eliding the different kinds of shock that art can deliver. There are artworks that are simply repellent, ugly in a way that one would never want to revisit. The disgust they induce is the limit of their interest; we are likely to conclude of them that we would simply rather not have known of their existence. There are artworks to which we can return for instruction once the jolt that they have delivered has passed; it is a matter of familiarity – the aesthetic equivalent of the medical student and the cadaver. There are artworks that seek to shock as a means thereafter to anaesthetize, as in Warhol's pictures of wrecked cars and planes. (As Warhol himself observed, 'when you see a gruesome picture over and over again, it doesn't really have any effect.') There are shocking works to which one returns in order to contemplate their *non*-shocking qualities: their relations to other works, their formal properties (colour, form, etc). There is the experience delivered by horror movies, where there is pleasure to be had in being scared; one peeps at the screen through

latticed hands. And there are works that exist to meet a certain 'bourgeois' demand for novelty, what Claes Oldenburg correctly dismissed as the kind of work that disturbs a little bit but is then assimilated into the repertoire. And last there are those works that shock as a preliminary to putting the audience in danger. In such instances, the quality of threat will be preserved.

The commonest kind of shock art is one that combines the intertextual with the sensational. The films of Quentin Tarantino are exemplary of this kind. An artwork's 'intertextuality' draws the viewer's attention to its relations with other artworks, thereby identifying itself to the viewer as an aesthetic object. An artwork's sensationalism, by contrast, arrests the viewer's attention in the immediate experience of the work itself. In film, this means the demand that we submit to the illusion of reality at 24 frames a second, while the inter-textual provides us with the means by which we may resist that demand. We are not obliged to take film's illusions as reality unconditionally. Tarantino's compelling, energetic films mix these contradictory aesthetic effects. They derive their force from their ability to affect us – indeed, to be direct assaults upon our sensibilities – and yet also to achieve a powerful intertextual reso-nance. They disturb *and* cite; we cower *and* make connections. Shocking, scaring, film audiences has been part of the aesthetic of the cinema since its inception. Films are events that happen to their spectators. In *Theory of Film Practice* (1973), Noel Burch analyses the forms of aggression the film image is capable of inflicting on the victim-viewer. Pain, he asserts, is part of aesthetic experience. When the pain is acute, it paradoxically returns the viewer to the intertextual, if only defensively, as he reminds himself, 'It's only a movie.' But by then, as Burch remarks, it is too late: 'the harm will already have been done; intense discomfort, and perhaps even terror, will have crept across the threshold.' Burch's example is the prologue to *Un Chien andalou*; we might take as our own examples the ear-slicing scene in *Reservoir Dogs* (1991) or the needle in the heart scene in *Pulp Fiction* (1994). And yet, for example, *True Romance* (1993) declares its debt to *Badlands* (1973) and *Blood Simple* (1984). The very casting of *Reservoir Dogs* announces the film as implicated in a certain genre: Lawrence Tierney, star of many gangster movies, plays Joe Cabot, while the ex-convict turned novelist Eddie Bunker plays Mr Blue. Tarantino's films make victims *and* critics of us.

The avant-garde artist hopes, says the critic Peter Bürger, that his artwork will shock its audience into self-interrogation and thereby usher in changes to

their lives. But, Bürger objects: shock is generally nonspecific; the typical reactions of the audience are either furious distaste or an aggrieved perplexity; the effect of shock is likely to reinforce existing attitudes, not dislodge them; shock is temporary and hard to repeat – nothing loses its power more quickly than shock. Our wariness before the avant-garde work, our anticipation of precisely that shock that it has in store for us, creates a kind of affective impasse, as our receptiveness to the work collides with a certain resistance to it. We are open to the work and yet we are also apprehensive of it: an impossible, unstable combination. In consequence, our impression of the work will be limited to the moment of exposure itself and is unlikely to modify our sensibility. We will remember the shock, but the work itself will have left no mark. This ephemeral nature of shock, its insubstantiality as an aesthetic imperative, is thus likely to dismay the artist too. He will want his work to make a somewhat more lasting impression on its audience. Art's capacity to demoralise its audience thus demoralises its maker as well.

Or, finally, the transgressive artist may make his denial of belatedness radical, appropriating the very 'end of art' thesis as his own and asserting: with me, art has a new beginning. The transgressive art made by previous generations is now obsolete. I must start over; the project begins with me. No painting, Duchamp once remarked, has an active life of more than 30 or 40 years. Once that period has expired, it loses 'its aura, its emanation', and is either forgotten or becomes part of art history. By implication: art renews itself in new art. Artworks cease to challenge, giving way before fresh works that deliver fresh, art-prescribed shocks. Formerly taboo-breaking artworks no longer scandalise, and new work is needed to dislodge contemporary audiences out of their complacencies. The greater art project of boundary-disturbance requires new artworks to take the place of old ones. Frequenters of gallery openings might well conclude that this indeed is the premise on which much of contemporary art is constructed. Certainly, new taboo-breaking work meets the need of contemporary artists themselves to violate the taboos violated by their predecessors. There is a pleasure to be had in the making of such artworks that mere contemplation of other taboo-breaking artworks does not deliver. This may lead to the encouragement of an art-amnesia. American critic Rachel Gurstein does not go far enough when she writes that 'literary transgression has become such an empty ritual that the new poets no longer remember the icons they are shattering'. (For 'literary' read 'art-making', and

for 'poets' read 'artists'.) It is not that they no longer remember; it is rather that they are obliged to forget. They must forget, that is, as a condition of making transgressive work, and they depend upon a similar suppression of cultural memory by their audiences.

Art's Vulnerability

In 1862, Napoleon III sent troops to Mexico to enforce the repayment of debts owed to France. It was a pretext for conquest, like so many other imperial ruses of those and other times. His troops very quickly subverted the new republic and forced the president to leave the capital. By June 1864, Archduke Ferdinand Maximilian, brother of Franz Joseph, emperor of Austria, had been installed in Mexico City as emperor. It seemed to the world as if, with one bold stroke, France had succeeded in both challenging American hegemony and creating an alliance with Austria. But then Louis Napoleon lost his nerve. He could not hold what he had won and withdrew his troops, leaving Maximilian defence-less. The Mexican Juaristas, armed by the United States, captured the emperor and executed him on 19 June 1867. His final words, spoken before his firing squad, were 'Long live Mexico! Long live Independence!' In Europe, Maximilian was regarded as an innocent, tragically betrayed by the incompetent

Edouard Manet
The Execution of Maximillian
1867
(London version)

intriguing of Louis Napoleon. He was admired for the nobility of his death, while his erstwhile backer was scorned for the ineffectual trickiness of his stratagems. The Mexican enterprise was described as 'la grande pensée de Napoléon III' and it was a bloody fiasco. It was the most ambitious project of Napoleon's career, and it was an unqualified failure.

Manet's response to this affair was to paint *The Execution of Maximilian*. Or rather, to paint in 1867–8 a number of executions of Maximilian. There are three paintings, and there is also a lithograph and an oil sketch. Common to the paintings is the image of the former emperor and two of his generals facing the Mexican firing squad. But while in the first painting (which is now in Boston) the soldiers wear guerilla costume, in the second (in the London National Gallery) they appear to be wearing French uniforms. In the first picture, the squad is armed with US Springfield muskets, whereas in the second, the soldiers have standard French infantry muskets. The third version (now in Mannheim) adds a backing wall. Of the second version, only four fragments remain: the shooting party, the soldier standing to one side, ready to administer the *coup de grâce*, and the head and part of the body of General Miramon, executed alongside Maximilian. The painting of Maximilian's execution was the most ambitious project of Manet's career, and it was an immense success.

The pictures could not, however, be exhibited. There was vigorous censorship in France of images of the Mexican affair. Photographs of the execution squad were banned, as were photographs of the emperor's clothes, which bore the holes of the bullets that killed him. It was in this political climate that the following item appeared in a Paris art journal:

M. Edouard Manet has painted the tragic episode that brought our intervention in Mexico to a close... It would appear that this lamentable event has still not become accepted history, since [he] has been informed that there is every likelihood that his picture... would be rejected at the next Salon if he insisted on presenting it. This is strange, but what is even stranger is that when [he] executed a sketch of this picture on a lithographic stone, and the printer... presented it for registration, an order was immediately given that the image should not be authorised for sale, even though it bears no title.

Zola commented that the censors had responded to the work's cruel irony, which by the uniform and arms of the squad showed France shooting Maximilian. By 1873, Manet had concluded that the picture (in any version) would probably never be shown. It was, said his wife, 'an impossible project'. Though the third version was exhibited briefly, and to little effect, in the United States, it remained unseen in France, except by a few of the artist's friends.

The Execution is an attacking work, attacked. The point-blank range at which the squad fires is the equivalent of picture-viewing distance, as Michael Fried has pointed out. But who then is the attacker, and whom the attacked? Audience and artist each perform both roles. The picture can be read, that is, as an attack on the artist by his audience and as an attack on the audience by the artist. This doubleness reflects the actual relations between the two. Manet himself, in his relation with his audience, was both victim and aggressor. His works were condemned by juries, mocked by critics and rebuffed by the public. (Manet to Baudelaire, in March 1865: 'Insults are beating down on me like hail, I've never been through anything like it'; and to Proust, a little earlier, anticipating the reaction to *Le Déjeuner*: 'They'll slaughter me.' A contemporary wrote that *Olympia* was 'the victim of Parisian lynch law'.) They were also taken to be assaults on juries, critics, the public (the precedent for Edward and Nancy Kienholz's *Still Live*?). They were both targets of hostility *and* expressions of hostility. Fried describes *The Execution* as offering a 'metaphorics of spectatorly aggression'. He also regards it as a 'real allegory' of Manet's enterprise. Manet's second, mutilated version offers a further allegory, one particular to the history of its own misfortunes. Distinguish between the reception-history and the material history of an artwork – roughly, between how it is viewed, and how it is handled. While the two are related (if esteemed, artworks are more likely to be well treated), they are not the same. In the reception-history of the *Maximilian* project, the hostility to the work, so plainly local and limited in duration, faded fast, and the pictures hang, both undisturbed and undisturbing, in major galleries. The material history of the second version of the painting, however, is a chronicle of violations suffered and mitigated.

At some point during Manet's lifetime, the second version was damaged by water. As a result, following the artist's death his family allowed it to be cut up and dispersed. Degas hunted down four of the fragments and attempted a reconstruction of the work. (Degas, on contemplating the destruction wrought by Manet's family: 'Again the family! Beware of the family!') When

they were put up for sale at the posthumous auction of the artist's collection, they were acquired for the National Gallery by the British government. There they now hang, jigsaw pieces suspended on a blank mount. It is an ignominious history for such a subversive work. To begin with: suppressed, neglected, damaged, cut up, scattered. And then: retrieved, sold and finally exhibited in its dismembered, incomplete form by another imperial power, quite indifferent to the offence it caused a half-century earlier. Manet's work has fallen victim to the 'museum effect', abstracted from all contexts, inviting only the purest, most disengaged of gazes from its passing audience. The painting's history is thus a veritable catalogue of the indignities that an artwork can suffer, the last being the most disabling. It once was witness to an injustice and had to be repressed; it now is merely witness to its own, and thus to art's, vulnerability.

Jacob Epstein
Sculptures for the British Medical Association
As seen after 1937

This has been the fate of other representative transgressive works of the modern period. Jacob Epstein's 1908 sequence of nude sculptures for the British Medical Association building survived the immediate, widespread and hysterical opposition of newspapers and other moral vigilantes, as it did the somewhat later, more cautiously expressed, disapproval of the building's new owner. But when, in 1937, stone from one of the works fragmented and fell to the ground, the sequence was 'made safe', that is, vandalised, by a party that included the then President of the Royal Academy. Klimt's *Medicine* and *Jurisprudence* were among works destroyed by retreating SS troops when they set fire to the castle where the works were housed for safe-keeping. Francis Bacon's *Painting* (1946) has become immobile through age, its material infirmity in radical contrast with its continuing potency as an image. A headless carcass looms crucifix-like above the concealed head of a robed man, with microphones and sides of meat occupying the foreground. At the time of making this work, Bacon did not know that when pastel is used along with oil paint it adheres better to the surface if the artist works

Francis Bacon
Painting
1946

Damien Hirst
The Physical
Impossibility of Death
in the Mind of
Someone Living
1991

on the reverse side of a primed canvas, as David Sylvester has explained. This was not done, however, and so the work is now too brittle to be moved. Such fragility, such energy! And then there is Damien Hirst's *The Physical Impossibility of Death in the Mind of Someone Living* (1991). The shark is decaying. It smells, it is green, and a fin has fallen off. It is an attacking work, deteriorated. This is transgressive art's predicament: how to combat its own vulnerability. But there is a *non*-transgressive art that takes just this vulnerability as one of its points of departure. It is derived from an aesthetic of impermanence, of vulnerability and of a certain artistic humility.

Against artworks' destructive capacities this aesthetic sets their fragility, their weakness, their passivity and the consequent risks to their survival. Their essential condition of inert givenness exposes them to harm. Artworks are always frail, even when they are subversive too. They are defenceless before the privileges of authorship and ownership, the self-justifying indignation of certain kinds of iconoclast, acts of wartime destruction and the intimidating

disapproval of the state. At risk of suppression, subject to legal constraint, liable to deterioration – the continued existence of most artworks is won (*when* it is won) against the odds. They are powerless before the dissatisfaction of their makers, the violence of owners and other vandals, and before time itself. There is a non-transgressive art that takes as its subject this powerlessness, and in particular the powerlessness of transgressive art, which has its own, special poignancy.

Let me offer a contrast between two artworks, for the purposes of summary exposition: Alighiero Boetti's *Me Sunbathing in Turin on 19 January 1969* (1969) and Ana Mendieta's *Silueta* series (1973). These works are self-portraits. Boetti's work comprises a figure created from hand-moulded balls of fast-drying cement, and a small butterfly that rests on its nose. The butterfly perches on a cement ball, while the cement balls themselves rest against an unyielding wooden floor. The work was first shown in the Kunsthalle, Berne, and then at the Sperone gallery, Turin, later that year. Secure within the art world, stored when not exhibited, protected from the weather and from circumstance, it is a work rich in privileges. By radical contrast, Mendieta's work is site-specific, defenceless before both the elements and the attentions of passers-by, and thus certain not to last. Its very posture of surrender, hands high, indicates its imminent disappearance. What we see is a photograph taken by the artist of a work that no longer exists. It is quite without the art-world privileges enjoyed by Boetti's work. The broken stones out of which it

Left
Alighiero Boetti
Me Sunbathing in Turin on 19 January 1969
1969

Right
Ana Mendieta
Untitled
from the *Silueta* series
1973

Jasper Johns
Catenary
(Manet-Degas)
1999

has been assembled will soon merge with those other stones that surround it. The contours of the work will blur and then vanish. These two works, in certain respects so similar, are the products of two radically distinct art practices, two radically distinct aesthetics. The one confidently, humorously, appropriates a low, man-made material for an art purpose. Setting one's work in concrete becomes an assertion of its claim to permanence. The other modestly, poignantly, borrows natural materials to make a temporary human sign. It is a trace on the ground, almost as short-lived as a drawing at the beach's edge. It defers to nature and admits its vulnerability as art.

It is not a matter of preferring one work over the other. They are both admirable and engaging, each in its own way. Indeed, they complement each other, and when brought together disclose a truth about art. Artworks have a capacity to affront and are highly susceptible to attack, two qualities that do not merely coexist but have a dynamic relation. Transgressive art will always also be vulnerable art, a fact that the transgressive aesthetic itself tends to suppress. The art that is now being made, and that has been emerging over the last

decade or so, explores just this suppressed information about art's vulnerability. I take Manet's *The Execution of Maximilian* to be exemplary of the suppression, and Jasper Johns's *Catenary (Manet-Degas)* (1999) and British artist Jo Spence's *Cultural Sniper* (1990) to be exemplary of its exploration.

A 'catenary' is a curve formed by a piece of string or cord of uniform width suspended freely between two points. It is a means of relating one such point to another, prompting thoughts about the connections between them, but of the lightest, least coercive nature. Though each point is independent of the other, the string makes a connection between them, one among a number that might be made. The hyphen in the title is itself a string that connects Manet to Degas, respectively, the maker and the salvager of *The Execution*. We may also imagine a further string, this one connecting Degas to Johns, who likewise seeks to preserve Manet's work, here in the medium of his own art. By honouring Degas, Johns treats as integral to an artwork a quality hitherto dismissed as contingent to its existence, that is, its vulnerability. Its exposure to risk is given an ontological weight by Johns. It is part of the definition of what an artwork is. Spence's image discloses transgressive art's stance of belligerent weakness. A naked woman, her face ineffectually masked, addresses the viewer with slingshot and stone. She is painted and snarling, and threatens violence. But her weapon is pitiful and she herself, notwithstanding her tensed stance, is unprotected. This is art unmasked. Spence has done that marvellous, rare thing: she has not just made an artwork, she has photographed art.

The prehistory of this non-transgressive aesthetic reaches back deep into the 20th century; it is also an aesthetic for the 21st century. To understand its potential is, among other things, to begin to understand the conditions for art's engagement with the Holocaust. Art that commemorates the Holocaust is likely to be of a kind that risks violation, one that is not so much transgressive as transgressed against. For example, there is a monument, known as the Mariensaule (Column of the Virgin Mary), in a square in the centre of the city of Graz, Austria. It was erected in the late 17th century to celebrate a victory over the Turks; it was the site of a celebration in 1938, when Hitler awarded the city an honorary title for being most stalwart in support of Nazism; it was the site of a commemoration in 1988, when the city authorities invited the city's population to remember Nazism's local victims. Working from photographs taken

Jo Spence
in collaboration with
David Roberts
Cultural Sniper
1990

Top left
Nazi rally
Eisernes Tor, Graz
25 July 1938

Above middle, above
and right
Hans Haacke
*And You Were Victorious,
After All*
Eisernes Tor, Graz
1988
Before and after
installation, and
after arson

in 1938, Hans Haacke replicated the structure, but added at the base the names of those dead. Within days, the structure had been fire-bombed. Though Haacke had taken precautions, these proved to be insufficient. Those responsible for the arson were convicted and gaoled. Do we not welcome the punishment of these transgressors? 'Transgression' feels the right word. The fire-bombing was an assault on the dead, comparable to the desecration of a grave.

Another memorial, *Monument against Fascism* (1986–93), made by Jochen Gerz and Esther Shàlev-Gerz, carried this inscription:

> We invite the citizens of Hamburg and visitors to the town to add their names here to ours. In doing so, we commit ourselves to remain vigilant. As more and more names cover this 12-metre-tall lead column, it will be gradually lowered into the ground. One day it will

have disappeared completely, and the site of the Hamburg monument against Fascism will be empty. In the end it is only ourselves who can rise up against injustice.

The column is no longer there. While the work's title mocked the pomposities of totalitarian statuary, the column itself mocked art's pretensions to eternity. This is a work to which the three defences of transgressive art do not respond. It is content-laden, overburdened with the responsibility of representing the unrepresentable, and so refuses the protection of the formalist defence. It is short-lived, in contrast to the masterpieces that comprise the tradition of Western art, and so refuses the protection of the canonic defence. It is anti-redemptive, alive to art's essential uselessness before the terrors of the 20th century, and so refuses the protection of the estrangement defence. Among its many merits, it thus discloses transgressive art in relief.

Jochen Gerz and Esther Shàlev-Gerz
Monument against Fascism
1986–93

So compare Jake and Dinos Chapman's *Hell* (1999–2000). This work, which in certain respects is exemplarily transgressive, consists of a set of rectangular structures supported by wooden trestles which form a swastika. Across the surface of these structures scenes of torture and death are played out. The artists have choreographed torments in arrested time. Small figures in Nazi costume, many wearing swastika armbands, are subjected to physical abuse by naked, mutant-like men and women. Bloody torsos are suspended,

Jake and Dinos Chapman
Hell
1999–2000

men are jerked, puppet-like, by wires threaded through their hands, while others are pulled apart, limb by limb. Bodies, and parts of bodies, pile up, bloodied, mutilated. These are scenes of silent, petrified horror. The artists, it has been argued, have fathomed the depth of the horror of the Holocaust. They have peered into the abyss. Drama is the only form that our expiation can take; the Chapmans stage a piacular rite. In *Hell* we witness the folly and

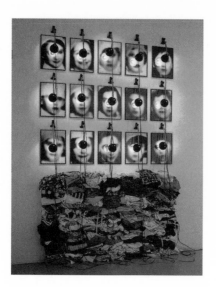 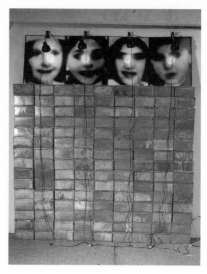

Christian Boltanski
Réserve
1989

bestiality of mankind, which is thus our folly and bestiality too. It has been described as a work of imaginative empathy, and thus an affirmation of art. We need to confront evil visually, and not take refuge in superficial beauty. *Hell* is an attempt to tame the reality it represents. It is, one critic concludes, a demanding, moral work.

I find this praise misconceived. The crimes of genocide are both too specific and too atrocious to permit the deployment of metaphors of responsibility. *Hell* is a work made by an imagination drawn to tableaux of carnage and death, to Nazis and to freaks, to the gory unrealities of cartoon and special-effects violence, and captive to the limited pleasures of picturing violated bodies, regardless of context or circumstance. It is an instance of what has been termed, in the wake of Holocaust Denial, 'anti-memory'. Events give way to mere scenarios in the Chapmans' work. The Peninsular War, World War II, it is all the same to them. The cultural correlatives of *Hell* are not the counter-memorials of the Holocaust but shlock-horror movies. We may conclude that the indefatigable energy of the transgressive enterprise (so evident in *Hell*), its commitment to the breaching of every boundary, one that is both relentless and undiscriminating, has had mixed consequences for the making of artworks. Of the adverse consequences, a certain triviality has come to characterise much contemporary transgressive art. It has tended to be both insignificant and to articulate a nihilism falsely presented as something

liberating, and should make way for an *anti*-transgressive art, one committed to the construction of criteria rather than the breaking of taboos (to appropriate Susan Sontag's judgment on quotidian avant-garde art).

Emphatically, then: the Holocaust does not mandate transgressive art. To the contrary, an art-making responsive to the Holocaust demands a break with the transgressive aesthetic. This is evident from *Hell*, a work that precisely is *not* at home in the company of artworks that address aspects of the Holocaust. The best of these works contend with these dilemmas: how can the Holocaust be represented, when representation seems to entail the making of art objects inviting purely aesthetic contemplation? How should the Holocaust be remembered, when the mind is incapable of encompassing its enormity? Only a non-transgressive art practice, one that acknowledges the certainty of its defeat and is willing to efface itself before its subject, while knowing that this subject is an impossible one, can negotiate such perplexities. It must be allusive, modest, fragile, provisional. It must give witness to the inadequacy of images, and therefore its own inadequacy, to retrieve the meaning of the lives that were extinguished: see the lost, unrecognisable faces in Christian Boltanski's *Réserve* (1990). It is an art that meets its subject at the mind's limits. It knows that there are limits to representation that cannot be removed, in the critic Geoffrey Hartman's phrase, 'without psychic danger'. It must reject as bogus all claims to redemptiveness made on art's behalf and by art itself, because they cannot survive the Holocaust's de-sanctification of humanity. Against the darkness of the Holocaust, this art can throw mere counter-shadows, such as those made by Shimon Attie in his *Sites Unseen* project of 1991–6. This is an art of heartbreak, not of taboo-violation. Such self-defeating endeavours of representing and remembering, each one a confirmation of art's limitations, are not for the transgressive aesthetic, with its

Shimon Attie
Steinstrasse 22
from the
Sites Unseen series
1994

ultimately metaphorical, art-insulated understanding of the nature of transgression, its adversarial stance towards piety, and the *immodesty* of its conception of art's authority and power. It cannot grasp, because it is itself too compromised by, what the historian Dominick LaCapra has described as the 'negative sublime' of National Socialist ideology, that is, its fascination with a vertiginous and traumatizing, but also radical and boundless, transgressiveness.

V

Coda: Every Work of Art
Is an Uncommitted Crime

Among the summary judgments on modern culture that comprise Theodor Adorno's *Minima Moralia* (1951), there is the epigram 'Every work of art is an uncommitted crime'. Floating in this statement is the transgressive and its negation, the 'crime' that is 'uncommitted'. Though expressed as a proposition about art in general, it is better read as a proposition about both the capacities and the fate of art made under the regime of the transgressive aesthetic. Consisting of eight words, by chance the epigram is susceptible to eight interpretations. They are not alternatives; it is only in the density of their combination that the epigram's meaning emerges.

But as a preliminary move, the plain sense of the epigram must be suspended. However elastic the tolerance (or is it indifference?) of the contemporary West towards art may be – the critic Alain Jouffroy has mused, 'it seems difficult to conceive of an illegal painting' – we do know, nonetheless, that there are some artworks that are indeed crimes, and that have thus led to their makers being convicted of offences by criminal courts. Artists may commit crimes in the making of their artworks, or through the works themselves. The state is very good at gaoling artists. The story is told of the postwar performance artist Tomislav Gotovac who would walk naked through Zagreb. His purpose was to offer himself as a metaphor to passers-by, similarly without cover before the totalitarian state, however layered in actual clothing they might be. Arrested and tried, he attempted an explanation: 'I am an artist, and my métier consists of stripping, and walking.' To which the judges responded: 'Yes, and our métier consists of gaoling you.'

Against this, the first interpretation of 'uncommitted crime' is that it denotes a crime committed in one's mind, where everything is possible and nothing has consequences. In dreams begin irresponsibilities. 'This is why I love Art,' declares Flaubert. 'It's because at least there, in the world of fictions, everything can happen.' And then he declares: 'No limits.' I committed that crime, one might say, in my head. It is not an intended crime, one that realises

Opposite

Joseph Beuys leaving the Academy of Arts in Düsseldorf after being dismissed from his teaching post, 1972

itself when enacted. It is instead complete in itself, but transacted within the safe precincts of the imagination. One cannot be held to account for such a crime. To characterise artworks as uncommitted crimes in this sense is to claim for art the same freedom from sanction enjoyed by crimes of the imagination. Artists are imagination's representatives in that foreign country that is the external world. They claim for their work diplomatic immunity from prosecution. The forbidden becomes the protected. Every artwork has the potential to be unlawful. The epigram expresses the aspiration: art should be as free from restraint as thought itself. It should provide a haven in which an antinomian creativity may be realised.

This haven is frequently invaded by the state. Among too many examples, perhaps three will be sufficient. In 1912, for example, Egon Schiele was convicted of disseminating indecent drawings. One of his nude studies, seized by the police from his rooms, was burned in court in his presence. The uncommitted crime of the artwork may lead to the committing of a crime against the artist. In 1915, New York police raided the exhibition of the artist Clara Tice's sketches and confiscated her drawings for indecency. A mock trial organised by Tice's supporters followed. 'She will be tried,' declared an ad in *Vanity Fair*, 'and therefore acquitted, of the charges of having committed unspeakable, black atrocities on white paper, abusing slender bodies of girls, cats, peacocks and butterflies.' The object of this 'trial' was to return Tice's work to the safety of art's own realm. The uncommitted crime is the innocent act. The artwork is innocent though condemned, while 'violent gnomes cloak their criminal natures in the roles of guardians of order, as policemen, judges' (says the Vienna Actionist Otto Muehl). These gnomes see vice in beauty, crime in art. Arrested in 1987 for the forgery of banknotes, the American artist Boggs recalls his police interview: 'They were talking crime, and I was talking art. It was kind of a hilarious conversation.' Art is an act or event that, were it not for its artistic status, *would* be a crime.

The epigram is thus a defence of Breton's 'simplest Surrealist act', as described in the *Second Surrealist Manifesto* (1930). It consists, he says, 'of dashing down into the street, pistol in hand, and firing blindly, as fast as you can pull the trigger, into the crowd.' Breton does not by this account advocate murder. His statement is a provocation-exposition, a means both of explaining Surrealism's unplanned, irrational and violent aspect and of giving it an imaginary realisation. It is only in the imagination that the crowd – as distinct

from the separate human beings who comprise it – can be attacked. The crowd is a crass group consciousness, susceptible to manipulation, unreflective rather than instinctual. Breton would slay it. Adorno's epigram makes explicit this non-lethal ambition. Transgressive artists are thus *not* to be taken for criminals. They merit our sympathetic attention, not our censure, notwithstanding their errors and their sins. We should have pity for those who fight at the frontiers of the future, and who embrace the limitless. 'Pitié pour nous qui combattons toujours aux frontières de l'illimité et de l'avenir,' entreats Apollinaire, 'pitié pour nos erreurs, pour nos péchés.' These artists are dreamers, and we live more intensely in consequence of their imaginings. The Italian artist Gilberto Zorio explains that he likes to talk about 'things without lateral and formal perimeters'. And he adds: 'Sometimes I dream that I am a thief who opens a safe with a blowtorch, not to steal the jewels, but to steal a little bit of the interior.' Artists are criminals of the fantastic.

Second, the epigram implies a certain parallel between the artist and the criminal. The iconoclasm of the one may resonate in the criminal damage of the other, for example. The artist may, on occasion, attract the attention of the police. Consider the photograph of Joseph Beuys leaving the Academy of Arts in Düsseldorf following his dismissal from his teaching post. The police stand by, puzzled and ill at ease, having been called in by the Academy to inhibit protest. What matters in this picture? Beuys's smile, and the collective vacuity of expression of the policemen. They cannot press their authority; the artist is triumphant. Artists and criminals share certain characteristics. The artist is as resourceful and as amoral in the pursuit of his project as is the criminal. This likeness of the artist to the criminal was celebrated by Degas, and is a familiar trope in art writing. 'A painting calls for as much cunning, roguishness, and wickedness as the committing of a crime,' Degas commented, and advised the neophyte artist to be 'devious'. Were they not artists, one might say, these men and women might have made superlative criminals. Artworks substitute for crimes. The uncommitted crime is the realised artwork. 'What I could have done only by throwing a bomb – which would have led to the scaffold – I attempted to realise in art, in painting, by using colours of maximum purity,' wrote Maurice de Vlaminck. 'Thus I satisfied my desire to destroy old conventions, to disobey.' His artworks are his uncommitted crimes. This is a trope of the avant-gardist autobiography. 'We were all revolutionists,' said Diaghilev. 'It was only by a small chance that

I escaped becoming a revolutionist with others things than colour or music.'

Third, the epigram encourages us to regard artworks as crimes in a metaphorical sense. They are 'uncommitted' because they are of no interest to the criminal justice system. Art has its 'own secret laws and devices', says E.H. Gombrich. An artwork may therefore be a 'crime' against these laws, these devices. It may, at the very least, violate artistic convention. These violations will be more than those minor transgressions of the boundaries of the academic system sanctioned by the system itself in the cause of 'originality'. Consider this gang of criminals: Manet, Miró, Matisse. In his *Mademoiselle Victorine in the Costume of an Espada* (1862), Manet reproduced a work of Goya's from the *Tauromaquia* series (c. 1815–16), but did it in such a way as to violate the laws of perspective. The group, suspended in the middle distance, is too small. By a

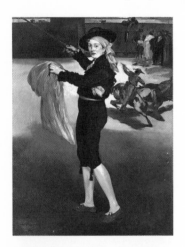

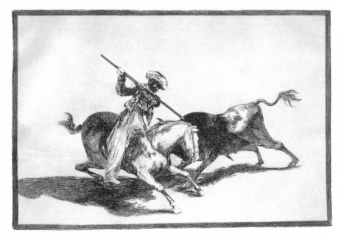

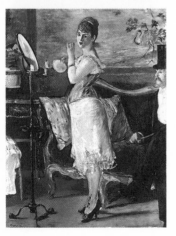

conceit one might say: it is a crime against perspective. And of Manet's *Nana* (1877), a critic who defended the artist against the Salon wrote: 'Manet's great crime is not so much that he paints modern life, but that he paints it life-size... Only the Romans had the right to do that... Lesbia perhaps, but not Nana.' Drawing on the vocabulary of crime and the criminal, when describing an artist's ambitions, is another trope of art writing. The Dadaist Tristan Tzara said of Miró that he was aiming to kill painting by its own means – to turn it against itself, in a kind of coerced suicide. Miró himself was heard to announce, 'I want to murder painting' (and he thereafter, for a while, denied himself paint and canvas). After a mock trial, Matisse

was convicted of 'artistic murder and rapine' by students of the Chicago Art Institute, and a copy of the *Blue Nude* (1907) was burned, together with copies of two other works of the artist's. It was an 'uncommitted crime' against 'law-breaking' artworks. This conviction that artworks were metaphorical crimes shaded at times into the conviction that they should be outlawed:

> In a well-organised civilisation, overt individualism is held in check by law – the profligate is debarred from society, the bomb-thrower is imprisoned, the defamer and the lunatic is confined, not for the good of the individual, but for the protection of the many who might be harmed. Why then, may we ask ourselves, do we so blithely tolerate these same crimes in art?

This was the complaint of a critic of the Armory Show. Against such sentiments, Adorno's epigram may be read as entering a plea of tolerance for the artwork.

Fourth, the epigram also relates the effect that certain artworks have on their audiences to the effect that crimes have on their victims. In each case, this effect is one of dispossession. Artists and criminals each remove us from the realm of the secure and the routine. But the artwork's 'crime' is 'uncommitted' because, while it provokes in its audience a response analogous to the

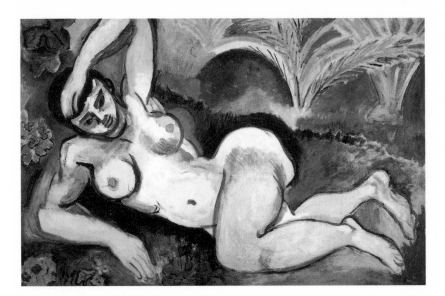

Henri Matisse
*Blue Nude
(Souvenir de Biskra)*
1907

experience of (say) a burglary, it breaks no law in so doing. And this is true, even though what the artist 'takes' from us by his work may be more valuable than any property lost through crime. Artists can rob us of our peace of mind. They can threaten our comfort, sometimes in the most direct of ways. Consider, for example, this comically menacing manifesto, which was intoned by seven Dadaists at an early Dada demonstration:

> TO THE PUBLIC:
> Before going down among you to pull out your decaying teeth,
> your running ears, your tongues full of sores,
> Before breaking your putrid bones,
> Before opening your cholera-infested belly and taking out for
> use as fertiliser your too-fatted liver, your ignoble spleen
> and your diabetic kidneys,
> Before tearing out your ugly sexual organ, incontinent
> and slimy,
> Before extinguishing your appetite for beauty, for ecstasy,
> sugar, philosophy, mathematical and poetic metaphysical
> pepper and cucumbers,
> Before disinfecting you with vitriol, cleansing you and
> shellacking you with passion,
> Before all that,
> We shall take a big antiseptic bath,
> And we warn you:
> We are murderers.

Art's threats are rarely so direct, and rarely so fanciful. Its subversive designs on its audiences are more usually oblique. But there is implicit in every work of transgressive art just that self-description 'We are murderers'.

Fifth, the epigram points up the apolitical nature of transgressive art and is a rebuke to the critic who holds every artwork to be subversive, a revolt against existing political conditions, an ideologically driven crime. To this critic Adorno responds, yes, every artwork is indeed a crime, but an uncommitted one. Do not expect artists to be manning barricades. Do not expect art to provide the critique that will precipitate revolution. It will in itself be an uncommitted crime, at best; the crime will have to be committed by the audience. The

epigram is a version of the argument in Adorno's 1962 essay 'Commitment'. Our own time is not right for political works of art, Adorno argues. Politics lives in the autonomous work of art, and it quickens in works that appear to be politically dead. This paradoxical reasoning makes way for the paradoxical epigram I am glossing here. The political artwork is the *a*political work; the committed artwork is the *un*committed work; every artwork is an uncommitted crime. The political potential of art lies instead in its form. Its autonomy from given social relations means that it both protests, and rises above, them. Art thus subverts the dominant consciousness, ordinary experience. Every authentic work of art is revolutionary in its refusal of 'commitment'. It is an indictment of established reality. It 'un-commits' the crimes of everyday life. If it attempts a more direct engagement with the world, it is likely to fail as art. If it is made by an artist from whom 'commitment' has been coerced, it will almost certainly fail as art. Its power lies in its very remoteness. Adorno gives a subversive twist to Flaubert's aestheticism: 'It is so as not to think about the stupidities and crimes of this world that I take refuge in art.' But for the philistine revolutionary, works of art are crimes of uncommitment. Their refusal to 'commit' dismays and affronts him. Does art change *anything*? That is to say: can it precipitate a modification in our consciousness, even in our moral practices? The implication of Adorno's epigram is that it does not, that it cannot.

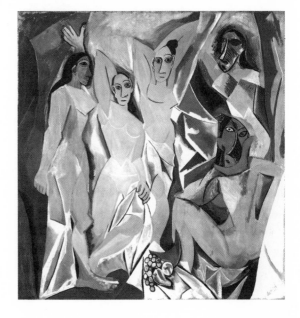

Pablo Picasso
Les Demoiselles d'Avignon
1907

Against the sobriety of this judgment must therefore be placed Nietzsche's celebration of the *successful* crime: 'There is a continual moiling and toiling going on in morality – the effect of successful crimes (among which, for example, are included all innovations in moral thinking).' Artworks lack the moral authority of the successful crime, even though there are some works which are made possible by crimes (for example: the mask in *Les Demoiselles d'Avignon* (1907) was a stolen one).

Sixth, 'uncommitted crime' echoes, and thus invites reflection upon, the description given by Emil Nolde to his watercolours, secretly produced during

Edouard Manet
*The Escape
of Henri Rochefort*
1880–1

George Wesley Bellows
Club Night
1907

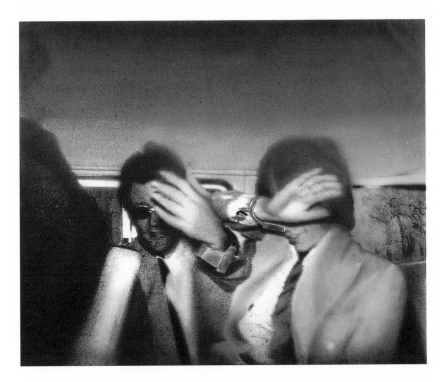

Left
Richard Hamilton
Swingeing London '67
1968–9

Below
Luis Jimenez Jr
Border Crossing
1988

the years he was banned from creating new works by the Nazis – 'unpainted pictures'. They were, indeed, pictures, but so inaccessible that they were invisible to the predatory state. This was an art that had no public existence. The uncommitted crime may be similarly invisible, a crime that escapes the attention of the state. If it isn't prosecuted, it isn't a crime; if it isn't exhibited or burned, it isn't art. It is an unpainted picture. This sixth meaning is evidence of the rootedness of Adorno's epigram – notwithstanding its ostensibly general reference – in the art of the modern period, here perhaps especially in those decades when that art was made in the shadow of a totalitarian threat.

Seventh, there are artworks that, while not amounting to crimes themselves, invite sympathetic responses to the pictured law-breakers. For example, Manet's *The Escape of Henri Rochefort* (1881) celebrates the flight of a former Communard from the penal settlement in New Caledonia. Consider also the illegal boxing match in George Wesley Bellows's *Club Night* (1907) or the illegal Mexican immigrants, the 'wetbacks', in Luis Jimenez Jr's *Border Crossing* (1988), or Richard Hamilton's *Swingeing London '67* (1968–9), which pictures Mick Jagger arriving at his trial for possession of drugs. These works celebrate what

they picture, or condemn its state persecution. The Surrealists were virtuosi of just this kind of provocation. Aragon exulted over 'the parricide Violette Nozière, the anonymous criminal of common law, the conscious and refined perpetrator of sacrilege', while Man Ray placed the portrait of Germaine Berton, who had assassinated a royalist politician, at the centre of the photographic ensemble published in *La Révolution surréaliste, numéro un*.

These works, which cheer from the sidelines, are to be distinguished from those canonic works, such as Rubens's *The Rape of the Daughters of Leukippos* (c. 1618), that represent mythological crimes, and from modern works, such as Bruce Conner's *BLACK DAHLIA* (1960), that take as their subject tabloid crimes. One would say of these works that they are uncommitted crimes as a caution against confusing the representations with the subjects represented.

Peter Paul Rubens
The Rape of the Daughters of Leukippos
c. 1618

La femme est l'être qui
projette la plus grande
ombre ou la plus grande
lumière dans nos rêves.
Ch. B.

Man Ray
*Germaine Berton
and the Surrealists*
1924

Bruce Conner
BLACK DAHLIA
1960

BLACK DAHLIA, for example, is made up of items that evoke a notorious unsolved crime, and the work's title is the nickname given by the American tabloids to the murdered woman herself. The artist does not so much represent the crime as re-enact it in the medium of his art, assembling an object that becomes both the victim and the crime. It is an ugly, glamorous work, one in which a certain disregard for women is implicit, and is thus cognate with the work of the Berlin Dadaists (Grosz, Dix, Schlichter) who were fascinated by sex crimes. The violence visited on women was both a theme of their work and an expression of their own misogyny. Dix's *Sex Murder* (1922) is one such uncommitted crime. The Surrealist Hans Bellmer once remarked, with a toneless candour, that were it not for the fact that he drew young girls so often, he might have had to resort to sex murder. His late work *The Blue Eye* (1964) has been taken to be the artist's acknowledgment of just this redirected misogyny.

Adorno's epigram is, last, a self-cancelling statement, because an 'uncommitted crime' is a zero. The adjective negatives the noun and the phrase thereby undoes itself (try to imagine an incorporeal body or an unexecuted execution: there would be no body, no execution). The epigram is a joke at the expense both of certain contemporary artists, for whom the transgressive is the normative, and of those philosophers who struggle to bring every instance of art under general categories. It is a joke at the expense of artists, because when the transgressive becomes the rule, and avant-gardism becomes indistinguishable from established, 'academic' culture, then the 'criminal' becomes indistinguishable from the 'lawful' and art is no more than an uncommitted crime, that is to say, a rule that bears merely the trace of its former deviancy. What Adorno expresses with an incisive wit has been noticed elsewhere and with greater severity by others – Susan Sontag, for example. 'Transgressions presuppose successful notions of order,' she points out. 'But transgressions have become so successful that the idea of transgression has become normative for the arts – which is a self-contradiction. Modern art

wished to be – maybe even was, for a brief time – in an intractable, adversary relation to the established high culture.' The wish is now unrealisable. Art can no longer be – if it ever was – in that adversary relation. Adorno's epigram teases those who persist in thinking otherwise.

It is a joke also, then, at the expense of philosophers, because while aesthetics operates in the medium of universal concepts, art is radically nominalistic. 'Art,' Adorno argues in *Aesthetic Theory* (1970), 'revolts against its essential concepts while at the same time being inconceivable without them.' When artworks are subsumed under schemata, they are no longer recognisable for what they are. Their diversity frustrates the making of any non-trivial, general statements about art. The American artist David Smith, celebrating just this resistance of art to the rule of concepts, affirmed that 'art is a paradox that has no laws to bind it'. In consequence of modern art's protean qualities, general claims about art are as contentless as an uncommitted crime. Adorno's vanishing epigram thus exposes, at the very moment of its own disappearance, the hopelessness of philosophy's project. The epigram is rich with meaning, and one of its meanings is that it has no meaning. It is a strategic nullity.

I do not feel the need to choose between these readings. The epigram points to the multiple connections between artworks and crimes, artists and criminals. To identify these connections, I have rewritten it in duller and more qualified prose. Epigrams tend not to admit qualification. They are categoric and unconditional, and have the character of propositional overstatement. They go further than they should in order to compel our attention. They are thus themselves transgressive. Adorno's epigram means everything that it *could* mean. It is as overdetermined as a dream. Its multiple meanings invite reflection on the nature of artistic transgression. In this book I have tried to respond to just that invitation.

Top
Otto Dix
Sex Murder
1922

Above
Hans Bellmer
The Blue Eye
1964

Bibliographical Essay

General

What I have defined, not altogether respectfully, as the received version of the transgressive is evident in a number of works from which I have learned a great deal. Michel Foucault's short essay 'A Preface to Transgression' in *Aesthetics* (London, 1998) is a rhapsodic account of transgression as a counter-principle, though it is limited by its occasion, a contribution to a special issue of the journal *Critique* devoted to Bataille. 'Perhaps one day,' Foucault writes, '[transgression] will seem as decisive for our culture, as much a part of its soil, as the experience of contradiction was at an earlier time for dialectical thought.' 'The twentieth century,' he adds, 'will undoubtedly have discovered the related categories of exhaustion, excess, the limit, and transgression.' Foucault's definition of criticism as a 'reflecting upon limits' is from 'What Is Enlightenment?' in *Ethics* (London, 2000).

The literature on Bataille is very substantial. Of his own works, I have relied mainly on *Eroticism* (London, 1962) and *The Accursed Share*, vols 1–3 (New York, 1993). The selection edited by Michael Richardson, *Georges Bataille: Essential Writings* (London, 1998), usefully groups material drawn from various works. Richardson's own introduction to Bataille's thought, *Georges Bataille* (London, 1994), was a useful starting point. The reference to Bataille's 'base materialism' comes from Jaleh Mansoor, 'Piero Manzoni', *October* 95 (Winter 2001). Rosalind Krauss's essay on Giacometti in the two-volume catalogue *Primitivism in 20th-Century Art*, edited by William Rubin (New York, 1984), elaborates upon Bataille's influence on 'the imaginative circuit of the period'. I found the Mauss quotation in Pierre Macherey, *The Object of Literature* (Cambridge, 1995). Derrida has some interesting things to say about Bataille in *Writing and Difference* (London, 1978). The Kristeva passage comes from her essay 'The Ethics of Linguistics' in *Desire in Language* (New York, 1980). Suzanne Guerlac, *Literary Polemics: Bataille, Sartre, Valéry, Breton* (Stanford, 1997) is, among much else, an immensely engaging account of Bataille's importance at a particular juncture in French culture. If there is a single term poststructuralist theory could not do without, Guerlac writes, it is 'transgression' as inherited from Bataille. (Of course, the word has acquired a cant aspect. The spoof article written by the scientist Alan Sokal, designed to expose the pretensions and credulity of the literary world, bore the title 'Transgressing the Boundaries'. Sokal no doubt reckoned that such a title would be irresistible to the editors of the cultural journal *Social Text*: see Alan Sokal and Jean Bricmont, *Intellectual Impostures* [London, 1998], and *The Sokal Hoax* [Lincoln, 2000], edited by the editors of *Lingua Franca*.)

My conception of the transgressive is more differentiated, and more modest, than Bataille's. His may be characterised as a meta-theory of the transgressive. Mine exists at a lower, empirical level. Too much is subsumed within Bataille's conception, with the consequence that the distinctness of individual artworks – indeed, of art itself – disappears from view. For me, while some artworks are transgressive, others are not, and 'transgression' itself is a broad term, embracing several discrete practices. On occasion, Bataille abandons his theory of taboo in order to entertain another, more commonplace one: taboos relate to man's animal needs, which needs man denies. This explains the conventions regarding our bodily waste which are so absolute that we do not even list them as taboo. Bataille is also uninterested in how artworks depart from given rules of composition and genre, and he is committed to a theory of art that is indifferent to the specifities of period and style. That is to say, he disregards both purely formal transgressions and the discontinuities in art's history. Habermas has criticised Bataille (correctly in my view)

for his 'artificial mystification of something so close into something supposedly so primordial'. He is guilty, Habermas believes, of the 'fabulation of pre-civilisational states': Jürgen Habermas, *Autonomy and Solidarity: Interviews*, edited by Peter Dews (London, 1986).

Rosalind Krauss and Yve Alain-Bois, *Formless: A User's Guide* (New York, 1997) is an explication of what might be termed, were the characterisation not an absurd one, 'Bataillism'. I have taken from the book the reference to Warhol's 'piss paintings' in chapter I, and Bataille's account of *Olympia* and the quotation from Merleau-Ponty in chapter II. Alain-Bois is the 'Bataille scholar' cited in chapter I. The authors identify four 'operations' of the 'formless' (horizontality, base materialism, pulse and entropy). These operations have modernism as their target and create an internal division within the more generalised transgressiveness characteristic of the modern period. The distinction that Krauss and Alain-Bois draw between the Kristevan notion of the 'abject' and Bataille's notion of the 'formless' has helped me to clarify my own thinking about transgression. Kristeva analyses the abject in *Powers of Horror* (New York, 1982). Her deployment of the word brings it close, in certain respects, to the received version of the transgressive: 'It is thus not lack of cleanliness or health that causes abjection but what disturbs identity, system, order. What does not respect borders, positions, rules. The in-between, the ambiguous, the composite. The traitor, the liar, the criminal with a good conscience, the shameless rapist, the killer who claims he is a saviour... Any crime, because it draws attention to the fragility of the law, is abject.' Kristeva overstates her meaning in order to make the abject coextensive with the transgressive as most generally conceived. For a sensible assessment of the cultural impact of Kristeva's theorising, see Martin Jay, 'Abjection Overruled' in *Cultural Semantics* (Amherst, 1998). In 'Obscene, Abject, Traumatic' in *Law and the Image*, edited by Costas Douzinas and Lynda Neal (Chicago, 1999), Hal Foster gives a sophisticated account of the abject in contemporary art, one that is written from a perspective quite different from my own (and that in certain respects is an alternative to it). 'Why,' he asks, 'this fascination with trauma, this envy of abjection, today?' It is because, he suggests, 'a special truth seems to reside in traumatic or abject states, in diseased or damaged bodies.'

Everyone who writes about transgressive art is in the debt of Steven C. Dubin, whose *Arresting Images* (London, 1992) is an indispensable guide to the subject. John A. Walker, *Art and Outrage* (London, 1999) usefully summarises a parallel history in postwar Great Britain and is the source of my story about the Chapmans in chapter I. John Jervis, *Transgressing the Modern* (Oxford, 1999) employs the concept of the transgressive in an attempt to unlock the antinomies of modern culture. Linda S. Kauffman successfully draws together works by Orlan, J.G. Ballard, David Cronenberg and others under the rubric of the transgressive in *Bad Girls and Sick Boys* (Berkeley, 1998), praising them in the particularity of their transgressiveness, while also affirming that 'today's transgression is tomorrow's television commercial'. She identifies six aspects of the modern transgressive aesthetic: it rejects the doctrine that art mirrors life; it acknowledges the transgressive impulse in the art-making of earlier times; it repudiates all aestheticisms; it refuses modernist integrity in favour of the fragmentary, the ephemeral and the disorienting; it dissolves cultural dichotomies; it defines postmodernism in politically oppositional terms. Kauffman's book offers an unqualified celebration of the transgressive, one respect in which my perspective differs from hers.

Bell Hooks's writings on the nature of the transgressive – see, for example, *Teaching to Transgress* (London, 1994) and *Art on my Mind: Visual Politics* (New York, 1995) – are both rewarding and troubling. Her essay 'Being the Subject of Art' is a movingly tentative exploration of the limits of the transgressive, and in particular of her own lack of preparedness for its invasions of her privacy. Lucy Lippard's art criticism also embraces the transgressive. 'I like blurred boundaries,'

she says in *The Pink Glass Swan* (New York, 1995). Lippard is a valuable guide to the contemporary scene, and is astute about those kinds of art that claim the title of transgressive in defence of their nihilism. What she writes about the art phenomenon of 'retrochic' could be applied to the Chapmans' work: 'Retrochic is... part of a TV culture that offers insult, assault, torture. Yawn.' Lucy Sargisson, *Utopian Bodies and the Politics of Transgression* (London, 2000) defines the transgressive as internally subversive, challenging from within the aims and assumptions of the ground whence it comes, and flexible, resistant to permanence and order, accepting its own imminent dissolution. She offers an account of a transgressive utopianism that breaks rules, confronts boundaries (rendering them meaningless or emphasising their porosity), challenges paradigms, and creates new conceptual and political space. It is oppositional.

Peter Stallybrass and Allon White, *The Politics and Poetics of Transgression* (London, 1986) likewise finds much to celebrate in the transgressive, and relates it to the ethos of the carnival as interpreted by Mikhail Bakhtin. The authors are, however, troubled by the celebration of the pig at carnival time because it incorporated popular anti-Semitism. Eliding Jews with pigs, the carnival crowd effected that grotesque union of opposites that Bakhtin finds most admirable. Stallybrass and White term this an 'offensive transgression', the consequence of what they disapprovingly describe as 'displaced abjection', where an oppressed group turns its power on an even lower group rather than against its oppressors. They dismiss it as a false transgression, not overturning but reaffirming the dominant Christian dispensation. Stallybrass and White thus write out of the transgressive aspects of it that they find reprehensible. For a more thorough account of the relations between Jews, pigs and the carnival, see Claudine Fabre-Vassas, *The Singular Beast* (New York, 1997). For an examination of the carnival counter-principle in the context of film practice, see Laura Mulvey, 'Changes: Thoughts on Myth, Narrative and Historical Experience'

in *Visual and Other Pleasures* (London, 1989). On the reception history of Bakhtin's theory, see Caryl Emerson, *The First Hundred Years of Mikhail Bakhtin* (Princeton, 1997). She observes that 'Bakhtin's carnival idea has the thrill of a cultural and biological universal'.

Among the philosophical treatises on art that I consulted in the writing of this book, the most important for me was G.W.F. Hegel, *Aesthetics: Lectures on Fine Art* (Oxford, 1975). All quotations from Hegel are from the *Aesthetics* unless otherwise stated. Of the many critical commentaries on Hegel's philosophy of art, I found the most stimulating to be Beat Wyss, *Hegel's Art History and the Critique of Modernity* (Cambridge, 1999) and Stephen Bungay, *Beauty and Truth* (Oxford, 1987). Bungay observes that the origin of the doctrine of 'the end of art', a phrase that never appears in the *Aesthetics*, is to be located in the 'loose talk' of those who heard Hegel lecture. I used the Clarendon Press edition of Kant's *Critique of Judgment*, in the translation by James Creed Meredith, and most relied upon Salim Kemal, *Kant and Fine Art* (Oxford, 1986) and John H. Zammito, *The Genesis of Kant's 'Critique of Judgment'* (Chicago, 1992). Andrew Bowie, *Aesthetics and Subjectivity* (Manchester, 1990) and J.M. Bernstein, *The Fate of Art* (Oxford, 1992) were useful surveys of the German tradition in aesthetics (Bernstein puts Derrida in this context). John Dewey, *Art as Experience* (New York, 1980) was a valuable counter to Hegel, both more appreciative of art's continuing value and entirely uninterested in any notion of artistic period. Benedetto Croce's *Aesthetic* (London, 1953) was another corrective. 'The arts have no aesthetic limits,' he declares. Croce takes pleasure in artists' insubordination:

> From the theory of artistic and literary kinds derive those erroneous modes of judgment and of criticism, thanks to which, instead of asking before a work of art if it be expressive and what it expresses, whether it speak or stammer or is altogether silent, they ask if it obey the *laws* of epic or of tragedy, of historical painting or of landscape.

While making a verbal pretence of agreeing, or yielding a feigned obedience, artists have, however, really always disregarded these *laws of the kinds*. Every true work of art has violated some established kind and upset the ideas of the critics, who have thus been obliged to broaden the kinds, until finally even the broadened kind has proved too narrow, owing to the appearance of new works of art, naturally followed by new scandals, new upsettings – and new broadenings.

This is trenchant at the expense of art's legislators, though it neglects the reality of genre's constraints, and the extent to which art-making is a dialogue with the rules.

Of the philosophers who have endeavoured to reinvent aesthetics post-Duchamp, I have learned most from Arthur Danto. I have been reading Danto, on and off, for over a decade now. I am sure that much of what I say here bears the influence of his thinking on art. The books that I read, or re-read, in preparation for writing this book were *Encounters and Reflections* (New York, 1990), *Embodied Meanings* (New York, 1995), *After the End of Art* (Princeton, 1997) and *The Madonna of the Future* (New York, 2000). Danto also has some interesting things to say in an interview published in Suzi Gablik, *Conversations before the End of Time* (London, 1992). For the exposition, and criticism, of his 'end of art' thesis, the following were helpful: Stephen Davies, 'End of Art' in *A Companion to Aesthetics*, edited by David Cooper (Oxford, 1992); Jonathan Gilmore, 'Danto's End of Art Thesis' in the *Encyclopedia of Aesthetics*, edited by Michael Kelly (Oxford, 1998); and Robert C. Solomon and Kathleen M. Higgins, 'Atomism, Art, and Arthur: Danto's Hegelian Turn' in *Danto and his Critics*, edited by Mark Rollins (Cambridge, Mass., 1993). Danto himself gives a useful summary of the development of his thinking, as at 1997, in his *After the End of Art*, the first footnote in chapter I.

I came quite late in the writing of this book to Jean-Marie Schaeffer. He offers an anti-aesthetics, one that acknowledges the heterogeneity of art and the consequent untenability of any essentialist art theory. The papers collected under his direction in *Think Art* (Rotterdam, 1998) develop arguments liberated from this untenable aesthetics. Art today, he proposes, consists of 'the open generic network of practices that are the contemporary heirs of what was formerly, until the middle of the twentieth century, largely the domain of painting and sculpture'. His suggestion for the direction that art theory should now take is one that I found that I had myself adopted in the writing of *Transgressions*: 'the function of theory may no longer be to legitimize or exalt *art*, but to facilitate the experiencing of *art works*.' His *Art of the Modern Age: Philosophy of Art from Kant to Heidegger* (Princeton, 2000) develops these arguments and puts them in the context of the German aesthetic tradition. Arthur Danto has contributed a foreword to this book.

As for more general works on aesthetics, and anthologies, I found the following of use: *Aesthetics*, edited by Susan Feagin and Patrick Maynard (Oxford, 1997); the *Encyclopedia of Aesthetics*, edited by Michael Kelly (Oxford, 1998); *A Companion to Aesthetics*, edited by David Cooper. Among the many anthologies of artists writing about art, I have used: (1) *Theories and Documents of Contemporary Art*, edited by Kristine Stiles and Peter Selz (Berkeley, 1996), for the quotations from Gottlieb and Rothko in chapter I, from Emilio Vendova and Max Bill in chapter III, from Anselm Kiefer in chapter IV, and from David Smith in chapter V; (2) *Art in Theory 1648–1815*, edited by Charles Harrison, Paul Wood and Jason Gaiger (Oxford, 2000), for material on the theory and institution of the academy, and in particular the quotation from Poussin in chapter III; (3) *Art in Theory 1815–1900*, edited by Charles Harrison, Paul Wood and Jason Gaiger (Oxford, 1998), for Zola and for many of the contemporary reactions to *Olympia*; (4) *Art in Theory 1900–1990*, edited by Charles Harrison and Paul Wood (Oxford, 1992), for the Levine and Kruger quotations, the Haim Steinbach phrase (in the transcript of an excerpted conversation)

and the definition of 'détournement', all in chapter II; (5) *Theories of Modern Art*, edited by Herschel B. Chipp (Berkeley, 1968), for the quotations from Chirico and Kandinsky in chapter I, and the quotations from Masson and Denis's 'Definition of Neotraditionalism' in chapter IV. (6) *Modern Artists on Art*, edited by Robert L. Herbert (Englewood Cliffs, NJ, 1964), which contains essays by Gleizes and Metzinger, Kandinsky, Le Corbusier, Malevich, Gabo and Mondrian. Ben Shahn's 'On Nonconformity' in *The Shape of Content* (New York, 1957) argues that nonconformity is the basic precondition of art.

I have continued to learn from E.H. Gombrich, *The Story of Art* (London, 1972) since I first read it over 25 years ago; all quotations from Gombrich are taken from this book unless otherwise indicated. He considers Manet to have initiated merely the 'third wave' of the permanent revolution that characterised the art of the 19th century. First there was Delacroix, then Courbet, and only then Manet. And it is Manet the Impressionist that qualifies, not the Manet of *Olympia* or *Le Déjeuner*. Malraux, by contrast, in his similarly synoptic, but more thesis-driven *The Voices of Silence* (Princeton, 1978), credits Manet with initiating 'a complete break' in art history. David Sylvester has likewise taught me a great deal. I carried around with me *About Modern Art* (London, 1997) for a few weeks and it was always stimulating, instructive company. What he has to say about Gilbert and George, and in particular the *Naked Shit Pictures*, has not – so far as I know – been bettered elsewhere (and the Bonnard story in chapter III is his). As for Harold Rosenberg, the judgments that he makes on modern artists and movements seem to me to be always just and illuminating. My citations from him are taken from *Discovering the Present* (Chicago, 1973), *Art on the Edge* (London, 1976), *The Case of the Baffled Radical* (Chicago, 1985) and *Art and Other Serious Matters* (Chicago, 1985). Clement Greenberg has, by contrast, not been the influence that I expected him to be when I began reading my way through *The Collected Essays and Reviews 1–4* (Chicago, 1986). This surprised me, and it may be that

I have simply missed what he has to teach. In any event, I cannot accept his dismissal of Dada and the Surrealists: see, for example, his contemptuous aside on 'academically Surrealist painting' in the 1967 essay 'Where Is the Avant-Garde?' His assessment of Manet as being the first modernist – 'by virtue of the frankness with which [his pictures] declare the flat surfaces on which they were painted' – seems to me to miss much of Manet's actual significance: see 'Modernist Painting' (1960). Likewise, his judgment in 'Towards a Newer Laocoön' (1940) is contrary to the premise of my own work: 'The arts lie safe now, each within its "legitimate" boundaries, and free trade has been replaced by autarchy.'

Of the many modern and contemporary art surveys around, I consulted: Jonathan Fineberg, *Art since 1940: Strategies of Being* (London, 1995), which is encyclopaedic in scope and safe in its judgments; Michael Archer, *Art since 1960* (London, 1997); David Hopkins, *After Modern Art* (Oxford, 2000); Sandro Bocola, *The Art of Modernism* (Munich, 1999), which treats contemporary art under the heading 'Opportunism and the Rejection of Innovation: The Primacy of Disrespect'; and Irving Sandler, *Art of the Postmodern Era: From the Late 1960s to the Early 1980s* (New York, 1996), which is the source for my discussion of Colescott. Sandler is too often, however, merely the artists' spokesperson. Of Kiefer, for example, he writes: 'Were these historically loaded portraits a neo-Nazi paean to a nationalistic and militaristic Germany, or did they confront and expose Teutonic and Nazi myths? Whether or not one believes that Kiefer was critical of or complicit with Nazism, it was generally acknowledged that he was a powerful artist.' Anthony Hadden-Guest, *True Colours* (New York, 1996) was the source for the Jouffroy quotation in chapter V. There is an art world-weary quality to this book that I have tried to avoid in my own. For example, Hadden-Guest writes: 'It is as if somewhere a computer has been stuttering out every possible combination and recombination of the moves of Duchamp, Joseph Beuys, and Andy Warhol as game plans for young artists.'

I have not analysed in any depth the multiple uses to which the words 'rule' and 'law' have been put by writers on art. These tend to be metaphorical, deriving their sense from either positive law or the laws of nature, although sometimes they refer to the content of the lessons taught at academies. Hegel has some very interesting things to say about conformity to law in art, which he distinguishes from mere regularity. Such discriminations are rare, however. Baudelaire, for example, writes in the 'Salon de 1846' that 'the principal characteristic of drawings by supreme artists is the truth of movement, and Delacroix never violates (*viole*) this natural law' (*Oeuvres complètes* [Paris, 1961]). Odilon Redon described his art thus: 'I speak to those who surrender themselves gently to the secret and mysterious laws of the emotions and the heart.' Hans Hoffman, artist and teacher of artists in Munich and then in New York, was ready to assert that 'painting possesses fundamental laws', and that 'these laws are dictated by fundamental perceptions'. For both Redon and Hoffman, see *Theories of Modern Art*, and for Hoffman, see Dore Ashton, *The New York School: A Cultural Reckoning* (New York, 1973).

In an earlier draft of the book, I considered at length the following passage about the training of art students from Joshua Reynolds's *Discourses*, lectures delivered at the London Royal Academy between 1769 and 1790:

I would chiefly recommend that an implicit obedience to the *Rules of Art*, as established by the practice of the great MASTERS, should be exacted from the *young* Students. That these models, which have passed through the approbation of ages, should be considered by them as perfect and infallible guides; as subjects for their imitation, not their criticism.

I am confident, that this is the only efficacious method of making a progress in the Arts; and that he who sets out with doubting, will find life finished before he becomes master of the rudiments. For it may be laid down as a maxim,

that he who begins by presuming on his own sense, has ended his studies as soon as he has commenced them. Every opportunity, therefore, should be taken to discountenance that false and vulgar opinion, that rules are the fetters of genius; they are fetters only to men of no genius; as that armour, which upon the strong is an ornament and a defence, upon the weak and mis-shapen becomes a load, and cripples the body which it was made to protect.

How much liberty may be taken to break through these rules, and as the Poet expresses it,

To snatch a grace beyond the reach of art.

may be a subsequent consideration, when the pupils become masters themselves. It is then, when their genius has received its utmost improvement, that rules may possibly be dispensed with. But let us not destroy the scaffold until we have raised the building.

Reynolds thus offers three accounts of the relation between art and rule: artworks are constituted by rules; in the making of artworks the artist needs rules; rules ultimately confine the creativity of the artist. This engagement with the concept of the rule, so productive of ambiguity in 18th-century aesthetics, abated in the 19th century and offers no guide to the transgressive practices of Manet and his successors. So the passages in my first draft on 'rules', which derived from a consideration of just this kind of 18th-century precedent, were deleted.

Foreword

The David Freedberg defence of dangerous art concludes his essay in *The Play of the Unmentionable: An Installation by Joseph Kosuth at the Brooklyn Museum* (New York, 1992). On the subject of 'art crimes', there is an interesting page in Damien Hirst, *I Want to Spend the Rest of my Life Everywhere, with Everyone, One to One, Always, Forever, Now* (London, 1997) devoted to the artist's prosecution of

fellow artist Mark Bridger, who had poured black ink into Hirst's work *Away from the Flock*. Bridger's defence, that his act was an artistic statement, impressed neither Hirst nor the court, and he was convicted of criminal damage. The Eco phrase comes from his exchange with Stefano Rosso on postmodernism, in *Zeitgeist in Babel*, edited by Ingebord Hoesterev (Bloomington, 1991). Prince Albert's speech is quoted in Richard Bretell, *Modern Art 1851–1929* (Oxford, 1999). Chagall's remark about the decline of national art is quoted in Avram Kampf, *Chagall to Kitaj: Jewish Experience in 20th-Century Art* (London, 1990). Chagall goes on to say that if he were not a Jew, he would not be an artist, or at least he would be a very different one. Leon Golub's remark is made in *Do Paintings Bite?*, edited by Hans-Ulrich Obrist (New York, 1997).

Chapter I

Serrano's quoted remarks about his work are taken from an interview in *Talking Art 1*, edited by Adrian Searle (London, 1993). I have only summarised, in the briefest terms, the opposing stances adopted during the controversy over *Piss Christ*. There was much hysterical overstatement on both sides. I have drawn on the accounts given of the controversy in: Michael Brenson, *Visionaries and Outcasts* (New York, 2001); Steven C. Dubin, *Arresting Images*; Robert Hughes, *The Culture of Complaint* (Oxford, 1993), who says that in the matter of visual art the American 'culture war' began on 18 May 1989, the day that the Serrano photograph was torn up in the Senate; Linda Weintraub, *Art on the Edge and Over: Searching for Art's Meaning in Contemporary Society 1970s–1990s* (Litchfield, CT, 1996), from which I have also taken the Schneeman quotation below and the Serrano quotation in chapter IV; and the invaluable *Culture Wars: Documents from the Recent Controversies in the Arts*, edited by Richard Bolton (New York, 1992). The defender of the work who valued its 'cruel juxtaposition' was the art critic Donald Kuspit, as quoted in Bolton's compilation; the 'forbidden frontiers' and 'US government' quotations in chapter I, the Robert Hughes judgment on Serrano and the defender of

Mapplethorpe, both quoted in chapter III, are also from this book. Richard Serra makes his First Amendment point in his essay 'Art and Censorship' in *Art and the Public Sphere*, edited by W.J.T. Mitchell (Chicago, 1992). Peter Selz, in *Beyond the Mainstream* (Cambridge, 1997), is the critic who praises Serrano for defying the trivialisation of religious experience. Following the Serrano affair, one critic wrote of the 'now all-but-official hostility to art and demonization of the artist in America', which surely goes too far: Michael Brenson, 'Resisting the Dangerous Journey' in *The Crisis of Criticism*, edited by Maurice Berger (New York, 1998). The Philip Roth phrase comes from *The Human Stain* (London, 2001).

It is Cynthia Freeland who maintains that 'Serrano's critics don't understand' that *Piss Christ* could mean something other than 'Piss on Christ' (quoted in Eileen John, 'Art and Knowledge' in *The Routledge Companion to Aesthetics* [London, 2001]). James Davison Hunter, *Culture Wars* (New York, 1991) contains a mild account of the Serrano controversy, and gives equal space to the artist's defenders and detractors. The critic who relates Serrano to early-modern Christian art and literature is Richard Rambuss in *Closet Devotions* (Durham, 1998). I found the Goncourt quotation (which comes from their novel *Manette Salomon* [1866]) in Alan Krell, *Manet* (London, 1996). As for the baiting of the spectator, Rochelle Gurstein, *The Repeal of Reticence* (New York, 1996) asks how puritan-baiting (mocking sexual inhibitions, naiveté) and rights talk (asserting First Amendment rights) together 'displaced principled debate about the quality and character of our common world'. She adds that the frequent resort to law, by one side or the other, 'has made it impossible to address many vital issues that fall outside its narrow precincts'. I admire this book (it contains the Malinowski phrase quoted in chapter III), while not always assenting to its conclusions. Serrano himself remarked: 'I wasn't avant-garde until Jesse Helms made me that way': quoted in Alice Goldfarb Marquis, *Art Lessons* (New York, 1995).

In the Book of Esther, the author writes: 'So Mordecai went his way, and did according to all that Esther had commanded him' (4:17). The opening words in the original Hebrew are '*vaya'avore mordechoy*', which could either mean 'Mordecai crossed over' or 'Mordecai sinned'. The sages of the Talmud offer two interpretations of this phrase. Samuel says: Mordecai crossed the water, because the king's palace (where Esther lived) was separated by a river from the city. Rab says: Mordecai transgressed the law by obeying Esther and fasting, which is forbidden on a festival (in this case, Passover). For an exposition of these interpretations, see the commentary to *The Five Megilloth*, edited by the Rev. Dr A. Cohen (London, 1984). Of course, they are not mutually exclusive, and there is in their combination just that openness to the multiple meanings of 'transgression' that I seek to emulate in this book. My brief etymology is indebted to the *OED*, and the approach influenced by the precedent of Raymond Williams's *Keywords* (London, 1976). Williams describes his book as 'the record of an inquiry into a vocabulary'. Williams correctly observes of the *OED* that 'it is much better on range and variation than on connection and interaction'. I have tried to remedy this bias in my own examination of the meanings of 'transgression'.

The references to St Paul are given in the text in accordance with the convention that scriptural references are always the exception to foot- or end-noting regimes. The critical literature on Paul's complex understanding of 'law' is enormous, and I have only sampled it. But of this literature I have been most struck by Leo Baeck, *Judaism and Christianity* (New York, 1970); Jerome Murphy-O'Connor, OP, *Paul: A Critical Life* (Oxford, 1996); John G. Gager, *Reinventing Paul* (Oxford, 2000); Daniel Boyarin, *A Radical Jew: Paul and the Politics of Identity* (Berkeley, 1994); and Hans Hubner, *Law in Paul's Thought* (Edinburgh, 1984). A number of commentaries are helpfully assembled in *The Writings of St. Paul*, edited by Wayne A. Meeks (New York, 1972). I plan to write about the significance of Paul's conception of the relations between law and love in English literature one day.

The passage from the South African constitution is in the Publisher's Note to Antje Krog, *Country of My Skull* (London, 1999). Krog reports an exchange with the leader of the National Party. She taxes him with the responsibility of the apartheid regime for the murder and abuse of the Black population. He responds that she has fallen for ANC propaganda. 'I will not take the blame for people who acted like barbarians, who ignored the parameters of their duties.' They are *not* transgressors. They are both outside the polity altogether ('barbarians') and they are bureaucrats of the polity who have (merely) exceeded certain parameters. By this contradictory verbal gesture – it's an offence by people for whom we are not responsible, it's a minor offence – he denies the transgressive nature of the crimes. In his little book of moral philosophy, *Being Good* (Oxford, 2001), Simon Blackburn writes that 'it [is] easy to see why causing death should be the crime that it is; if a person is prepared to *transgress* against that rule, it seems that anything goes' (my italics). 'Transgress' seems right; 'break' would be weak.

The distinction that I make between the two kinds of transgression of a discourse was prompted by the distinction that Denis Hollier makes between 'high' and 'low' transgression in *Against Architecture* (Cambridge, Mass., 1995). The quotation from Kraus is in Peter Vergo, *Art in Vienna 1898–1918* (Oxford, 1986), from which I have also taken Schiele's dying words and the details of the story about his prosecution in chapter V. On 1848, I relied on Jonathan Sperber, *The European Revolutions 1848–1851* (Cambridge, 1994 – and thank you, Richard Evans, for the recommendation). The de Ris quotation is in Linda Nochlin, *The Politics of Vision* (London, 1991). It was *La Gazette de France*, 16 January 1848, that commented that people stop being reasonable in the time of revolution (quoted in *Documents on the French Revolution of 1848*, edited by Roger Price [London, 1996]). On the nature of revolutionary 'celebration', see Jean Baechler, *Revolution* (Oxford, 1975), and the more generally Sartrian context for my analysis comes from Ronald Aronson,

Jean-Paul Sartre: Philosophy in the World (London, 1980). It is in T.J. Clark, *The Absolute Bourgeois* (London, 1982) that I found the most helpful account of post-1848 French art.

On the esteeming of trespassing, see, for example, Albert O. Hirschman, *Crossing Boundaries* (New York, 1998): 'The idea of trespassing is basic to my thinking. Even my first book was... a book of breaking down barriers... Attempts to confine me make me unhappy.' Hirschman explains that 'trespassing' tends to be given a negative sense, but in the way he uses it the term assumes a positive value: 'the injunction to trespass means passing beyond the disciplinary boundaries or passing from one discipline to another without rigidity.' A blurb in the *New York Review of Books*, 31 May 2001, puffs a volume of essays on 'the interplay between art and science' for 'tak[ing] our understanding to an exciting new level as they transgress the traditional boundaries between the two disciplines'. Marjorie Garber, *Academic Instincts* (Princeton, 2001) examines 'discipline envy' in the academy: 'boundary marking by disciplines... is about training and certification and belonging to a guild, but it is also, sometimes, about... a sibling rivalry among the disciplines.' On genre-blurring, see Clifford Geertz, *Local Knowledge* (London, 1993) and Frederic Jameson, *The Cultural Turn* (London, 1998). Disagreements regarding the proper domain of art history – disputes that themselves reflect this blurring of disciplinary boundaries – are examined in Donald Preziosi, *Rethinking Art History* (New Haven, 1989). The text against which all these other texts brace themselves is Immanuel Kant, *The Conflict of the Faculties* (Lincoln, 1992), first published in 1798. Kant writes: 'as soon as we allow two different callings to combine and run together, we can form no clear notion of the characteristic that distinguishes each by itself.' This passage is discussed in Mark A. Cheetham, *Kant, Art and Art History* (Cambridge, 2001). Linda Nochlin, in an essay that considers Jean-Paul Gaultier's 'Hasidic' collection, takes pleasure in the 'transgressive gesture' of its cross-dressing women in the traditional garb of

Hasidic Jews: 'The Couturier and the Hasid' in *Too Jewish? Challenging Traditional Identities*, edited by Norman L. Kleeblatt (New York, 1996). For Lichtenberg, see *Aphorisms* (London, 1990). The internet art store advert selling Hirst works appeared in the *Guardian*, 1 September 2000.

On the three defences in general, the Rushdie essays 'In Good Faith' and 'Is Nothing Sacred?' are to be found in *Imaginary Homelands* (London, 1992). Rushdie's own defenders, of course, deployed these defences. Among many examples, there was a particularly poignant, self-critical use of the canonic defence by the Libyan poet Abbas Baydoun. 'We no longer possess,' he wrote, 'the courage of our ancestors when we write on such subjects as religion, history, literature, sexuality, and morality.' Out of this failure, for which modern writers cannot be blamed, comes culture's subordination 'to the mercy of the streets and the propagandists of the streets', and 'transgressing the limits' set by these propagandists becomes 'heresy and apostasy': *For Rushdie: Essays by Arab and Muslim Writers in Defence of Free Speech* (New York, 1993).

My characterisation of the estrangement defence, in its most typical formulations, derives from a number of sources, but chief among them are Eleanor Heartney, *Critical Condition: American Culture at the Crossroads* (Cambridge, 1997) and *Interventions and Provocations: Conversations on Art, Culture, and Resistance*, edited by Glenn Harper (New York, 1998). The Lyotard reference is from *The Postmodern Condition: A Report on Knowledge* (Manchester, 1989). The Magritte scholar is Suzi Gablik, and the place where she makes her case is *Magritte* (London, 1985). The Apollinaire quotation comes from John Golding, *Visions of the Modern* (London, 1994). Vienna Actionism can be studied in Brus, Muehl, Nitsch and Schwarzkogler, *Writings of the Vienna Actionists* (London, 1999). It is Nelson Goodman, in *Languages of Art* (Indianapolis, 1976), who argues for art's cognitive capacities. He tells the story of Picasso's response to a complaint that his portrait of Gertrude Stein did not look like its model: 'No matter, it will.' Goodman reaches the Wildean conclusion that 'Nature is a product of art and

discourse'. The curator and critic Henry Geldzahler was once asked, 'Have you ever felt excitement because you were in front of something that seemed new?' His somewhat startling answer was: 'Three times I've thrown up.' And he then elaborated, 'I wasn't ready to accept [the work]. I had to accustom myself to an unfamiliar, an astonishing new way of seeing. I had to face it over a period of time': Henry Geldzahler, *Making It New* (New York, 1994). Agnes Denes celebrates art's freedom from restriction in her essay 'The Dream' in *Art and the Public Sphere*. It is in *The Enchantment of Modern Life* (Princeton, 2001) that Jane Bennett defines 'enchantment' as 'a state of openness to the disturbing-captivating elements in everyday life'. Bennett, for whom art too 'enchants', offers an especially benign (and persuasive) formulation of the estrangement defence. Joseph Margolis, *What, After All, Is a Work of Art?* (Pennsylvania, 1999) values art for its ability to make the alien familiar. The reference to Margolis in chapter I is drawn from this book. Frederic Jameson has argued, in *Postmodernism; or, The Cultural Logic of Late Capitalism* (London, 1991), that the estrangement aesthetic is today meaningless and must be admired as one of the most intense historical achievements of the cultural past. The utopia of a renewal of perception, he concludes, has no place to go.

On the formalist defence, Peter Gay, in *Art and Act* (New York, 1976), comments, 'Oddly enough, Zola, the chief of the realists, was a founder of formalism', by which he means a founder of the formalist defence. Michael Fried, in *Manet's Modernism* (Chicago, 1996), proposes that by 1884 nearly all the elements of the formalist-modernist point of view 'were not only articulated but also specifically brought to bear on Manet's painting, which in turn seemed to fit them perfectly'. It is Francis Haskell, in *Past and Present in Art and Taste* (New Haven, 1987), who praises Zola's ingenuity. For Shklovsky, I referred to Victor Erlich, *Russian Formalism* (Paris, 1969). On the Soviet version of formalism, see Christine Lindey, *Art in the Cold War* (London, 1990),

which concludes that 'the voice of dissent in fact sang on within the Soviet Union while the free and subversive cries of Western artists were contained within manageable boundaries'. The conversation between Bacon and Sylvester is in *The Brutality of Fact: Interviews with Francis Bacon* (London, 1987). In December 1996, a New York state prison guard was suspended after he was discovered flying a Nazi flag on his porch. The guard was also reportedly a member of the National Association for the Advancement of White People. When asked about the flag, he said, 'I am not a racist and not a Nazi. I like the colour of the flag' (see Institute for Jewish Policy Research, *Antisemitism World Report 1997* [London, 1997]). This guard was no artist, and his response was clearly a dishonest one. But the point is that it will *always* be absurd to defend by reference to its formal properties the deployment of such material. The phrase of Arnheim's is from his *Film as Art* (London, 1957), and I found it quoted in Murray Smith, 'Film' in the *Routledge Companion*. The argument for a formalist period, the 'Formalesque', is made in Bernard Smith, *Modernism's History* (New Haven, 1998). The quotations from Clive Bell are taken from his 1914 work *Art* (Oxford, 1987). Anthony Savile, *Kantian Aesthetics Pursued* (Edinburgh, 1993) argues that Kant's formalism 'is no more than a superficial trait of his thinking'.

The first quotation from Mapplethorpe is in Arthur Danto, *Playing with the Edge: The Photographic Achievement of Robert Mapplethorpe* (Berkeley, 1995); the second in Ann Higonnet, *Pictures of Innocence* (London, 1998). Wendy Steiner discusses Mapplethorpe, and much else of interest and relevance to the present book, in *The Scandal of Pleasure* (Chicago, 1995). In *Mapplethorpe: A Biography* (London, 1995), Patricia Morrisroe writes that 'Mapplethorpe attempted to eroticise almost everything he photographed'. Jack Fritscher, who knew Mapplethorpe, writes that the artist 'mooned the world with contempt': *Mapplethorpe: Assault with a Deadly Camera* (New York, 1994). Mapplethorpe has a very knowledgeable eye, remarked one of his subjects,

Louise Bourgeois. Of her own work, she once commented: 'I am not particularly aware of, or interested in, the erotic in my work, in spite of its supposed presence. Since I am exclusively concerned, at least consciously, with formal perfection, I allow myself to follow blindly the images that suggest themselves to me. There is no conflict whatsoever between these two levels': *Destruction of the Father/Reconstruction of the Father: Writings and Interviews 1923–1997* (Cambridge, Mass., 1998). The Tarantino quotation is from an interview included with the screenplay of *True Romance* (London, 1995). Susan Sontag, *On Photography* (London, 1978) advances an aesthetic of photography that anticipates, and meets, the challenge of Mapplethorpe's work. She writes of 'a leading tendency of high art in capitalist countries, to suppress, or at least reduce, moral and sensory queasiness. Much of modern art is devoted to lowering the threshold of what is terrible. By getting us used to what, formerly, we could not bear to see or hear, because it was too shocking, painful, or embarrassing, art changes morals – that body of psychic custom and public sanctions that draws a vague boundary between what is emotionally and spontaneously intolerable and what is not.' John House, 'Manet's *Maximilian*: Censorship and the Salon' in *Suspended Licence: Censorship and the Visual Arts*, edited by Elizabeth C. Childs (Seattle, 1997) discusses Manet's 'detachment and open-endedness', which it characterises as 'a distinctively Parisian language of opposition to Napoleon's empire'. David Bomberg is quoted by Richard Cork, 'The Vorticist Circle, Bomberg, and the First World War' in *British Art in the 20th Century: The Modern Movement*, edited by Susan Compton (London, 1987). Bomberg described himself to the *Jewish Chronicle* as a Futurist and explained: 'Futurism is in accordance with Jewish law, for its art resembles nothing in heaven above, the earth beneath, nor the waters under the earth.' For a sophisticated, contemporary defence of certain formalist positions, see Yve-Alain Bois, *Painting as a Model* (Cambridge, Mass., 1993), and for an authoritative

rejection of formalism, see Leo Steinberg, *Other Criteria* (Oxford, 1972).

That the canonic defence is a reflex of art theory, as well as art criticism, is clear, I think, from the following: 'I will begin in the rather grisly present-day world of art, dominated by works that speak of sex or sacrilege, made with blood, dead animals, or even urine and faeces. My aim is to defuse the shock a little by linking such works with earlier traditions': Cynthia Freeland, *But Is It Art?* (Oxford, 2000). The question must be: what is the merit of seeking to defuse the 'shock'? Freeland concludes that 'contemporary ugly or shocking art like Serrano's has clear precedents in the Western European art canon'. The Clark quotation is from *The Nude* (New York, 1956). The public and critics who screamed with horror at the nude in Manet's *Le Déjeuner*, Clark says, were unaware that her outlines were taken direct from Raphael. The remarks about Gilbert and George are taken from Daniel Farson, *Gilbert and George: A Portrait* (London, 1999). The Cork quotation comes from Virginia Button, *The Turner Prize* (London, 1997). On the Fauves, see Bruce Altshuler, *The Avant-Garde in Exhibition* (New York, 1994). The *Times* columnist is Godfrey Barker, writing on 23 August 2000. The *Tilted Arc* affair is documented in *The Destruction of 'Tilted Arc'*, edited by Clara Weyergraf-Serra and Martha Buskirk (Cambridge, Mass., 1991). The 1968 manifesto from which I quote is one of a number collected in *Bamn: Outlaw Manifestos and Ephemera 1965–1970*, edited by Peter Stansill and David Zane Mairowitz (London, 1971).

Jerrold Levinson's 'historical theory' is developed in *Music, Art, and Metaphysics* (Ithaca, 1990). Apollinaire had some wise words to say about revolutionary art: '[even] if it succeeds in freeing itself from the art of the past, [it] will not necessarily cause the latter to disappear; the development of music has not brought in its train the abandonment of the various genres of literature, nor has the acridity of tobacco replaced the savouriness of food': *Theories of Modern Art*, edited by Herschel B. Chipp. Harold Bloom names as the 'Covering Cherub' the 'demon of

continuity' that seeks to 'imprison the present in the past' and 'reduce a world of differences into a greyness of uniformity': *The Anxiety of Influence* (Oxford, 1975). The Walcott quotation is from *Tiepolo's Hound* (London, 2000). Rosalind Krauss, in *The Optical Unconscious* (Cambridge, Mass., 1994), writes: 'The art historian thinks with the mind of a scholastic. Typologies. Recensions. The world seen through old men's eyes, looking with that fixedly backward stare that intends to find ladders of precedent, ladders by means of which to climb, slowly, painfully, into the experience of the present. Into a present that will already have been stabilized by already having been predicted.' For the Corot/Manet comparison, see George Heard Hamilton, *Manet and his Critics* (New York, 1969). My quotation from Eakins is taken from Charles Rosen and Henri Zerner, *Romanticism and Realism: The Mythology of Nineteenth-Century Art* (London, 1984). They remark that the 'concepts of originality and initial misunderstanding gradually became inseparable'. The canonic defence can be turned, with a twist, into an indictment: '*Piss Christ* is simply a continuation of such works of the past twenty-five years as an artist canning his faeces, another having himself shot in the arm, another masturbating in an art gallery' (Don Gray, letter to the Senate Subcommittee on Education, 5 April 1990, reproduced in *Culture Wars: Documents from the Recent Controversies in the Arts*). The ready reversibility of these canonic arguments is an indication of the defence's hermeneutically dubious character.

The account of the Cincinnati trial strategy is taken from Steven C. Dubin, 'The Trials of Robert Mapplethorpe' in *Suspended Licence*. Wendy Steiner comments on the formalist defence (without describing it as such) in *The Trouble with Beauty* (London, 2001). As for graffiti, the graffiti artist Lee Quinones complained about New York mayor Koch's $6.5m campaign to expunge subway graffiti: 'They erased history. It was one of the most hideous art crimes of the decade' (quoted by Phoebe Hoban, *Basquiat* [New York, 1998]). On Courbet's nudes, there are some instructive remarks of David McCarthy's in 'The Nude...' in *The Nude in Contemporary*

Art (Ridgefield, CT, 1999). Giorgio de Chirico, in his manifesto 'On Metaphysical Art', was realistic about new art. Those who claim that it can redeem or regenerate humanity, that it might give humanity a new sense of life, or even a new religion, are simply deluded, he wrote. Humanity is and will continue to be just what it has been in the past. It will in due course accept this art. One day, it will even go the museums to look at it. And he concludes: 'To be or not to be understood is a problem for today': see *Theories of Modern Art*.

Chapter II

Why begin the modern period with Manet? While periodising can bring interpretive benefits, arguing about the precise beginning and end of periods will invariably be fruitless (periods are not people; they do not arrive, or die, on specific days). Richard Bretell, *Modern Art 1851–1929* proposes that modern art began in 1851 because that was the year of the Great Exhibition at the Crystal Palace in London. The reasons for its significance are several: it was the first truly international exhibition of manufactured goods; it contained works of plastic art as part of a larger exhibition of cultural products; Delamotte's photographs of Crystal Palace's reconstruction broke with compositional conventions, the picturing of the Palace thus being as modern as the Palace itself (form following content). That the show was in London and not Paris indicates both that modern art is not an entirely French affair, and that this modernity is to be related to the Industrial Revolution, which England led. Bretell concedes that other years are also candidates. There is 1846, because in Baudelaire's review of the Salon of that year he called on artists to be 'of their time' – but, Bretell says, few paid attention. And then there is 1848, because of the revolutions in Europe – but England didn't pay attention, Bretell points out, and so he dismisses that year too. There is 1855, the year of Courbet's masterwork *The Studio of the Painter, A Real Allegory* – but this, contends Bretell, was only made possible by earlier developments (it did not originate, it was merely a very important

consequence). And last of all, there is 1863, in which the Salon des Refusés was established and where Manet's *Le Déjeuner sur l'herbe* was first exhibited – this year has the greatest appeal, but to privilege it over 1851, Bretell says, would be to give undue weight to the dissenting aspect in modern art, skewing its history away from any recognition of its indebtedness to the art canon. It is precisely because my book is about this 'dissenting aspect' that I begin with Manet.

The McLuhan quotation, which comes from *Understanding Media*, is quoted in John Berger, *Selected Essays and Articles* (London, 1972). The Thoré passage that I summarise near the beginning of this chapter is taken from Fried, *Manet's Modernism*. Thoré's sentiments became something of a trope in art writing. Ozenfant was expressing precisely the same sentiments in 1931 in his *Foundations of Modern Art* (New York, 1952): 'Can we really believe any longer in the existence of frontiers as regards ideas? Can we really go on working only for a chapel, a school, a clan, a group, a province, a nation? And not for all races: mankind in fact? Away with insularity. Each race has its proper genius and must exploit it for all races. Such an art is possible, because all men react unanimously to broad daylight or full night, or red or black, or love or death.' Flaubert's 4 September 1852 letter to Louise Colet is to be found in Gustave Flaubert, *Selected Letters* (London, 1997). My précis is an interpretation. The letter is very obscure in places.

Manet by Himself, edited by Juliet Wilson-Bareau (London, 1995) brings together passages from the artist's letters and reminiscences of him by friends. The quotations from Manet are taken from this volume. Of the two religious pictures, Wilson-Bareau comments: 'even today these compositions are less easy to accommodate than Manet's secular subjects.' I have learned a great deal from Beth Archer Brombert's biography, *Manet* (Chicago, 1996). She tells the story of Manet's misadventure with the young boy, the source of Baudelaire's 'The Rope'. It would seem from her account of this story that the mother's role was Baudelaire's

invention. (Brombert is also the source for the quotations from Renan and Valéry in chapter II, and the remark of the Académie des Beaux-Arts secretary quoted in chapter III.) George Heard Hamilton, *Manet and his Critics* (New Haven, 1954) quotes generously from the early criticisms of Manet, as does T.J. Clark, *The Painting of Modern Life* (Princeton, 1984). My own quotations from the critics are drawn from these books, from Krell, *Manet*, and last, from Michael Fried, *Manet's Modernism*. I am indebted to Fried in particular, for the remarks about realist religious art, the second of the quotations from Gautier and the reference to Manet ('everything...'), in chapter II, and the reference to Géricault in chapter III. I also quote from Fried himself in chapter III. He deals comprehensively in a series of footnotes with the question of whether Christ should be seen as reviving in *Dead Christ*. He also suggests that when Manet took, for one of the tormentors, a French angel from Le Nain's *Nativity of the Virgin*, blasphemy was intended (though Fried later retracts the suggestion: see page 139 of his work).

The transgressive qualities of *Le Déjeuner* have most recently and succinctly been summarised thus: '[it] posed basic problems of classification. It refused to conform to accepted boundaries, both as a work of fine art and in its imagery. It could be viewed within a range of different categories, but it consistently flouted and travestied the defining characteristics of those categories. It was too big to be a genre painting, too contemporary to be a pastoral, too illegible to be a conversation piece. Its imagery invited comparison with popular prints, but it was intended for the Salon, and its composition invoked hallowed Old Master models. Moreover, both subject and composition engaged the viewer in ways that, in the specific context of its original appearance, were particularly disconcerting': John House, 'Manet and the De-Moralized Viewer' in Manet's *'Le Déjeuner sur l'herbe'*, edited by Paul Hayes Tucker (Cambridge, 1998). The distinction that I draw between *Olympia* and *Le Déjeuner* is a pragmatic one. I could, just about, have begun my

discussion of the nude with the latter. As Robert Hughes remarks, *Le Déjeuner* is an intensely serious work and one of the victims of its seriousness is the stereotype of the nude: *Nothing If Not Critical* (London, 1990). Likewise, *Olympia* is both indebted to, and mocking of, Titian's *The Venus of Urbino* (c. 1538).

An early critic of *Olympia* complained that it presented 'a sort of monkey, making fun of the pose and the movement of arm of Titian's Venus, with a hand shamelessly flexed' (quoted by John Richardson in *Manet* [London, 1982]). This last grievance is especially odd, because it is Titian's model whose hand is the more 'shameless'. Zola's dismissive judgment on Cabanel is recorded in Peter Gay, *Pleasure Wars* (London, 1998). Kenneth Clark, *The Nude* is my source of the genre's principles. The naked body, says Clark, must undergo a severe formal discipline if it is to survive as art. This leads him, in one place, to insist that the nude is not a subject at all, though elsewhere he says that it is art's most serious subject. He is equally divided on its erotic appeal. Where the nude is treated in such a way that it stimulates desires appropriate to the material subject, 'it is false art, and bad morals'. Elsewhere, however, he is more equivocal on the nature of the spectator's (that is, the male spectator's) interest in the nude. He cannot quite come to terms with *Le Déjeuner*. Raphael's *Judgment of Paris* inspired a long line of academic compositions which ended, 'most surprisingly', he says, with the Manet work. Though some take as a joke against academicism Manet's borrowing (from Marcantonio's engraving of the Raphael work) of the poses of the river god and naiads, it is (says Clark) an intelligent acceptance of academicism's value. For Manet's competition, see Jennifer Shaw, 'The Figure of Venus: Rhetoric of the Ideal and the Salon of 1863' in *Manifestations of Venus: Art and Sexuality*, edited by Caroline Arscott and Katie Scott (Manchester, 2000). On the kitsch aspect of Cabanel's work, see Karsten Harries, *The Meaning of Modern Art* (1968). Harries is also interesting on the 'sadistic' aspect of modern art.

Fred Orton and Griselda Pollock write of 'boundary policing' in *Avant-Gardes and Partisans Reviewed* (Manchester, 1996). They praise Linda Nochlin's juxtaposition of a Gauguin painting with a 19th-century pornographic photograph of a woman with her bare breasts nestling on a tray of apples. In a later chapter, they discuss the difficulties confronting artists under the modernist regime who wished to paint nudes. How could the imperative to work with the surface of the painting be reconciled with the representational requirements of the nude genre? Artists who committed to such a project were engaged in what Orton and Pollock describe as a 'genre struggle for survival'. In a more comprehensive account than mine of the fortunes of the nude post-Manet, this aspect would play its part. Tamar Garb's *Bodies of Modernity: Figure and Flesh in Fin-de-Siècle France* (London, 1998) is one such account, and I have learned a good deal from it. She makes a convincing case, for example, for the French Impressionist Gustave Caillebotte as a transgressive artist whose work transformed the genre of the nude.

On pornography, I have drawn on the following: Walter Kendrick, *The Secret Museum* (Berkeley, 1996), the source for my Vasari quotation and for my rough dating of the emergence of the category of the pornographic; Nicholas Harrison, *Circles of Censorship: Censorship and its Metaphors in French History, Literature and Theory* (Oxford, 1995), from which I have taken Pinard's speech (though in places I have preferred Kendrick's translation); Brian McNair, *Mediated Sex: Pornography and Postmodern Culture* (London, 1996), which is very good on the contemporary cultural significance of pornography; and Isabel Tang, *Pornography: The Secret History of Civilisation* (London, 1999), which praises video for 'crossing sexual boundaries, taboos and stereotypes', and concludes that 'the sense of pornography as something shameful and transgressive seems to be fading'. The Richard Hamilton remark about *Playboy* is taken from a larger extract, and reproduced in Harrison, *Art in Theory 1900–1990*. And as for anxieties about the congruence of Feminist art and the

pornographic, consider Jo Spence: 'We were often concerned about offering potential readings which might be construed as "pornographic"' (this last word in distinct, equivocal quotation marks): *Cultural Sniping: The Art of Transgression* (London, 1995). In *Pleasuring Painting: Matisse's Feminine Representations* (London, 1995), John Elderfield defends Matisse against feminist reservations, and I have drawn some of my arguments here from him. He argues for Matisse's 'benevolent attitude' towards his female subjects: 'He prevents our staring; dissolves the strength of our gaze.' And, Elderfield concludes: 'Matisse can and does tell us two things at once – of the fact of boundaries as well as the transgression of boundaries.' The Matisse and Pollock quotations, together with the *Nude with a White Scarf*/Barberini Faun juxtaposition, are taken from this book, and he is of course the Matisse scholar mentioned in connection with the artist's double representations. The quotation from Grosz is taken from *An Autobiography* (Berkeley, 1998). Lynda Nead, *The Female Nude: Art, Obscenity and Sexuality* (London, 1992) offered the best account I found in my researches of the complex relations between the canonic and the pornographic.

On Duchamp, I found the Apollinaire quotation in Octavio Paz, '*Water Writes Always in *Plural' in *Marcel Duchamp*, edited by Anne d'Harnoncourt and Kynaston McShine (Munich, 1989). It is Thierry de Duve, in 'Echoes of the Readymade: Critique of Pure Modernism' in *The Duchamp Effect*, edited by Martha Buskirk and Mignon Nixon (Cambridge, Mass., 1996), who made the connection for me between *The Bride Stripped Bare by her Bachelors, Even* and *Etant Donnés*. John Golding, *Visions of the Modern* puts *The Bride* in the context of Duchamp's earlier studies of the female figure. Dawn Ades, Neil Cox and David Hopkins, *Marcel Duchamp* (London, 1999) is the best introduction to Duchamp that I know, and it taught me a great deal. The anecdote about the 1912 Nude and Salon des Indépendants is told by Tony Godfrey, *Conceptual Art* (London, 1998), a book that also has the Broodthaers remark that I quote in chapter III. It was Wittgenstein's

discussion of the duck-rabbit in *Philosophical Investigations* (Oxford, 1963) that caused me to think about the relevance of this figure to post-Manet nudes. William James Earle, 'Ducks and Rabbits: Visuality in Wittgenstein' in *Sites of Vision*, edited by David Michael Levin (Cambridge, Mass., 1999) offers interesting glosses on Wittgenstein. My observation about Pop art was prompted by Sidra Stich, *Made in U.S.A.* (Berkeley, 1987), to which I am also indebted for the Kaprow quotation in chapter IV. Pop art's duck-rabbit trick could not survive the militancy of the Vietnam era. It became, says an historian of the period, 'the illustration of American imperialism': quoted by Michèle C. Cone, *French Modernisms* (Cambridge, 2001). Eleanor Heartney considers contemporary art's ambivalences about the pornographic in 'Sexuality and Transgression' in *Critical Condition* (Cambridge, 1997).

There is a certain Feminist project likewise engaged with the female nude. It runs in parallel to the subversive and revisionist projects, and it keeps Manet at a distance. It aims to rescue the female body from appropriation by male artists and spectators. 'The body,' declares performance artist Carolee Schneemann, 'is innocent.' (Against which naiveté I would place Tamar Garb's unillusioned observation: 'Naked or clothed, the body in representation is cloaked in convention': *Bodies of Modernity*.) Schneemann has enacted her distance from Manet by staging *Olympia* as part of the installation *Mink Paws' Turret* (1963), and in her impersonation of Olympia in Robert Morris's *Site* (1964). Judy Chicago's exploration of the female body could only by a certain interpretive violence be assimilated to the transgressive aesthetic initiated by Manet. Her *Red Flag* (1971), for example, pictures the removal of a bloodied tampon, a private article in the guise of a public banner. It makes a spectacle of an action customarily undertaken privately. It is a special, new kind of flag art, made in a nation that esteems flags. Chicago's self-understanding is as a taboo-breaking artist: 'Having internalized so many taboos throughout the years, I was sure that people

would have violent reactions to the print [i.e. of *Red Flag:*]': *Through the Flower* (New York, 1975). Yet her work also has a conservative, even retrograde quality. She has returned to Manet's own point of departure in order to repudiate that version of the academic nude that now lives exclusively in popular culture. I first encountered *Red Flag* in Robert Hewison, *Future Tense* (London, 1990), a book about the art of the 1980s. Hewison says of it that its 'depiction of the menstrual cycle breaks a long-held taboo'. Edward Lucie-Smith's monograph *Judy Chicago: An American Vision* (New York, 2000) praises the artist for crossing intellectual and physical boundaries, and quotes her report of her nightmares. Lucy Lippard praises Chicago's 'early feminist work [which] deliberately confront[s] taboos': 'Drawing on Strength' in *Judy Chicago: Trials and Tributes* (Florida, 1999). Chicago's work 'challenges long-standing taboos surrounding... areas of female experience,' say Roszika Parker and Griselda Pollock in *Old Mistresses* (London, 1981). Under Chicago's tutelage, students in a Feminist Art Program in the 1970s 'vied with each other to come up with images of female sexual organs by making paintings, drawings, and constructions of bleeding slits, holes and gashes'. This signified to the students 'an awakening consciousness about our bodies and our sexual selves': quoted in Toby Clark, *Propaganda* (London, 1997).

The Courbet remark is my summary version of exchanges reproduced in Gerstle Mack, *Gustave Courbet* (New York, 1951). To his students, Courbet remarked: 'painting is an essentially *concrete* art which can exist only in the representation of *real* and *actual* things... An *abstract* object, invisible, nonexistent, does not lie within the domain of painting.' It is Thomas Crow who relates David's *Marat* to Christ's sacrifice: 'Marat's pose, the instruments of violence, the inscriptions, the plain wood of the upright box, the insistently perpendicular compositional order, all conjure up Christ's sacrifice without leaving the factual realm of secular history': 'Patriotism and Virtue: David to the Young Ingres' in *Nineteenth-Century Art: A Critical History*, edited by T. Crow

et al (London, 1994). In my reference to the positioning of Jesus' wound I have drawn on Vladimir Gurevich, 'Observations on the Iconography of the Wound in Christ's Side, with Special Reference to its Position', *Journal of the Warburg and Courtauld Institutes* (1957). Thierry de Duve has argued that 'religiousness is extremely difficult to avoid when you want to testify to death from within the society of spectacle': 'Come On, Humans, One More Stab at Becoming Post-Christians!' in *Heaven*, edited by Doreet Levitte Harten (New York, 1999). The reading of *Guernica* as an icon is made, for example, in *Picasso's Guernica*, edited by Ellen C. Oppler (New York, 1998).

I found F. Holland Day's work in John Pultz, *Photography and the Body* (London, 1995). Pultz writes that in *Crucifixion* and in his 'eroticization of young boys, [Day] revealed himself as one of the many photographers of this period to be fascinated by the nature of transgression'. I am also indebted to Pultz for the information about Serrano's photographing of corpses. The exceptional freedom of medieval artists to brood over Christ's physical humiliations in the saving context of the Resurrection is explored in Mitchell M. Merback, *The Thief, the Cross and the Wheel* (London, 1999). For general studies of the representation of Christ, I found the following most useful: John Drury, *Painting the Word* (New Haven, 1999); *The Image of Christ* (London, 2000), the catalogue of the London National Gallery exhibition *Seeing Salvation*; and Neil MacGregor with Erika Langmuir, *Seeing Salvation: Images of Christ in Art* (London, 2000). It is striking that none of these books has a word to say about Manet. Drury argues that 'our own kind of western European civilisation' is 'secular and pluralist'. The art he is concerned with is Christian and 'we are visitors to this Christian world'. As if in deliberate qualification of this proposition, MacGregor places Kollwitz's *The Downtrodden* (1900) against Holbein's *Dead Christ* (1521), Christ's death resonating in the plight of the Berlin poor. As early as 1890, Maurice Denis could write that while a Byzantine Christ is a symbol, the Jesus of the modern painter is merely literary: see *Theories of Modern Art*.

The brief reference to the difficulty of making secular art was prompted by some remarks made about Van Gogh in Orton and Pollock, *Avant-Gardes*. David Sylvester's remarks are taken from his *Francis Bacon: The Hayward Gallery* (London, 1998) and his *Looking Back at Francis Bacon* (London, 2000). While I accept that Sylvester is without peer as an interpreter of Bacon, Ernst van Alphen's *Francis Bacon and the Loss of Self* (Cambridge, Mass., 1993) answers more closely to my own sense of Bacon's work (he is the acute critic I quote in chapter II). The book begins: 'Seeing a work by Francis Bacon hurts. It causes pain.' Van Alphen writes about the 'affective' aspect of Bacon's art, pondering its ability to 'incapacitate' its audience. It is Michel Leiris, in *Francis Bacon* (London, 1998), who describes Bacon's art as 'demystified'. He argues that Bacon's *Crucifixions*, 'for the most part, have no iconographical relationship with the death of Christ'. Allon White's review essay 'Prosthetic Gods in Atrocious Places: Gilles Deleuze/Francis Bacon' in *Carnival, Hysteria and Writing* (Oxford, 1993) relates Bacon to Kristevan notions of the abject. 'Too often,' White writes, 'abstract modernism takes refuge in its purism and its rationalism. It is safe art. In Bacon, the formalism and aesthetic purity of his contemporaries are estranged.' Michael Peppiat, *Francis Bacon: Anatomy of an Enigma* (London, 1996) regards Bacon's deployment of the swastika as 'inspired impudence'. He has turned it, says Peppiat, into a 'decorative device'. This is a piece of 'homosexual bravura'. Bacon was 'obsessed with the Crucifixion', Peppiat adds. Andrew Brighton's lucid monograph *Francis Bacon* (London, 2000) relates Bacon's work to certain themes in counter-Enlightenment thought, while also stressing the artist's atheism. I owe the Gowing story to this book. Gowing adds, in a passage that Brighton does not quote, 'the links with the past have been precious to [Bacon]. He has a kind of piety toward them': Lawrence Gowing and Sam Hunter, *Francis Bacon* (London, 1989). Hunter writes of Bacon's 'visual assaults on taboo subject matter and conventional taste'.

Ruskin's observations are made in the course of his

Lectures on Art (New York, 1986). The Spengler remark is taken from volume 1 of *The Decline of the West* (London, 1971), a book that I bought in 1975 and have yet to finish. Gérard Genette, *Literature in the Second Degree* (Lincoln, 1997) is an encyclopedic, analytical account of the different kinds of derivative literature. K.E. Maison, *Themes and Variations: Five Centuries of Master Copies and Interpretations* (London, 1960), with an introduction by Michael Ayrton, and Jean Lipman and Richard Marshall, *Art about Art* (New York, 1978) are excellent guides to the variety of relations between the canonical artists, the latter written just before the emergence of appropriation art. I found Warburg's account of Manet's *Le Déjeuner* in E.H. Gombrich, *Aby Warburg* (London, 1986). The elaboration of Warburg's conception of art as involved in a fight against the constraints of social convention and superstitious fear is to be found in Michael Podro, *The Critical Historians of Art* (New Haven, 1982). He quotes Warburg: 'With the intention of restoring antiquity, good Europeans began their struggle for enlightenment, and they did so in an age of the world-wide circulation of imagery which we all too mystically call the Renaissance.' Linda Nochlin's comments on Manet are to be found in *The Politics of Vision*. I have taken the summary of Picasso's engagements with Manet from Paul Hayes Tucker, 'Making Sense of *Le Déjeuner sur l'herbe*', in the collection of essays edited by him *Manet's 'Le Déjeuner sur l'herbe'*. Charles Stuckey refers to Andy Warhol's 'trademark plagiarist fashion' in his introductory essay to the catalogue *Heaven and Hell Are Just One Breath Away* (New York, 1992). Matthew Collings, in *Blimey!* (London, 1997), says that Glenn Brown is one of the few artists who can still 'do' appropriation, without it seeming *passé*, though on the evidence Collings offers, this seems generous. Dürer inscribed on a woodcut: 'Woe to you! You thieves and imitators of other people's labour and talents. Beware of laying your audacious hand on this artwork': quoted by Ralph E. Lerner and Judith Bresler, *Art Law* (New York, 1998, 2nd edn).

For Rosalind Krauss, the 'deconstruction' by Sherrie

Levine of 'the sister notions of origin and originality' establishes a schism between postmodernism and 'the conceptual domain of the avant-garde, looking back at it from across a gulf that in turn establishes a historical divide. The historical period that the avant-garde shared with modernism is over': 'The Originality of the Avant-Garde' in *The Originality of the Avant-Garde and Other Modernist Myths* (Cambridge, Mass., 1986). My reading of Levine's work as a kind of 'reconception' of art is indebted to the general discussion in Nelson Goodman and Catherine Z. Elgin, *Reconceptions in Philosophy and Other Arts and Sciences* (London, 1988). On Koons, Andrew Graham-Dixon observes that the artist is 'a canny student of the art of the past' and that *Bunny*, for example, is a parody Brancusi: 'Kitsch and Tell', *Sunday Telegraph*, 17 September 2000. John A. Walker, *Art in the Age of Mass Media* (London, 1994) writes unsympathetically about Koons and Bidlo, and sympathetically about Lawson and Levine. On the theological aspect of Reinhardt, see Mark C. Taylor, *Disfiguring: Art, Architecture, Religion* (Chicago, 1992) and Anna Moszynska, 'Purity and Belief: The Lure of Abstraction' in *The Age of Modernism: Art in the 20th Century*, edited by Christos M. Joachimides and Norman Rosenthal (Berlin, 1997). For a mention of the iconicism of Malevich's *Black Square* (1915), see my *Idolizing Pictures* (London, 2000).

I found Picasso's prescription for art in John Richardson, *A Life of Picasso. Volume I: 1881–1906* (London, 1991), and Apollinaire's prescription in Gay, *Pleasure Wars*. The quotation from Bataille is taken from his counter-definition of the 'informe' in *Encyclopaedia Acephalica* (London, 1995). The notion of an 'ideal type' is of course Weber's, and I found it conveniently glossed in Julian Freund, 'German Sociology in the Time of Max Weber' in *A History of Sociology*, edited by Tom Bottomore and Robert Nisbet (London, 1979).

Chapter III

The extent to which the ostensibly empirical particulars in artists' biographies derive from long-established cultural assumptions is examined in Ernst Kris and Otto Kurz, *Legend, Myth, and Magic in the Image of the Artist* (New Haven, 1979). They write about the 'flotsam of ancient conceptions of the artist [that is] carried forward on biographical waves'. The art textbook mentioned at the opening of the chapter is *Art of the 20th Century*, edited by Ingo F. Walther (Köln, 2000). The Blanchot phrase is taken from Maurice Blanchot, 'The Birth of Art' in *Friendship* (Stanford, 1997). The artist who claims sainthood for members of her guild is Rosemarie Castoro, and she makes the claim in the course of some remarks captured in *Art in Theory 1900–1950*. Arthur Danto writes about intractably avant-garde art in 'Hegel, Biedermeier, and the Intractably Avant-Garde', the foreword to Linda Weintraub, *Art on the Edge and Over: Searching for Art's Meaning in Contemporary Society 1970s–1990s*.

The Cold War defenders of modern art are considered in Irving Sandler's Introduction to Alfred H. Barr, Jr, *Defining Modern Art* (New York, 1986). I have drawn on Barr's writings in various places (it is Barr, for example, who has the Goebbels threat, quoted in chapter III). The reading of Flanagan's hare figure as a boundary-crossing artist was prompted by Richard Cork, 'The Seventies and After' in *British Art in the 20th Century*. The Ensor quotation may be found in Stephen F. Eisenman, 'Symbolism and the Dialectics of Retreat' in *Nineteenth-Century Art: A Critical History*. The Picasso quotations are taken from *Picasso on Art*, edited by Dore Ashton (New York, 1972). For the work of the Arte Povera group of artists, I have relied mainly on the images and texts collected in *Arte Povera*, edited by Carolyn Christov-Bakargiev (London, 1999). The quotations from Gilberto Zorio in chapters I and V and the picture of the Boetti work discussed in chapter IV are also taken from this book. The Malevich quotation in chapter III and the Maurice de Vlaminck quotation in chapter V come from Bruce Altshuler, *The Avant-Garde in Exhibition* (Berkeley, 1994). The Cragg quotation may be found in *Tate Modern: The Handbook*, edited by Iwona Blazwick and Simon Wilson (London, 2000). The Soviet unwritten rules are examined in *The Quest for Self-*

Expression: Painting in Moscow and Leningrad 1965–1990, edited by Norma Roberts (Ohio, 1990). The quotation from Tyshler's widow is taken from this catalogue. It is Kirk Varnedoe, in *A Fine Disregard: What Makes Modern Art Modern* (London, 1990), who makes the 'playing by/playing with' the rules distinction.

The Freud quotation is taken from *Civilisation and its Discontents* (London, 1973). The Franz Marc quotation comes from Wieland Schmidt, 'Developments in German Art' in *German Art in the 20th Century* (Munich, 1985). The Gunther Uecker remark comes from another essay in the same volume: Stephan von Wiese, '1958–1966: ZERO Group'. Rosalind Krauss's 'Grids' is in *The Originality of the Avant-Garde and Other Modernist Myths*. The phrase 'transgressive thought of the human', which I apply to Jane Alexander's work, is Krauss's account (in 'No More Play', another essay in the same volume) of the photograph of the insect-headed man that appeared in Bataille's *Documents*, 2:2 (1930). The passage on Gordon Matta-Clark is in Pamela M. Lee, *Objects to Be Destroyed* (London, 2000). The Barthes quotation is from 'Is Painting a Language?' in *The Responsibility of Form* (Berkeley, 1985). The Armory Show quotation is in Milton W. Brown, *The Story of the Armory Show* (New York, 1988); for an analysis of the art-historical implications of the show, see Mayer Shapiro, 'The Armory Show' in *Modern Art: 19th and 20th Centuries* (New York, 1979). The Ruskin quotation comes from Gay, *Pleasure Wars*. The 'dancing in chains' passage from Nietzsche comes from *Human, All Too Human* (Cambridge, 1986). The other Nietzsche quotations in the book are taken from *Ecce Homo* (London, 1992), *Daybreak: Thoughts on the Prejudices of Morality* (Cambridge, 1982) and *On the Genealogy of Morals* (New York, 1969). The best study of Nietzsche's aesthetics that I have read is Julian Young, *Nietzsche's Philosophy of Art* (Cambridge, 1993).

I have mainly relied for my characterisation of Smithson's work on the artist's own writings, collected in *Robert Smithson: The Collected Writings* (Berkeley, 1996). I found the Tinguely quotation in Calvin Tomkins, *Ahead of the Game: Four Versions of Avant-Garde* (London, 1986). On

the art/money nexus, Robert Hughes's 'Art and Money' in *Nothing If Not Critical* (London, 1990) is trenchant. The Duchamp letter is quoted in Francis M. Naumann, *New York Dada 1915–23* (New York, 1994). The Warhol statement about business art is made by him in *The Philosophy of Andy Warhol (From A to B and Back Again)* (New York, 1975). The Boggs story is told in Lawrence Weschler, *Boggs: A Comedy of Values* (Chicago, 1999), to which I am also indebted for the Gotovac story in chapter V, and in Geoffrey Robertson, *The Justice Game* (London, 1998). My characterisation of Metzger relies upon remarks made by John Berger in *Selected Essays and Articles* (London, 1972). The Golub exchange is taken from *Talking Art 1*. Several years later, in response to a question about his portrait of Nelson Rockefeller, Golub said: 'What [MoMA] should have done is purchase [it]. That would have been the way for a true aristocrat to handle dissension.' This interview was carried by the *Art Newspaper*, June 2001, from which I have also taken the headline 'Transgression + Media Coverage = Big Bucks'. Gay, *Pleasure Wars* examines at length art's commerce with commerce, and summarises the extreme anti-bourgeois position thus: 'to sell was to sell out.' The characterisation of the YBAs is Vasif Kortun's, made in *Fresh Cream* (London, 2000). Pierre Bourdieu analyses that aspect of the art world 'where the laws of economic necessity are suspended' in *The Field of Cultural Production* (Oxford, 1993). It is the place where instant success is seen as the mark of intellectual inferiority. I also found in this book an argument about the congruence of Flaubert and Manet that confirmed my own intuition of their complex affinities.

On Goya, I have learned most from Gwyn A. Williams, *Goya and the Impossible Revolution* (London, 1984). It finds in the group of engravings to which *Great Deeds!* belongs a 'manic intensification of atrocity'. Victor I. Stoichita and Anna Maria Coderch, *Goya: The Last Carnival* (London, 1999) persuasively relates the artist to Bakhtinian themes. The reference in chapter IV to Marat is just one of my debts to this book. The characterisation of the Enlightenment as a project of dissolution and liberation comes from Max

Horkheimer and Theodor Adorno, *Dialectic of Enlightenment* (London, 1973). They conclude that 'the fully enlightened earth radiates disaster triumphant'. The Callot, Goya and Dix works that I discuss in chapter IV are brought together for critical examination in the catalogue to the 1998–9 National Touring Exhibition 'Disasters of War: Callot, Goya, Dix' (Manchester, 1998). Sarah Symmons, *Goya* (London, 1998) refers to the Chapman Brothers, and comments that Goya's *Great Deeds!* is 'still potent enough to inspire young artists'. Arthur Danto develops the argument that Goya is not to be regarded as an Enlightenment artist in 'Goya and the Spirit of Enlightenment' in *Encounters and Reflections*. The artist was too much of a pessimist, and his work does not so much reflect, as indicate an abandonment of, Enlightenment hopes. Riem's essay, the full title of which is 'On Enlightenment: Is it and Could it Be Dangerous to the State, to Religion, or Dangerous in General? A Word to Be Heeded by Princes, Statesmen and Clergy', is anthologised in *What Is Enlightenment?*, edited by James Schmidt (Berkeley, 1996).

The starting point for any inquiry into the nature of taboo is Franz Steiner, *Taboo* (London, 1956). I have also relied upon Roy A. Rappaport, *Ritual and Religion in the Making of Humanity* (Cambridge, 1999), in which I found the definition of 'taboo' that I quote in chapter III as the current anthropological meaning of the word. I also found helpful Adam Kuper, *Anthropologists and Anthropology* (London, 1973). The *Encyclopaedia Britannica* quotation comes from this work. Freud's contribution to the trashing of taboos was to relate them to mental sickness. In *Totem and Taboo* (1913), he argued that communal taboos are analogous to obsessional neuroses. There are people, Freud observes, who have created for themselves individual taboo prohibitions and who obey them just as strictly as communal taboos are followed by 'savages'. Indeed, these individuals may be said to suffer from 'taboo sickness'. Taboos cast a kind of spell; they incapacitate. So detached was Freud from Judaism, however, that he could assert in *Totem and Taboo*

that taboo restrictions are distinct from religious prohibitions and are not based on divine ordinances. They have, he says, no grounds and are of unknown origin. Although his anthropology was bad, his psychology was (of course) excellent: it is precisely this sense of the groundlessness of taboos that induces the experience of vertigo when they are breached. Freud equivocates on the historical debt of morality to taboo. While taboos do not differ in their psychological nature, says Freud, from Kant's categorical imperative (that is to say, they have the same force as moral duties), they have a different subject matter to morality, they operate in a compulsive fashion, and they reject any conscious motives.

The Bono item comes from the *Guardian*, 12 November 1999. My edition of Lippmann's work was published by the University of Michigan Press in 1962. The Tunisian filmmaker that I mention in this chapter is Nouri Bouzid, and his essay 'Mission Unaccomplished' appears in *Index on Censorship*, 6/1995. The remark of David Smith's on totems and taboos is to be found in Carla Gottlieb, *Beyond Modern Art* (New York, 1976). Mary Douglas outlines the influence of 19th-century rationalism on earlier generations of anthropologists in the preface to *Leviticus as Literature* (Oxford, 1998). Judith Devlin, *The Superstitious Mind* (New Haven, 1987) is a study of French peasants and the supernatural in the 19th century which is valuable for the light it sheds on the beliefs of a particular community, but is too dependent on the Enlightenment binarism of reason/folly to be more generally illuminating. Robin Lane Fox mocks the dietary rules of the Jews in *The Unauthorized Version* (London, 1991), listing those anomalous creatures that 'transgressed the classes of a tidy mind'. Writing this book gave me the opportunity of returning to Owen Chadwick, *The Secularisation of the European Mind* (Cambridge, 1975), and I have learned anew from it. It is the source of the quotation from Renan in chapter II. On the political tensions between local allegiances and universalist obligations, Onora O'Neill is illuminating. See, for

example, her 'Distant Strangers, Moral Standing and Porous Boundaries' in *Bounds of Justice* (Cambridge, 2000).

On the distinctiveness of morality, Alasdair MacIntyre, *A Short History of Ethics* (London, 1974) was especially valuable, principally for the bridge that it establishes between moral rules and forms of social life. It is MacIntyre who describes, in his chapter on Kant, the test of a genuine moral imperative. I also found helpful MacIntyre's *After Virtue* (London, 1985) and *Three Versions of Moral Inquiry* (London, 1990). Berys Gaut, 'Art and Ethics' in the *Routledge Companion* is typical of the tendency to characterise in exclusively ethical terms the challenge of artworks such as Mapplethorpe's photographs. 'Art,' Gaut writes, 'has real power: power to disturb, power to pummel against the bulwarks of our ethical convictions.' The ethical question posed by the homoerotic works is: are the acts represented part of a coherent sexual *ethic*? The taboo-laden question is: why do these works trouble us so much? Gaut distinguishes two senses in which an artwork can be 'transgressive'. It can question moral attitudes; it can embrace immoral attitudes. Sidgwick's *History of Ethics* (London, 1931) went through six editions and was still on the reading list for the English Moralists Paper in Part II of the Cambridge University English tripos when I sat it in 1977. There was a precedent for *Myra*. About 30 years earlier, Warhol had created a mural-size painting drawn from a number of 'wanted' posters for dangerous criminals. It had been commissioned for the 1964 New York World's Fair, and was withdrawn within hours of its installation under pressure from sponsors.

The paragraphs on the challenge of classical sociology to philosophical accounts of morality, its relation to transgressive art and the nature of collective values (as distinct from the restricted notion of moral rules) derive largely from my reading of Durkheim. See *Sociology and Philosophy* (New York, 1974), *The Rules of Sociological Method* (London, 1982) and *Selected Writings*, edited by Anthony Giddens (Cambridge, 1972). Steven Lukes, *Emile Durkheim* (London, 1973) was an initial, helpful guide. R.A. Nesbit, *The Sociological Tradition* (London, 1970) was useful, and is

the source of my quotation from Holbach. It is Roger Scruton, in *Modern Philosophy* (London, 1994), who defines Durkheim's theory of religion as an affirmation of the first person plural. Zygmunt Bauman, *Modernity and the Holocaust* (Oxford, 1991), and especially chapter VII, 'Towards a Sociological Theory of Morality', implies modifications of Durkheim. The quotations from Voltaire come from his *Philosophical Dictionary* (London, 1971). I found the quotation from Leiris in Chris Turner, 'Shock Treatment', *Tate*, summer 2000.

Since I first starting thinking about this book, I have been collecting usages of 'taboo'. Almost without exception, they are dismissive. 'Taboo subjects,' Lucy Lippard writes, 'include a panoply of feminist preoccupations.' Tina Brown 'talked eagerly about breaking old *New Yorker* taboos by introducing photographs', reports Alexander Chancellor in *Some Times in America* (London, 1999). John Sutherland, 'On Sense and Censorship', *Guardian*, 18 October 1999, sets 'taboos' against 'gentility'. Sally Cline describes her book *Lifting the Taboo: Women, Death and Dying* (London, 1995) as 'break[ing] through our most sacred taboo' and 'split[ting] open the silence' on the subject of death. Ronald Steel, in his study of Robert Kennedy, *In Love with the Night* (New York, 2000), writes regarding the 1960 presidential campaign that 'the Kennedys badly needed to carry this heavily Protestant state [West Virginia] to break the taboo against a Catholic in the White House'. Steel says that Robert 'kept pushing beyond the limits of politics', and that JFK 'made his own rules'. Of the Kennedy administration's military adventurism, Steel remarks, 'nothing was off-limits'. None of this is intended to be complimentary. One hostile reviewer of an art show criticised a work by the modernist American Adelheid Roosevelt on the ground that it 'belonged to the sticks and stones and senseless things of the African taboo' (quoted in Francis M. Naumann, *New York Dada 1915–23*). This is perhaps one of those rare occasions when an artwork finds itself condemned for being taboo, rather than taboo-breaking.

The question of whether we owe duties to the dead is considered in John Casey, *Pagan Virtue* (Oxford, 1991). I am also indebted to its exposition of the concept (derived from Aquinas) of 'pietas'. My sense of the distinctness of pieties in respect of the dead, as against the moral questions that relate to death (Is death an evil? When is taking life justified?), was assisted by a reading of Blackburn, *Being Good*. Freud interprets piety towards the dead as the modern resolution of a former, primitive ambivalence, in which 'hatred and pained affection fought each other': *Totem and Taboo*. His remark about the continuity of our feelings about death is made in 'The Uncanny' in *The Pelican Freud Library: 14. Art and Literature* (London, 1985). There is an interesting discussion in James O. Young, 'Authenticity in Performance' in the *Routledge Companion* of this question in the context of the performance of musical compositions. Are performers under a moral obligation to respect composers' intentions? When composers are dead, the existence of such an obligation depends on the claim that the dead can be harmed by performers who disregard their intentions. The disregarding by artists of canonic constraints is a kind of disrespect of the dead. I read the Giuliani story in the magazine *Art in America*, April 2001.

My preliminary examples of contemporary (or near-contemporary) taboo-breaking art are intended to be representative of works of a certain quality as well as of a certain kind. As to Serrano's *Milk, Blood*, Cynthia Freeland, *But Is it Art?* has interesting things to say about blood in art. Lucy Lippard insists, however, on reading it in entirely formalist terms as a 'wholly abstract work' (in *Culture Wars: Documents from the Recent Controversies in the Arts*). The Sally Mann photograph is discussed by Amy Adler in 'Photography on Trial', *Index on Censorship*, 3/1966. The historian of images of children is Anne Higonnet and I have drawn extensively from her *Pictures of Innocence* in chapter III. She praises Mann for 'flout[ing] the sexual innocence that was at the core of the Romantic child ideal'. She concludes: 'Art asks us on its own terms to take our children seriously.' On Orlan, my principal sources are

Amelia Jones, *Body Art: Performing the Subject* (Minneapolis, 1998) and Linda Weintraub, *Art on the Edge and Over: Searching for Art's Meaning in Contemporary Society 1970s–1990s*, though her work is also discussed in most surveys of the contemporary art scene. Weintraub quotes Orlan: '[My work] is a struggle against the innate, the inexorable, the programmed nature, DNA (which is our direct rival as artists of representation) and God! My work is blasphemous.' Franko B's work is discussed in Rachel Campbell-Johnston, 'No Blood, No Glory', *The Times*, 9 May 2001. Barbara Rose, *Autocritique: Essays on Art and Anti-Art 1963–1987* (New York, 1988) briefly considers the career of Rudolf Schwarzkogler, the German artist who cut off slices of his penis until he finally bled to death. The Phaidon *20th-Century Art Book* (London, 1996), which is a digest of received critical opinion, celebrates the work of the American artist Chris Burden thus: 'By adopting extreme positions, he hoped to cross the threshold of the taboo in society and to question artistic responsibility.'

As for Ping, the story of the installation is told in Nathalie Heinich, 'Aesthetics, Symbolics, Sensibility: On Cruelty Considered as One of the Fine Arts' in *Think Art*, edited by Jean-Marie Schaeffer (Rotterdam, 1998). Hegel is interesting on the subject of the 'Degradation of the Animal' in classical art, as a development from Indian and Egyptian art (*Aesthetics*, Pt II, Sect. II, ch. I.I). Two examples of harm done to animals in the name of art: August Ortiz's proposed 'chicken-destruction ritual', which he announced at the 1966 Destruction in Art Symposium in London, and Newton Harrison's *Portable Fish Farm* (1971), in which catfish were electrocuted and eaten at the Hayward Gallery. These transgressive artists affirm the principle that animals exist for the sake of man, the very principle that animal liberationists contest: see Steven M. Wise, *Rattling the Cage* (London, 2001). (Wise is the activist I quote in this chapter.) Roger Scruton has interesting things to say both about animals and about pieties in *Animal Rights and Wrongs* (London, 1998), though he locates piety entirely within the realm of morality. I have drawn on some of the arguments in Steve Baker,

The Postmodern Animal (London, 2000) for my discussion of Jane Alexander's work. The Peter Fuller phrase is taken from *Images of God* (London, 1990), as are his other observations on Bacon that I quote in chapter II. I first came across the Grünfeld work in *Art at the Turn of the Millennium*, edited by Burkhard Riemschneider and Uta Groesenick (Köln, 1999). 'Art,' says Grünfeld, 'is a hybrid.' I have also taken the Group Material story in chapter III from this book. The Rimbaud poem is 'City' ('Ville') and the edition that I have used is the parallel-text translation by Enid Rhodes Peschel published by OUP.

As to the Chapmans' *Great Deeds*, note William Ian Miller, *The Anatomy of Disgust* (Cambridge, Mass., 1997): 'There are few things that are more unnerving and disgust-evoking than our partibility. Consider the horror motif of severed hands, ears, heads, gouged eyes… Severability is unnerving.' The artists were interviewed by Lynn Barber in the *Observer*, 28 March 1999. They want, they say, to produce intensely sadistic objects, to populate the world with objects that the world doesn't necessarily feel it deserves. They are out to victimise their viewers. Their work, they say, is intensely non-human, intensely cold and intensely cruel. It is made in an intensely uncaring manner – uncaring about the views of the person who is being invited to look at it, and not caring to reflect the emotions or the human empathy of the people who made the thing. And then, as if to make their point a little clearer, they add (to an interviewer): 'I want to rub salt into your inferiority complex, smash your ego in the face, gouge your eyes from their sockets and piss in the empty holes.' In this respect, then, *Hell* represents a failure of nerve, a defeat. It purports to justify the artists' delight in the representation of suffering by reference to a moral, punitive purpose.

On World War I, Modris Eksteins, *Rites of Spring* (London, 1990) was invaluable. Among other specific debts, I owe to this book the Huxley quotation (which is from *Point Counter Point*) and the Diaghilev quotation. On Dada: the Ball fragment and the Tzara passage are extracted in *Art in Theory 1900–1950*. The phrase 'principle

of disrule' is Christopher Middleton's, and taken from his 'Bolshevism in Art: Dada and Politics' in *Bolshevism in Art* (Manchester, 1978). But my principal guides to Dada were Robert Motherwell, *The Dada Painters and Poets* (Cambridge, Mass., 1981) and Hans Richter, *Dada: Art and Anti-Art* (New York, 1965).

The purpose of *Surrealism*, edited by Herbert Read (London, 1971), originally published in 1936, was to introduce the Surrealists to a prewar British audience. It introduced me to Surrealism somewhat later, in about 1972. Maurice Nadeau, *The History of Surrealism* (London, 1973) was my second introduction, and I have returned to the book several times since first buying it, nearly 30 years ago. *Realism, Rationalism, Surrealism: Art between the Wars*, edited by Briony Fer, David Batchelor and Paul Wood (New Haven, 1993) was an excellent, more recent, guide. André Breton, *Manifestos of Surrealism* (Ann Arbor, 1972) is indispensable. His *Anthology of Black Humour* (San Francisco, 1997) is a revelation. Julien Levy, *Surrealism* (New York, 1995), first published in 1936, introduced me to the Klee poem quoted in chapter I. David Gascoyne's definition of Surrealism, as putting the marvellous within our reach, comes from this volume. Of images of women in works by Magritte and Bellmer, Mary Ann Caws writes, in *The Surrealist Look* (Cambridge, Mass., 1999), 'we have been angry at these images; we still are.' 'Surrealism,' she argues, 'causes problems. It disturbs, as it wants to, even now.' Caws is the author of the phrase 'gestures of interpenetration' in chapter III, and the Breton line quoted in an earlier paragraph is also from her book. 'Things and people and ideas refuse to stay in their own domains,' she writes of Surrealism; 'they are – *just look at them!* – spilling all over the place.' Renée Riese Hubert, *Surrealism and the Book* (Berkeley, 1988) examines the collaborations between artists and writers indifferent to priorities of genre. The argument that Surrealism comprises, in some sense, a transgression of the modernist aesthetic is developed in Rosalind Krauss, *The Optical Unconscious*. She offers a 'counter-history' of the modernism that 'staked everything on form'. Walter

Benjamin, 'Surrealism' in *One-Way Street and Other Writings* (London, 1979) was very rewarding. Ruth Brandon, *Surrealist Lives* (London, 1999) is a well-researched biographical account of the leading Surrealists. As her caption to a photograph of *Fountain*, she writes, 'Duchamp pisses on Art'. Matthew Gale, *Dada and Surrealism* (London, 1997) provided me with background missing in other general accounts of these two movements.

Dawn Ades, *Dali* (London, 1995) describes the Surrealists' dismay at *Le Jeu lugubre* (which she translates as *Dismal Sport*). Bataille, by contrast, greatly esteemed it. The biographical aspect of the painting is related in Ian Gibson, *The Shameful Life of Salvador Dali* (London, 1997). Emanuelle de l'Ecotais and Alain Sayag, *Man Ray: Photography and its Double* (Corte Madera, CA, 1998) is an excellent study of the photographer. Sontag writes of Ray that his 'style and purposes straddle photographic and painterly norms': *On Photography*. In an interview, Ernst explained that *The Virgin Spanking the Christ Child* represents one of his own childhood memories, but without being a faithful portrait of his mother or himself. Of the shocked response to the work, he comments, 'that is exactly the kind of scandalised misunderstanding that I had hoped to provoke': Edouard Roditi, *Dialogues: Conversations with Artists at Mid-Century* (San Francisco, 1990). William A. Camfield, *Max Ernst: Dada and the Dawn of Surrealism* (Munich, 1993) is a thorough account of the artist's work during a particular period. The Tate Gallery catalogue *Max Ernst: A Retrospective* (Munich, 1991) contains an essay by Werner Spies in which he analyses what he terms 'the laws of Dada', which he calls 'this seeming contradiction in terms'. Gaston Diehl, *Max Ernst* (Naeffels, 1975) was also helpful. I have relied on Dorothea Dietrich, *The Collages of Kurt Schwitters* (Cambridge, 1993) for both the details of Schwitters's Merzbau and the misogyny of the Berlin Dadaists. Sue Taylor, in *Hans Bellmer: The Anatomy of Anxiety* (Cambridge, Mass., 2000); frets over the pleasures offered by Bellmer. She writes that 'Bellmer depicted female bodies reified, mutated, sodomized, bound, eviscerated. Is to call attention to

this material, one worries, unavoidably to promote its misogynistic effects?' Taylor is the source of my story about Bellmer in chapter V. For Paul McCarthy, see Ralph Rugoff, Kristine Stiles and Giacinto Di Pietrantonio, *Paul McCarthy* (London, 1996). The artist is praised as 'master of the taboo-smash'. The McCarthy quotation in chapter I comes from here.

Nietzsche's account of the morality of cruelty is investigated in Ivan Soll, 'Nietzsche on Cruelty, Asceticism, and the Failure of Hedonism' in *Nietzsche, Genealogy, Morality*, edited by R. Schacht (California, 1994). The Stendhal quotation is in Peter Gay, *Art and Act*. The Couture remark is quoted by Pierre Bourdieu, *The Field of Cultural Production*. The Wilde quotation is cited in Martin Jay, *Cultural Semantics*. I read about the Julia Scher work in *Art at the Turn of the Millennium*, edited by Burkhard Riemschneider and Uta Grosenick. There is an interesting, though somewhat inconclusive discussion of *Myra* in Julian Stallabrass, *High Art Lite* (London, 2000). The painting is 'about', Stallabrass maintains, the inseparability of two projects: Harvey's own glamorising of Hindley and the interrogating of the glamorisation of Hindley by others.

I found the Staeck poster, *Vorsicht Kunst!*, in Irit Rogoff, 'Representations of Politics: Critics, Pessimists, Radicals' in *German Art in the 20th Century: Painting and Sculpture 1905–1985*, edited by C.M. Joachimides et al (Munich, 1986). She says that its declaration, 'Beware Art!', maintains a century-long German belief that art not only performs a substantive social function, but also has a constant, alert and responsive audience. Judy Chicago's comments about the challenges to the control of representation are made in 'Welcome to Dinner', *Index on Censorship*, 3/1966. I found the Colescott picture in Irving Sandler, *Art of the Postmodern Era: From the Late 1960s to the Early 1980s* (New York, 1996). According to Murray Edelman, *From Art to Politics* (Chicago, 1995), Colescott's work comprises 'efforts to force audiences to think about their conventional ideological assumptions respecting status and social inequalities'. This seems to me to be too

generous an assessment. The Iris Murdoch quotations are taken from *Metaphysics as a Guide to Morals* (London, 1992). I have slightly modified Murdoch's language – but not the meaning – when required by the context. I have taken the claim for art's liberating nature from Herbert Marcuse, *The Aesthetic Dimension* (Boston, 1978). The Khrushchev threat is quoted in Christine Lindey, *Art in the Cold War*. Picasso's 'Why I Became a Communist' is reproduced in *Picasso's Guernica*.

The Baumeister picture is mentioned in Toby Clark, *Art and Propaganda*. Details of Baumeister's biography, and of his participation in the 'Entarte Kunst' exhibition, are contained in Stephanie Barron, *'Degenerate Art': The Fate of the Avant-Garde in Nazi Germany* (New York, 1991). The quotation from Baumeister comes from Lynn H. Nicholas, *The Rape of Europa* (London, 1994). As for Breker, I consulted Peter Adam, *The Arts of the Third Reich* (London, 1992) and Jonathan Petropoulos, *The Faustian Bargain: The Art World in Nazi Germany* (London, 2000). Though Breker died in 1991, and notwithstanding his immense importance in Nazi Germany, Harold Osborne omits him from *The Oxford Companion to Twentieth-Century Art* (Oxford, 1988). The ROCI story is told by Mary Lynn Kotz, *Rauschenberg/Art and Life* (New York, 1990). I drew my account of the Haacke affair from Brandon Taylor, *The Art of Today* (London, 1995). Danto's comments on it are taken from his essay on the artist in *Encounters and Reflections*. Haacke talks about his work in a series of interviews in Pierre Bourdieu and Hans Haacke, *Free Exchange* (Cambridge, 1995). The best discussion of Haacke I have found is in Benjamin H.D. Buchloh, *Neo-Avantgarde and Culture Industry* (Cambridge, Mass., 2000). This book is also the source for my Broodthaers quotation in chapter III. *Arte-Reembolso/Art Rebate* is discussed by Michael Brenson in 'Resisting the Dangerous Journey' in *The Crisis of Criticism* (New York, 1998). On flag art (and anti-art), I referred to Peter Selz, 'Oh Say Can You See? Flags: Johns to Burkhardt' in *Beyond the Mainstream*, which is the source for my Grosz quotation, and to Thomas Crow, *The Rise of the Sixties* (London, 1996), which also introduced me to

Bruce Conner's work and in which I found the New York World Fair story and the Anthony Caro remark (both also in chapter III).

On Kiefer, many of the Nazi salutes, in various media, are reproduced in Nan Rosenthal, *Anselm Kiefer: Works on Paper in the Metropolitan Museum of Art* (New York, 1998). It is Rosenthal who writes of Kiefer 'exploring the possibility of coming to terms with the Nazi past by transgressing postwar taboos against visual and sometimes verbal icons of the Third Reich'. Monica Bohm-Duchen, *After Auschwitz: Responses to the Holocaust in Contemporary Art* (London, 1995) writes that 'many view Kiefer's preoccupation, not to say his fascination with the Nazi past, as deeply and necessarily suspect'. Kiefer makes critics anxious. Sandy Nairne, *State of the Art: Ideas and Images in the 1980s* (London, 1987) insists that to name or picture something, even a taboo subject, is not to endorse it. Nairne quotes with approval Kiefer's claim that his work is about 'bringing to the light things that are covered, that are forgotten'. Though Kiefer knows what is good and what is bad, his works do not moralise. They do not *say* what is good and what is bad. In Nairne's view, Kiefer re-presents taboo images in order to force the past into our consciousness. Lisa Saltzman, in *Anselm Kiefer and Art after Auschwitz* (Cambridge, 1999), writes approvingly of the artist as an iconoclast. For an account of Kiefer that is less confidently partisan, but that nonetheless concludes that his 'unseemly willingness to play with fire' does not make him an 'eager arsonist' (let alone a 'closet Fascist'), see Simon Schama, *Landscape and Memory* (London, 1996). Is there a risk that by taking myth seriously, Schama asks, one can become morally blinded by its poetic power?

Leon Golub's various interventions are collected in *Do Paintings Bite?* His description of the *Collage* work is taken from Lucy Lippard, *A Different War: Vietnam in Art* (Seattle, 1990). For a generous, enthusiastic account of Golub's work, see Adrian Searle, 'A Half-Century of Pain, Violence, Torture, War, Evil and Anger', *Guardian*, 11 July 2000. Searle writes, 'you see things in Golub's work you've never

wanted to think about, much less look at, unless it has been in movies, or in morbid fantasy'. The Brecht remark is taken from his notebooks, extracted in *Art in Modern Culture*, edited by Francis Frascina and Jonathan Harris. *New World Order* may be found in Harold Pinter, *Plays: Four* (London, 1996). On the aesthetic of Fascism, see Susan Sontag, 'Fascinating Fascism' in *Under the Sign of Saturn* (London, 1980), and the discussion of Sontag's earlier engagement with Riefenstahl's work (in 'On Style') in Susan Sayres, *Susan Sontag: The Elegiac Modernist* (London, 1990). And see also Saul Friedländer, *Reflections on Nazism: An Essay on Kitsch and Death* (New York, 1984). It is instructive, but only for what it reveals of the thinking of the exhibition organisers, that the catalogue to the Royal Academy/Staatsgalerie, Stuttgart show 'German Art in the 20th Century: Painting and Sculpture 1905–1985' justifies the exclusion of Fascist art thus: 'One thing was very clear to us from the beginning: that which is denoted by the term Nazi art would be excluded from our exhibition. What the Third Reich celebrated as art was in fact monumental kitsch, serving the purposes of Fascist propaganda': Christos M. Joachimides, 'A Gash of Fire across the World', *German Art in the 20th Century*. The Habermas essay is in *Postmodern Culture*, edited by Hal Foster (London, 1985).

I found the quotation from the French minister of police in Elizabeth C. Childs, 'The Body Impolitic: Censorship and Daumier' in *Suspended Licence*. She writes of censorship efforts in the Second Empire that 'it was hard if not impossible to pin down the subtle sentiments of resistance that survived in a network of coded displacement and surrogacy'. The censors, she concludes, 'could not, in the end, eliminate or effectively police the power of the laugh or the liberty of the crayon'.

As to the congruence of the transgressive with postmodernism, see, for example, Terry Eagleton, *The Illusions of Postmodernism* (Oxford, 1996). Postmodernism, he writes, 'is stamped by a deep suspicion of the Law, but without its daunting presence would be bereft of its own deviations and transgressions, which are parasitic upon

it'. (Eagleton is the critic of the postmodern I cite in chapter IV.) The Schlemmer protest to Goebbels is discussed in Beat Wyss, 'The Two Utopias' in *The Age of Modernism: Art in the 20th Century*. Wyss quotes Schlemmer complaining in 1936 to his friend Baumeister of being 'lumped together with Stalin, Kerensky, murderers, robbers, and Jews'.

Chapter IV

The need to respect certain boundaries is a commonplace of moral philosophy. Slavery, the subordination of women, racial or ethnic persecution – 'we can properly see them as trespassing against boundaries that matter to us,' says the philosopher Simon Blackburn in *Think* (Oxford, 2001). 'They offend,' he adds, 'against boundaries of concern and respect that we believe ought to be protected.' The moral philosopher who writes about corpses and furniture is Thomas Nagel, and he does so in 'Death' in *Mortal Questions* (Cambridge, 1979). The Kolakowski essay is in *Freedom, Fame, Lying and Betrayal: Essays on Everyday Life* (London, 1999). Robert Hughes characterises as 'naive' the 'idea that all taboos on sexual representations are made to be broken' in *The Culture of Complaint*. Kenneth Thompson, *Moral Panics* (London, 1998) was helpful in trying to understand the differences between the personal experience of demoralisation, which can be aesthetic, and the collective experience of moral panic, which can never be aesthetic. Richard Cork's short monograph *Jacob Epstein* (London, 1999) is excellent on the contemporary reception of the sculptor's work. Elaine Scarry, *On Beauty and Being Just* (London, 1999) sets out to rehabilitate beauty, noting that 'the vocabulary of beauty has been banished or driven underground in the humanities for the last two decades'. Beauty has become, says Scarry, 'a taboo'. The Suzi Gablik epigram comes from her *Has Modernism Failed?* (London, 1984). On the Noel-Kelly case, my information is drawn from: (1) Kathy Marks, 'Artist Stole Dozens of Heads, Limbs, and Torsos, Court Is Told', *Independent*, 24 March 1998; (2) Catherine Pepinster, 'I Am Not a Monster. I Am an Artist', *Independent on Sunday*,

13 April 1997; (3) Kathryn Knight, 'Sculptor Jailed for Theft of Body Parts', *The Times*, 4 April 1998. Noel-Kelly discussed his experience of gaol in an interview with Emma Brockes, 'Out on a Limb', *Guardian*, 25 May 1999. The sculptor had defences under the 1984 Anatomy Act, though they failed to get him acquitted. The Anatomy Act discriminates in favour of medical research and against the use by artists of cadavers. It recognises as legitimate a person's wish for his or her body to be used for anatomical examination. Yet, if any person, during his last illness and in the presence of two witnesses, expressed the wish that his body be left to Mr Noel-Kelly, or to any other artist, the act would not permit it. Just under a decade earlier, a Canadian artist, Rick Gibson, had been convicted by a London jury of outraging public decency. He had made earrings out of human foetuses and was fined £5,000: see John A. Walker, *Art and Outrage*. The Kosher Luncheon Club story is in Rachel Lichtenstein and Iain Sinclair, *Rodinsky's Room* (London, 1999), and the Kovno story is in Ephraim Oshry, *Responsa from the Holocaust* (New York, 1989).

Lumping together the Viennese Actionists and McCarthy, as I do, risks eliding differences to which McCarthy himself is very much alive. 'Los Angeles is not Vienna,' he remarks in an interview. 'My work is more about being a clown than a shaman': Rugoff, Stiles and Di Pietrantonio, *Paul McCarthy*. Roger Malbert contrasts the two. McCarthy's exploration of extremes of visceral chaos 'mimic' the excesses of the Viennese Actionists, he says, but 'instead of blood he uses manufactured foodstuffs': 'Exaggeration and Degradation: Grotesque Humour in Contemporary Art', *Carnivalesque*, edited by Timothy Hyman and Roger Malbert (London, 2000). This is the catalogue of the touring exhibition of that name, organised by the London Hayward Gallery. Timothy Hyman says that implicit in the carnival is an 'ideology of unbuttoning'. John Latham's work is discussed in Richard Cork, 'The Emancipation of Modern British Sculpture' and 'Breaking the Boundaries' in *British Art in the 20th Century*. Cork relates Latham's activities to the desire to thwart attempts to treat art as mere investment fodder and to

engage with an audience beyond the restricted territorial limits of the art world. Margaret Garlake, *New Art, New World: British Art in Postwar Society* (New Haven, 1998) reports Latham's wish that his work be seen as a radical extension of the Western tradition. The Mariensaule project is explained in Pierre Bourdieu and Hans Haacke, *Free Exchange*. In conversation with Haacke, Bourdieu defines the artist as 'the one who is capable of making a sensation', by which he means moving people who would be indifferent to political issues that were articulated with 'the cold rigour of concept and demonstration'. I found the Carnesky picture in the 'Carnivalesque' catalogue. For an account of tattooing by Jewish artists as a post-Holocaust art practice, see Dora Apel, 'The Tattooed Jew' in *Visual Culture and the Holocaust*, edited by Barbie Zelizer (London, 2001). My edition of Herodotus is the Penguin one, in the translation of Aubrey de Sélincourt.

Simon Schama writes about the Bastille in *Citizens* (London, 1989). Edward Lucie-Smith, *Art Today* (London, 1999) argues that a reversion to the tradition of the academic is 'the most defiant gesture any artist can make against the shibboleths of contemporary art', and cites Nava's work as exemplary of this kind of gesture. This is a common enough observation, even a trope of writing about the contemporary art scene. John Ashbery, for example, writes in *Reported Sightings* (Cambridge, Mass., 1991), which consists of reviews and articles written in the period 1957–87, that 'almost all artists are somewhat subversive in their attitude towards art, and when you get a situation where everybody is a subversive, sabotage becomes the status quo. Marcel Duchamp really did it once and for all.' The remark of Duchamp's about the artwork's limited life is taken from an essay in Donald Kuspit, *Idiosyncratic Identities* (Cambridge, 1996). Albert Boime, in *The Academy and French Painting in the Nineteenth Century* (London, 1971), corrects the received tendency to pit the academic against the avant-grade. He concludes of Van Gogh, for example, that the artist was 'a true heir of the academic tradition'. It is continuities, rather than the opposite, that he finds between the academy and the

avant-garde. The Laverdant quotation comes from Renato Poggioli, *The Theory of the Avant-Garde* (London, 1968). The distinction I make between 'academy' and 'movement' is comparable to the distinction Poggioli makes between 'school' and 'movement'. Carl Goldstein, *Teaching Art* (Cambridge, 1996) is an instructive guide to academies and schools from Vasari to Albers. Of Manet, Goldstein remarks: 'there was no greater believer in [the practice of copying] than the artist widely regarded as the first modern painter.' And he quotes Van Gogh: 'although copying may be the *old* system, that makes absolutely no difference to me.' I have taken my Pevsner, Ingres and Motherwell quotations from this book. The reference to 'recyled genius' is his quotation from another work.

Regarding Tarantino, Walter Benjamin proposes Dadaism as an event in the prehistory of cinema: 'the work of art of the Dadaists became an instrument of ballistics. It hit the spectator like a bullet, it happened to him, thus acquiring a tactile quality. It promoted a demand for the film, the distracting element of which is also primarily tactile, being based on changes of place and focus which periodically assail the spectator': 'The Work of Art in the Age of Mechanical Reproduction' in *Illuminations*. In a footnote, Benjamin adds, speculatively: 'Film is the art-form that is in keeping with the increased threat to his life which modern man has to face. Man's need to expose himself to shock effects is his adjustment to the dangers threatening him.' On Tarantino generally, I consulted: Jami Bernard, *Quentin Tarantino: The Man and his Movies* (London, 1995); Wensley Clarkson, *Quentin Tarantino: Shooting from the Hip* (London, 1995); Jeff Dawson, *Tarantino: Inside Story* (London, 1995); and Quentin Tarantino, 'It's Cool to Be Banned', *Index on Censorship*, 6/1995. On intertextuality in general, Tzvetan Todorov, *Mikhail Bakhtin: The Dialogical Pinciple* (Manchester, 1985) gives the best brief account; on intertextuality in the cinema, see James Goodwin, *Akira Kurosawa and Intertextual Cinema* (Baltimore, 1994).

Sontag makes her remarks about the need to construct new criteria for art (and about transgression, quoted in

chapter V) in interviews reprinted in *Conversations with Susan Sontag*, edited by Leland Poague (Jackson, Miss., 1995). The 19th-century commentator that I quote is Edmond About, editor of *Le XIXe Siècle*, quoted in turn by Patricia Mainardi, *The End of the Salon* (Cambridge, 1993). It is Hal Foster, in 'What's Neo about the Neo-Avant-Garde?' in *The Duchamp Effect*, who observes that, 'with figures like Klein, Dadaist transgression is turned into bourgeois spectacle', and he quotes Robert Smithson on 'an avant-garde of dissipated scandals'. On the subject of 'shock', Peter Bürger, *Theory of the Avant-Garde* (Minneapolis, 1984), needs to be supplemented by, *inter alia*, Walter Benjamin, 'On Some Motifs in Baudelaire' in *Illuminations* (London, 1973) and B.R. Tilghman, 'The Shock of the New' in *But Is it Art?* (Oxford, 1984). David Pole writes about the anti-aesthetics of disgusting objects in *Aesthetics, Form and Emotion* (London, 1983). The Warhol remark comes from Peter Conrad, *Modern Times* (London, 1999). Oldenburg is quoted by Alain-Bois and Krauss, *Formless: A User's Guide*. On Kienholz, see Gerald Silk, 'Censorship in the Career of Edward Kienholz' in *Suspended Licence*. Rachel Gurstein writes about the contemporary writer's disregard for canonic literature in *The Repeal of Reticence* (New York, 1996).

For the opening paragraphs on Manet's *Maximilian* I have drawn on Juliet Wilson-Bareau, *Manet: The Execution of Maximilian* (London, 1992), which explains that any reference, and especially any visual reference, to the Mexican affair was for a while 'taboo' in France. *Catenary (Manet-Degas)* was made by Johns at the invitation of the London National Gallery to create a new work in response to a work in its collection. It is reproduced in the exhibition catalogue: Richard Morphet, *Encounters: New Art from Old* (London, 2000). (I have also taken the Lucian Freud quotation in chapter I and the Auerbach quotation in chapter III from this book.) While it seems that Bacon did not give much attention to Manet, he chose *The Execution* as one of a number of works he selected from the National Gallery collection to exhibit: Sylvester, *Looking Back at Francis Bacon*. On the Hirst work, an art critic who

saw it when it was first exhibited and then again after a few years drew the contrast very pointedly: 'When you stood in front of the tank of green liquid, and looked in the shark's grinning mouth, you could savour the illusion that a tiger shark was swimming towards you through the white space of the Saatchi Gallery. You were dinner': Jonathan Jones, 'Going, Going, Gone', *Guardian*, 20 June 2000. The Mendieta work is discussed in Lucy Lippard, *The Pink Glass Swan*.

I first read about the Gerz/Shalev-Gerz monument in James E. Young, *At Memory's Edge* (New Haven, 2000). The Shimon Attie photograph has been reproduced from plates that appear in this book. The possibilities of the counter-monument did not, of course, emerge out of a historical void. They are to be related to that 'fading of the logic of the monument' in the late 19th century which Rosalind Krauss analyses in 'Sculpture in the Expanded Field' in *The Originality of the Avant-Garde and Other Modernist Myths*. Monica Bohm-Duchen, in *After Auschwitz: Responses to the Holocaust in Contemporary Art*, says of the Gerz/Shalev-Gerz work that, 'for the artists, the spectacle of Germans burying their anti-Fascist monument seemed to exemplify Germany's national memorial ambivalence'. On Boltanski, see Didier Semin, Tamar Garb and Donald Kuspit, *Christian Boltanski* (London, 1999), and the essay by Danto on the artist in *Encounters and Reflections*. Manguel, *Reading Pictures* (London, 2001) has some interesting things to say about Holocaust memorial art. On the Chapman Brothers' *Hell*, please see the catalogue essays by Norman Rosenthal and James Hall, *Apocalypse* (London, 2000). It would seem that *Hell* was originally titled *F****** Hell*: see Martin Gayford, 'The Art of Outrage', *Daily Telegraph*, 26 August 2000. *Hell* is nothing more than a 'gorefest', the contemporary taste for which is parodied by the *Simpsons*' 'Itchy and Scratchy' cartoon-within-a-cartoon. 'The piece,' says Jake Chapman, 'should be fun to look at' (quoted in the supplement produced by the London magazine *Time Out* to accompany the opening of 'Apocalypse').

My comments on artworks commemorative of the Holocaust were prompted by, and in certain instances derived from a reading of, *inter alia*: Ziva Amishai-Maisels, *Depiction and Interpretation: The Influence of the Holocaust on the Visual Arts* (Oxford, 1993); Zygmunt Bauman, *Modernity and the Holocaust*; Ernst van Alphen, *Caught by History* (Stanford, 1997); Robert Nozick, *The Examined Life* (New York, 1989), on the 'desanctifying' effect of the Holocaust; *Holocaust Remembrance*, edited by Geoffrey H. Hartman (Oxford, 1994); *Probing the Limits of Representation: Nazism and the 'Final Solution'*, edited by Saul Friedlander (Cambridge, Mass., 1992), especially Berel Lang, 'The Representation of Limits', and Geoffrey H. Hartman, 'The Book of the Destruction'; and Dominick LaCapra, *Representing the Holocaust* (Ithaca, 1996).

Lang writes of the 'ideal of artistic representation as boundless in principle' which, he proposes, 'recurs in post-Renaissance conceptions of art and aesthetics'. He quotes Salman Rushdie, when 'confronted by unusually harsh claims for the limits of representation', on literature as 'the one place in any society where… we can hear the voices talk about everything in every possible way'. But Lang then asserts limits. The limits of historical representation apply also to historical fiction.

Hartman writes that 'contemporary literature and art have almost total freedom of expression. When rules or norms enter, they do so mainly as a foil, in order to be breached. My first thought, therefore, is that even in the case of the Shoah, there are no limits of representation, only of conceptualisation.' It is not, however, his last thought. We need a new Aristotle to formulate new rules of literary and artistic decorum. The archaic rules respected limits of human sensibility. We need to be reminded of the 'vulnerability of civilized life'. (It is Hartman who reminded me of the lines from Wordsworth's 1850 *Prelude* that I quote elsewhere in chapter IV.)

LaCapra writes of attempts to encompass the Holocaust: 'one cannot simply celebrate transgression, abstractly affirm limits, or confide in one aesthetic or

another. One is rather confronted with the problem of the actual and desirable interaction between normative limits (whose contestable nature always remains to be specified) and "transgressive" challenges to them – a problem made particularly difficult in the light of the extremity and distortions of the Nazi "experience".' I am also indebted to LaCapra for the distinction that I make in chapter I between 'thinking about' and 'thinking with'.

Coda

Minima Moralia was first published by Suhrkamp Verlag in 1951. I quote from the English translation, published in London in 1974. The transgressive nature of thought is celebrated by Alain de Botton in the charming *The Consolations of Philosophy* (London, 2001): 'What is considered abnormal in one group at one moment may not... always be deemed so. We may cross borders in our minds.' I found the Apollinaire lines in Francis Haskell, *History and its Images* (New Haven, 1995). The Manet critic who defended *Nana*'s crime was J. de Marthold, quoted in Françoise Cachin, *Manet* (London, 1991). Cachin is the Manet scholar I quote in chapter I on *Le Déjeuner*. The Dada

manifesto is quoted by Georges Ribemont-Dessaignes, whose 1931 'History of Dada' is reproduced in full in Motherwell, *The Dada Painters and Poets*. 'Commitment' is in Theodor W. Adorno, *Notes to Literature* (Volume 2) (New York, 1992), and see also, for a discussion of this essay, Raymond Geuss, 'Art and Theodicy' in *Morality, Culture and History* (Cambridge, 1999), and more generally on Adorno, see Lambert Zuidervaart, *Adorno's Aesthetic Theory* (Cambridge, Mass., 1991). In *The Velvet Prison* (London, 1989), his account of the experience of artists under state socialism, Miklos Haraszti writes: 'If art is to be a true reflection of reality, then art's new function conceals a taboo: we must exclude all art that might suggest that reality is, or sometimes is, nonaligned, indifferent, aimless, absurd, intangible, deaf, dumb, or blind. This taboo is a permanent feature of the cult of commitment.' The Miró story comes from Fred Orton and Griselda Pollock, *Avant-Gardes and Partisans Reviewed*. The photograph of Beuys leaving the Düsseldorf Academy, flanked by watching police, is in Rogoff, 'Representations of Politics' in *German Art in the 20th Century*. The remark of Nietzsche's is taken from *Daybreak*.

List of Illustrations

2/3 Edouard Manet, *Olympia* (detail), 1863. Oil on canvas, 130.5 x 190 (51 ¾ x 74 ¾). Musée d'Orsay, Paris. © Photo RMN – Hervé Lewandowski **12/13** Jasper Johns, *Map*, 1962. Encaustic and collage on canvas, 152.4 x 236.2 (60 x 93). Collection of Marcia S. Weisman. © Jasper Johns/VAGA, New York/DACS, London 2002 **14** Andres Serrano, *Piss Christ*, 1987. Cibachrome, silicone, plexiglass, wood frame, 152.4 x 101.6 (60 x 40), 162.5 x 112.8 (65 x 45 ⅛) with frame. Edition of 4. Courtesy Paula Cooper Gallery, New York. **15** Eugène Carrière, *Crucifixion*, 1897. Oil on canvas, 227 x 130 (89 ⅜ x 51 ⅛). Musée d'Orsay, Paris. Bought through the support of a group of admirers and friends, 1903 (EU 1900) **16 above** Dread Scott, *What is the Proper Way to Display a U.S. Flag?* (detail),1988. Installation for audience participation, 203.2 x 71.1 x 152.4 (80 x 28 x 60). Courtesy of Dread Scott **16 below** Dread Scott, *What Is the Proper Way to Display a US Flag?*,1988. Installation for audience participation, 203.2 x 71.1 x 152.4 (80 x 28 x 60). Courtesy of Dread Scott **28 centre left** Marcel Duchamp, *Fountain*, 1917. Replica 1963. Porcelain urinal, 33.5 (13 ¼).

Original destroyed. Indiana University Art Museum. © Succession Marcel Duchamp/ADAGP, Paris and DACS, London 2002 **28 centre right** René Magritte, *The Treachery of Images (La Trahison des images)*, 1929. Oil on canvas, 60 x 81 (23 ½ x 31 ½). Los Angeles County Museum of Art, purchased with funds provided by the Mr and Mrs William Preston Harrison collection. © ADAGP, Paris and DACS, London 2002 **28 below** Morton Schamberg, *God*, 1918. Mitre-block and cast-iron plumbing trap, h. 26.7 (10 ½). Philadelphia Museum of Art, The Louise and Walter Arensberg Collection. 1950–134–182 **29** Frank Stella, *Die Fahne Hoch!*, 1959. Enamel on canvas, 308.6 x 185.4 (121 ½ x 73). Whitney Museum of American Art, New York, Gift of Mr and Mrs Eugene M. Schwartz. © ARS, NY and DACS, London 2002 **34** Man Ray, *Untitled* 1933, Gelatin silver print, 17.8 x 21.3 (7 x 8 ⅜). Copyright Christies Images Ltd 2001. © Man Ray Trust/ADAGP, Paris and DACS, London 2002 **35 above** Luis Buñuel and Salvador Dali, *Un Chien andalou*,1929. Film still. © Salvador Dalí, Gala-Salvador Dalí Foundation, DACS,

London 2002 **35 below** Luis Buñuel and Salvador Dalí, *Un Chien andalou*, 1929. Film still. © Salvador Dalí, Gala-Salvador Dalí Foundation, DACS, London 2002 **37** David Bomberg, *Mud Bath*, 1914. Oil on canvas, 152.4 x 224.2 (60 x 88 ¼). © Tate, London 2002 **40** Edouard Manet, *The Execution of Maximilian*, 1868–9. Oil on canvas, 252 x 305 (99 ¼ x 120 ⅛). Städtische Kunsthalle, Mannheim **42** Francis Bacon, *Crucifixion*, 1965. Oil on canvas, triptych, each panel 198 x 147.5, (78 x 58). Staatsgalerie Moderner Kunst, Munich. © Estate of Francis Bacon 2002. All rights reserved, DACS **43** Richard Serra, *Tilted Arc*, Federal Plaza, NY 1981. Corten steel, 366 x 3658 x 6 (144 ⅛ x 1440 ⅛ x 2 ⅜). Now destroyed. © ARS, NY and DACS, London 2002 **45 above** Tracey Emin, *My Bed*, 1998. Installation shot at Tate Gallery, London. Mattress, linens, pillows, rope, various memorabilia, 31 x 83 x 92 (79 x 211 x 234). Courtesy Jay Jopling/White Cube, London © The artist. Photo Stephen White **45 below** Robert Rauschenberg, *Bed*, 1955. Combine painting: oil and pencil on pillow, quilt, and sheet on wood supports, 191.1 x 80 x 20.3 (75 ¼ x 31 ½ x 8). The Museum of Modern Art, New York. Gift of Leo Castelli in honor of Alfred H. Barr, Jr. © Robert Rauschenberg/DACS, London/VAGA, New York 2002 **46** Joseph Kosuth, *The Brooklyn Museum Collection: The Play of the Unmentionable*, 1990. Museum installation. Photo Ken Schles. © ARS, NY and DACS, London 2002 **47** André Breton with placard by Francis Picabia at the Dada Festival, Paris 1920. © ADAGP, Paris and DACS, London 2002 **49** Sherrie Levine, *Fountain/After Marcel Duchamp*, 1991. Cast bronze, edition of 6, 15 x 25 x 15 (5 ⅞ x 9 ⅞ x 5 ⅞). Courtesy Margo Leavin Gallery, Los Angeles **51** Robert Mapplethorpe, *Self-Portrait*, 1978. Gelatin silver print, edition of 5, 50.8 x 40.6 (20 x 16). © The Estate of Robert Mapplethorpe **52** Edouard Manet, *Le Déjeuner sur l'herbe*, 1863. Oil on canvas, 208 x 264 (82 x 104). Musée d'Orsay, Paris. © photo RMN – Hervé Lewandowski **58** Edouard Manet, *Portrait of M. and Mme Auguste Manet*, 1860. Oil on canvas, 111.5 x 91 (44 x 35 ¾). Musée d'Orsay, Paris **59** Edouard Manet, *Olympia*, 1863. Oil on canvas 130.5 x 190 (51 ¼ x 74 ¾). Musée d'Orsay, Paris. © Photo RMN – Hervé Lewandowski **61** Alexandre Cabanel, *Birth of Venus*, 1863. Oil on canvas, 130 x 225 (51 ⅛ x 88 ½). Musée d'Orsay, Paris **63 left** Gustav Klimt, *Philosophy*, 1897–9. Oil on canvas, 430 x 300 cm (169 ¼ x 118 ⅛). Now destroyed **63 centre** Gustav Klimt, *Medicine*, 1900–7. Oil on canvas, 430 x 300 (169 ¼ x 118 ⅛). Now destroyed **63 right** Gustav Klimt, *Jurisprudence*, 1903–7. Oil on canvas, 430 x 300 (169 ¼ x 118 ⅛). Now destroyed **65** Richard Hamilton, *Just What Is It That Makes Today's Homes So Different, So Appealing?*, 1956. Collage, 26 x 25 (10 ¼ x 9 ¾). Tübingen, Kunsthalle. © Richard Hamilton 2002. All rights reserved, DACS **66** Marcel Duchamp, *The Bride Stripped Bare by her Bachelors, Even (The Large Glass)*, 1915–23. Oil paint, varnish, lead foil, lead wire and dust on two glass plates (cracked), each mounted between two glass panels in a steel and wood frame, 272.5 x 175.8 (107 ¼ x 69 ¼). Philadelphia Museum of Art. Bequest of Katherine S. Dreier. 52–98–1. Photo Graydon Wood 1992. © Succession Marcel Duchamp/ADAGP, Paris and DACS, London 2002 **67 above** Man Ray, *Rrose Sélavy*, 1921. © Man Ray Trust/ADAGP,

Paris and DACS, London 2002 **67 below** Marcel Duchamp, *Nude Descending a Staircase (No. 2)*, 1912. Oil on canvas, 146 x 89 (57 ½ x 35). Philadelphia Museum of Art. The Louise and Walter Arensberg Collection. © Succession Marcel Duchamp/ADAGP, Paris and DACS, London 2002 **68** Marcel Duchamp, *Etant Donnés (View through the Door)*, 1946–66. Philadelphia Museum of Art. Gift of the Cassandra Foundation. © Succession Marcel Duchamp/ADAGP, Paris and DACS, London 2002 **69 left** Lucian Freud, *Painter and Model*, 1986–7. Oil on canvas, 159.6 x 120.7 (62 ¾ x 47 ½). © Lucian Freud **69 right** Henri Matisse, *Nude with a White Scarf*, 1909. Oil on canvas, 116.5 x 89 (45 ⅞ x 35). Statens Museum for Kunst, Copenhagen, J. Rump Collection. © Succession H Matisse/DACS 2002 **70** Henri Matisse, *The Painter and his Studio*, 1917. Oil on canvas, 146.5 x 97 (57 ⅝ x 38 ¼). Musée National d'Art Moderne, Centre Georges Pompidou, Paris. © Succession H Matisse/DACS 2002 **71 above** Pablo Picasso, *Sculptor and Reclining Model Viewing Sculptured Head*, 1933. Etching, 19.4 x 26.7 (7 ⅝ x 10 ½). © Succession Picasso/DACS 2002 **71 below left** Pablo Picasso, *Painter and Model*, 24 December 1953. © Succession Picasso/DACS 2002 **71 below right** Pablo Picasso, *Painter and Model*, 25 December 1953. © Succession Picasso/DACS 2002 **72 above** Thomas Eakins, *Study of a Seated Woman Wearing a Mask*, 1874–6. Charcoal on paper, 61.6 x 47.6 (24 ¼ x 18 ¾). Philadelphia Museum of Art. Given by Mrs Thomas Eakins and Miss Mary-Adeline Williams **72 below** Synagogue, detail from south transept portal of Strasbourg Cathedral, c. 1230. Musée de L'Oeuvre Notre-Dame, Strasbourg **73 above** Paul Cézanne, *The Rape*, c. 1867. Oil on canvas, 90.5 x 117 (35 ½ x 46). The Provost and Fellows of King's College, Cambridge (Keynes Collection), on loan to the Fitzwilliam Museum, Cambridge **73 below** David Salle, *Saltimbanques*, 1986. Acrylic, oil, wood on canvas, 152.4 x 254 (60 x 100). Courtesy Gagosian Gallery © David Salle/VAGA, New York/DACS, London 2002 **74 above** Ludwig Wittgenstein, *Duck-Rabbit* **74 below** Tom Wesselmann, *Little Great American Nude #6*, 1961. Acrylic and collage on board, 25.4 x 29.2 (10 x 11 ½). Collection Museum of Modern Art, Shiga. Photo Courtesy Sidney Janis Gallery, New York. © Tom Wesselmann/VAGA, New York/DACS, London 2002 **76** Paul Gauguin, *La Orana Maria*, 1891. Oil on canvas, 113.7 x 87.7 (44 ¾ x 34 ½). Metropolitan Museum of Art, New York, Bequest of Sam A. Lewisohn, 51.112.2 **77** J.-L. David, *The Death of Marat*, 1793. Oil on canvas, 165 x 128.3 (65 x 50 ½). Musées Royaux des Beaux-Arts, Brussels **78** Edouard Manet, *Jesus Mocked by Soldiers*, 1865. Oil on canvas, 190.8 x 148.3 (75 ⅛ x 58 ⅜). Courtesy of the Art Institute of Chicago. Gift of James Deering (1925.703) **79** Edouard Manet, *The Dead Christ and the Angels*, 1864. Oil on canvas, 179 x 150 (70 ½ x 59). Metropolitan Museum of Art, New York (29.100.51) **80 above** Andrea Mantegna, *The Dead Christ*, 1480–90. Tempera on canvas, 68 x 81 (26 ¾ x 31 ⅞). Pinacoteca, Milan **80 below** Ron Mueck, *Dead Dad*, 1996–7. Mixed media, 20 x 102 x 38 (7 ⅞ x 40 ⅛ x 15). Anthony d'Offay Gallery, London **81 centre left** Jean-François Millet, *The Sower*, 1850. Oil on canvas, 101 x 82.6 (39 ¾ x 32 ½). Museum of Fine Arts, Boston. Shaw Collection **81 centre right** Vincent Van Gogh, *The Sower*, 1888.

Oil on canvas, 32 x 40 (12 ¹/₂ x 15 ³/₄). Rijksmuseum Vincent van Gogh, Amsterdam **81 below** Jean Fautrier, *Head of a Hostage*, 1945. Lead and slate, 54 x 29.5 x 31 (21 ¹/₄ x 11 ⁵/₈ x 12 ¹/₄). Photo © Tate, London 2002. © ADAGP, Paris and DACS, London 2002 **82** Pablo Picasso, *Guernica*, 1st May–4 June 1937. Oil on canvas, 349.3 x 776.6 (1375 ¹/₄ x 3057 ¹/₂). Museo Nacional Centro de Arte Reina Sofía. © Succession Picasso/DACS 2002 **83 left** F. Holland Day, *Crucifixion*, 1898. Sepia/platinum print, 11.6 x 18.7 (4 ⁵/₈ x 7 ³/₈). Library of Congress, Washington, D.C. **83 centre** Francis Bacon, *Crucifixion*, 1933. Oil on canvas, 62 x 48.5 (24 ³/₄ x 19). Private Collection. © Estate of Francis Bacon 2002. All rights reserved, DACS **83 right** Francis Bacon, *Fragment of a Crucifixion*, 1950. Oil and cotton on canvas, 139 x 108 (54 ³/₄ x 42 ¹/₂). Stedelijk Van Abbemuseum, Eindhoven. © Estate of Francis Bacon 2002. All rights reserved, DACS **84 above** Francis Bacon, *Three Studies for Figures at the Base of a Crucifixion*, 1944. Oil and pastel on hardboard, triptych, each panel 94 x 74 (37 x 29). © Tate London 2002 **84 centre** Francis Bacon, *Three Studies for a Crucifixion*, 1962. Oil with sand on canvas, triptych, each panel 198.2 x 144.8 (78 x 57). Solomon R. Guggenheim Museum, New York. FN 64.1700. © Estate of Francis Bacon 2002. All rights reserved, DACS **84 below** Cimabue, *Crucifixion*, c. 1272–4 (inverted). Oil on wooden panel, 448 x 389.9 (176 ³/₈ x 153). Chiesa di Santa Croce, Florence. Photo Archiv Alinari – Firenze **85** Francis Bacon, *Triptych Inspired by T. S. Eliot's Poem 'Sweeney Agonistes'*, 1967. Oil and pastel on canvas, each panel 198 x 147.5 (78 x 58). Hirshhorn Museum & Sculpture Garden, Smithsonian Institution, Washington, D.C. © Estate of Francis Bacon 2002. All rights reserved, DACS **89 above** Edouard Manet, *Le Déjeuner sur l'herbe*, 1863. Oil on canvas, 208 x 264 (82 x 104). Musée d'Orsay, Paris. © Photo RMN – Hervé Lewandowski **89 below left** Giorgione, *Fête champêtre*, c. 1505. Oil on canvas, 111.1 x 138.4 (43 ¹/₄ x 54 ¹/₂). Louvre, Paris. Photo Giraudon **89 below right** Marcantonio Raimondi (after Raphael), *Judgment of Paris*, c. 1520. Engraving. British Museum, London **91 above** Andrea Mantegna, *The Man of Sorrows with Two Angels*, c. 1500. Tempera on wood, 198.1 x 121.9 (78 x 48). Statens Museum for Kunst, Copenhagen **91 below** Marcel Duchamp, *L. H. O. O. Q.*, 1919. Photographic reproduction and pencil, 19.6 x 12.3 (7 ³/₄ x 4 ⁷/₈). Private Collection. © Succession Marcel Duchamp/ADAGP, Paris and DACS, London 2002 **92** Pablo Picasso, *Le Déjeuner sur l'herbe after Manet*, 10th July 1961. © Succession Picasso/DACS 2002 **93** Robert Rauschenberg, *Erased de Kooning Drawing*, 1953. Traces of ink and crayon on paper with mat and hand-lettered (ink) label in gold leaf frame, 64.1 x 55.2 (25 ¹/₄ x 21 ³/₄). Collection of the Artist, New York. © Robert Rauschenberg/DACS, London/VAGA, New York 2002 **96 above** Sherrie Levine, *After Walker Evans #19*, 1981. Black and white photograph, 36 x 28 (10 x 8). Courtesy of Margo Leavin Gallery, Los Angeles **96 below** Sherrie Levine, *Buddha*, 1996. Cast bronze, 48 x 41 x 36 (19 x 16 x 14). Courtesy of Margo Leavin Gallery, Los Angeles **97** Jeff Koons, *String of Puppies*, 1988. Polychromed wood, 106.7 x 157.5 x 94 (42 x 62 x 37). © Jeff Koons **98** Barbara Kruger, *Untitled (Your Gaze Hits the Side of my Face)*, 1981. Photograph, 139.7 x 104.1 (55 x 41). Courtesy Mary

Boone Gallery, New York **101** Francis Picabia, *The Cacodylic Eye*, 1921. Oil and collage on canvas, 148.6 x 117.5 (58 ¹/₂ x 46 ¹/₄). © Photo CNAC/MNAM. Dist RMN. © ADAGP, Paris and DACS, London 2002 **103** Thomas Gainsborough, *The Blue Boy (Jonathan Buttall)*, 1770. Oil on canvas, 117.8 x 121.9 (70 x 48). Courtesy of the Huntington Library, Art Collections, and Botanical Gardens, San Marino, California **104** Judy Chicago, *Red Flag*, 1971. Photolithograph, 50.8 x 61.0 (20 x 24). © Judy Chicago 1971. Photo Donald Woodman **105 above** Barry Flanagan, *Hare on Curly Bell*, 1980. Bronze, edition of seven, 93.3 x 91.4 x 50.8 (36 ³/₄ x 36 x 20). © The artist, courtesy Waddington Galleries, London **105 below** Pablo Picasso, *Still Life with Chair Caning*, 1912. Oil and oilcloth on canvas with rope frame, 27 x 35 (10 ⁵/₈ x 13 ³/₄). Musée Picasso, Paris. © Succession Picasso/DACS 2002 **107** Hans Arp, *Collage Made According to the Laws of Chance*, 1916. Collage, 25.3 x 12.5 (10 x 4 ⁷/₈). Kunstmuseum, Basle. © DACS 2002 **109** Gilbert and George, *Spit on Shit*, 1996. Photograph, 151 x 127 (59 ¹/₂ x 50). © Gilbert and George **110** Joan Miró, *Man and Woman in Front of a Pile of Excrement*, 1935. Oil on copper, 32 x 25 (12 ⁵/₈ x 9 ⁷/₈). Joan Miró Foundation, Barcelona. © ADAGP, Paris and DACS, London 2002 **111** Salvador Dalí, *Lugubrious Game*, 1929. Oil and collage on card, 44.5 x 30 (17 ¹/₂ x 12). Private Collection. © Salvador Dalí, Gala-Salvador Dalí Foundation, DACS, London 2002 **116 above** Arman, *Crusaders*, 1968. Silver glue brushes in polyester and plexiglass, 122 x 122 (48 x 48). Private Collection. © ADAGP, Paris and DACS, London 2002 **116 below** Giulio Paolini, *Untitled*, 1961. Wood stretcher, tin of white paint, plastic, 21 x 21 (8 ¹/₄ x 8 ¹/₄). Collection of the artist, Turin **118** George Grosz, *Homage to Oskar Panizza*, 1917–18. Oil on canvas, 140 x 110 (55 ¹/₈ x 43 ³/₈). Staatsgalerie Stuttgart. © DACS 2002 **119** Judy Chicago, *Birth Project*, 1981. Prismacolour on black arches, 76.2 x 101.6 (30 x 40). © Judy Chicago 1971. Photo Donald Woodman **120 above** Christo and Jeanne-Claude, *Wrapped Coast*, 1968–9. Little Bay, Australia, 92937.00 (one million square feet). © Christo 1969. Photo Harry Shunk **120 below** John Chamberlain, *Etruscan Romance*, 1984. Painted and chromium-plated steel, 281.9 x 124.5 x 78.7, (111 x 49 x 31). Courtesy of Margo Leavin Gallery, Los Angeles. © ARS, NY and DACS, London 2002 **121** Gordon Matta-Clark, *Splitting*, 1974. Cibachrome photograph, 76.2 x 101.6 (30 x 40). Private Collection. © ARS, NY and DACS, London 2002 **125** Robert Smithson, *Spiral Jetty*, 1970. Rock, salt, crystals, earth and water, length 475 m, width 4.5 m (1558 x 14.76). Great Salt Lake, Utah. Now destroyed. © Estate of Robert Smithson/VAGA, New York/DACS, London 2002 **130 above** Jake and Dinos Chapman, *Great Deeds against the Dead*, 1994. Mixed media with plinth, total 277 x 244 x 152 cm (109 x 96 ¹/₈ x 59 ⁷/₈). Courtesy Jay Jopling/White Cube, London. © The artist. Photo Stephen White **130 below** Goya, *Grande hazaña con muertos*, c. 1812–15. Etching and lavis, 15.7 x 20.8 (6 ¹/₈ x 8 ¹/₄). **133** Goya, *One Can't Look*, c. 1810–12. Etching and lavis, 14.4 x 21 (5 ⁵/₈ x 8 ¹/₄) **135** Salvador Dalí, *Tuna Fishing (Homage to Meissonier)*, 1966–7. 304 x 404 (119 ⁵/₈ x 159). Paul Ricard Foundation, Ile de Bendor. © Salvador Dalí, Gala-Salvador Dalí Foundation, DACS, London 2002 **136 above** Sue Fox, *Untitled (Bitten)*, 1996. Photo © Sue Fox

136 below Andres Serrano, *The Morgue (Knifed to Death I)*, 1992. Cibachrome, silicone, plexiglass, wood frame, 125.7 x 152.4 (49 ¹/₂ x 60), 139.1 x 165.7 (54 ³/₄ x 65 ¹/₄) with frame. Edition of three. Courtesy Paula Cooper Gallery, New York **138** Andres Serrano, *Milk, Blood*, 1986. Cibachrome, silicone, plexiglass, wood frame, 101.6 x 152.4 (40 x 60), 114.6 x 165.1 (45 ¹/₈ x 65) with frame. Edition of four. Courtesy Paula Cooper Gallery, New York **139** Helen Chadwick, *Loop my Loop*, 1991. Cibachrome transparency, glass, steel and electrical apparatus, 127 x 76 x 15 (50 x 30 x 5 ⁷/₈). Photograph by Helen Chadwick and Edward Woodman **142 above** Damien Hirst, *Mother and Child, Divided*, 1993. Steel, GRP composites, glass, silicone sealant, cow, calf and formaldehyde solution, two tanks each 190 x 322.5 x 109 (74 ³/₄ x 127 x 42 ⁷/₈). Courtesy Jay Jopling/White Cube, London. © The artist **142 below** Laocoön. Vatican Museums, Rome **143 above left** Jane Alexander, *Butcher Boys*, 1985-6. Mixed media, 128.5 x 213.5 x 88.5 (50 ⁵/₈ x 84 x 34 ⁷/₈). Collection of the South African National Gallery, Cape Town. Photo Mark Lewis. © Jane Alexander **143 above right** Jane Alexander, *Bom Boys*, 1998. Mixed media, 105 x 360 x 360 (41 ³/₈ x 141 ³/₄ x 141 ¹/₄). Collection of the artist. Photograph courtesy of Tobu Museum, Tokyo. © Jane Alexander **143 below** Thomas Grünfeld, *Misfit (Cow)*, 1997. Animal preparation/taxidermy, 160 x 170 x 80 (63 x 66 ⁷/₈ x 31 ¹/₂). Courtesy the artist. © DACS 2002 **144 above** John Isaacs, *Say It Isn't So*, 1994. Mixed media, 204 x 129 x 132 (80 ¹/₄ x 50 ³/₄ x 52). The Saatchi Gallery, London. Photo Stephen White **144 below left** Arsen Savadov and Georgy Senchenko, *Bloody Mary*, 1998. C-print, 150 x 100 (59 x 39 ³/₈). Marat Guelman Gallery **144 below right** Paul McCarthy, *Spaghetti Man*, 1993. Fibreglass, metal, urethane rubber, acrylic fur, clothing, 254 x 84 x 57 (100 x 33 ¹/₈ x 22 ¹/₂). Penis length 1, 270 (500). Courtesy of the Artist **155** Edouard Manet, *The Bullfight*, 1864. Oil on canvas, 47.9 x 108.9 (18 ⁷/₈ x 42 ⁷/₈). The Frick Collection, New York **157** René Magritte, *The Menaced Assassin*, 1926. Oil on canvas, 150.5 x 195.3 (59 ¹/₄ x 76 ⁷/₈). Museum of Modern Art, New York. Kay Sage Tanguy Fund. The Museum of Modern Art, New York. © ADAGP, Paris and DACS, London 2002 **158** Meret Oppenheim, *Objet (Déjeuner en fourrure)*, 1936. Fur-covered cup, saucer and spoon; cup 11.1 (4 ³/₈) diameter, saucer 28.8 (9 ³/₈) diameter, spoon 20.3 (8) long, overall height 7.3 (2 ⁷/₈). Museum of Modern Art, New York. Purchase. Photo © 2001 The Museum of Modern Art, New York. © DACS 2002 **159** Max Ernst, *The Virgin Spanking the Christ Child before Three Witnesses: André Breton, Paul Eluard and the Painter*, 1926. Oil on canvas, 196 x 130 (77 ¹/₈ x 51 ¹/₈). Museum Ludwig, Cologne. © ADAGP, Paris and DACS, London 2002 **160** Man Ray, *Monument to de Sade*, 1933. Telimage, Paris © Man Ray Trust/ADAGP, Paris and DACS, London 2002. **161** René Magritte, *The Battle of the Argonne*, 1959. Oil on canvas, 50 x 61 (19 ⁵/₈ x 24). Private Collection, New York. © ADAGP, Paris and DACS, London 2002 **162 left** Paul McCarthy, *The Garden*, 1991-2. Wood, fibreglass, motors, latex rubber, artificial turf, clothing, trees, rocks, 853 x 609 x 670.5 (335 ⁷/₈ x 239 ³/₄ x 264). Courtesy the Artist **162 right** Paul McCarthy, *Cultural Gothic*, 1992. Metal, motors, fibreglass, clothing, compressor, urethane rubber,

stuffed goat, 241 x 235 x 235 (94 ⁷/₈ x 92 ¹/₂ x 92 ¹/₂). Courtesy the Artist **165** Edouard Manet, *The Absinthe Drinker*, 1858-9. Oil on canvas, 81 x 106 (31 ⁷/₈ x 41 ³/₄). Ny Carlsberg Glyptothek, Copenhagen **166** Marcus Harvey, *Myra*, 1995. Acrylic on canvas, 396 x 320 (155 ⁷/₈ x 126). Courtesy Jay Jopling/White Cube, London. Photo Stephen White **167** Klaus Staeck, *Beware Art!*, 1982. Poster. © DACS 2002 **170 above** Robert Colescott, *George Washington Carver Crossing the Delaware: Page from an American History Textbook*, 1975. Acrylic on canvas, 137.2 x 274.3 (54 x 108). Photo Courtesy Phyllis Kind Gallery, New York. Collection Robert H. Orchard **170 below** Robert Rauschenberg, *Mexican Canary/ROCI MEXICO*, 1985. Acrylic and collage on canvas with metal frame, 204.2 x 382.9 x 15.4 (80 ³/₈ x 150 ³/₄ x 6). Collection of the Artist. © Robert Rauschenberg/DACS, London/VAGA, New York 2002 **171** Anonymous, *Goddess of Democracy*. Photo Rex Features, London **172** Various Artists, *Collage of Indignation*, 1967. Courtesy New York University Archives **173** Willi Baumeister, *Arno Breker's 'The Avenger' with Head Drawn by Willi Baumeister*, c. 1941. Head 5 x 4.5 (2 x 1 ³/₄). Archiv Baumeister, Stuttgart. © DACS 2002 **175** Hans Haacke, *Shapolsky et al: Manhattan Real Estate Holdings, a Real-Time Social System, as of May 1, 1971* (detail), 1971. Two maps, each 61 x 50.8 (24 x 20); 142 black and white photographs and data sheets, each 50.8 x 19.1 (20 x 7 ¹/₂). Collection of the Artist. Photo Fred Scruton © DACS 2002 **176 left** Anselm Kiefer, *Occupations*, Courtesy the Artist **176 right** Anselm Kiefer, *Untitled (Heroic Symbols)*, 1969. Watercolour on paper, linen strips, mounted on cardboard, 65 x 50 x 8.5 (26 x 19 ¹¹/₁₆ x 3 ⁵/₁₆). Private Collection. Courtesy the Artist **179** Leon Albert Golub, *Interrogation II*, 1980-1. Acrylic on canvas, 304.8 x 426.7 (120 x 168). The Art Institute of Chicago, Gift of the Society for Contemporary Art, 1983.264. Ronald Feldman Gallery, New York, and Anthony Reynolds Gallery, London **181** Leon Golub, *White Squad/Disinformation*, 1985. Drawing and newspaper clipping, 155 ⁷/₈ x 126 (22 x 39). Ronald Feldman Gallery, New York, and Anthony Reynolds Gallery, London. Photo David Reynolds **182** David Wojnarowicz, *Globe of the US*, 1990. Mixed media, 41 x 30 (16 x 20). Courtesy of the Estate of David Wojnarowicz and P.P.O.W., New York **185** Edouard Manet, *Boy with Cherries*, 1858-9. Oil on canvas, 67 x 54 (26 ³/₈ x 21 ¹/₄). Calouste Gulbenkian Foundation, Lisbon **187** Edward & Nancy Kienholz, *Still Live*, 1974. Environment for performance: chair, metal container with loaded gun, timer, warning light, barricades, wood, steel, paper, paint and polyester resin, 200 x 1000 x 1000 (78 ³/₄ x 393 ³/₄ x 393 ³/₄). Courtesy L.A. Louver, Venice, CA. © Kienholz Estate **188** Jacob Epstein, *The Rock Drill*, 1913-14. Bronze, 71.1 x 63.5 (28 x 25). Leeds Museums and Galleries (Centre for the Study of Sculpture) **192** Marisa Carnesky, *Jewess Tattooess*. Live performance at The Green Room, Manchester, 25/02/00. By kind permission of the artist. Photo Johnny Volcano **193** Max Ernst, *Totem and Taboo*, 1941. Oil on canvas, 72.5 x 92.5 (28 ¹/₂ x 36 ³/₈). Bayerische Staatsgemäldesammlungen, Staatsgalerie moderner Kunst, Munich. Theo Wormland Stiftung .© ADAGP, Paris and DACS, London 2002 **198 left** Marcel Duchamp, *In Advance of the Broken Arm*,

replica of lost 1915 original. Readymade: snow-shovel, wood and galvanized iron, 121.3 (47 ¾). Philadelphia Museum of Art. The Louise and Walter Arensberg Collection. © Succession Marcel Duchamp/ADAGP, Paris and DACS, London 2002 **198 right** Andy Warhol, *Brillo Boxes*, 1964 and 1968. Serigraphy on wood, each 109.2 x 109.2 x 88.9 (43 x 43 x 35). Sonnabend Collection, New York. © The Andy Warhol Foundation for the Visual Arts, Inc ARS, NY and DACS, London 2002 **199** Jeff Koons, *Inflatable Flower and Bunny*, 1979. Plastic and mirrors, 81.3 x 30.5 x 61.0 (32 x 12 x 24). © Jeff Koons **202** Emese Benczúr, *I Am Doing my Duty*, 1995. Embroidery on curtain sash, 3 x 380 (1 ⅛ x 149 ⅝). Courtesy the Artist **205 above** Mike Bidlo, *Not Andy Warhol (Brillo Boxes)*,1991. Wood, 51 x 51 x 43 (20 ⅛ x 20 ⅛ x 16 ⅞). Courtesy Galerie Bruno Bischofberger, Zurich **205 below** View of Mike Bidlo's studio in New York, 1987. Courtesy Galerie Bruno Bischofberger, Zurich. Photo Beth Phillips, New York **206** John Nava, *Dancer (Teresa)*, 1992. Oil on canvas, 122 x 122 (48 x 48). Courtesy Lizardi Harp Gallery, Pasadena, CA **210** Edouard Manet, *The Execution of Maximilian* (2nd Version), 1867. Oil on canvas, four fragments on a single support, 193 x 284 (76 x 111 ⅞). Reproduced by courtesy of the Trustees of the National Gallery, London **213 above** Jacob Epstein, BMA Building, after being vandalised. Photo Courtauld Institute of Art **213 below** Francis Bacon, *Painting*, 1946. Oil and pastel on linen, 197.8 x 132.1 (77 ⅞ x 52). The Museum of Modern Art, New York. Purchase © Estate of Francis Bacon 2002. All rights reserved, DACS **214** Damien Hirst, *The Physical Impossibility of Death in the Mind of Someone Living*, 1991. Glass, steel, silicone, shark in five per cent formaldehyde solution, 213.4 x 1333.5 x 213.4 (84 x 252 x 84). Courtesy Jay Jopling/White Cube, London. © The artist **215 left** Alighiero Boetti, *Me Sunbathing in Turin on 19 January 1969*, 1969. Cement, butterfly, 175 x 90 (68 ⅞ x 35 ⅜). Archivio Boetti, Rome. Photo Giorgio Colombo. © DACS 2002 **215 right** Ana Mendieta, *Untitled* from the *Silueta* series, Salina Cruz, Mexico, 1973. Colour photograph documenting earth/body work with sand, water and red pigment. Edition of twenty, 50.8 x 40.6 (20 x 16). Courtesy of the Estate of Ana Mendieta and Galerie Lelong, New York **216** Jasper Johns, *Catenary (Manet-Degas)*, 1999. Encaustic and collage on canvas with objects, 96.5 x 145.5 (38 x 57 ¼). Private Collection. © Jasper Johns/VAGA, New York/DACS, London 2002 **217** Jo Spence in collaboration with David Roberts, *Cultural Sniper*, 1990. Colour print, 50 x 70 (19 ⅝ x 27 ½). Courtesy Terry Dennett/Jo Spence Archive Collection **218 above left** Nazi Rally, Graz, 25 July 1938, Bild- und Tonarchiv, Landesmuseum Joanneum, Graz **218 above centre left** Hans Haacke, site for installation *And You Were Victorious, After All*, 1988. Eisernes Tor, Graz, 1988 Photo Hans Haacke. © Hans Haacke. DACS 2002 **218 centre left** Hans Haacke, *And You Were Victorious, After All*, 1988. Eisernes Tor, Graz. Photo Hans Haacke © Hans Haacke. DACS 2002 **218 right** Hans Haacke, *And You Were Victorious, After All*, 1988. Graz, November 3, after arson. Photo Angelika Gradwohl © Hans Haacke. DACS 2002 **219 above** Jochen Gerz and Esther Shàlev-Gerz, *Monument against Fascism*,

1986–93. Hamburg-Harburg. Photo Esther Shàlev-Gerz. **219 below** Jake and Dinos Chapman, *Hell*, 1999–2000 Glass-fibre, plastic and mixed media (nine parts), eight parts: ₂43.84 x 121.92 (96 x 48 x 48)/one part 121.92 x 121.92 x 121.92 (48 x 48 x 48). Courtesy Jay Jopling/White Cube, London © the artist. Photo Stephen White **220 left** Christian Boltanski, *Réserve*, 1990. Black and white photographs, metal lamps, wire, second-hand clothing, 250 x 200 (98 ⅜ x 78 ¾). Courtesy Christian Boltanski & Yvon Lambert. © ADAGP, Paris and DACS, London 2002 **220 right** Christian Boltanski, *Réserve*, 1990. Black and white photographs, metal lamps, wire, tin boxes 240 x 210 (94 ½ x 82 ⅝). Courtesy Christian Boltanski & Yvon Lambert. © ADAGP, Paris and DACS, London 2002 **221** Shimon Attie, *Steinstrasse 22*, 1994. Ektacolour photograph, 50.8 x 61 (20 x 24). Courtesy of Jack Shainman Gallery, New York **223** Joseph Beuys leaving the Academy, 1972. Photo: Bernd Nanninga **226 centre left** Edouard Manet, *Mademoiselle Victorine in the Costume of an Espada*, 1862. Oil on canvas, 165.1 x 127.6 (65 x 50 ¼). The Metropolitan Museum of Art, Bequest of Mrs H.O. Havemeyer, 1929. The H.O. Havemeyer Collection (29.100.53) **226 centre right** Goya, *The Valiant Moor Gazul Is the First to Spear Bulls According to Rules*, from *Tauromaquia*, c. 1815–16. Etching and aquatint, 23 x 35 (9 x 13 ¾). **226 below** Edouard Manet, *Nana*, 1877. Oil on canvas, 154 x 115 (60 ¾ x 45 ¼). Kunsthalle, Hamburg **227** Henri Matisse, *Blue Nude (Souvenir de Biskra)*, 1907. Oil on canvas, 92.1 x 140 (36 ¼ x 55 ⅛). Baltimore Museum of Art, The Cone Collection. © Succession H. Matisse/DACS 2002 **229** Pablo Picasso, *Les Demoiselles d'Avignon*, June–July 1907. Oil on canvas, 243.9 x 233.7 (96 x 92). Museum of Modern Art, New York. Acquired through the Lillie P. Bliss Bequest. Photo © 2002 The Museum of Modern Art, New York. © Succession Picasso/DACS 2002 **230 above** Edouard Manet, *The Escape of Henri Rochefort*, 1880–1. Oil on canvas, 143 x 114 (56 ¼ x 44 ⅞). Kunsthaus, Zurich **230 below** George Wesley Bellows, *Club Night*, 1907. Oil on canvas, 109 x 135 (43 x 53 ⅛). National Gallery of Art, Washington **231 above** Richard Hamilton, *Swingeing London '67*, 1968–9. Acrylic and metal on board, 67.3 x 85.1 (26 ½ x 33 ½). Photo © Tate London 2002. © Richard Hamilton 2002. All Rights Reserved, DACS **231 below** Luis Jimenez Jr, *Border Crossing*, 1988. Fibreglass, 76 x 20.3 x 20.3 (30 x 8 x 8). Lew Allen Gallery, Santa Fe, New Mexico. © ARS, NY and DACS, London 2002 **232** Peter Paul Rubens, *The Rape of the Daughters of Leukippos*, c. 1618. Oil on canvas, 222 x 209 (87 ⅜ x 82 ¼). Alte Pinakothek, Munich **233** Man Ray, *Germaine Berton and the Surrealists*, from *La Révolution surréaliste*, *numéro un*, December 1924. © Man Ray Trust/ADAGP, Paris and DACS, London 2002 **234** Bruce Conner, *BLACK DAHLIA*, 1960. Mixed-media assemblage, 67.9 x 27.3 x 7 (26 ¾ x 10 3/4 x 2 ¾). Collection Walter Hopps, Houston, TX. Photo George Hixson **235 above** Otto Dix, *Sex Murder*, 1922. Watercolour on paper, 61 x 47.5 (24 ⅜ x 18 ¾). Otto Dix Stiftung, Vaduz. A 1922.54. © DACS 2002 **235 below** Hans Bellmer, *The Blue Eye*, 1964. Drawing, 54.5 x 42 (21 ½ x 16 ½). Collection A.F. Petit. © ADAGP, Paris and DACS, London 2002.

Index

Numbers in *italic* refer to illustrations

Abstract Expressionism 42, 94

Adorno, Theodor 11, 225, 227, 228, 229, 231, 234, 235, 254; *Aesthetic Theory* 235; 'Commitment' 229; *Minima Moralia* 222

aesthetic alibi, the 8, 26, 142

AIDS 139, 150, 152

Alan-Bois, Yve 237

Albert, Prince 12

Alexander, Jane 143, 147; *Bom Boys* 143, 143; *Butcher Boys* 143, 143

American Family Association 25

Anderson, Perry: *The Origins of Postmodernity* 201

Andre, Carl 97, 126

Anti-Semitism 193, 195–6, 238; see also Holocaust

anti-Vietnam War art 113, 172

Apollinaire, Guillaume 32, 65, 99, 129, 225, 246

appropriation art 58, 96, 98, 119, 121, 140

Aragon, Louis 127, 157, 161, 162, 232; *Un Cadavre* 157

Arman: *Crusaders* 116, 116

Armory Show, the 45, 227

Arnheim, Rudolf 37

Arp, Hans: *Collage Made According to the Laws of Chance* 107, 107

art and law 7, 8, 9, 21, 26, 119, 128, 140, 188, 190, 191, 224; and money 126, 127, 128; and morality 7, 8, 19, 33, 34, 136–7, 141, 145, 146, 163, 164, 165; and pornography 7, 59–74, 123–4, 179, 249; and propaganda 45, 95, 112, 178, 179, 180

art crimes 7–9, 86–8, 92, 194,

'Art Treasures of England' exhibition, Royal Academy 47

Arte Povera 108, 119

Arte-Reembolso/Art Rebate 175

Art Newspaper 201

Attie, Shimon: *Sites Unseen* 221, 221

Auerbach, Frank 117

avant-garde, the theory of the 98, 198, 200, 201, 225

Avedon, Richard 164

Bacon, Francis 18, 41, 42, 76, 78, 82, 83, 85, 86, 92, 162; *Crucifixion* (1965) 41, 42, 83; *Crucifixion, A* (1933) 83; *Fragment of a Crucifixion* 83, 83; *Painting* 213, 213; *Three Studies for a Crucifixion* 82, 84; *Three Studies for Figures at the Base of a Crucifixion* 83, 84; *Triptych Inspired by T.S.Eliot's Poem 'Sweeney Agonistes'* 82, 85, 85–6

Bakhtin, Mikhail 193, 194, 238; *Rabelais and his World* 193

Barberini Faun, the 69

Barr, Alfred H. 134

Barthes, Roland 96, 122

Barzun, Jacques 194

Bastille, the 161, 200

Bataille, Georges 21–4, 40, 59, 99, 108, 153, 191, 236, 237

Baudelaire, Charles 39, 61, 78, 212, 241; 'Rope, The' 184–5

Baudrillard, Jean 96

Bauman, Zygmunt 171

Baumeister, Willi 172, 176; *Arno Breker's 'The Avenger' with Head Drawn by Willi Baumeister* 172–3, 173

Baydoun, Abbas 244

Bell, Clive 37, 168

Bellmer, Hans 234; *Blue Eye, The* 234, 235

Bellows, George Wesley 108; *Club Night* 230, 231

Benczúr, Emese: *I Am Doing my Duty* 202, 202

Benjamin, Walter 24, 263

Bennett, Jane 49

Berger, John: *Ways of Seeing* 64

Berton, Germaine 232

Beuys, Joseph 44, 128, 169, 225

Bill, Max 107

Bidlo, Mike 204; *Not Andy Warhol (Brillo Box)* 204, 205,

Blackburn, Simon 243, 261

Blake, William 90, 100, 126

Blanchot, Maurice 100, 125, 178

Bloom, Harold 246

body art 50, 114, 124, 152

Boetti, Alighiero 215; *Me Sunbathing in Turin on 19 January 1969* 215, 215–16

Boggs, J.S.G. 128, 224

Boltanski, Christian: *Réserve* 220, 221

Bomberg, David 246; *The Mud Bath* 37, 37

Bonaparte, Joseph 132

Bonnard, Pierre 164

Bono 150

Borges, J.L. 148

Bourdieu, Pierre 262

Bourgeois, Louise 245–6

Boursin, Marie 164

Brancusi, Constantin 43

Braque, Georges 105, 155

Brecht, Bertolt 178

Breker, Arno 172–3

Bretell, Richard 247

Breton, André 21, 47, 110, 126, 127, 143, 154, 156, 160, 162, 164, 194, 224, 225; *Anthology of Black Humour* 194

Bridger, Mark 241–2

Broodthaers, Marcel 106, 127

Brus, Günter 191

Buchanan, John 27

Bunker, Eddie 208

Buñuel, Luis: *Un Chien andalou* 35, 35

Burch, Noel: *Theory of Film Practice* 208

Buren, Daniel 95

Burger, Peter 208–9

Burgin, Victor 95, 169

Bush, President George 25

Cabanel, Alexandre: *Birth of Venus* 61, 61

Camus, Albert 194

canonic defence, the 10, 26–7, 28, 30, 38, 42–8, 49, 51, 129, 146, 219

Carnesky, Marisa: *Jewess Tattooess* 192, 192

carnival 193–4

Caro, Anthony 118

Carrière, Eugène: *Crucifixion* 15, 15

Castoro, Rosemarie 102

Cattelan, Maurizio 201

Cellini, Benvenuto 164

censorship 7, 9, 172, 211

Cézanne, Paul 37, 72; *Rape, The* 72, 73

Chadwick, Helen 146; *Loop my Loop* 139, 139,140

Chagall, Marc 12, 82, 242

Chamberlain, John: *Etruscan Romance* 120, 120–1,

Chandler, Raymond 105

Chapman, Jake and Dinos 181, 219; *Great Deeds against the Dead* 44, 130, 131–3, 258; *Hell* 219, 219–21

Chicago, Judy 169, 250–1; *Birth Project* 119, 119; *Red Flag* 104, 104–5, 250–1

Chirico, Giorgio de 33

Christianity, and Christian iconography 16, 22–3, 27, 28, 60, 75–86, 139, 141, 149, 156, 160, 191, 192

Christo and Jeanne-Claude 119; *Wrapped Coast* 119, 120

Cimabue: *Crucifixion* 84, 85

civil disobedience 113

Clark, Kenneth 43, 60

Clarke, T.J. 24–5

Cold War, the 38, 118

Colescott, Robert: *George Washington Carver Crossing the Delaware: Page from an American History Textbook* 169–70, 170

Colet, Louise 55

Collage of Indignation 172, 172

Collings, Matthew: *This is Modern Art* 129

conceptual art 127

concrete art 107

Conner, Bruce: *BLACK DAHLIA* 232–4, 234

Cook, Captain 149

Corbusier, Le 107

Cork, Richard 45

Corot, J.B.C. 44

Courbet, Gustave 10, 75, 76, 81, 119

Couture, Thomas 165

Cragg, Tony 121

Craig-Martin, Michael 120

Croce, Benedetto 238–9

Cronenberg, David: *Crash* 7

Cubism 106, 115, 121

Dada 127, 153, 154, 204, 226, 228, 234

Dalí, Salvador 110, 111, 126, 134, 160, 206; *Lugubrious Game, The* 110, 110, 162; *Tuna Fishing (Homage to Meissonier)* 134, 135; *Un Chien andalou* 35, 35

Danto, Arthur 50, 114, 122, 164, 174, 188, 202, 203, 239

David, Jacques-Louis: *Marat at his Last Breath* 76, 77

Day, F. Holland: *Crucifixion* 82, 83

dead, respect for the 80, 132, 136, 157, 190, 218

Debord, Guy 95

Degas, Edgar 70, 212, 217, 225

Denes, Agnes 33

Dewey, John: *Art as Experience* 171

Diaghilev, Sergei 225

Dix, Otto 234; *Sex Murder* 234, 235

Documents group, the 153, 191

d'Offay, Anthony 44

Douglas, Mary 147, 192; *Purity and Danger* 147

Dowson, Sir Phillip 47

Dubin, Steven 49–50

Duchamp, Marcel 26, 62, 64, 65, 67, 91, 92, 95, 97, 105, 106, 123, 124, 126, 169, 199; *Etant Donnés* 67, 68, 209; *Fountain* 28, 28, 108, 123, 169; *In Advance of the Broken Arm* 198, 200; *L.H.O.O.Q.* 91, 91, 173; *Nude Descending a Staircase* 67, 67; *The Bride Stripped Bare by her Bachelors, Even* 66, 67

duck-rabbit picture 74, 74, 143

Durkheim, Emile 156

Eakins, Thomas 44, 72, 74–5, 98, 178; *Study of a Seated Woman Wearing a Mask* 71–2, 72

Eco, Umberto 11

Elderfield, John 249–50

Eliot, T.S. 85

Eluard, Paul 161

Emin, Tracey: *My Bed* 45, 45

'end of art' thesis, the 202, 209, 238, 239

Ensor, James 117

Epstein, Jacob: *Rock Drill, The* 188, 188; *Sculptures for the British Medical Association* 213, 213

Ernst, Max 92, 116, 126, 160, 192, 259; *The Virgin Spanking the Christ Child before Three Witnesses: André Breton,*

Paul Eluard, and the Painter 159, 160; *Totem and Taboo* 192, 193
estrangement defence, the 10, 26, 27, 30, 31, 32–6, 49, 51, 95, 134, 219

Fascism 138, 180
Faulkner, William 164
Fautrier, Jean: *Head of a Hostage* 81, 81–82
Fauves, the 46, 115
Feminist art 64–5, 152
Fischl, Eric 72
Flanagan, Barry 104; *Hare on Curly Bell* 105
Flaubert, Gustave 55–6, 63, 222, 229; *Madame Bovary* 55, 63
Formalism 36, 37–8, 132; Russian 31
formalist defence, the 10, 27, 30, 31, 36–42, 49, 51, 219
Foster, Hal 201, 237
Foucault, Michel 20, 96, 236
Fox, Sue: *Untitled (Bitten)* 135–6, 136
France, Anatole 156–7
Franko B 141
Frazer, J.G. 148, 149, 151, 153
Freedberg, David 9
Freeland, Cynthia 147
Freud, Lucian 32; *Painter and Model* 69, 69
Freud, Sigmund 108, 137, 162, 255, 256, 257
Fried, Michael 58, 81, 90–1, 116, 212, 245
Friedlander, Saul 180
Fuller, Peter 83, 97
Fuseli, Henry 90
Futurism 115; Italian 46

Gablik, Suzi 192
Gabo, Naum 106
Gainsborough, Thomas: *Blue Boy* 103, 103
Gauguin, Paul: *La Orana Maria* 75, 76
Gautier, Théophile 78
Gay, Peter 245, 254
Geldzahler, Henry 244
Genette, Gérard 87
Géricault, J.L.A.T. 116
Gerz, Jochen, and Shàlev-Gerz, Esther: *Monument against Fascism* 218–19, 219
Gestapo, the 173
Gilbert and George 44, 108, 109, 111; *Naked Shit Pictures, The* 45; *New Testamental Pictures* 109; *Spit on Shit* 109, 109–10
Giorgione 43, 90; *Fête champêtre* 89, 89
Giuliani, Mayor Rudolph 137
Gleizes, Albert 53, 116
Goddess of Democracy 171, 171
Goebbels, Joseph 112, 178
Gogh, Vincent Van: *The Sower* 81, 81
Golub, Leon 12, 128, 172, 178–81, 182, 254; *Interrogation II* 178–9, 179; *White Squad/Disinformation* 180–1, 181
Gombrich, E.H. 32, 43, 44, 103, 226, 240

Goncourt brothers, the 16
Goodman, Nelson 244
Gotovac, Tomislav 222
Gottlieb, Adolph 32
Gowing, Lawrence 83, 92
Goya, Francisco 129, 131, 132, 137, 152, 154, 182, 185, 226; *Caprichos, Los* 131; *The Sleep of Reason Produces Monsters* 129; *Disasters of War* series: *Grande hazaña con muertos (Great Deeds! Against the Dead!)* 130, 132; *One Can't Look* 133, 133; *Tauromaquia* series: *The Valiant Moor Gazul Is the First to Spear Bulls According to Rules* 226, 226
graffiti 8
Great Exhibition, the 12
Greenberg, Clement 38, 240
Gropius, Walter 126
Grosz, George 69, 172, 180, 234; *Homage to Oskar Panizza* 118, 119
Group Material 102
Grünfeld, Thomas: *Misfit (Cow)* 143, 144
Gurstein, Rachel 209

Haacke, Hans 174, 176, 188, 218; *Shapolsky et al. Manhattan Real Estate Holdings, a Real-Time Social System, as of May 1 1971* 174, 175; *And You Were Victorious After All* 218
Habermas, Jürgen 183
Hamilton, Richard 65; *Just What Is It That Makes Today's Homes So Different, So Appealing?* 65, 65; *Swingeing London '67* 231, 231
Haraszti, Miklos 265
Harrison, Newton 257
Hartman, Geoffrey 221
Harvey, Marcus: *Myra* 7, 165–7, 166
Hegel, G.W.F. 10, 78, 202, 238, 241
Herodotus 196
Hindley, Myra 7, 165–7, 166
Hirschman, Albert O. 244
Hirst, Damien 20, 145, 162; *Mother and Child, Divided* 142, 142, 143; *Physical Impossibility of Death in the Mind of Someone Living, The* 214, 214
Hitler, Adolf 173
Holbach, Paul d' 156
Hollier, Denis 64
Holmes, A.M.: *The End of Alice* 7
Holocaust, the 193, 197, 217, 219, 221
Holocaust denial 220
Holzer, Jenny 95
Hooks, Bell 19, 237
Homer 115
Horkheimer, Max 254
Hughes, Robert 50, 89, 114, 160
Hugnet, Georges 26
Huxley, Aldous 152

iconoclasm 25, 88, 97, 125, 178, 194, 214, 225
Impressionism 44

Independants, the New York 123
Indépendants, Salon des 67
Ingres, J.A.D. 90
installation art 117
intertextuality 208
Isaacs, John: *Say It Isn't So* 144, 144

Jagger, Mick 231
Jarry, Alfred: *Ubu Roi* 108
Jimenez Jr, Luis: *Border Crossing* 231, 231
John, St 17
Johns, Jasper 217; *Catenary (Manet–Degas)* 216, 217; *Map* 12, 13
Joseph, Emperor Franz 210
Jouffroy, Alain 222
Judaism 72, 139, 147, 149, 192

Kandinsky, Wassily 20, 183
Kant, Immanuel 35–6, 74, 105, 183, 244
Kaprow, Allen 126
Kauffman, Linda S. 237
Keats, John 164
Kennedy, Robert 256
Khrushchev, President Nikita 113
Kiefer, Anselm 177, 204, 260; *Occupations* 176, 177; *Untitled (Heroic Symbols)* 176, 177
Kienholz, Edward and Nancy 199; *Still Live* 187, 198, 212
Klee, Paul 18
Klimt, Gustav 213; *Jurisprudence* 21, 62, 63, 213; *Medicine* 62, 63, 213; *Philosophy* 62, 63
Kolakowski, Leszek 145; 'On Superstition' 189
Kooning, Willem de 42, 93, 94, 104
Koons, Jeff 97, 199; *Inflatable Flower and Bunny* 199, 200; *Made in Heaven* series 64; *String of Puppies* 97, 97
Kosher Luncheon Club 195
Kosuth, Joseph 46, 94; *The Brooklyn Museum Collection: The Play of the Unmentionable* 46, 46
Kovno 195–6
Kraus, Karl 21
Krauss, Rosalind 38, 95, 96, 122, 143, 237, 246–7; *Grids* 121; 'Originality of the Avant-Garde, The' 96
Kristeva, Julia 23–4, 237
Krog, Antje 243
Kruger, Barbara 98; *Untitled (Your Gaze Hits the Side of my Face)* 98
Kuspit, Donald 202

LaCapra, Dominick 221
Laocoön 142, 142
Latham, John: *Untitled Wall Relief* 195
Lautréamont, Comte de 158
Lawson, Richard 95
Léger, Fernand 119
Leiris, Michel 118
Levine, Sherrie 96, 97, 98; *After Walker Evans #19* 96, 96; *Buddha* 96, 96; *Fountain/After Marcel Duchamp* 49, 49

Levinson, Jerrold 47
Lichtenberg, G.C. 20, 155
Lippard, Lucy 127, 152, 237–8
Lippmann, Walter: *A Preface to Politics* 150
Lissitzky, El 43
Lyotard, J.-F. 33

McLuhan, Marshall 54
Mach, David 127
MacIntyre, Alasdair 255
Magritte, René 32, 158; *Battle of the Argonne, The* 161, 161; *Menaced Assassin, The* 157, 157, 158; *Treachery of Images, The* 28, 28
Malevich, Kasimir 28, 98, 117, 118
Mallarmé, Stéphane 60
Malraux, André 39, 76, 105, 114, 118, 201, 240
Manet, Édouard 10, 11, 36, 39, 40, 43, 44, 50, 53, 57–62, 64, 67, 68, 69, 70, 72, 74, 75, 76, 78, 80, 82, 90, 91, 92, 95, 114, 117, 155, 185, 186, 211, 212, 217, 226; *Absinthe Drinker, The* 165, 165; *Balcony, The* 39, 91; *Bar des Folies-Bergère* 39; *Boy with Cherries* 184–5, 184; *Bullfight, The* 155, 155; *Dead Christ and the Angels, The* 19, 58, 60, 76, 78, 79, 80, 91; *Déjeuner sur l'herbe, Le* 19, 39, 43, 52, 53, 58, 67, 89, 89, 90, 91, 158, 212; *Escape of Henri Rochefort, The* 230, 231; *Execution of Maximilian, The*, Mannheim version (1868–9) 40, 40; *Execution of Maximilian, The*, London version (1867) 210, 211, 212, 213, 217; *Jesus Mocked by Soldiers* 58, 67, 76, 78; *Mademoiselle Victorine in the Costume of an Espada* 226, 226; *Nana* 226, 226; *Olympia* 39, 58, 59–60, 59, 61, 67, 69, 70, 76, 114, 212; *Portrait of M. and Mme Auguste Manet* 57–8, 58
Mann, Sally: *Virginia at 6* 141
Mantegna, Andrea: *The Dead Christ* 80, 81; *The Man of Sorrows with Two Angels* 91, 91
Manzoni, Piero 108
Mapplethorpe, Robert 41, 49, 50, 150, 163, 181, 186; *Self-Portrait* 50–1, 51
Marat, Jean-Paul 194
Marc, Franz 115
Marcuse, Herbert 174; *A Critique of Pure Tolerance* 174; *One-Dimensional Man* 174
Margolis, Joseph 43, 245
Marx, Karl 201
Marxism 35, 178
Masson, André 118
Matisse, Henri 70, 226–7; *Blue Nude* 227, 227; *Nude with a White Scarf* 69–70, 69; *Painter and his Studio, The* 70, 70
Matta-Clark, Gordon: *Splitting* 121, 121
Mauss, Marcel 23

Maximilian, Archduke Ferdinand 210–11
McCarthy, Paul 34, 163, 191, 207; *Cultural Gothic* 163, 163; *Garden, The* 163, 163, 207; *Spaghetti Man* 144
Mendieta, Ana: *Silueta* series: *Untitled* 215, 215–16
Merleau-Ponty, Maurice 85
Merz, Mario 108
Metaphysical painters, the 115
Metzger, Gustav 125, 127
Metzinger, Jean 53, 116
Michelangelo Buonarroti 45
Millet, Jean-François: *The Sower* 81, 81
Milton, John: *Paradise Lost* 17
Miramon, General 211
Miró, Joan 111, 119, 126, 207, 226; *Man and Woman in Front of a Pile of Excrement* 110, 110
Monchiaté, René 164
Mondrian, Piet 30, 36, 37, 48, 107
Moscow 'Bulldozer' show, the 113
Motherwell, Robert 92
Mueck, Ron: *Dead Dad* 80, 80
Muehl, Otto 224
Murdoch, Iris 54, 75, 181
'museum effect, the' 213

Napoleon III 210–11
National Endowment for the Arts 25, 175
Nava, John: *Dancer (Teresa)* 204, 206
Nazism 28, 43, 150, 173, 177, 221, 231, 261
Newman, Barnett 48
Nietzsche, Friedrich 28, 65, 115, 146, 148, 151, 154, 155, 229; *Daybreak: Thoughts on the Prejudices of Morality* 151; *Ecce Homo* 28, 151; *Human, All Too Human* 115, 152
Nisbet, Robert 156
Nitsch, Hermann 147
Noel-Kelly, Anthony 190, 261
Nolde, Emil 229
Nozière, Violette 232

Ofili, Chris 108, 201
Oldenburg, Claes 74, 119, 208
Oppenheim, Meret: *Objet: Déjeuner en fourrure* 158, 158–9
Orlan 140, 141, 257
Ortiz, August 257
Orton, Fred 249
Oupeinpo 107
Ozenfant, Amédée 200, 201, 248; *Foundations of Modern Art* 200

Paolini, Giulio: *Untitled* 116
Paul, St 17, 192
Paz, Octavio 67
Peninsular War, the 220
People for the American Way 28

Peppiat, Michael 252
performance art 50, 114, 127, 146
perspective 115–16, 117, 226
Picabia, Francis 47; *Cacodylic Eye, The* 101, 127
Picasso, Pablo 43, 45, 70, 75, 92, 99, 103, 105, 119, 126, 155, 164, 172; *Demoiselles d'Avignon, Les* 229, 229; *Guernica* 82, 82; *Le Déjeuner sur l'herbe after Manet* 92, 92; *Painter and Model (24 December 1953)* 71, 71; *Painter and Model (25 December 1953)* 71, 71; *Sculptor and Reclining Model/ Viewing Sculptured Head* 70–1, 71; *Still Life with Chair Caning* 105, 105
Ping, Huang Yong 145, 146; *Le Théâtre du monde* 140
Pinter, Harold: *New World Order* 179
plagiarism 8, 87, 88, 97
Plato 8; *Philebus* 38–9
Political Art Documentation/ Distribution 127
Pollock, Jackson 138
Pop art 62, 65, 74, 90
Poussin, Nicolas 161
Prince, Richard 96
Prodigy: 'Smack My Bitch Up' 7
Prokofiev, Sergei 38
Proust, Antonin 43, 61, 212
Purism 107
Pygmalion 65

Raimondi, Marcantonio: *Judgment of Paris, The* 89, 89
Raphael 90
Rauschenberg, Robert 93, 94, 171; *Bed* 45, 45; *Erased de Kooning Drawing* 93; *Mexican Canary/ROCI Mexico* 170, 171
Ray, Man 67, 116; *Untitled* 34, 34; *Monument to de Sade* 160, 160; *Marcel Duchamp as Rrose Sélavy* 67, 67; *Germaine Berton and the Surrealists* 232, 233
Rayonism 115
Refusés, Salon des 54, 89
Reinhardt, Ad 93, 94, 95, 98; *Twelve Rules for a New Academy* 124
Renan, Ernest 80
repressive tolerance, the theory of 174
Revolution, the February 1848 24
Reynolds, Joshua 103, 241
Richter, Hans 153
Riegl, Alois 38
Riem, Andreas 154, 155
Rimbaud, Arthur 146, 156, 157; *Les Illuminations* 146
Ringold, Faith: *The Flag is Bleeding* 177
Ris, Clément de 24
Rogers, Art 97
Romanticism 19

Rosenberg, Harold 37, 42, 48, 67, 92, 105, 115, 240
Rosenthal, Norman 8, 167
Roth, Philip 25
Rothko, Mark 32
Rubens, Peter Paul: *Rape of the Daughters of Leukippos, The* 232, 232
Rushdie, Salman 144, 244; *The Satanic Verses* 20, 30, 144
Ruskin, John 88, 123

Sade, Marquis de 161, 194
Salle, David 72, 98; *Saltimbanques* 72, 73
Sandler, Irving 64
Sargisson, Lucy 238
Savadov, Arsen, and Georgy Senchenko: *Bloody Mary* 144, 144
Scarry, Elaine 190
Schaeffer, Jean-Marie 122, 239
Schama, Simon 200
Schamberg, Morton: *God* 28, 28
Scher, Julia 164
Schiele, Egon 44, 224
Schiller, Friedrich 19–20
Schlemmer, Oskar 178
Schlichter, Rudolf 234
Schneemann, Carolee 112
Schwitters, Kurt 43
Scott, Dread: *What Is the Proper Way to Display a U.S. Flag?* 16, 16
Senchenko, Georgy, and Arsen Savadov: *Bloody Mary* 144, 144
'Sensation' exhibition, Royal Academy 7, 8, 47, 201
Serra, Richard 26; *Tilted Arc* 43, 43
Serrano, Andres 15, 26, 30, 50, 136, 160; *Milk, Blood* 30, 138, 138–9; *Piss Christ* 14, 15–16, 17, 25–30, 50, 51, 81, 114, 160; *The Morgue (Knifed to Death I)* 136, 136
Shahn, Ben 168
Shàlev-Gerz, Esther, and Jochen Gerz: *Monument against Fascism* 218–19, 219
Sherman, Cindy 201
Shklovsky, Viktor 31
Sidgwick, Henry: *History of Ethics* 149
Simmel, Georg 156
Situationism 95
Smith, David 134, 235
Smith, W. Robertson: *The Religion of the Semites* 149
Smithson, Robert 184, 201; *Spiral Jetty* 125, 125
Socialist Realism 38, 162
sociology 22, 156
Socrates 154
Sokal, Alan 236
Sontag, Susan 180, 221, 234, 246
South African Constitution, the 19
Spence, Jo: *Cultural Sniper* 217, 217

Spengler, Oswald 90
Spero, Nancy 96
Staeck, Klaus: 'Beware Art!' 167, 167
Stallybrass, Peter 238
Steinbach, Haim 97
Steinberg, Leo 38
Steiner, Wendy 39, 41
Stella, Frank: *Die Fahne Hoch!* 28, 29
Stendhal 154
Stoller, Ilona 200
Surrealism 34, 38, 111, 114, 118, 123, 127, 143, 156, 158, 160, 161, 162, 163, 178, 183, 194, 197, 206, 224, 232, 234
Sylvester, David 41, 82–3, 85, 92, 94, 197, 203, 214, 240

Tarantino, Quentin 41, 208
Tatlin, Vladimir 43
Thoré, Théophile 54, 80, 155
Tice, Clara 224
Tierney, Lawrence 208
Tinguely, Jean 122
Turner, J.M.W. 45
Turner Prize, the 45
Tyshler, Alexander 38
Tzara, Tristan 153, 226

Uecker, Gunther 191

Vasari, Giorgio 102
Vendova, Emilio 102
Vienna Actionism 35, 147, 191, 224
Vlaminck, Maurice de 225
Voltaire 150–1, 155

Wagner, Richard 53
Walcott, Derek 48
Wallinger, Mark: *A Real Work of Art* 204
Warburg, Aby 90
Warhol, Andy 28, 44, 128, 199, 207; *Brillo Boxes* 198, 200, 203; *$ series* 128
Weber, Max 156
Wesselman, Tom: *Little Great American Nude #6* 74, 74
White, Allon 238, 252
Wilde, Oscar 164
Williams, Raymond 243
Wilson-Bareau, Juliet 57
Wittgenstein, Ludwig: duck-rabbit picture 74
Wojnarowicz, David 149, 152; *Globe of the US* 182, 182–3
Wölfflin, Heinrich 38
Wordsworth, William 195
World War I 151, 152
World War II 220

Zheltovsky 113
Zola, Emile 39, 40, 61, 212
Zorio, Gilberto 20, 225